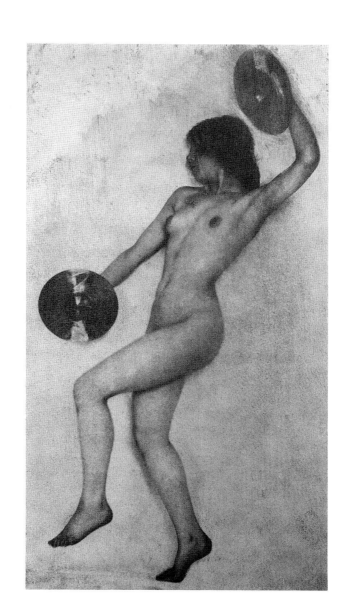

William A. Ewing

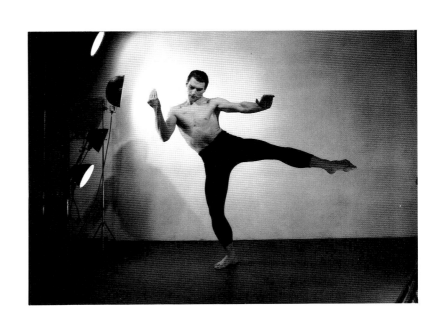

Masterpieces of

with 233 illustrations, 208 in duotone

THE FUGITIVE GESTURE

Dance Photography

Thames and Hudson

Half-title: *L'Allegro*, by William B. Dyer, 1902

Titlepage: Martha Graham and Erick Hawkins,
contact prints by Barbara Morgan, 1939

Page 6: Self-portrait with Daniel Ezralow
and David Parsons, by Lois Greenfield, 1983

© 1987 Thames and Hudson Ltd, London

Printed and bound in Japan

Contents

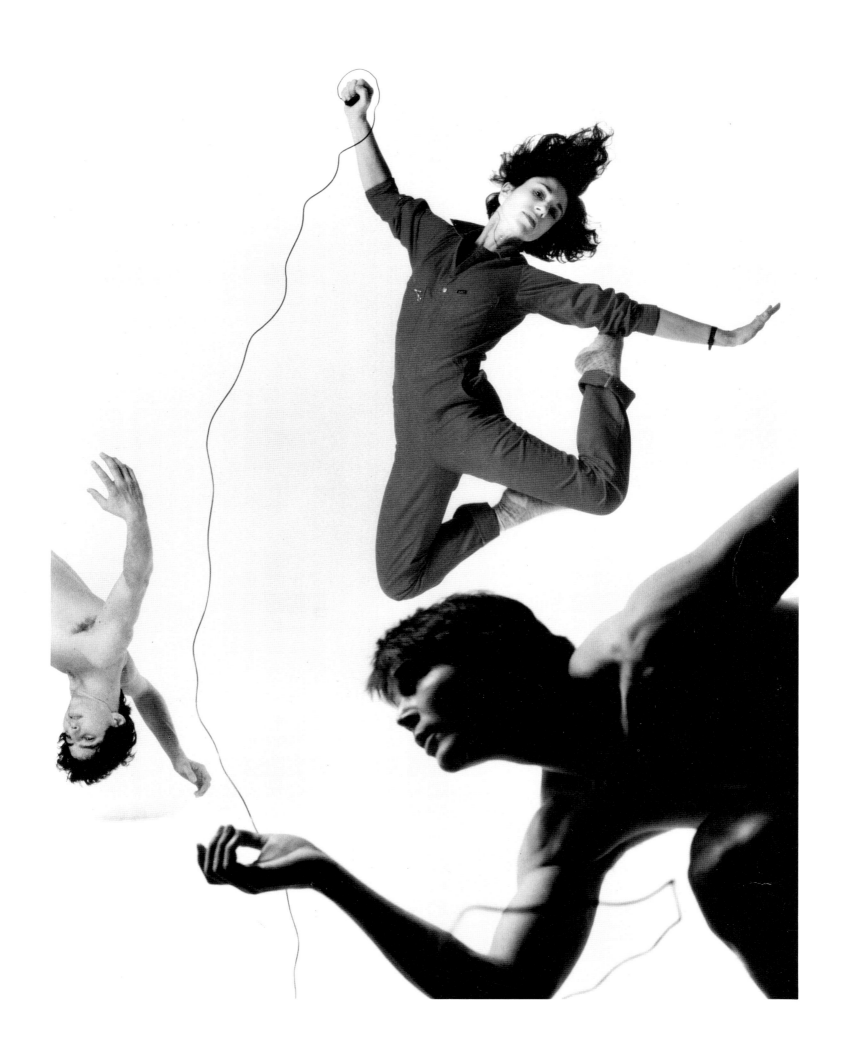

The Photographers

James Abbe
Lucien Aigner
Wayne Albee
Aldene Studio
Gordon Anthony
Ollie Atkins

Baruch Studio
Cecil Beaton
Lou Goodale Bigelow
Ilse Bing
Margaret Bourke-White
Bill Brandt
Brassai
Alexei Brodovitch
David Buckland
René Burri
Joseph Byron

Cornell Capa
Jean-Philippe Charbonnier
Yvonne Chevalier
William Coupon
Imogen Cunningham

Bruce Davidson
Lynn Davis
Edgar Degas
Robert Demachy
Baron Adolphe de Meyer
André Adolphe Eugène Disdéri
Robert Doisneau
František Drtikol
Pierre Dubreuil
William B. Dyer

Arthur Elgort
Harry Ellis
Hugo Erfurth
Walker Evans
Larry Fink

George Fiske
Martin Frič

Arnold Genthe
Gerschel Studio
Bob Golden
Lois Greenfield
John Gutmann

Philippe Halsman
Ira Hill
Paul Himmel
Lewis Hine
Emil Otto Hoppé
Horst
George Hoyningen-Huene
Eugene Hutchinson

Lotte Jacobi
William James

Arthur Kales
André Kertész
Rudolph Koppitz

Lafayette Studio
Larss and Duclos Studio
Jacques Henri Lartigue
Lomen Brothers Studio
George Platt Lynes

Robert Mapplethorpe
Etienne-Jules Marey
Gjon Mili
Herman Mishkin
Jack Mitchell
Peter Moore
Barbara Morgan
Alphonse Mucha
Martin Munkacsi
Nickolas Muray

Eadweard Muybridge

Nadar
Arnold Newman
Helmut Newton
William Notman and Son Studio

Toby Old
Walter E. Owen

Bertram Park
Jack A. Partington
Karel Paspa
Irving Penn

Man Ray
Théodore Rivière
Charlotte Rudolph

August Sander
Aaron Siskind
Edward Steichen
Bert Stern
Soichi Sunami

Al Taylor
Edwin F. Townsend

Jan Unger

James Van Der Zee
C. Van Wagen

Max Waldman
Dan Weiner
White Studio
Witzel Studio

Christina Yuin

Count Zichy

and seventeen unidentified photographers

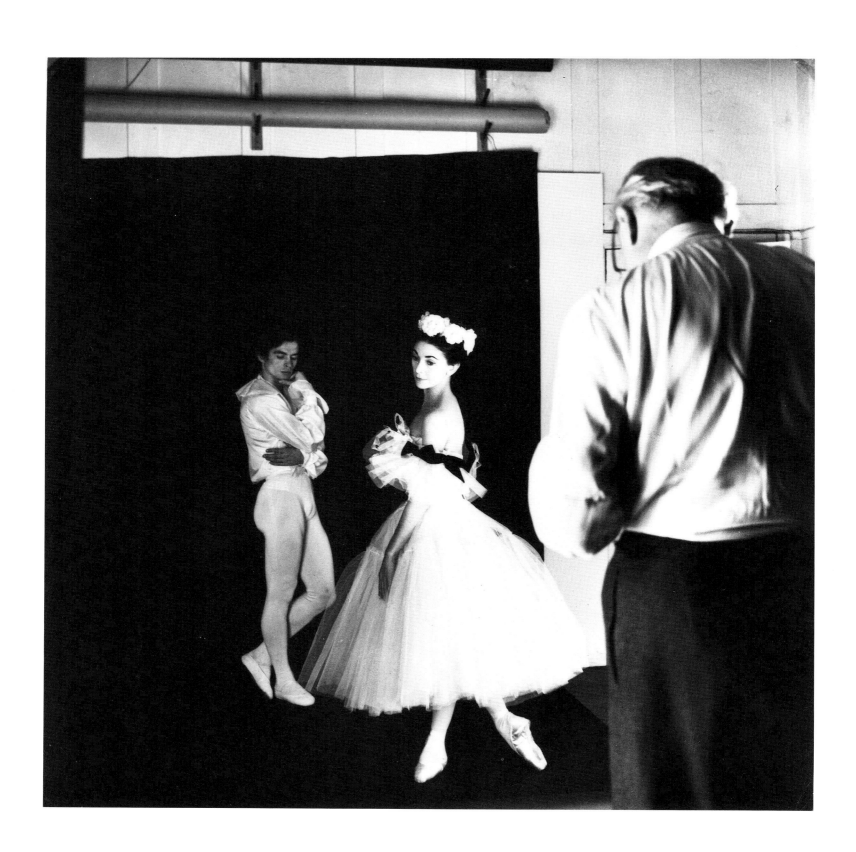

Foreword

WHAT MAKES A GREAT DANCE PHOTOGRAPH? To the balletomane, a great photograph shows a celebrated ballerina, in classic tutu, performing a flawless *arabesque* or in seemingly effortless flight, wearing an expression of otherworldly serenity; or, if a male dancer, in muscle-revealing tights and incredible *elévation*, the very essence of virility. 'Such a picture', writes dance photographer Anthony Crickmay, 'is popular with editors and will . . . always find a public.'

When I began my search for the photographs in this book these were the pictures that balletomanes, dancers and professional dance photographers showed me with enthusiasm. I was more often than not disappointed. I found the majority of these pictures stiff and artificial – simply not credible. I could see that the dancer's identity was a central concern to my guides, triggering all sorts of associations which had little to do with the strengths of the images themselves; to my mind, these photographs were a means of satiating a hunger for idols. The photographic images were icons, little two-dimensional shrines at which to worship not the art, but the cult, of the dance. On this score I had many arguments; when I found fault with a picture, it was as if I were criticizing the subject itself. But why should a great dancer automatically make a great dance photograph any more than an exquisite Chanel ensemble automatically makes a great fashion photograph? In fact, as a number of photographers have explained to me, some dance is simply not photogenic. The choreography of Twyla Tharp, for example, does not slice up easily into coherent split seconds. But the arguments were never resolved, because their basis was, in a manner of speaking, faith: they were talking about the dance, as seen through the window of photography, and I was talking about the nature of the window itself.

I could sympathize, of course. The dancer's art is fugitive, leaving nothing of permanence except these fragments, a few hundredths of a second to represent an entire career. Can we blame a dancer for making great demands of them? Even fame cannot confer immortality; as great a name as George Balanchine recognized that photographs were all that would remain of his art in a hundred years.

I also found myself – to a lesser degree – at odds with dance critics. To David Linder, who in 1979 devoted an entire issue of *Dance Life* to the subject, photography was an aid, like opera glasses: 'To see better. To see more of what is happening so fast on the stage. This is what the thinking viewer is after.' Furthermore, he argues that photographs can take the place of 'uneconomical' writing and lend authority to an argument because they seem to be objective description (whereas writing's subjectivity is taken for granted). Others have demanded even more of photography; writing of a 1890 series of Pierina Legnani pictures, Anthony Crickmay explains: 'None of the Legnani photographs would be accepted by a dance publication today, for no attempt has been made to improve on the balletic position or to prettify the feet.' That is, we are not to be content with photography as documentation, but must enlist the medium as propaganda.

Robert Greskovic, who has written about photographs with insight in recent dance publications, still sees them as 'frozen fragments of first-hand fleeting experiences', best appreciated after experiencing the performance itself. The

Rudolph Nureyev and Margot Fonteyn with Cecil Beaton, photographed by a studio assistant, *c.* 1965.

Many outstanding dance photographs survive only in the pages of newspapers or magazines. This anonymous photograph of Serge Lifar in the south of France is preserved as a newspaper clipping, probably of the 1920s.

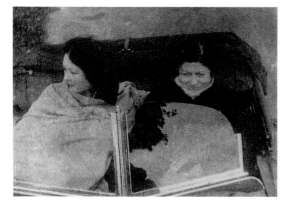

Isadora Duncan (left) in the car in which she died. Anonymous photographer, 1927.

renowned dance critic Edwin Denby would have agreed; he had praise for Baron de Meyer's studies of Nijinsky in *L'Après-midi d'un faune*, because they forcefully demonstrated Nijinsky's 'luminous dance intelligence'. But when it came to the expressive aspirations of photographers, Denby had nothing but scorn:

A dancer on stage doesn't look strained and she isn't a dry, amoeba-shaped blob, a configuration of swirls of cloth and rigid muscles and swollen veins fixed forever in a small square of nothing, like a specimen on a slide. The dancer isolated in the camera field seems to be hanging in a void, in a nowhere.

And as for depicting movement, there was no sense even trying, for 'the more painstaking [the movement], the more pointless the effect. You don't see the change in the movement, so you don't see the rhythm, which is dancing.'

It would appear that critics are quite content with photography's status as handmaiden to the dance. 'It is the duty of the photographer,' lectured Elizabeth McCausland in a 1937 issue of *Dance Observer*, 'to find the resolution to [technical problems] . . . No art form needs the friendly collateral support of photography as does the dance.'

I believe dance photography to be more than opera glasses, more than a supply of icons, more than a diminished reflection of the dance. At its best it takes on an artistic life of its own; its four sides frame a tiny theatre, it is an independent medium subject to its own laws. Photography may serve the dance without being subservient. Thinking about this independence, I realized that dance photography, no less than dance, can be regarded as a language, with a vocabulary, grammar and syntax. What is more, a true appreciation is only possible within these terms. The iconic and documentary are among these terms, or functions, but by no means exhaust the expressive potential of the language. Photographers have never been bound by the stage, or even by the studio. They peer backstage into dressing and rehearsal rooms, roam the streets for spontaneous gestures and search out the latest crazes in ballrooms and discothèques. They travel across cultures to record the Eskimo Dance of Triumph and the dances brought from many countries to Ellis Island. And looking at these images, the viewer travels in time back and forth over 150 years. Whatever photography is in relation to the dance, it is not itself a fugitive art.

And so we return to our initial question: what is a great dance photograph? It seems to me that ultimately a dance photograph must be judged with the same standards as any photograph; that is, no special allowance can be made, no handicap given, for subject matter. Edward Steichen's study of Isadora Duncan in the portal of the Parthenon (plate 161) must stand comparison with Alfred Stieglitz's *The Steerage*, and it does. George Platt Lynes's photographs of *Orpheus* (plates 148–151) must compare with Edward Weston's studies of *Peppers*, and they do; Barbara Morgan's *War Theme* (plate 152) must stand up to Robert Capa's *Death of a Spanish Loyalist Soldier* – and it does. But 'the masterpiece' – and no one, I should think, would dispute the term in these instances – is only another one of the terms in our 'language'. By itself, it is not sufficient to embrace the full range of photographic achievement. Should we ignore the equally valid – if artless and naive – snapshot? What of the photograph shown here, of Isadora Duncan in her car shortly before she was strangled by her scarf as it caught in the spokes of the wheel? It is truly a shocking image, but only for what we bring to it. Our horror comes from knowing what is about to happen, and yet being powerless to stop it. The photograph may seem accessible, but the moment we try to enter its space and time we hit an invisible barrier.

Perhaps our appreciation is diminished if we insist on thinking in terms of a hierarchy of values: 'masterpiece', 'snapshot' and so on. Perhaps it is better to think in terms not of 'great' photographs but of 'extraordinary' ones, a less heated and more flexible concept. This book, then, is a celebration of the art and craft of dance photography, with the net cast wide over genre, geography and

time. It is the result of a search for the extraordinary – the pioneering, the ingenious, the accomplished and the fortuitous – photography as invention, record, icon, collaboration and masterpiece. The plates have been organized with this scheme in mind.

A photograph can carry many messages, however – more than this framework may imply. George Platt Lynes's mock-heroic portrait of Balanchine could have been placed in the 'Invention' section, and it may just as easily be considered as a 'tour-de-force'. But I think an argument can be made for its primary function being iconic – or iconoclastic – and I have placed it there. The idea of the sections is constantly to remind the reader of photography's many and varied functions.

At some point well into my research I realized that the most dynamic pictures were generally created at the extremes of a continuum: either they were made in intense and sustained collaboration with a dancer or choreographer, or they were made without the dancer's awareness. But the in-and-out service of the commercial studio photographer was unlikely to produce extraordinary results. As for in-performance pictures and those which resulted from 'photo calls', they were even less likely to result in impressive pictures. It is more likely to have been the fiercely independent spirits that have produced the most noteworthy work. Take, for example, Ilse Bing, the German-born photographer known for her pioneering work in 1930s Paris. Like her illustrious colleagues Brassai, Lucien Aigner and Henri Cartier-Bresson, Bing made use of the latest miniature cameras and fast film (she was the first to have it imported from Germany) to portray dance candidly, as it would appear to any casual observer. During a visit to her apartment in Manhattan, I showed her a picture from the same period by a well-known studio photographer. The treatment of the subject, weighed down with nineteenth-century props and heavily retouched, provoked her wrath. 'That!' she exclaimed, jabbing at the picture with her finger, '*That* is what we were fighting against!'

Although this book ranges over the history of dance photography from the age of the daguerreotype to the present, I cannot maintain that it is a complete history, for I do not believe that such a history can be written until we have a fuller overview of the field, and know where to look for the contributions of Arthur Kales, Walter E. Owen, Wayne Albee and a host of other superb practitioners largely unrecognized today. The terrain can't be mapped if it hasn't been explored.

Perhaps it never will be. One of the great myths about photography concerns its supposed unlimited reproducibility, from which we infer that there are many copies of any particular image floating around in archives. I can think of no bigger gap between theory and practice. Photographers seldom make more than a print or two from a given negative, sheer boredom being a curb. In fact, I would be hard pressed to find a second print of almost any image in this book more than a few years old. But believing in the myth of unlimited reproducibility, people are inclined to conserve and treasure photographs less than paintings, drawings and prints. It is true that a dance photographer's work, at least in this century, may appear in a host of dance magazines, but these too are ephemeral, and more often than not the photographs were carelessly cropped, badly reproduced and even unattributed – a photographer's legacy scattered to the winds. In this sense photography, like the dance, can be a fugitive art.

Nevertheless, the field is immensely rich. Even the masters, whose work we think we know (Barbara Morgan, Edward Steichen, André Kertész) hold surprises in store. In archives the world over are hundreds of thousands of dance pictures. To reproduce the holdings of the Dance Collection of the New York Public Library, for example, we would be required to print 1,500 volumes the size of this book. The Paris Opéra might require an equivalent number. But although this vast terrain has yet to be fully explored, nothing prevents us from making a thrilling reconaissance flight.

Introduction: The Twin Arts

On a cold February day in 1915, Anna Pavlova, the great Russian *prima ballerina*, arrived at the Manhattan studio of Herman Mishkin, a well-known photographer of theatre and dance. Undoubtedly she was accompanied by an entourage of anxious agents, well-heeled sycophants and aggressive members of the press. The dancer had been pleased with Mishkin's earlier work for her, which included photographs of her in *The Swan*, and she was returning with *Dragonfly*, which she had choreographed in Russia the summer before. She had already performed this 'balletic vignette', as she called it, before English audiences and hoped to repeat her success on this, her second American tour. The citizens of New York certainly knew they were going to see the greatest dancer in the world. Spiritually, Pavlova was following in the footsteps of the legendary Marie Taglioni – following, in Lincoln Kirstein's words, 'the brilliant, dangerous tradition of modern virtuosity'. She could be certain that Mishkin's pictures would do nothing to dispel her mythic aura when they were splashed across the pages of the dailies. Between a majestic, stormy backdrop true to the Romantic era and another nineteenth-century relic – an imposing large-format plate camera with its extensions and accoutrements – she performed her *attitudes* and *arabesques*, holding her poses for twenty seconds or longer.

No one seemed to mind that the same backdrop had been used often in the past, nor that its tone was antithetical to the mood of *Dragonfly*, which was meant to be light and sunny. (In fact, whether he knew it or not, the picture-making tradition guiding the photographer was that of the wildly popular phantasmagorical lithographs of the Romantic Ballet nearly a hundred years earlier.) Yet, by the standards of the day, the picture was highly accomplished. If a clothesline was required to prop Pavlova up for the long exposure, as it was for *The Swan*, it has been expertly retouched. The pose is graceful, light and seemingly effortless; the delicate fabric flutters as if caught by the breeze. The dancer cleverly exhibits the wings, bringing up the right in perfect counterpoint to the supporting leg. Pictorially speaking, it is this long, unbroken line, from the tip of the wing downward to the pointed toe which gives the image its axis or anchor and enhances the feeling of Pavlova's exquisite balance and control.

But isn't the point itself a little *too* perfect? On examination it becomes evident that its miraculous sharpness owes more to the retoucher's art than it does to that of the dancer. Surely a ballerina of Pavlova's stature would not require this kind of crude intervention? In fact she did, but not because of any deficiency on her part. It was a result of the demands of her admirers, who were conditioned to expect from a photograph both what they had seen on the stage, and what they expected to see in a picture. If photographic truth did not conform to these expectations, it would simply have to be altered.

To clarify this, let us recall the meaning of the *pointe*. We must remember that it was of relatively recent invention. With the Romantic movement of the early nineteenth century, artists had turned to medieval legends and fairy tales, depicting man as torn between spirit and flesh. Lovely creatures of the air came down to

Anna Pavlova in her solo *Dragonfly*, by Herman Mishkin, 1915.

earth and fell in love with mortal men, while dead maidens rose from their graves. The earliest of these ethereal creatures flew across the stage by means of wires, the kind of breathtaking theatricality audiences have always loved. When the novelty wore off, wires were found to be bothersome, and dancers began to think of alternatives in keeping with other newly developed techniques of the art. It was only natural that dancers would rise up onto their toes, and in this they were soon helped by the reinforced slipper. When Taglioni danced *sur la pointe* in *La Sylphide* in 1832, audiences were riveted. What they saw seemed to be a new form of human locomotion. By Pavlova's time, every ballerina could perform the feat as standard practice; it had become – like the tutu – part of the quintessence of dance itself.

Balletomanes would have been dismayed by Mishkin's undoctored photograph, for it did not conform to the expectations that had been created by first-hand experience in the theatre and the pictorial conventions well established in drawings and prints. A dancer, like a magician, must keep an audience at a distance if illusions are to be maintained. The camera violated this distance, it pushed too close, and the illusion shattered. Consequently, it had to be reintroduced by hand.

Pavlova understood all this better than anyone. She knew that her myth would be preserved largely in photographs. 'Abbe', she once confided to a favoured photographer, 'my art will die with me. Yours will live on when you are gone.' She always insisted on final approval of prints and even on occasion demanded that one of her own party dictate viewpoints and lighting effects to the photographer, an interference which must have been galling. Pavlova experimented with candid performance photographs, but detested them, preferring the type, John Lazzarini tells us, 'in which her feet seemed to taper away to delicate points, an effect she sometimes contrived herself with a pencil': she knew that the crude marks would not show up in half-tone newspaper reproduction (see plate 6). Thought of in theatrical terms, this makes good sense; the ends justify the means, the undoctored print no more acceptable for public exposure than offstage exercise. She knew from experience what people wanted to see, and they were not ready for the unsettling revelations of candid photography. This is as true today as it was in Pavlova's time. The doctoring of such photographs is still commonplace and almost every portrait of a celebrity or star is idealized in this manner. Photographic verisimilitude is often far from welcome.

An album of fragments

The flowering of the Romantic Ballet coincided with the birth of photography. As the ballet techniques were being perfected on the stage of the Paris Opéra, the craze for the newly invented art of lithography swept up a Frenchman and his son in the south of France. Isidore and Joseph Niépce were soon making their own lithographs, which led to experiments with 'sun drawings', as Joseph later called them. By 1826 Joseph, now working alone, had succeeded in producing the world's first permanent photographic image after an eight-hour exposure. It was a magnificent achievement, greater than he realized, as he was preoccupied with the still unsolved problem of how to pull prints from the image. It was in order to achieve this end that Niépce entered into partnership with a Parisian entrepeneur, L. J. M. Daguerre, a man equally obsessed with fixing images permanently. 'He cannot sleep at night for it,' worried his wife.

Through the next decade, year by year, each triumph of the ballet can probably be matched by a development which brought photography closer to being a reality. In 1831 the spirit of the Romantic Ballet crystallized in *Robert le Diable*, with Marie Taglioni leading the nuns in a macabre flight that thrilled the fans of the Opéra. Not far across the city two men had cause for a more private celebration: the key discovery by Daguerre of the lightsensitivity of iodide of silver. In

Idealized lithographs of the Romantic Ballet set audience's expectations for the first dance photographs. This picture of the great Fanny Cerrito is by J. S. Templeton after a drawing by A. de Valentini, 1840.

1834 Fanny Elssler, Taglioni's arch rival, made her debut in *La Tempête*, while in the English countryside Henry Fox Talbot began his own attempt 'to cause natural images to imprint themselves durably and remain themselves fixed upon the paper'. In 1841 came the triumph of *Giselle*, the zenith of the Romantic era; Talbot patented his 'Calotype' process the same year, two years after Daguerre (Niépce having died) had unveiled his invention to the world. Now photography was centre stage, just as the Romantic Ballet entered its long decline.

In its early manifestations, photography was too new, too slow and too clumsy to deal with the highly refined art of the Romantic Ballet. In vain we look for a picture of the famous *Pas de quatre* when Carlotta Grisi, Lucile Grahn, Taglioni and Fanny Cerrito, four of the greatest dancers of the century, were shepherded together in 1845 to perform at Her Majesty's Theatre in London. In vain do we look for a photograph of Taglioni in *Robert le Diable*. 'Taglioni!' laments Kirstein, 'How did she dance? All we know is what she meant to those who saw her.' We can only piece together an album of fragments: a sedentary portrait of a withered old lady (can one believe that this woman in her prime inspired a new verb – *Taglioniser* – to dance?); a series of portraits of Fanny Cerrito looking unsure of herself (plate 5), even though she had long since proven her talents to the world; a portrait of Emma Livry, in a remorseful pose which can only make us question Taglioni's wisdom in coming out of retirement to choreograph for her. Photography could do justice to neither the great figures nor the events of the dance. It simply arrived too late to record the Romantic era.

The uncertain gesture

Photographers, however, were from early on interested in the problems that dance created for them. Nonetheless, the daguerreotype was not even considered as a medium for the recording of dance movement. With its exquisite detail and elaborate frame (necessary to protect its delicate surface), it was naturally seen as an alternative to miniature portrait painting. No daguerreotypist would have expected his work to compete with the lively and colourful lithographs in wide circulation, which showed sylphs flying high above forests and ruined towers or swimming – in tutus – across deep mountain lakes. Nor would they or their sitters have wanted it to: the stage was the place for fanciful illusions, while daguerreotypes were prized for their vivid realism. Moreover, being forced to sit still or stand propped upright in the studio (often braced), confronted with the daunting apparatus, inhaling unpleasant vapours of mercury, iodine and other chemicals, would, I should think, drive otherworldly fancies far from even the most romantic dancer's mind.

Even straightforward daguerreotype portraits of dancers are extremely rare. Neither the Paris Opéra nor Dance Collection of the New York Public Library has a single example in their immense holdings. It was astonishing to find, therefore, in the archives at George Eastman House, in Rochester, New York, not only a daguerreotype of a dancer (unfortunately unidentified), but a depiction of a simple dance step (plate 1). Even though the exposure time must have been a minute or even longer, the image has undeniable vitality and none of the wooden quality we have learned to expect as the nineteenth-century norm. Surprisingly, what may be the earliest known photograph of the dance is a delight to the eye. Unfortunately, we cannot acknowledge its creator, who remains anonymous.

Within a span of ten years the daguerreotype would succumb to faster, less fragile, and cheaper methods of producing photographs. It was a false start, a thing of great beauty but incapable of being reproduced. But the spirit of invention and entrepreneurship continued unabated in France where another step forward in the development of dance photography was made when in 1854 André Adolphe Eugène Disdéri came up with a novel idea of enormous consequence. His *carte-de-visite* is considered an invention but was really a clever adaption of the

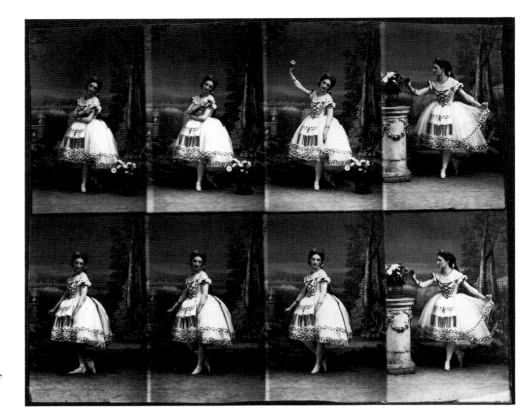

Uncut sheet of *carte-de-visite* portraits of Marthe Muravieva, by André Adolphe Eugène Disdéri, *c.* 1863. Muravieva, a star of the Bolshoi Theatre, was one of the first Russian ballerinas to dance at the Paris Opéra – probably the occasion for these photographs.

wet plate, or collodion-on-glass negative process invented three years earlier. Disdéri simply divided the plate into eight or ten rectangles which were exposed simultaneously (thus reproducing with ten times the efficiency) or in series (thus producing ten variants where there had been a single image). Nor was the small size (6 × 9 cm) a disadvantage, for it corresponded to the convention of the visiting card. The portraits were cheap and could be afforded by almost all classes of people. To balletomania was added cartomania. In her fascinating study of Disdéri, Elizabeth McCauley has given an interesting explanation of their immense appeal:

Unlike the lithographs or engravings of entertainers that had been produced throughout the nineteenth century, the photograph produced an iconic verity, a proximity to the living subject that enhanced its ritual powers. The process of reducing people to tiny, two-dimensional patterns and placing them in velvet-covered albums with intricate clasps modeled on medieval prayerbooks – of transforming them into portable objects of private devotion – signals a new form of cultism that culminated in the 1860's. The rich, the powerful, and the talented, or those who wanted to be so perceived, allowed a physical reproduction of themselves to be circulated among the people. The unseen, all powerful pagan gods whose shifting contours gave free play to the popular imagination, were tamed and framed, approachable and reproachable. Genius and talent no longer hovered in the ethereal spheres, but rested on the parlor table, to be invoked at the turn of a page.

Carte studies of dancers are disappointing in their uniformity. Backdrops and props were designed to suggest Renaissance painting or monumental architecture, with a particular penchant for the Baroque. The poses partook of no risk; dramatic leaps were not within the bounds of possibility, but why not an *arabesque* or *plié*? McCauley theorizes that Disdéri's standard, or model – and that of the dancer – was not the dance itself, but the popular idea of the dance derived from the ubiquitous lithograph, which usually depicted the dancer in the

fourth or fifth of the five basic positions of the feet in classical ballet. So the pose was partly a response to the demanding nature of the photographic session – that is, a pose which the ballerina could hold with some degree of control, if not comfort – and partly modelled on other visual images of the dance with which she would be familiar. In Disdéri's picture of Marthe Muravieva, McCauley notes a motif much favoured by lithographers, the rear leg trailing into the background. 'Introducing such physical suggestions of coy innocence as a drawn-in chin, an under-the-brow glance, a tilted head, and modest, crossed arms, Disdéri molds Muravieva into the fairies and Romantic Ballet heroines he had seen depicted in his youth.' Many *cartes* exhibit similar uncertainty as to appropriate steps and gestures, but we should remember that many dancers were being photographed for the first times in their lives, an experience no less intimidating than appearing on television today.

Within ten years the fad had run its course. Stereographs, which had been invented more or less simultaneously, had a much longer life that continued well into the twentieth century. These photographs, mounted in pairs on a card, could be privately examined through a portable viewer or mounted in a machine that would flip through a number at a sitting. The effect was rather like a private stage performance, in which the photographer thoughtfully placed the viewer in the best seat in the house. The novelty of stereographs was the three-dimensional effect that they produced and the need to exploit this required the photographer to take the widest possible view, which usually meant including the proscenium arch. This breadth resulted in the dancers appearing as tiny figures. To compensate for this, they were required to assume the most dramatic poses possible, with wildly extended arms and legs. If today, with televised dance so familiar, these pictures seem lifeless or uninteresting, we should remind ourselves that many people in the nineteenth century, remote from urban centres or too poor to attend the theatre, would have been given their only glimpse of the ballet by means of the stereograph.

Meanwhile, the tiny *carte* evolved into the much larger cabinet card (6½ × 4¼ inches), which, although filling similar functions, responded to the public's demand for greater legibility of an individual's features and was much more suitable for groups. But these cards possess no aesthetic novelty and, other than providing invaluable records of costume, they are of minimal attraction today.

In society, the ballroom counted for as much as the stage. Among nineteenth-century studio photographers who grappled with social dance and the limitations of a medium which ruled out instantaneous photographs, none was more ingenious than William Notman, a Montreal entrepreneur whose empire encompassed twenty-one studios in the United States and Canada. Notman specialized in

The cabinet card: an unidentified dancer posing as a chicken, photographed by Nadar, *c.* 1880.

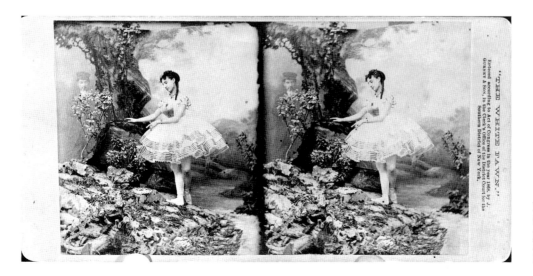

Marietta Bonfanti in *The White Fawn* at Midlow's Garden, New York. Stereograph by an anonymous photographer, 1868. Bonfanti was an Italian ballerina who became a teacher in New York, where Ruth St Denis was one of her pupils.

17

St Andrew's Ball, Montreal, by the studio of William Notman and Son, 1878. This composite photograph has been constructed from dozens of individual portraits such as that shown below: these girls appear in the centre of the ballroom.

photographic 'composites', enormous tableaux made up out of hundreds of individual figures, each cut from a separate photograph and mounted according to a detailed plan. For his picture of a St Andrew's Ball in 1878, foreground figures were shot on 8 × 10 inch plates; middleground figures on 5 × 7 cabinet cards, and the smaller figures on *cartes*. The figures were posed in separate studio sessions according to the master plan, and their size adjusted to conform to sizing marks, made on the photographer's ground glass. After the cut-outs had been pasted up, unsightly seams would be retouched and the whole then rephotographed. Notman knew that these works would be enormously popular and pay their own way, as each participant would want a copy. Proud of his achievements, he sent them to important exhibitions abroad.

Such ambitious undertakings aside, nineteenth-century dance photography after Disdéri continued in the form of studio portraiture, with scant aesthetic progress. For new ideas, vigorous development, and dynamic picture-making we must turn away from professional photographers to scientists, painters and amateurs.

A closer scrutiny

Eadweard Muybridge is justly acknowledged as the pioneer of analysis of human movement through photography. He sought first to dissect motion by still photography, in order to rid science and art of false conceptions, and then to reconstitute it by means of his 'zoopraxiscope', an invention which anticipated cinema. Among the plates in his great work *Animal Locomotion* (1887) are a number showing men and women demonstrating various dance movements (see 'First Ballet Action', plate 4) as well as men waltzing with women and women dancing together and alone. Muybridge's stop-action photography was extremely complex and expensive (it required the patronage of the University of Pennsylvania) and

was therefore of no immediate application in the commerical sphere of dance photography. But it had enormous interest for painters such as Thomas Eakins and Edgar Degas as well as for other scientists, foremost among them the French physiologist E.-J. Marey.

Much taken with Muybridge's results, Marey continued with his own investigations, utilizing techniques of his own invention. Some involved devices attached to the subject which activated a pen across paper. A repeating-shutter camera allowed him to record individual images on a single plate, which produced a more fluid representation of movement than had hitherto been possible. Marey's work was as influential as Muybridge's in establishing modern techniques of movement analysis; in addition he shares with his colleague an undeniable – if unintended – aesthetic that similarly inspired aritists, in particular the Futurists. His striking imagery was remembered by Gjon Mili when he began his strobe work with dancers in the 1940s (plates 10 and 11).

One of the artists intrigued by the work of the scientists was Edgar Degas, whose own involvement with photography dated from at least 1860. Degas painted a number of portraits using *cartes* as models, although it was never a matter of slavish imitation, but rather of creative re-interpretation. Moreover, his later style of painting, with its seemingly arbitrary cropping, unusual viewpoints and sense of frozen motion, was certainly influenced in part by snapshot realism. As his fascination with Muybridge and Marey demonstrates, he was keenly interested in new means of seeing.

Little is known about the photographs Degas himself took of dancers. It is not certain how he used them. Figures very similar to those in plates 14 and 15 reappear in a number of pastels, but Robert Gordon, who has given a good deal of thought to these images, cautions us against reading too much into them. Degas was an indefatigable experimenter and innovator who made countless trials of various media. The photographs may have been offhand investigations or they may have been part of a more sustained undertaking. Perhaps they are simply studies of light, or compositional experiments, or just attempts to capture 'the springing girl' described in a sonnet by Degas, who 'wears out my poor eyes straining to follow her'. He was not the only artist who made use of photographs. Although Manet, for example, did not take photographs himself, he used bits and pieces of studies of dancers made by Disdéri and other photographers when creating his paintings of the *Ballet Espagnol* (1862-3).

While artists were exploiting photography for their own ends, a group of impassioned amateur photographers pressed for the medium's acceptance as an art form in its own right. The amateur movement, which coalesced around 1890 into the style known as pictorialism, was generated partly in response to the low esteem to which photography had fallen as a commercial and professional activity, and partly in reaction to the turgid, high art pretensions of certain photographers – notable O. G. Rejlander and H. P. Robinson – who had preceded them. Pictorialism stressed formal concerns and atmospheric effects rather than subject matter and borrowed from painting and drawings – notably from Turner, Whistler, Monet and Degas. In order to prove the validity of their claim to art, handworking the print was much encouraged; the gum-bichromate print, which required such intervention and had varied and beautiful effects was particularly popular. From the leading pictorialists – Heinrich Kuehn in Austria, Robert Demachy in France, Baron Adolf de Meyer in England and Edward Steichen in America – came a number of fine dance studies. Nevertheless, the propensity to imitate the more superficial aspects of painting was all too obvious. Demachy's *Une balleteuse* (plate 17), for instance, prompted a contemporary critic to note that the resemblance to Degas should have 'gone further to emulate the great painter in exercises of movement'.

Pictorialists formed clubs, organized international exhibitions and fought protracted battles in journals and books. In doing so they established a platform

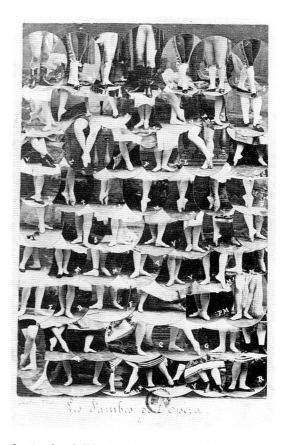

Les jambes de l'Opéra, by André Adolphe Eugène Disdéri, *c.* 1864. This mosaic *carte-de-visite* is possibly the earliest montage in dance photography.

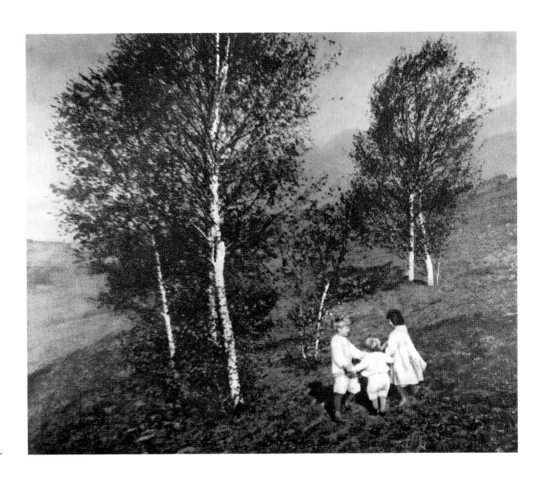

The pictorialist vision: three children dancing, a gum-bichromate print by Heinrich Kuehn, c. 1902.

from which the most far-seeing of their brotherhood, once they had assimilated the lessons of the avant-garde, could launch modernist assaults. In ballet itself, the fire had long been extinguished. But now, as the new century dawned, Fokine, Diaghilev and Isadora Duncan were rekindling the flames. Photography had come of age and its practitioners were ready to undertake a fruitful partnership with the revitalized world of dance.

Toward new plastic arts

This partnership first appeared as an extraordinary collaboration between the great dancer and choreographer Vaslav Nijinsky and the celebrated portrait photographer Baron Adolf de Meyer (plates 134–137). *L'Après-midi d'un faune* was choreographed and danced by Nijinsky for Diaghilev's Ballets Russes. Based on a poem by Mallarmé, it told the story of a faun's unconsummated desire for a group of woodland nymphs. In 1912 Nijinsky was a veritable deity himself, yet nothing had prepared the audience for his breathtaking innovations. Indeed it was less a dance, noted Diaghilev, than a 'new plastic art'. In the span of twelve minutes, a Greek bas-relief came to life as the dancers moved in profile with abrupt, broken, angular movements which had no precedents on the stage. Even by today's standards these movements would seem extraordinary.

Baron de Meyer, born Adolf Meyer, was at the time a member of Diaghilev's circle, and, with his wife, an ornament of international café society. He was also a serious photographer and a leading exponent of the pictorialist school who had won the praise of both Stieglitz and Steichen. 1912 finds him at the peak of his powers. He had by this time photographed Nijinsky on four occasions, most notably during performances of *Le Carnaval* and *Le Spectre de la Rose*.

In a sequence of thirty-three pictures, thirty of which would comprise an limited-edition album for Diaghilev, De Meyer followed Nijinsky's narrative with a deep respect for the choreographer's intent and yet still succeeded in creating a

masterful photographic work. The poses, it has been suggested, were not simply lifted out of the piece, but rechoreographed specifically for the camera. Through the sequence, De Meyer moves rhythmically from panoramic groupings to close-up, partial studies of faces and bodies; in these close-ups, the cropping deftly reinforces the bold angularity of the dancers' gestures. The figures are bathed in the soft, radiant luminosity of a long summer afternoon which distances us psychologically and contributes to a dreamlike, mythological aura. De Meyer did not simply 'take' pictures, and have them developed, as the layman assumes is the normal working procedure today; he started with a large-format negative, made a paper print, cropped it extensively, worked it by hand (probably in consultation with Nijinsky, who would want an exacting depiction; one image, for example, shows part of a hand has been drawn in), and then re-photographed. Inexpensive collotypes (a bichromate process for obtaining high-quality ink reproductions) were then produced and mounted into the albums, of which, incidentally only four survive.

'I hope', wrote Rodin after seeing *L'Après-midi d'un faune*, 'that such a noble undertaking may be understood in its wholeness.' Some writers find this synthesis in De Meyer's photographs. In his introduction to a new edition of the work, exquisitely produced with palladium prints copied from the collotypes by Richard Benson, Leslie Katz sees 'a masterpiece of collaboration and combination of arts, an extension into photography of Diaghilev's power to catalyze and unite different mediums. The choreography and dancing of Nijinsky, the décor of Bakst, the music of Debussy, the poetry of Mallarmé.' But in truth, is this not asking too much of photography, or rather, reading too much into it? Nijinsky's dance, indeed. Bakst's decor only in part, for it is much diminished by the absence of colour. But Mallarmé's poetry and Debussy's music? However much we admire these pictures, Rodin's quest for 'wholeness' remains an impossible goal for photography. In the context of the dancework itself, we must admit that the photographs remain the broken fragments of a once beautiful vessel.

It is fitting that the first great collaboration in the history of dance photography should have featured a work which heralded the age of the avant-garde, yet ironic that it employed a style of photography, pictorialism, that was on the wane and

Two nymphs from *L'Apres-midi d'un faune*, photographed by Baron Adolf de Meyer in 1914.

within a year or two would be supplanted by modernism. As they had been throughout the nineteenth century, dance and photography were still out-of-step.

With Isadora Duncan and Edward Steichen, a harmony both formal and spiritual was achieved. By 1920, Steichen had long since put pictorialism behind him and was showing great interest in Matisse, Cézanne and other avant-garde artists. To the photographer, Isadora represented 'a symbolic revolutionary whose bid for liberty was likened to [the photographer's] struggle for the acceptance of photography as a valid medium of artistic expression', writes Dennis Longwell in *Steichen, the Master Prints*. Isadora had not been content to prune the deadwood from the dance, to use critic John Martin's phrase, but went to the root of the malaise. All that was academic was anathema to her – points, turned out feet, tutus, elaborate sets. She danced barefoot in a simple tunic, finding inspiration in the nobility of ancient Greece and deep within her own being. Viewed through the telescope of time, concludes Kay Bardsley, her genius can be appreciated in three forms:

As a supreme artist on the stage whose style, flamboyance and personification of universal human emotions altered the course of dance as an art form and influenced the direction of all the theatrical arts; as a creator who broke with convention to compose dance masterworks to great music, utilizing dance themes never before attempted; and as a teacher-prophet for the role of dance in the education of children.

Steichen had been invited to accompany the Duncans to Athens, where early every morning they ascended the Acropolis. Although Isadora herself was in a truculent mood during this period, and was normally averse to posing for the camera, this did not prevent Steichen from making his masterful portrait of her in the portal of the Parthenon (plate 161). But he was better able to work with Maria Theresa, whom he found to be the most talented of the students. She was, in his words, 'a living reincarnation of a Grecian nymph'. Plate 162 ('in which the arms make the gesture of worship to the sun') shows the dancer seeking union with nature. *Wind Fire* (plate 26), which called for Steichen to dig once more into the pictorialist bag of tricks, inspired a poem by Carl Sandburg, his friend and brother-in-law:

Goat girl caught in the brambles, deerfoot or fox-head, ankles and hair of feeders of the wind, let all the covering burn, let all stopping a naked plunger from plunging naked, let it all burn in this wind fire, let the fire have it in a fast crunch and a flash.

For the German-born American photographer Arnold Genthe, ancient Greece was perhaps even more deeply felt, as he had studied classical Greek (as well as other classical and modern languages, including Hebrew, Anglo-Saxon and Latin). He was well-educated (with a German PhD) and erudite, with wide-ranging interests in travel, dance and music. For a man of such sensibilities, Isadora was both 'liberator and prophet'.

Genthe photographed Isadora and her students, as well as the students of Isadora's sister, Elizabeth, between 1915 and 1918, during the dancers' visits to New York. He photographed them both out-of-doors and in a studio Isadora's friend Max Eastman called 'a little genial museum of art presided over by a philosopher and friend of ideas'. Genthe's images were always soft, in the pictorialist manner, as he believed that sharpness paid too much attention to a superficial, surface reality instead of revealing a person's underlying character. His statuesque portraits of Isadora in *La Marseillaise*, taken in 1916, are monuments to the dancer, as well as reverent homage to the spirit of dance itself. Quite different are his figures of the Isadorables as scampering nymphs on the beach or in the forest. There is a dynamism to these pictures which is truly thrilling – with Genthe, the camera is learning to abandon its passive role as onlooker; it is learning to dance.

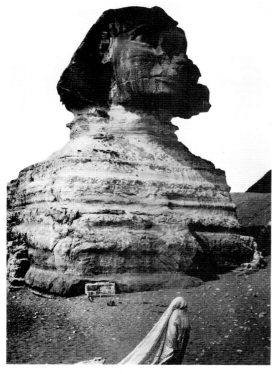

Loie Fuller dancing in front of the Sphinx, by Harry Ellis, 1914.

22

Genthe published his pictures in *Isadora Duncan: Twenty Four Studies* in 1929. Although she did not live to see the book, its publication would have greatly pleased her. In her memoirs she voiced a dept of gratitude to the photographer: 'He has taken many pictures of me, which are not representations of my physical being, but representations of conditions of my soul.'

Genthe's passion for the dance had borne other fruit as well. He made a number of superb studies of Doris Humphrey, Ruth St Denis and Pavlova, among others, many of which appeared in his *The Book of the Dance* (1916). In his studies of Pavlova, including the first ever of her in free movement (plate 57), Genthe took the approach of the sculptor, looking for a pose 'which indicates the preceding as well as the following movement, be it rapid or slow. [Otherwise] a suggestion of movement – fluent, dynamic, natural – cannot be conveyed.' Descending from the Olympian heights, Genthe and Pavlova went off together to visit the dives of the San Francisco waterfront, where she could see the latest dance crazes, such as the Grizzly Bear and the Turkey Trot.

As moths to a flame

Isadora was not the only early American innovator to have left a legacy of photographs. Loie Fuller's art was one of continual motion, transformation and regeneration, made even more spectacular by her pioneering use of electric light, coloured gels and slide projections. Her body disappeared inside cocoons of voluminous fabric, then metamorphosed into a butterfly. There were elements of magic and the supernatural, exaltation and mystery in a Fuller performance, and photographers were drawn to her as moths to a flame. Isaiah West Taber, Harry C. Ellis (who billed himself while in Europe as 'America's Flashlight Photographer') and Théodore Rivière were among the photographers who tried to bottle her elusive spirit. In 'snapshots' by the latter (plates 52 and 53) we find photography not by the professional or the high-minded amateur, but by the bystander, friend, or acquaintance. Straightforward as they are, they are as valuable as any detailed description of Fuller's art.

By the outbreak of World War I, America and Europe were in the throes of a dance craze, and magazines used photography to communicate such topics as the 'New Dances for the Winter, with Photographs of Each Step Especially Posed by Mr and Mrs Castle'. The highbrow *Vanity Fair* decided the tango and fox trot were to be encouraged, provided that the dance impulse was not misdirected. It decreed: 'America has been too busy with the great task of rendering a new land habitable to take time for considering the emotional outlets of its people; it has been too much occupied in hewing forests, digging canals, laying tracks, erecting buildings, and acquiring material riches to pause and consider the need of its people for emotional and artistic expression.'

Ruth St Denis and Ted Shawn took the lead in directing this new impulse to dance. Denishawn, the school which they created in Los Angeles in 1915, was a rich fabric of many threads. Spectacular sets and costumes were inspired by Eastern mystics, warring Samurai, North American Indian chiefs, Spanish Flamenco. For ideas they drew on vaudeville, acrobatics, the circus, travel, books, films, photographs, even a cigarette advertisement. Through the Denishawn company and school they offered a rich and eclectic programme whereby dance was seen as a means of achieving harmony of mind and spirit, yet in a down-to-earth idiom quite unlike the lofty Greek.

Not surprisingly, photographers were drawn to the pair; what normally studio-bound photographer would miss an opportunity to record Ruth's heroic gestures at the foot of Half-Dome in Yosemite, or capture Shawn cast as a living statue in the gardens of Lolita Armour? How could a photographer resist battling Samurai (plate 46), Prometheus bound to a wall of rock (plates 163 and 164), or a kaid of

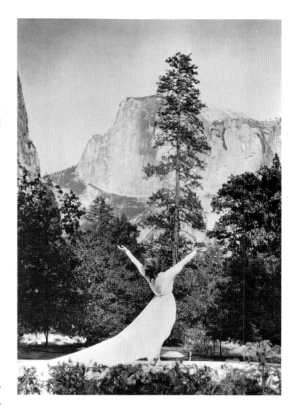

Landscape and dance: Ruth St Denis at Yosemite. Undated anonymous photograph.

the Sahara Desert, in authentic costume? Baron de Meyer, E.O. Hoppé, George Hoyningen-Huene and Edward Weston were among those who were captivated. With many others they catalogued the rich legacy of the Denishawn era and in the process created a virtual pocket history of photography, which embraces all facets of the medium.

The Denishawn archive, now in the Dance Collection of the New York Public Library, contains more than 4000 photographs. Every kind of camera was employed (large-format plate cameras, panorama-format cameras, Kodak Brownies) and a full range of printing processes (silver, platinum, bromoil, gum). There are glamorous publicity shots for magazines, newspapers and Denishawn programmes; straightforward records of sets, costumes, even jewellery for company use; documentation of the performers in expressive poses typical of this or that dance; so-called 'art photographs', in which the photographers were given great freedom for self-expression; and snapshots taken by the dancers themselves and their friends, which were eventually mounted in albums and treasured as personal mementoes. Studio approaches ranged from the straightforward to the elaborate, from soft-focus pictorialism to crisp modernism. Particularly fascinating is the range of approaches to lighting, both natural and artificial. The majority of the photographs were taken in the studio, but others were made of actual performances and some were taken outdoors, with varying degrees of candour. When in 1931 the two dancers parted, Shawn formed a new company of all-male dancers and continued to commission in-depth documentation (plate 193).

Meanwhile, radical surgery was also being performed on the dance in Central Europe, led by the versatile Rudolf Laban, teacher, theorist and inventor. His most important ideas concerned the meaning of movement itself. Dance was a sacred trust which drew on sources in ordinary, workaday life. His pupil Mary Wigman took these ideas and fashioned them into a strong expressive language all her own. Like her admiring Expressionist friends, Ernst Ludwig Kirchner and Emil Nolde, who turned against the dazzling charms of Impressionism and the soothing decoration of Art Nouveau, Wigman also rejected the art of the past – which in her case was the received vocabulary of classical ballet. The body of the dancer was not a passive instrument for the display of a predetermined script, but a vessel for the communication of profound emotion. 'Time, energy, and space: these are the elements which give life to the dance' she wrote. And space could be a powerful ally or adversary, 'an invisible partner' or a force to challenge, combat or succumb to; her dancers could be crushed by its weight, or form an impregnable fortress against it. What counted for Wigman was the intensity of the struggle and that it be vividly communicated to the audience. 'Her art can thus be considered an art of the "image"', notes Hedwig Muller, 'as long as this is not understood as a creation of static effects and visual stops, as the contemplation of immobile beauty.'

Quite naturally photographers were drawn to this striking and graphic personality. Hugo Erfurth, a famous Dresden portrait photographer, made perhaps the most dynamic image ever of Wigman's art: his interpretation of *Hexentanz*, Wigman's first public appearance (plate 179), well expresses its demoniacal fury. Surprisingly, Wigman preferred the more passive documentation of Charlotte Rudolph. Of their first collaboration she said: 'This is the first time in my life that photographs of the dance give me complete satisfaction.' Unlike Erfurth, Rudolph Duhrkoop, d'Ora and others who had photographed Wigman, Rudolph did not impose a visual style or her own artistic personality; in this she had more in common with the proponents of the straightforward realism of the 'New Objectivity' movement than she did with the Expressionists.

With the experimentation of Duncan, Denishawn, Fuller and Wigman, the ground was laid for the full deployment of modernist strategies and ideas. In America, a student of Denishawn left the fold with ideas of her own; in the course of 'inventing herself,' as Kirstein puts it, Martha Graham would blaze a trail for

generations of young dancers and choreographers. Her innovations were varied, running the course from the severe and uncompromising to the fluid and lyrical. She vies with Ruth St Denis for the title of 'most photographed dancer', and a series of volumes could be filled with photographs of her by Imogen Cunningham, Soichi Sunami, Nickolas Muray, E. O. Hoppé, and, above all, Barbara Morgan.

Modern, muscular materials

Initially Barbara Morgan resisted the blandishments of her husband, Willard, to take up photography. She preferred painting and poetry. She found herself sympathetic to the idea shared by many non-Western peoples that a photograph could steal a person's soul. 'I won't be a thief!' she would flatly admonish her husband. But when he brought home a tiny Leica, one of the first in the country, and left it casually lying around, the temptation to give it a try was too much to resist. She soon discovered that the camera was more than a mechanical device; in the hands of an artist it could be used, as could the pen or the brush, in a poetic, expressive way. By the time Morgan met Graham in 1935, she had achieved mastery over this new medium, and was looking for new realms to explore.

In an interview in *Dance Life* in 1979 she explained:

I was moved by her dance (*Primitive Mysteries*) and I wondered if there was a relationship to these Indian rituals. She said 'Exactly that. The Indian ritual experiences were one of the most moving experiences of my life.' Just like that, bang, I said 'Then I'd like to do a photograph book on your dance.' She replied, 'I'll work with you.' Then we began.

It wasn't as a record of the dancer's art that the collaboration excited Morgan, although she could appreciate that it would serve this function; it was the inner life of the dancer which appealed to the poet in Morgan. Graham had learned to use her body to give voice to her innermost conflicts and yearnings.

Morgan evolved an 'extinction method' of working, by which she means she would let time pass between seeing the performance and dealing with it. With enough time, 'the lesser things would vanish and the intense moment would be right there in my brain. I'd see a pre-vision. Then I'd call Martha up and say I could do it now and we'd set up a time.'

In *Deaths and Entrances*, a work inspired by the Brontë sisters, linear time is abandoned as Charlotte (Graham) revisits the past. Morgan created double-images to depict these simultaneous times (plate 154). In *Letter to the World*, the story of Emily Dickinson's despair and reaffirmation, Morgan located a moment at the juncture of these states of mind (plate 155): the rigidity of the body and the gesture of the arm convey despair; the fluidity of the skirt the hope of spiritual recovery. *War Theme*, on the other hand, held out no such hope (plate 152). It was not, strictly speaking, a dance. William Carlos Williams had asked Morgan if she could create an image which could accompany one of his poems on the tragedy of the Spanish Civil War. Morgan in turn approached Graham, who agreed to collaborate. After a number of attempts, both were satisfied with one image in particular, in which the body seemed caught in the very instant of its annihilation. In a graphic tonal language of stark black and white (as life fades, light fades, and darkness overwhelms), the life-force yields to destruction.

For Morgan, Martha Graham was a medium through which a greater rhythmic force, that of life itself, pulsed. There were other dancers who had this shamanistic gift, and the photographer worked with them as well – Doris Humphrey, Charles Weidman, Erick Hawkins and Valerie Bettis (plate 181). Moreover, the essence of dance was not confined to a human vehicle, but could be found in a crowded street, the trunk of a tree, or a corn leaf. But no matter where it was to be found, every image was handled in the bold modernist spirit which the critic Elizabeth McCausland had called for in dance photography only a few years earlier:

Photography and the metaphor of dance: *Corn Leaf Rhythm* by Barbara Morgan, 1945.

The modern dance is like modern painting and modern sculpture, clean, with crisp edges, of rigid and muscular materials. The photographs of the modern dance must be likewise, with great definition of values, not flowing draperies, with forms solidly modeled in light, but not swept by theatrical or stagey spotlights.

In the history of twentieth-century dance, one long chapter must be reserved for the story of George Balanchine, a story which flows through and connects Russia, Europe and America. Balanchine's legacy is one of enormous diversity. It includes new versions of the classics, his plotless dance ballets, his school, his companies – American Ballet, American Ballet Caravan, and the Ballet Society, which continues as the New York City Ballet. In his staging of *Orpheus* (1948), part of a Greek trilogy with *Agon* and *Apollo*, the choreographer turned to the one photographer he knew could distil the essence of his art.

To the music of Stravinsky's classic score, Orpheus, griefstricken by the death of his wife, is led by the Dark Angel to the underworld, where he reclaims Eurydice, but loses her again when she insists upon tearing off the mask he has sworn to wear. Back on earth he is torn to pieces by the Thracian Bacchantes, whom he had in his overwhelming grief treated with contempt. The ballet ends as Apollo invokes the spirit of Orpheus as the source of song.

Balanchine lamented the ephemerality of ballet, which 'had only the permanence of a classical vocabulary renewed for every generation of young aspirants and its criterion of efficient performance'. In the work of George Platt Lynes, his friend and collaborator, he saw 'all that will remain of my own repertoire in a hundred years'. Their work in the studio was laboured, minutely controlled and intense. Lynes took great pains with the lighting, building a platform for the dancers so that he could place some of the lights below, which had the effect of creating a horizon and, as the light gradually faded with height, an impression of sky. Exquisite lighting was Lynes's trademark; the figures are always modelled masterfully. Balanchine marvelled at the results. In Lynes's handling of the figures he saw the finesse of a superb sculptor. When Lynes had completed the lighting, Balanchine – having posed the dancers with equal consideration – triggered the shutter. He admitted that the photographs were much more than a record. They were also exceptional portraiture, important social history and independent works of art.

The landscape of dance

In our own time, Lois Greenfield has emerged as one of the most innovative photographers of the dance, and the foremost photographer of postmodern experiment. Greenfield has never been concerned with documentation – the literal transcription of a choreographer's work into two dimensions – which she leaves quite happily to other professionals. Instead, she stands for a vigorous, independent art; what the dancers bring to her studio is fashioned into dynamic imagery in her own inimitable style. 'Dance is my landscape', she explains, telling her dancers to leave their choreography at the door.

She began her collaboration with David Parsons (soon to be joined by Daniel Ezralow) in 1982, soon after Parsons had been chosen by a New York newspaper as one of the best dancers of the year. She was attracted to Parsons's unique combination of athleticism and lyricism and the floating quality of his body in the air. Ezralow she admires for his 'kamikaze spirit'. He has likened himself to a ball of clay which is thrown up in the air where it takes shape, then returns to the ground as clay. She wished to capture in photographs the seeming impossibility of their movements.

Greenfield was using a square-format camera for the first time. She discovered that the format broke the tyranny of the normal rectangular frame, with its perceptually 'weighted' bottom – the square distributed the gravitational pull equally on all four sides. In these pictures the frame is, so to speak, the stage, with exits and entrances off sides, top and bottom. The performance stage has in effect been lifted from the horizontal to the vertical, and the dancers are responding to this new reality. Thus liberated, they rise and float, fly more than jump. The air has buoyancy, sometimes seeming heavier than the bodies themselves. Space has body and substance, just as delighted astronauts have experienced it.

Greenfield is a highly articulate spokeswoman, not only for her art, but for photography in general. She has interviewed and written about a number of the field's innovators, and not surprisingly we find her sensitive to qualities which define her own vision. She admired Man Ray's ability 'to dream and free associate'; his work was inspired by 'chance and accident'. In Lucas Samaras's little polaroids, she saw an immense expressive scope; she called his photographs 'tiny theaters'. In Duane Michals she found a sense of the paradox of time: he talked of life as 'a series of about to happens and have happeneds: the edge of the event so thin, so ephemeral, that it does not even exist, you can't touch it'. But this flash of super-reality would be Greenfield's target.

In plate 159 we see Parsons, Ezralow and Ashley Roland hurtling through space, each heading in a different direction. It is an explosive image, in tune with 'big bangs' and 'black holes' and the expanding universe of twentieth-century cosmology. Yet the force of the image is one of control and wholeness, not separation: the dancers' bodies lock together in a satisfying shape, albeit one that can exist for only a fraction of a second. We may feel that behind our ordered everyday image of the world are the violent energies that surge through the dancers, but we can also say that dance and photography have combined to make order out of that chaos. The wit, power and ambiguity of this unforgettable image seem to sum up our times no less than Barbara Morgan's *War Theme* did hers.

Time stands still

Dance is the movement of bodies through space and time. Dance is fluidity and continuity. Dance connects, dance unfolds. Dance envelops us; it enters through the eye and the ear. Photography imprisons in two dimensions. Photography flattens and shrinks. Photography tells the ear nothing. It fragments time and fractures space. Yet movement is the goal, ultimately the *sine qua non* of true dance photography. Elizabeth McCausland voiced the paradox when she called

for 'an image which though it cannot move and never can hope to move, yet will seem about to move'.

Photographers did learn to split time, as scientists had learned to split the atom. Armed with his electronic flash, Gjon Mili realized that 'for the first time, time could truly be made to stand still'. There were now 'unlimited possibilities for dissecting movement'. But dissecting movement was *not* what dance critics had in mind. Such pictures petrified the dance and denied its fluidity. 'Frozen motion' was a well chosen term; it denied the beating human heart.

Still, McCausland believed the solution was technical. What if one took a movie of the entire dance, she wondered, studied it frame-by-frame for the one which captured the essence, and then re-photographed that frame with a large format camera for clarity of detail? But this could never work. For one thing film is not a continuous medium – it only appears to be. It shoots each frame automatically, 24 times each second from a fixed position. This is not how still photographs are conceived. A photographer chooses the moment with great consideration, selecting a vantage point, framing the subject anew for each shot, moving in closer or pulling back, turning the camera to the vertical from the horizontal, and so on. The cinematic idea rules out these options; McCausland's method would result in lifeless imagery.

The solution to the problem is not technical, but conceptual: photographers have always had the means to convey motion. The issue is not really the 'capturing' of it, but the creation of a credible illusion. The dancer may be in violent motion when photographed, or posed and immobile; a good photographer would know how to fabricate a convincing image from either situation. Thus George Hoyningen-Huene, faced with the impossibility of truly capturing movement in the studio in 1931 with the large plate cameras which all Condé Nast photographers were required to use, placed his model flat on the floor and shot from

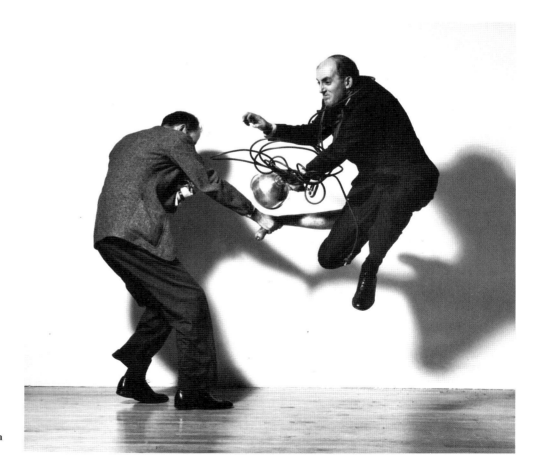

The photographer as dancer: Beaumont Newhall and Ansel Adams photographed by Barbara Morgan in her studio, 1942.

above (plate 9). Moreover, he turned the studio limitation to advantage; he was able to arrange the folds of the dancer's dress in the manner of classical Greek sculpture, something the strobe would never have allowed him to do. Huene's colleague and rival, Cecil Beaton, also made a virtue of limitation; for his study of Robert Helpmann and Margot Fonteyn (plate 8) he has selected an exposure time which would 'erase' the other dancers on the stage by blurring; it was a photographic equivalent to the stage's spotlight. And Paul Himmel found that continuity could best be expressed in an extended time frame, leaving a trace of the ballerina's graceful path across the stage (plate 7).

As imagemakers in any medium have always known, movement is a pictorial characteristic. An accomplished photographer can animate a rock, a corn leaf or even a building by the use of bold diagonals and strong, sweeping lines. Other photographers and critics argue that too much has been made of movement. Francoise Le Coz believes that Théodore Rivière's straightforward snapshots of Loie Fuller (plate 52 and 53) benefit from their stillness:

Better than film, photography was able to give synthetic images and express the poetic, or dramatic content of this art. In the final analysis, photography was able to reveal most completely the fascinating immobility at the heart of motion.

George Platt Lynes seems to have arrived at a similar conclusion. He found the essence of the dance not in in violent peaks of movement, or 'instants of combustion' as Barbara Morgan has described them, but in set poses and gestures. Balanchine described Lynes's goal as the synthesis of the atmosphere or 'bouquet' of the dance. Perhaps more than any other photographer Lynes could accept that still photography was an art, not a limitation.

Some great dance, it is said, is simply not photogenic. Conversely, writes Robert Greskovic, photographers find that dance – he gives Béjart as an example – can be 'photographable, but *sans* camera unwatchable'. Photography 'feeds back' into dance in unexpected ways. Greskovic has observed that contemporary ballerinas when dancing sometimes take up quotations from posed pictures of other dancers they have seen, 'mistaking the subject's typical portrait poses for the choreographer's actual vocabulary'. A similar literal interpretation of De Meyer's photographs of Nijinsky's *L'Après-midi d'un faune* may have been responsible for Nureyev's stop-action poses in his performances of the work.

One recent highly successful result of the camera's relationship with the dancer is David Parsons's *Caught*, which was inspired by his collaboration with Lois Greenfield. The dance takes place in an absolutely dark space. Parsons holds the strobe release and, as he dances, decides when and where he will appear to the audience, which cannot tell where he will be next. The effect is like that of seeing a series of completely different, vividly clear still photographs.

Learning the language

Dance is often described as a language. So too is photography. Dance has movements and gestures; photography has images rendered in tones and contrasts. Dance has positions, *arabesques*, *jetés*; photography has time exposure, blur, double-exposures, montage. Dance has costumes and decor; photography has texture and grain. One has the stage; the other the frame. Both have lighting effects, illusion and their own chemistry.

In a sense the photographer reinvents his medium whenever he makes a picture. At every stage of the process he must make critical decisions concerning approach, treatment and, ultimately, presentation. Will his subjects be moving or still? Posed, or moving freely? Are they to be caught unawares or asked to participate? Will he work outdoors, on stage, in rehearsal or in the studio? How will he light his subject? How shall he frame it? What camera lens and film format will he use? How long will his exposure last? What might be accomplished with the

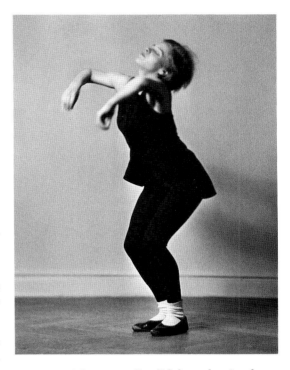

Record and document: Trudi Schoop dancing, by Lotte Jacobi, before 1935. Trudi Schoop is best known for her comic ballets, with which she toured Europe in the 1930s.

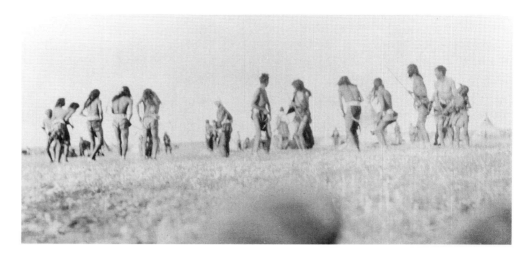

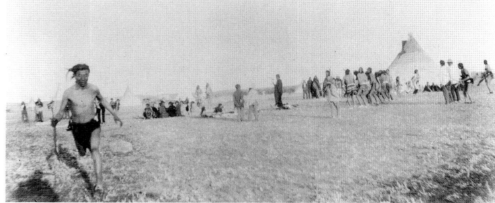

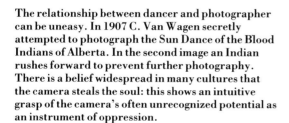

The relationship between dancer and photographer can be uneasy. In 1907 C. Van Wagen secretly attempted to photograph the Sun Dance of the Blood Indians of Alberta. In the second image an Indian rushes forward to prevent further photography. There is a belief widespread in many cultures that the camera steals the soul: this shows an intuitive grasp of the camera's often unrecognized potential as an instrument of oppression.

printing in the darkroom – solarization, for example, or multiple printing? Finally, how shall the work reach the public – in newspapers or specialized magazines, a book or an exhibition? In fact, the options are infinitely more varied than this brief synopsis allows. Although it is seldom perceived as such by the public, photography is a truly plastic art.

A photographic image carries many messages, for those whose sensitivities are attuned to them, and the framework of chapters provided here is at best a tentative guide to these varied functions. In this scheme, the plates have been organized in terms of photographic ideas and concepts.

The first section, 'Invention', is an inventory of varied intentions (for example, scientific analysis versus artistic expression); applications (illustration, promotion, graphic design or advertising); media and formats (daguerreotype, *carte-de-visite*, gum print); and approaches (indoor, outdoor, collaboration, abstraction and so on). In addition, this section presents a vocabulary of terms, so to speak: the use of blur, tonality, grain and cropping; double exposure, multiple printing, solarization, negative printing, montage and other expressive devices; effective lighting; the marriage of photographic image with typography; manipulated prints; fabricated illusions; and surreal assemblage.

With the passage of time, all photographs are valuable as records of a fugitive art. Some, however, are made with documentation in mind, aesthetic expression being a secondary consideration, if it is one at all. 'Record and Document' is the subject of the second section. Of course, many photographs in this section, such as Horst's study of the costumes designed by Dali for *Bacchanale* (plate 55), satisfy on both aesthetic and documentary counts. In other instances, the provision of context enriches the image. One example is the photograph of St Andrew's Night at a theatre in the Yukon, taken in 1899 by Larss and Duclos (plate 72), in which the makeshift sophistication of this goldrush community is proudly displayed to the outside world.

A photograph can take us back in time on a nostalgic voyage to New York's fabulous Roxy Theater, where the 'Silver Hoop Number' is in progress (plate 70), or allow us some insight into the immigrant experience of Ellis Island (plate 71). Or transport us far afield, to witness the ancient dances of the Alaskan Eskimo or Australian aborigines (plates 62 and 63). But no less exotic to our eyes are the bizarre dance rituals of our own culture – the marathon dancers of the depression era (plate 75), or the dainty, refined gestures of the rich at a society ball (plate 69).

Finally, there remains a different kind of record – that which documents a photographer's achievement within the terms of his own discipline; such a photograph is that of Pavlova by Arnold Genthe (plate 57), the first photographic study ever of the dancer in free movement.

Some photographs, in contrast, are intended primarily to glamorize and mythologize their subjects, and these are represented in the third section, 'Icon and Idol'. Promotion and publicity are high on the list of the professional dancer's demands on the photographer, as we have seen with Herman Mishkin's pictures of Pavlova. But photographers less strait-jacketed may idealize for different ends. Lynes's portrait of his great friend Balanchine is mock-heroic (plate 78); these are decidedly not the tools with which the choreographer shaped the classical dance in the twentieth century. Arnold Newman's portrait of Martha Graham is, on the other hand, genuinely heroic: the starkly-contrasted composition functions as metaphor for the famed choreographer's uncompromising vision (plate 101). Max Waldman's study of Natalia Makarova in *Other Dances* (plate 104) is incorrectly read, I believe, as an idealization of the ballerina; it is, rather, a hymn of praise to the ideals of grace and perfection of the art of the dance itself.

Many photographers from outside the world of dance and dance photography have contributed superb dance pictures. The fourth section, 'The Independent Eye', samples their achievements. Some of these men and women, such as Margaret Bourke-White (plate 117), have been photojournalists, on assignment for newspapers and magazines. Dance was not their guiding interest, but an event which occurred within the context of a story they were pursuing. Other photographers were free-spirited 'independents', exploring their own agendas. For both groups, there is no interest in the glamorizing function, no respect for photography's handmaiden status in the dance world. If anything, these artists wish to strip away the veneer of glamour and perfection, seeking an 'unofficial', uncontrived vision of reality. This seeking after truthfulness can be gentle and supportive, as with Lucien Aigner (plate 122), gritty and abrasive, as with Walker Evans (plate 124), or tense and anxious, as with Lynn Davis (plate 131).

It is true that these pictures are also 'records and documents', but they communicate an element of critique in addition: Jean-Philippe Charbonnier's *La Nouvelle Eve* (plate 127) is a cool study of the female sex and male power; several remarkable studies of New York nightclub life by young contemporary photographers confront alienation and despair (plates 125 and 132).

Some of the finest photographs of the dance have resulted from sustained collaboration, which forms the subject of the fifth section: Baron de Meyer with Nijinsky; Arnold Genthe with Isadora Duncan and the Isadorables; Charlotte Rudolph with Mary Wigman; George Platt Lynes with Balanchine; Barbara Morgan with Martha Graham; and Lois Greenfield with David Parsons and Daniel Ezralow. In each case, a forceful, committed dancer or choreographer (sometimes they are one and the same) has met with an equally assured image maker. Each of these photographers accepted the dancer's vision, yet refused to relinquish his or her own.

The book concludes with 'Tour-de-force', which brings together some fifty outstanding twentieth-century dance photographs by professionals and amateurs alike. No two resemble one another. What they share is a spirit of photographic invention and a deep intuitive grasp of the meaning of dance.

14647

Miss Stevenson dressed as 'Photography' for a
costume ball in Montreal. Photographed by
the studio of William Notman and Son, 1865.

I
Invention

1 One of the earliest dance photographs: an unidentified American dancer in an anonymous daguerreotype, *c.* 1849.

2,3 Early studies of movement: two instantaneous photographs by the French physiologist Etienne-Jules Marey, *c.* 1890.

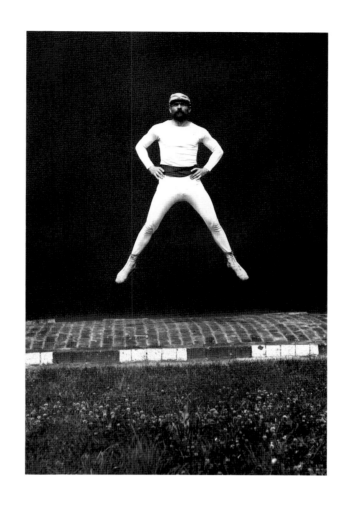

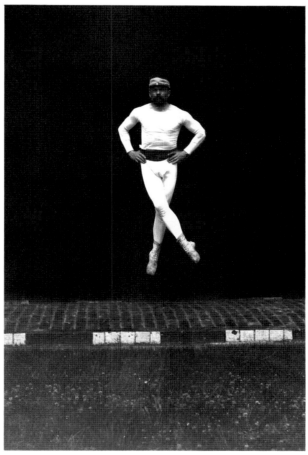

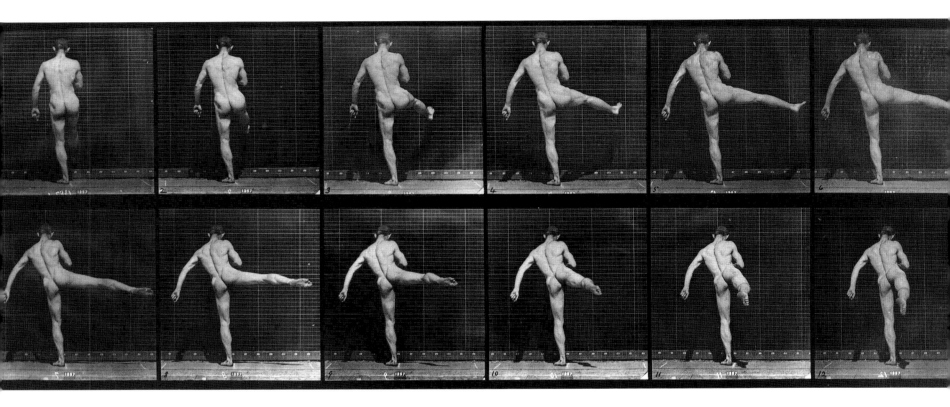

4 'First Ballet Action'. Plate 369 from
Eadweard Muybridge's pioneering study
Animal Locomotion, 1887.

5 Uncut *carte-de-visite* photographs of the
celebrated ballerina Fanny Cerrito, by André
Adolphe Eugène Disdéri, *c*.1855.

6 Anna Pavlova as the Dragonfly, by Ira Hill Studio,
New York, c.1915. The pencil lines and heavy retouching
indicate frustration with the difficulties of conveying
motion.

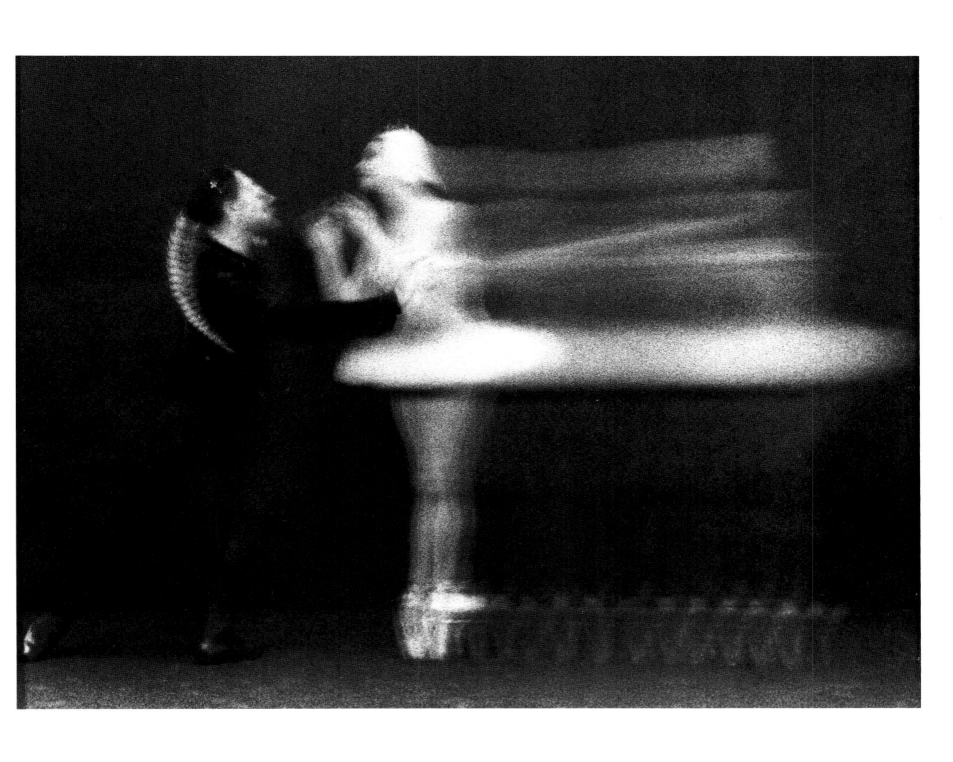

7 A lyrically successful solution to the
problem of Plate 6: an untitled study by Paul
Himmel, 1952.

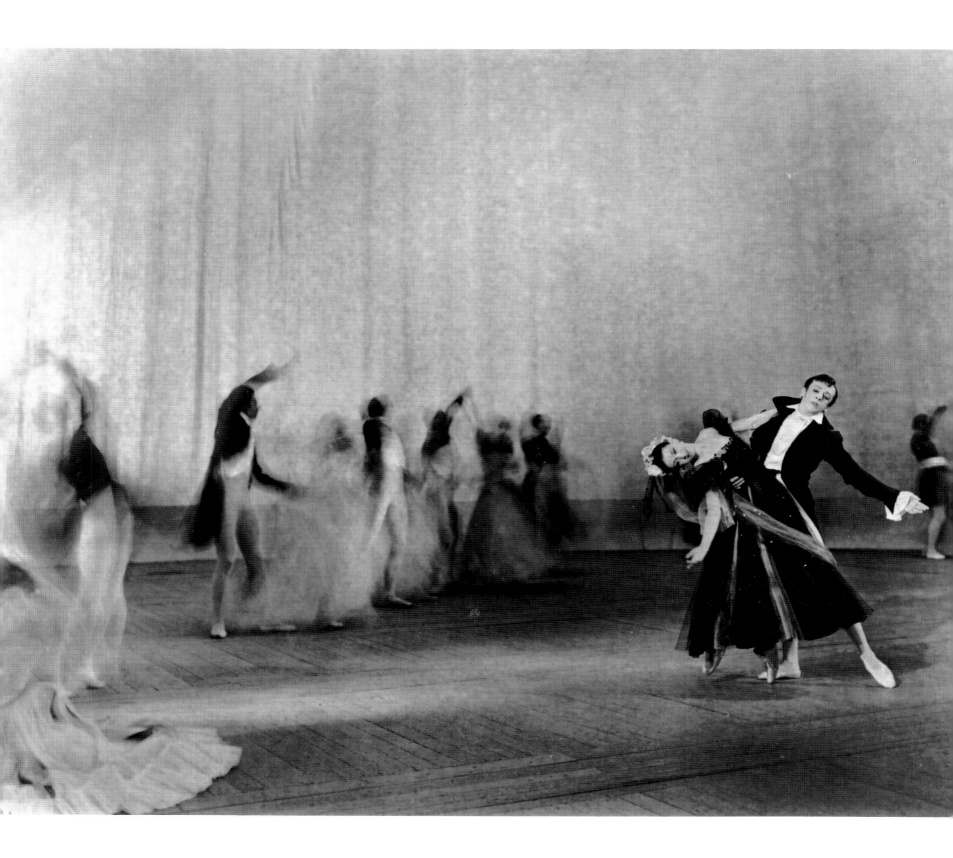

8 Cecil Beaton makes clever use of time
exposure to focus attention on Margot Fonteyn
and Robert Helpmann dancing in *Apparitions*
at Covent Garden in 1949.

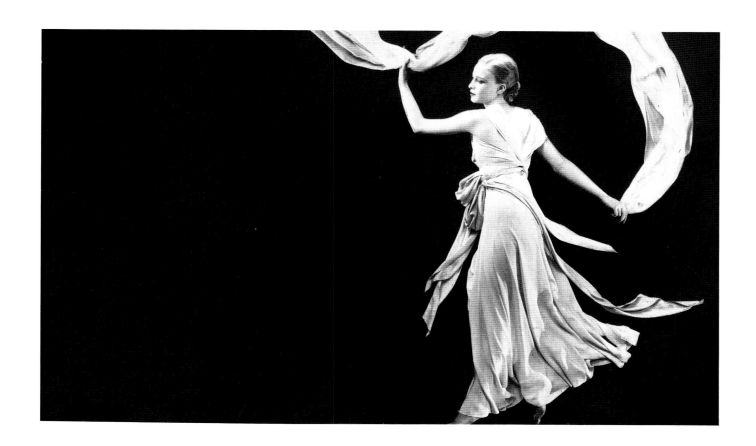

9 George Hoyningen-Huene, in contrast,
posed his still model on the floor to produce a
convincing illusion of fluid movement in this
fashion photograph of 1931.

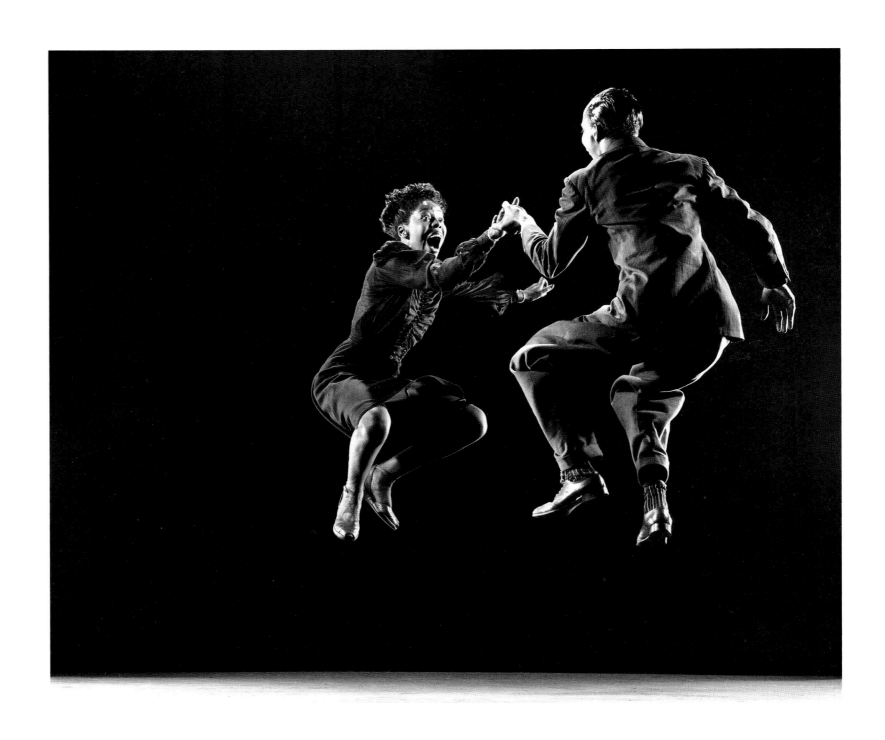

10 Gjon Mili's *Lindy Hop Improv* of 1943 is among the first photographs to use electronic flash and stroboscopic lighting to 'freeze' a split-second in a dance.

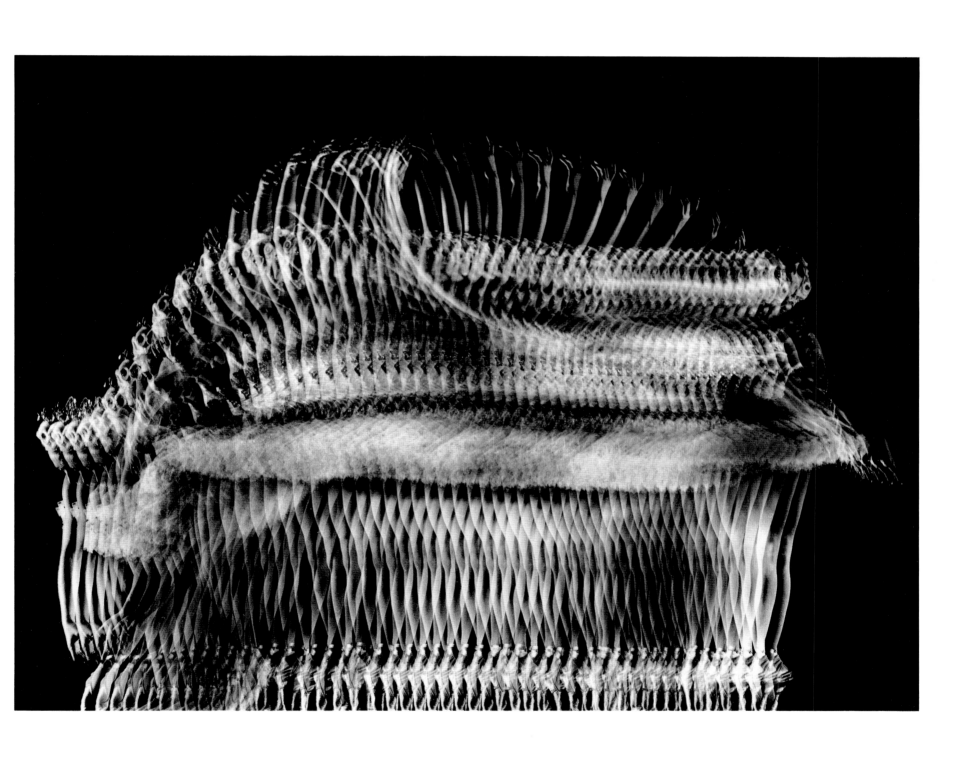

11 Here Mili combines stroboscopic lighting
with a time exposure to produce a depiction of
a complete *pas de bourrée*, danced by Nora
Kaye in 1947.

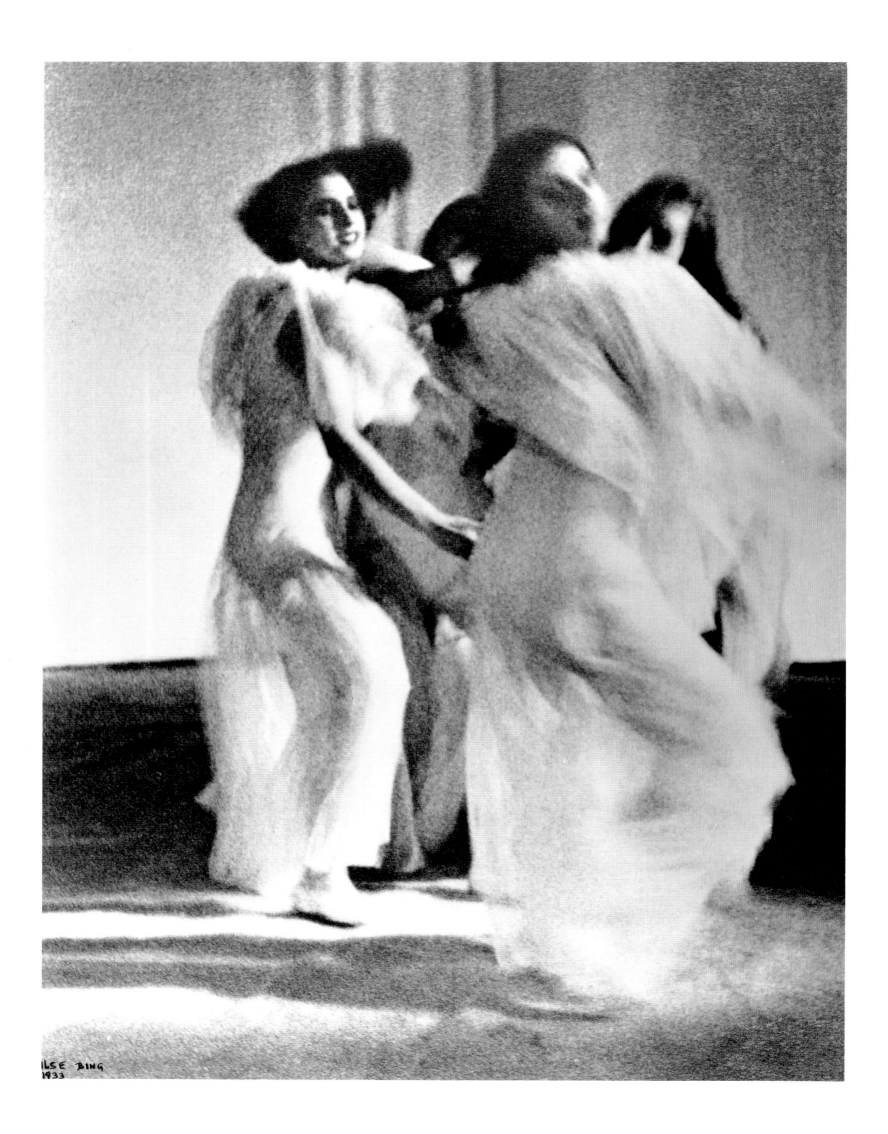

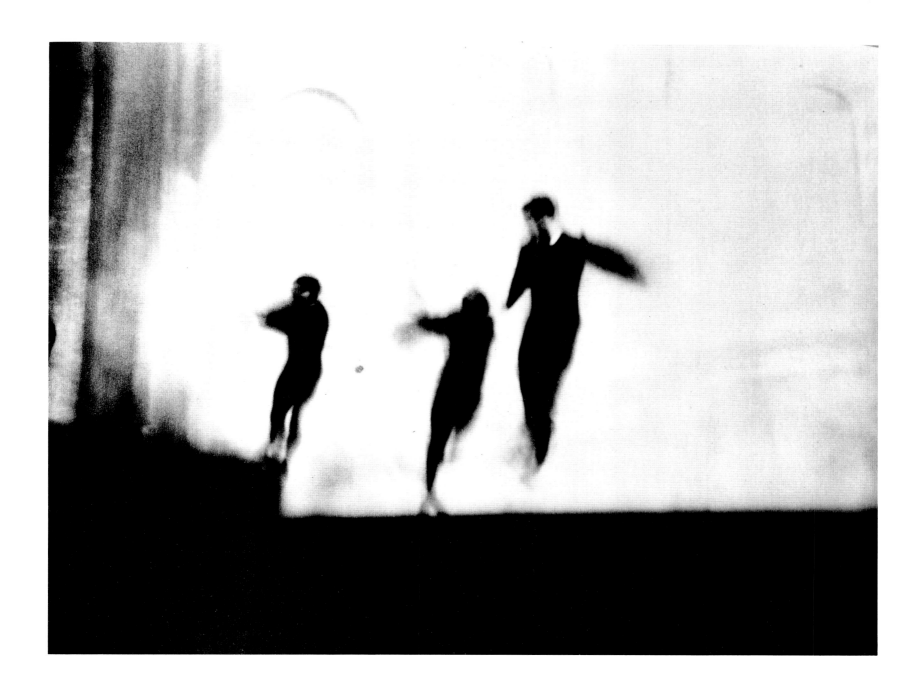

12 Tilly Losch in George Balanchine's
Errante, 1933, by Ilse Bing, who used newly
invented fast film to capture motion.

13 Alexei Brodovitch employed blurred
movement and high contrast in his expressive
studies of the Ballets Russes de Monte Carlo on
tour in the USA in the 1930s.

14, 15 Two photographic studies of ballerinas
attributed to Edgar Degas, possibly c.1895.
Similar figures appear in subsequent drawings
and pastels.

16 Alicia Markova and Prudence Hyman in Frederick Ashton's *Foyer de Danse*,
1932, by Bertram Park. Degas's work inspired many ballet photographers.

17 *Une balleteuse*, a Degas-like study
in the new gum-bichromate medium
by Robert Demachy, 1900.

18–22 Five dance poses
photographed in 1901 by Alphonse
Mucha, as an aid for his decorative art.

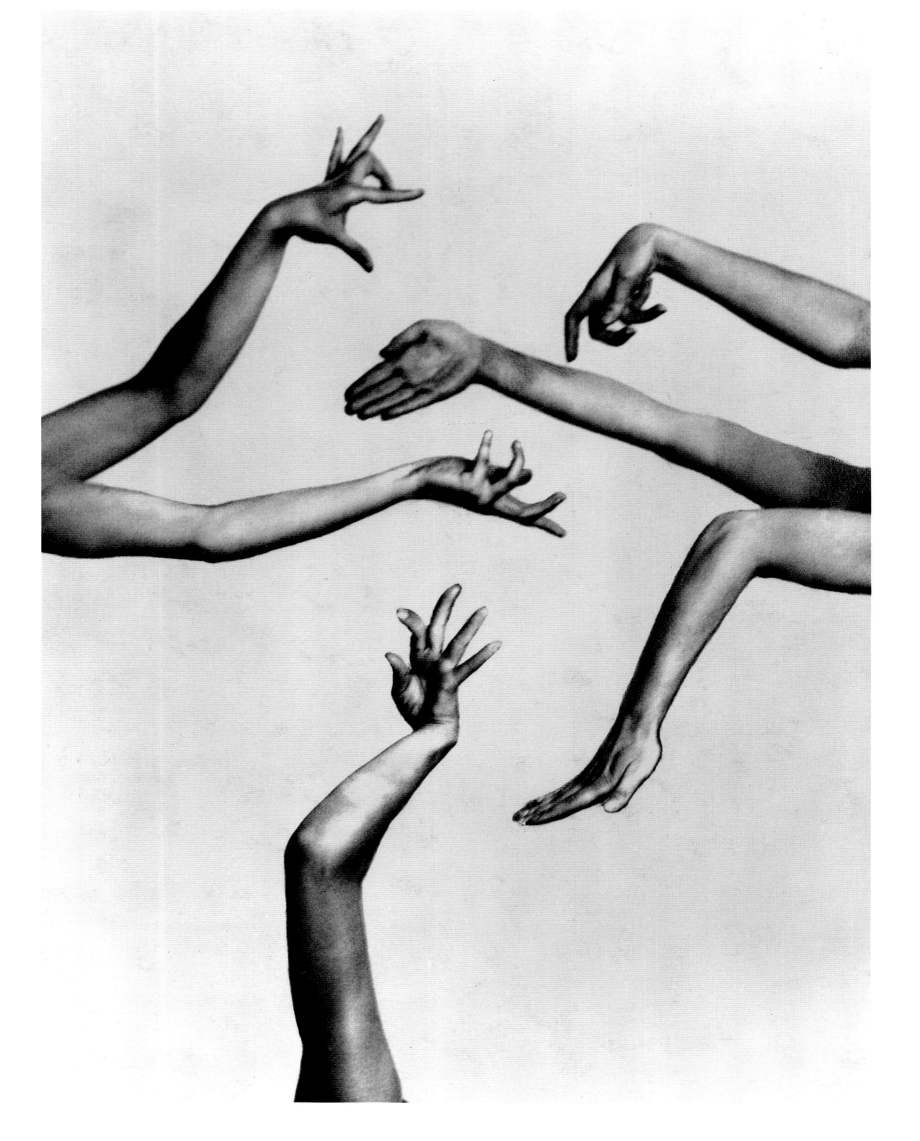

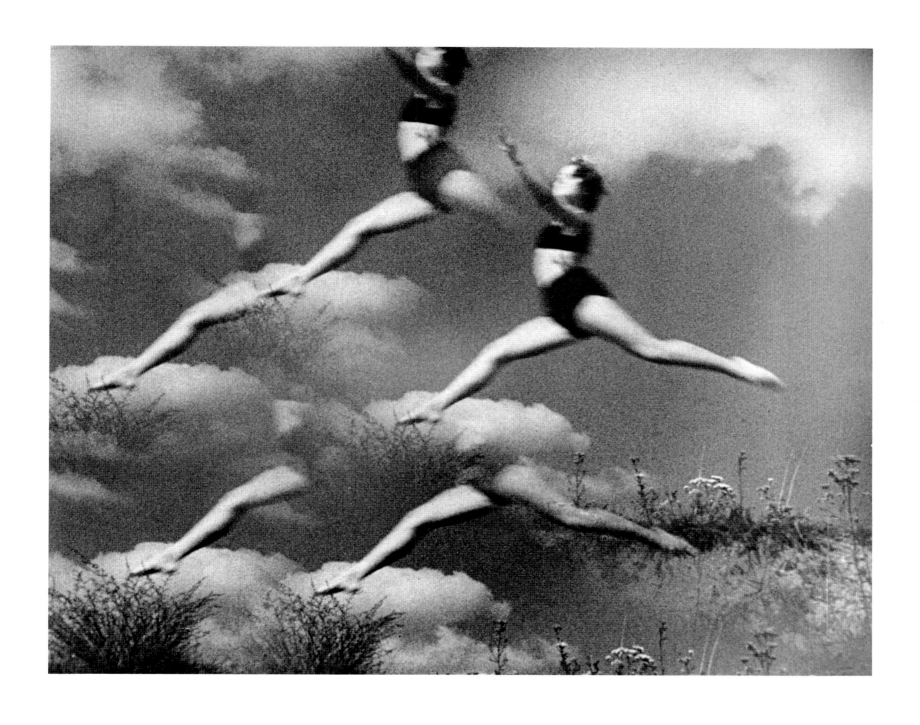

23 The photographer as choreographer: this
arm and hand study of the Mary Wigman
dancers was created for the camera by
Charlotte Rudolph in 1925.

24 *Black and White Rhapsody*, by
Martin Frič, 1937.

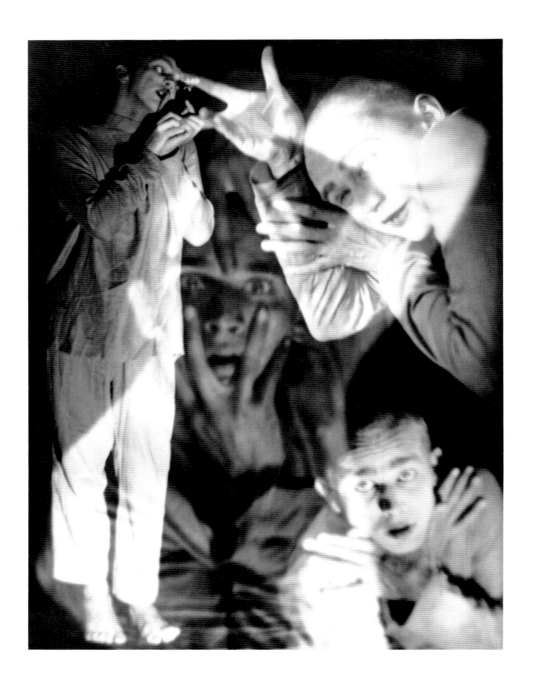

25 An early use of multiple printing in dance photography: *Danse Macabre, Harald Kreutzberg*, by Baruch, 1928.

26 *Wind Fire*: a study of Maria Theresa by Edward Steichen, 1920. The image has been manipulated by the photographer to suggest the forces of nature.

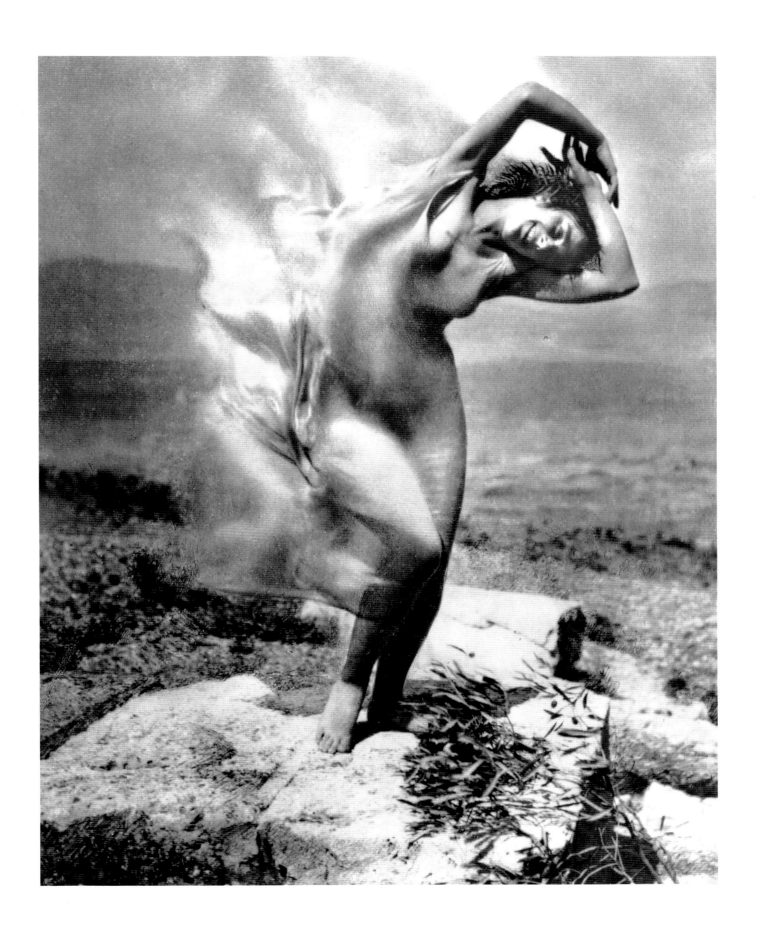

1712

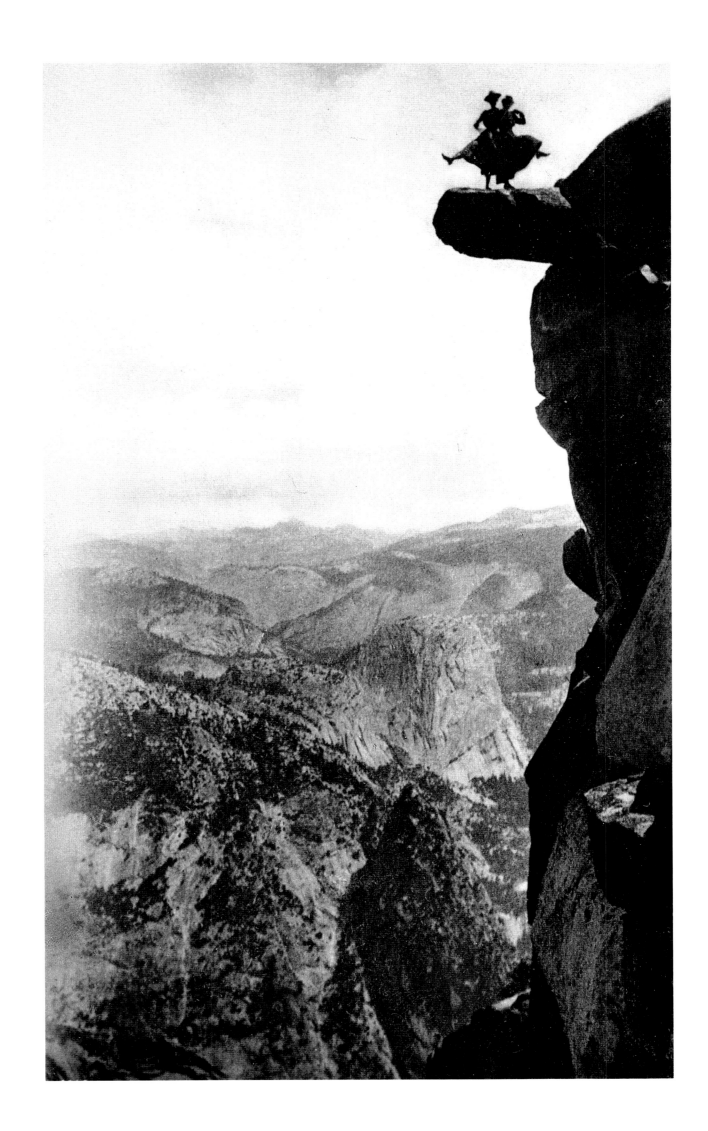

27 The frame of
nature: Ted Shawn at
Yosemite in an
anonymous snapshot
of 1921.

28 Clowning on
Observation Point,
Yosemite, by George
Fiske, c.1905.

29, 30 Studies of
balletic form by George
Platt Lynes, who
illustrates two gestures
within one long
exposure. The dancer is
Ralph McWilliams, 1952.

31 Martha Graham in a double exposure made within the camera by Imogen Cunningham in 1931.

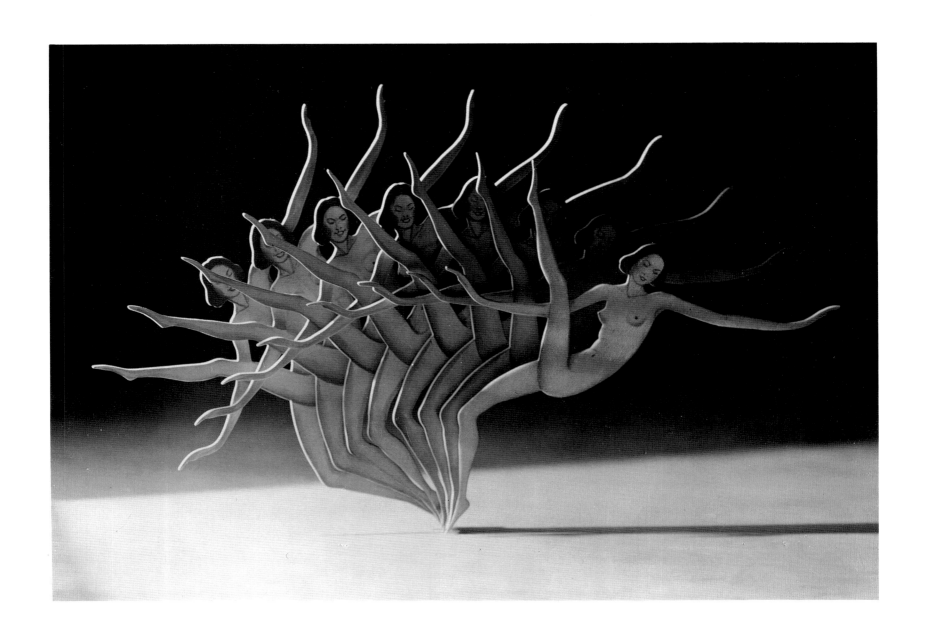

32 The avant-garde Czech photographer
František Drtikol made constructions which
he then photographed. This is titled
Fan dancer, *c.* 1935.

33, 34 Two letters from a Czech alphabet
montage published in 1926. This collaboration
of author, choreographer and book designer
employs photographs by Karel Paspa.

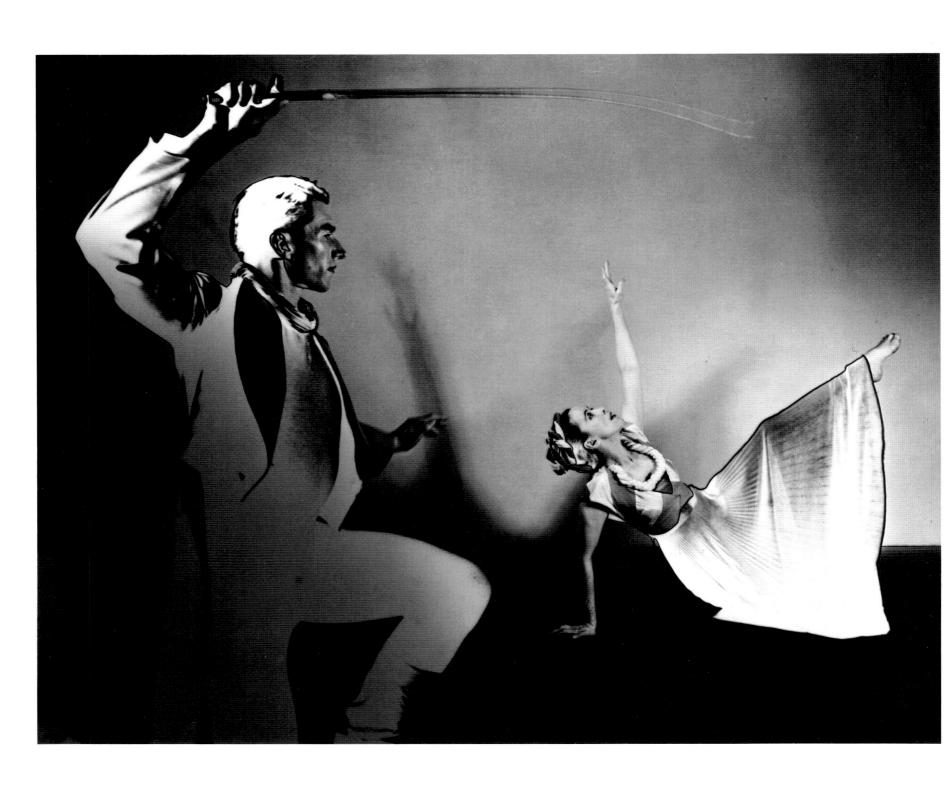

35 Erick Hawkins and Martha Graham in
Every Soul is a Circus, a solarized photograph
by Barbara Morgan, 1940.

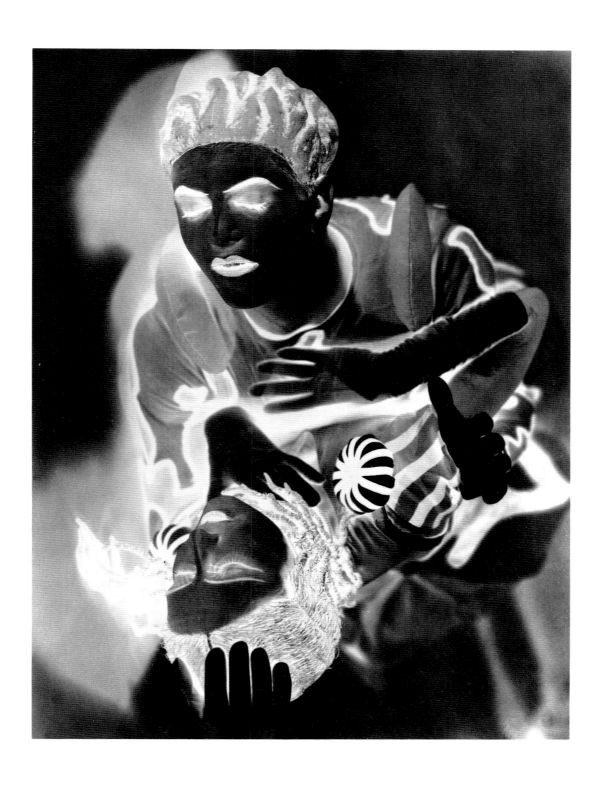

36 Serge Lifar and Olga Spessivtseva in
Bacchus and Ariadne, 1931, a negative print
by George Hoyningen-Huene.

37 Merce Cunningham in silhouette,
photographed by Jack Mitchell in 1975.

38 Ted Shawn in *The Mevlevi Dervish*, a
time-exposure of 1951 by Jack Mitchell.

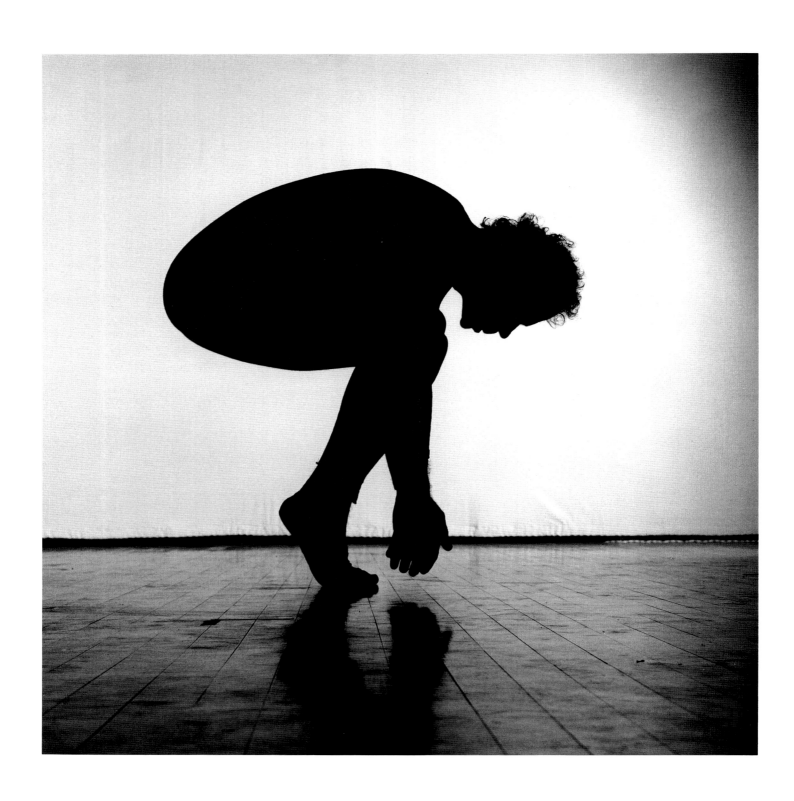

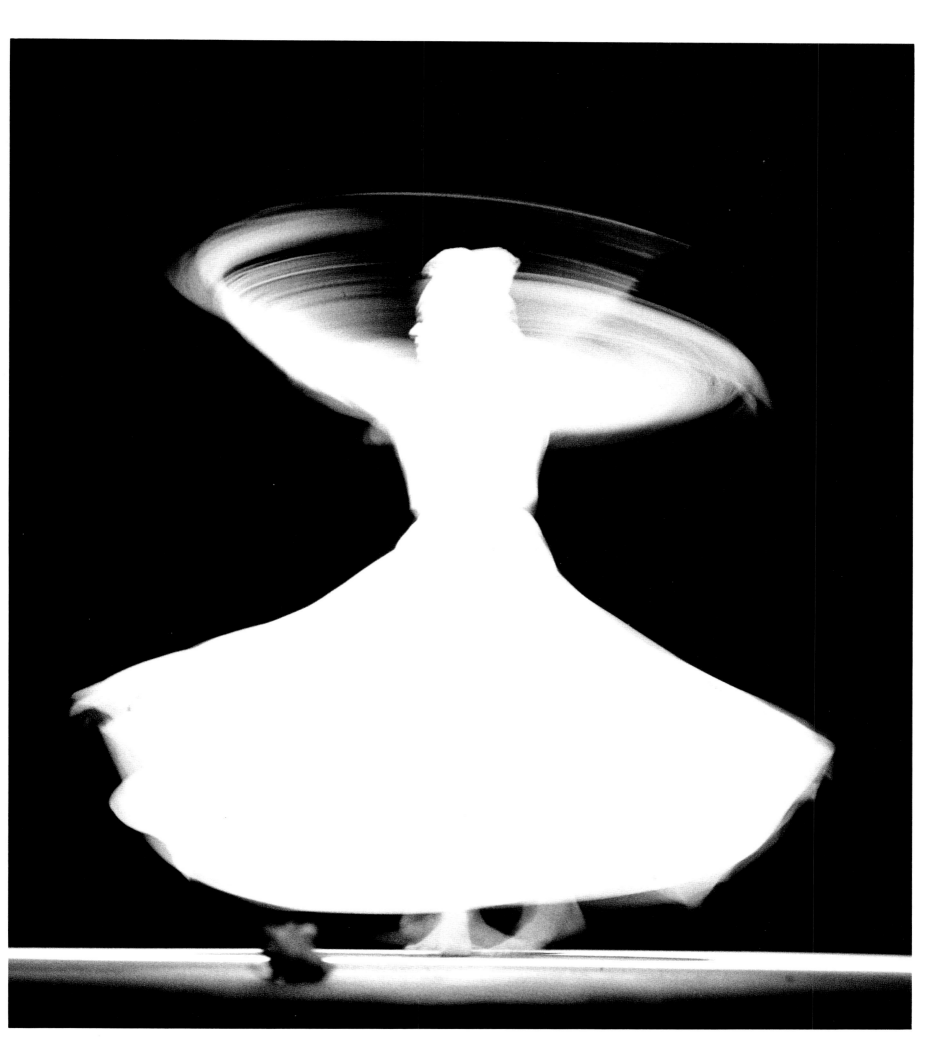

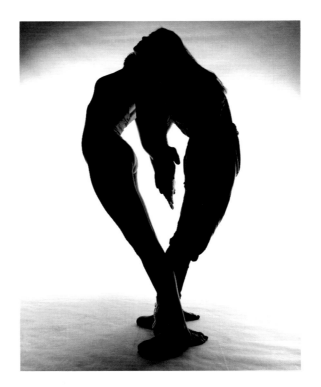

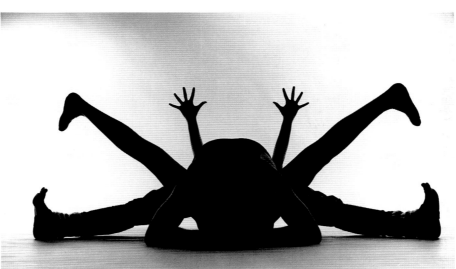

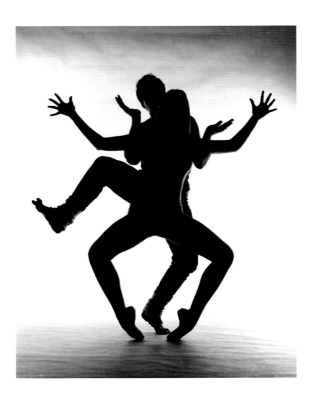

39–41 The photographer as
choreographer: *Sea Duet*, 'a ballet
for still photography', by Jack
Mitchell, 1983.

42 Still photography combined with
animation: Gene Kelly and Jerry the
Mouse in MGM's *Anchors Aweigh*,
1945.

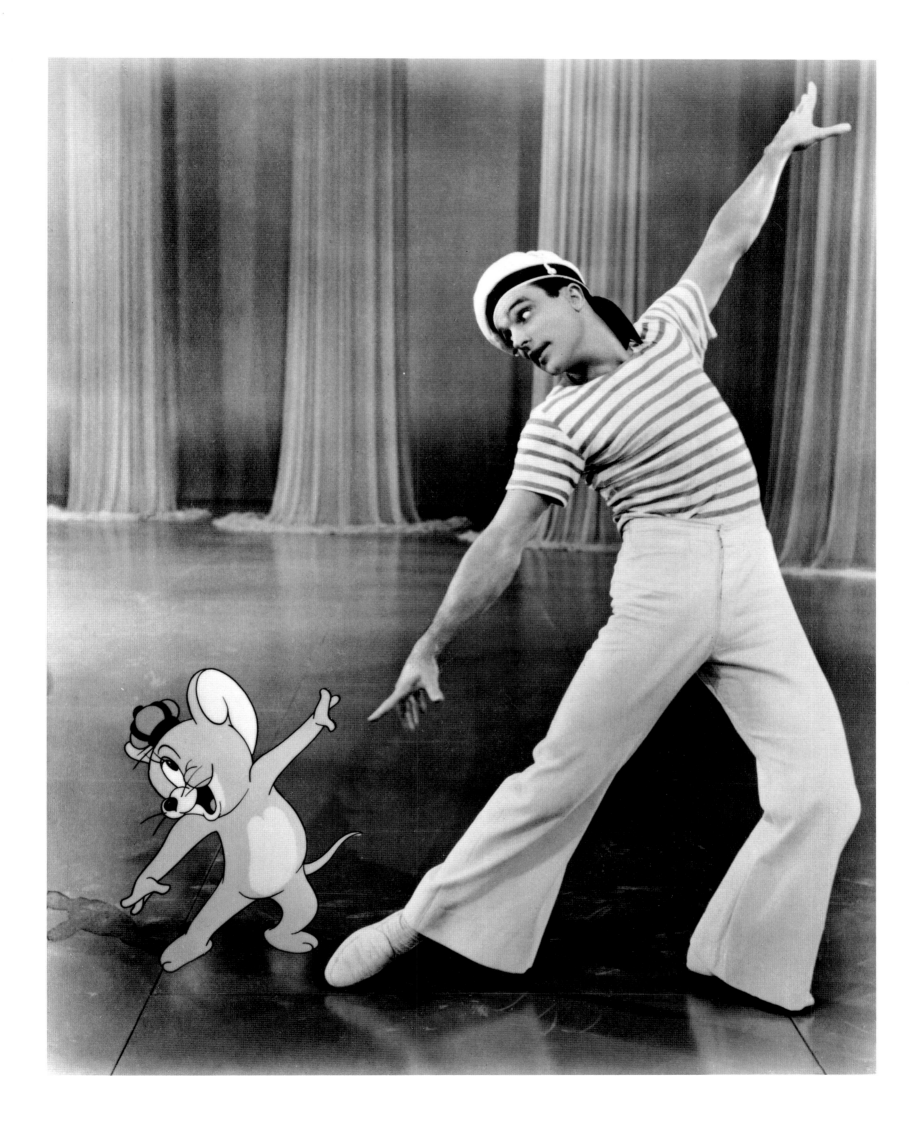

43 Anton Dolin's shoe, by Bob Golden, 1968. This advertisement uses a miniature set constructed by the photographer.

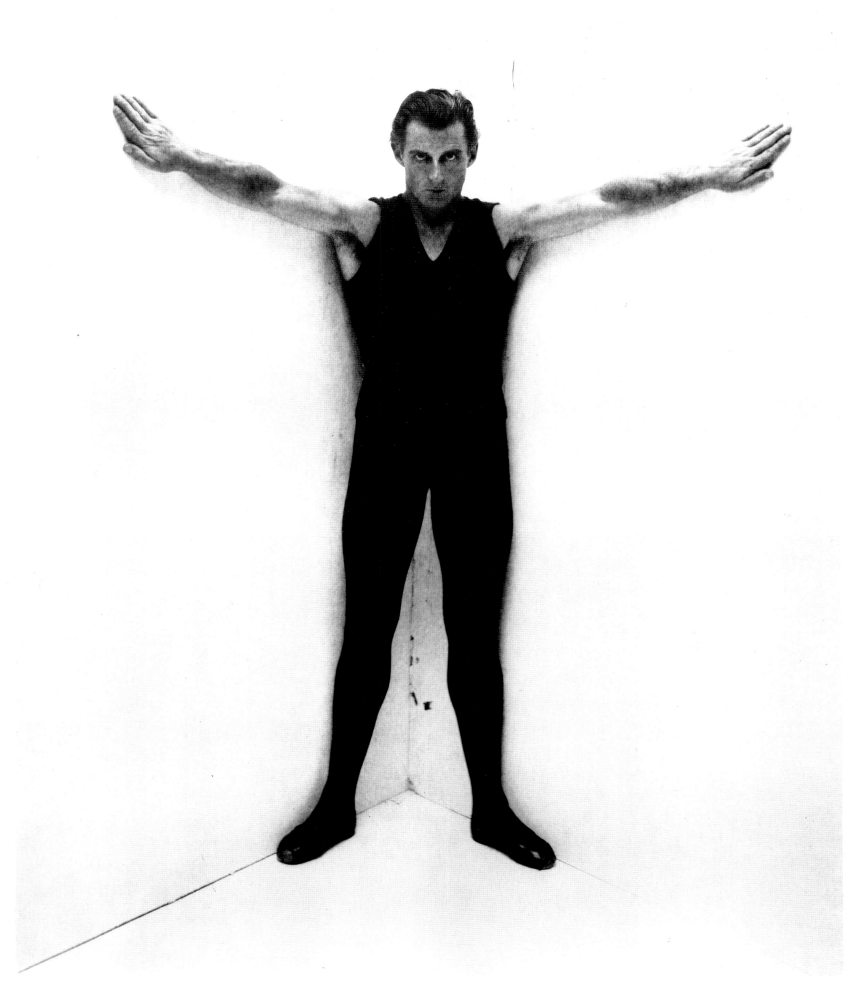

44 Anton Dolin, by Irving Penn, 1946. Penn exploits the limitations of the studio for psychological effect.

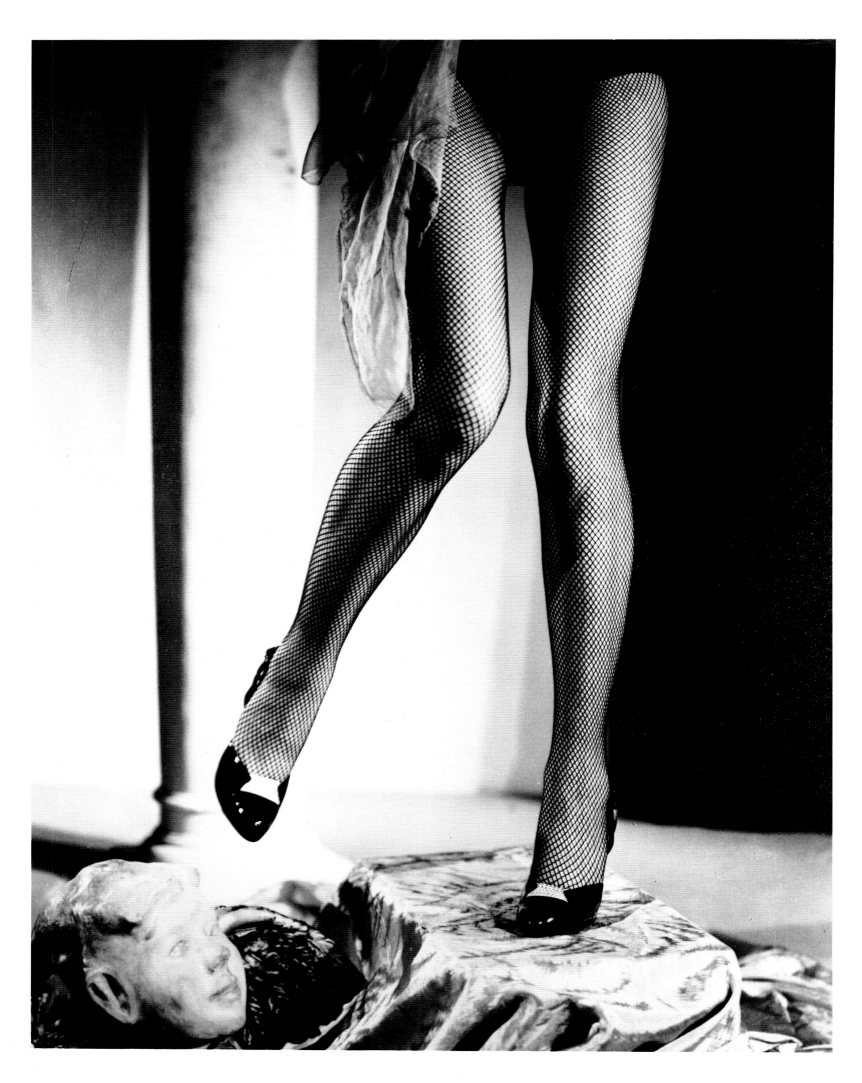

45 *Fishnet tights, Charleston, Cherub,* an assemblage by Count Zichy, 1953.

II
Record and Document

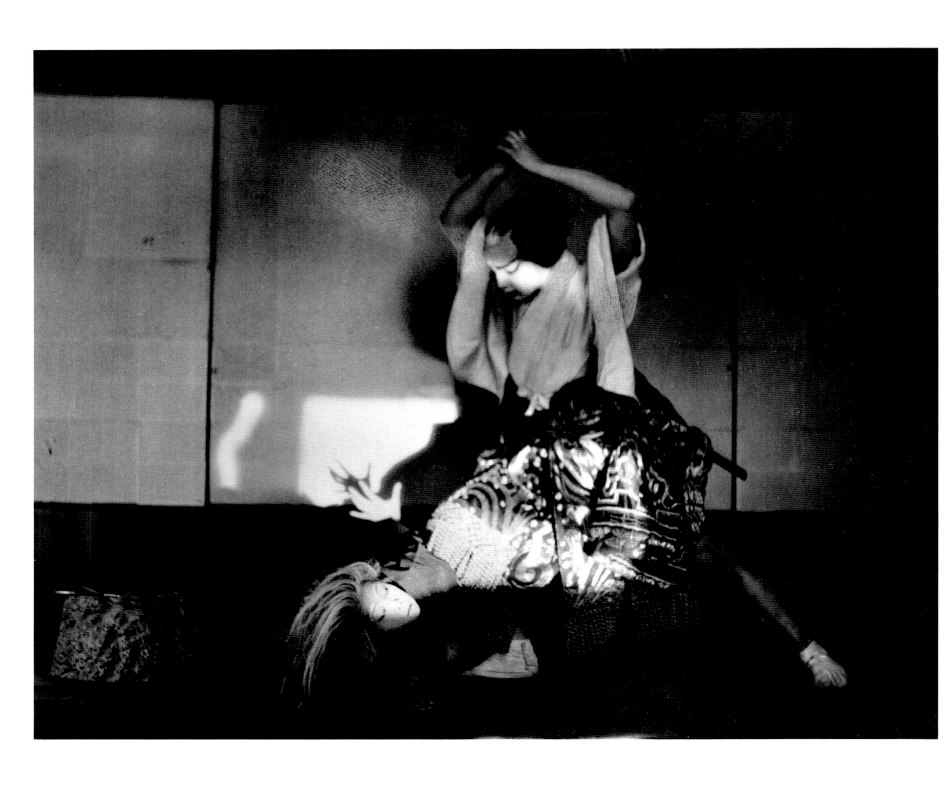

46　Ruth St Denis and her brother in *O-Mika*,
by Lou Goodale Bigelow, 1913.

47　Ruth St Denis in *Ourieda*, by Baron Adolf
de Meyer, *c*.1912.

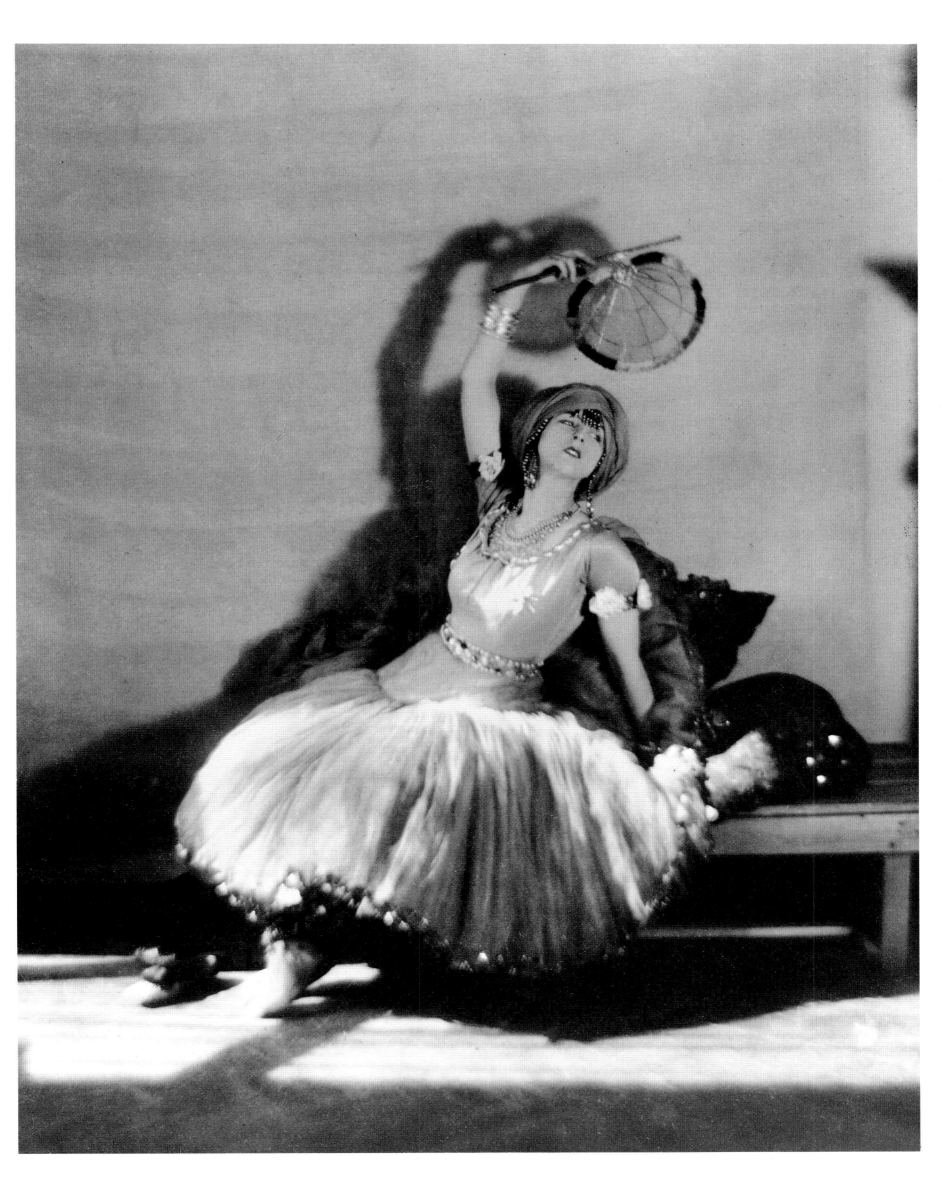

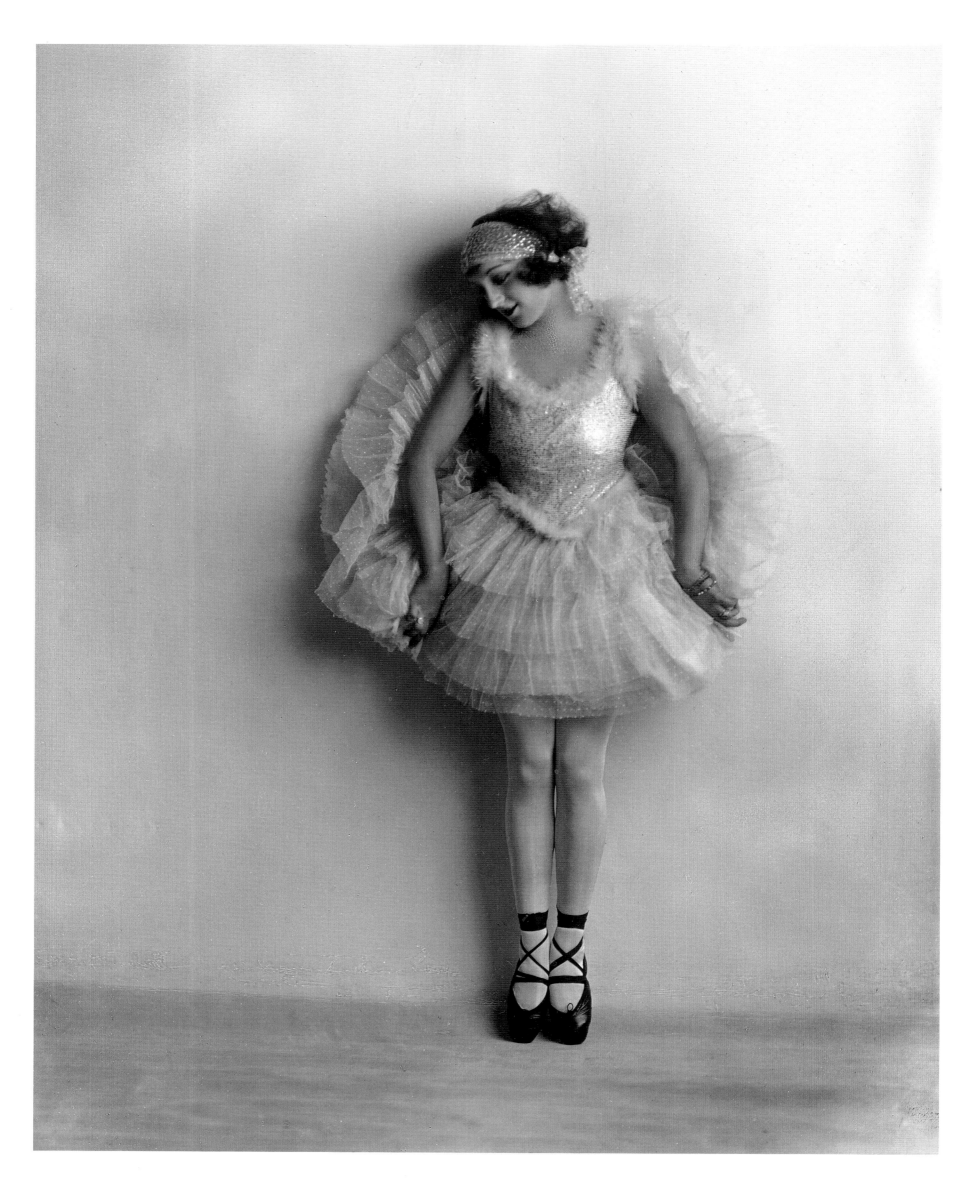

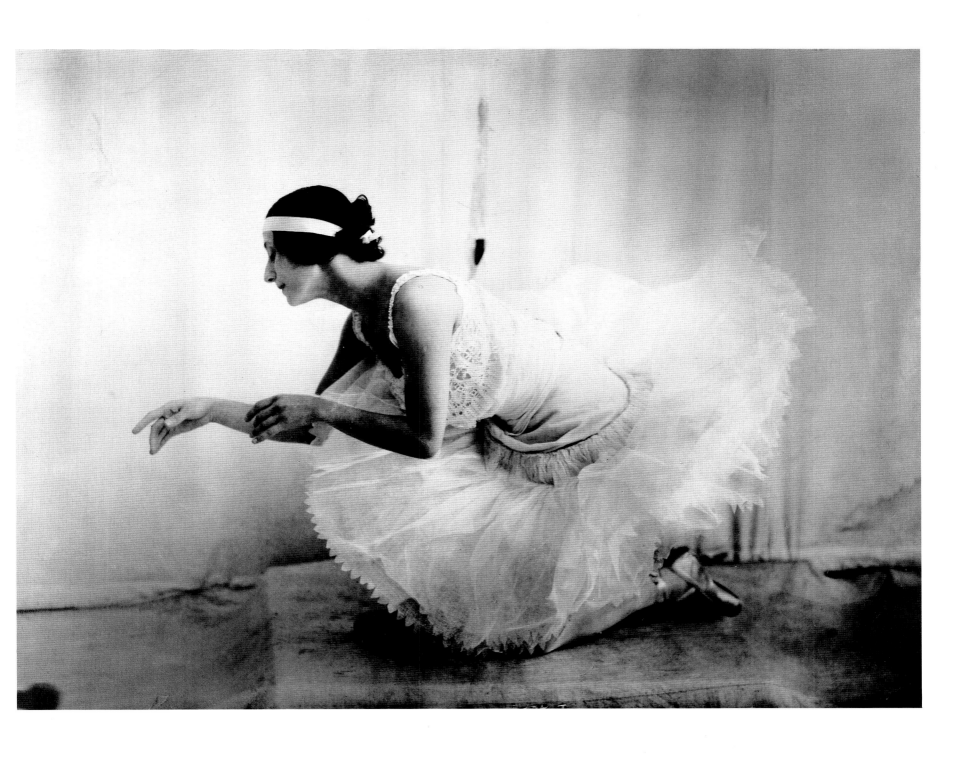

48 Mrs N.S. Horton in costume for a fancy-
dress ball, by the studio of William Notman
and Son, Montreal, 1924.

49 Anna Pavlova posing in the studio of an
anonymous photographer, *c.*1920.

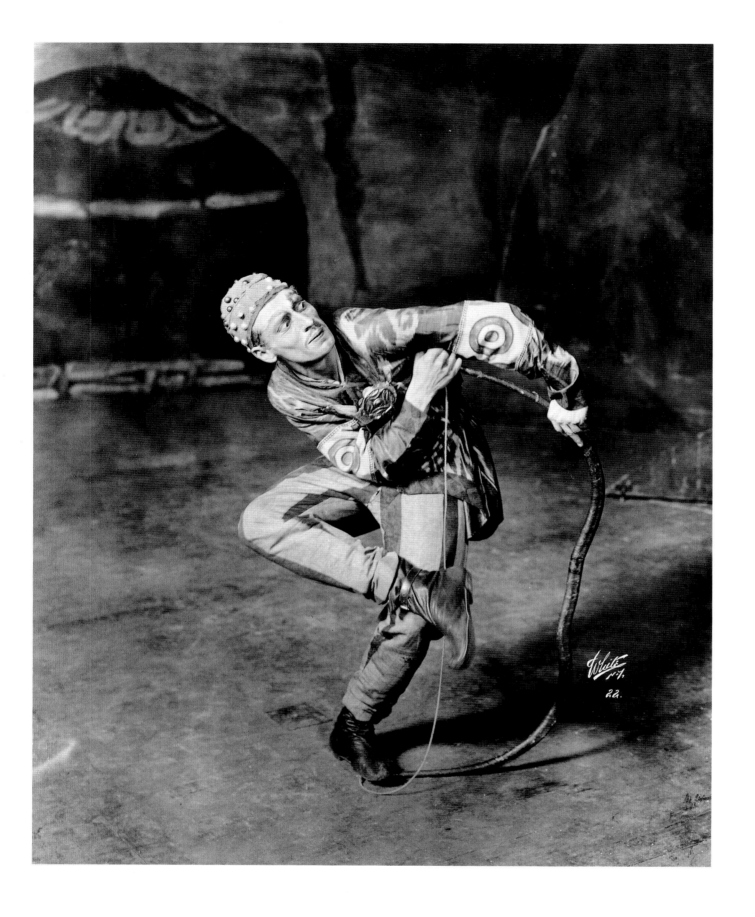

50 Adolph Bolm in the *Polovtsian Dances*
from *Prince Igor*, photographed by White
Studio in New York, 1916.

51 Ted Shawn in an Indian dance,
photographed by Arthur Kales in 1919.

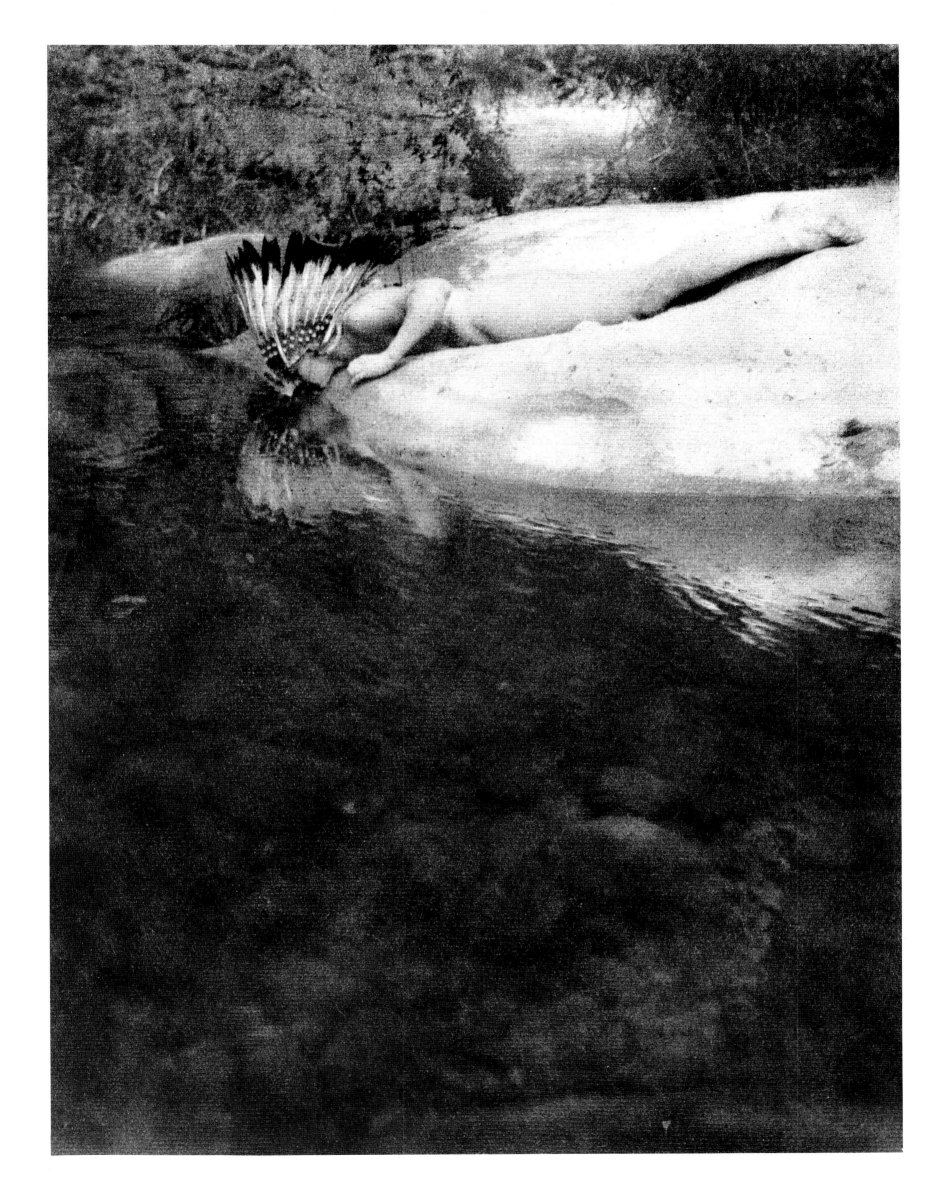

52, 53 Loie Fuller in *The Butterfly*, by
Théodore Rivière, *c*.1896.

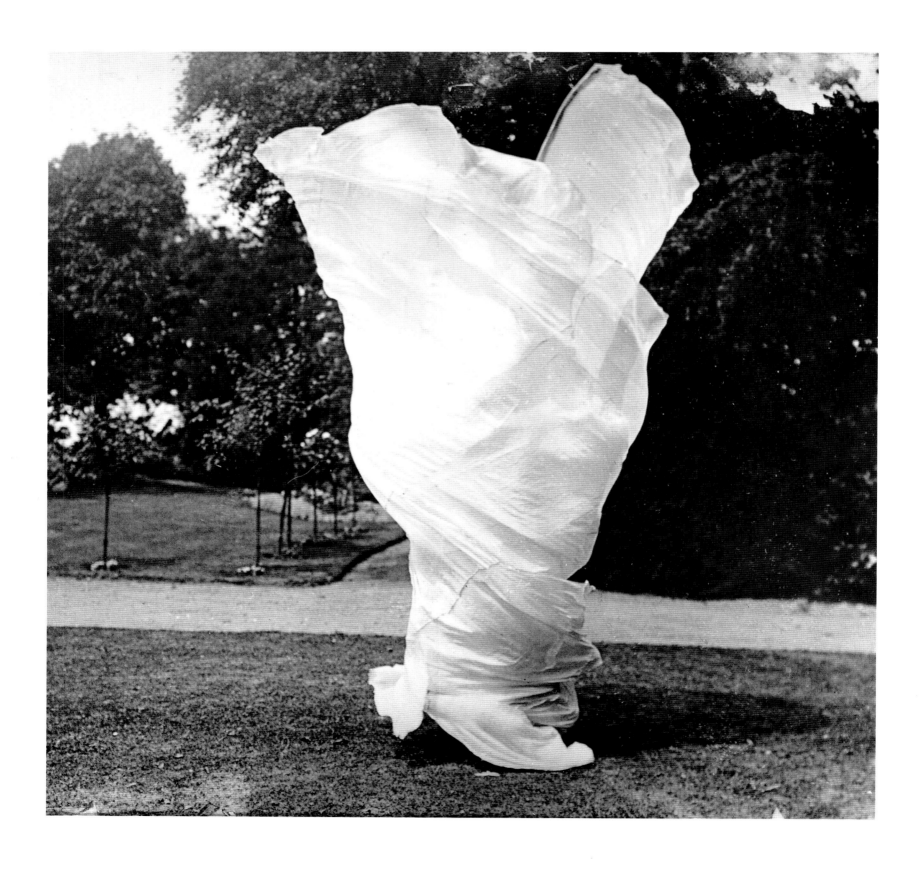

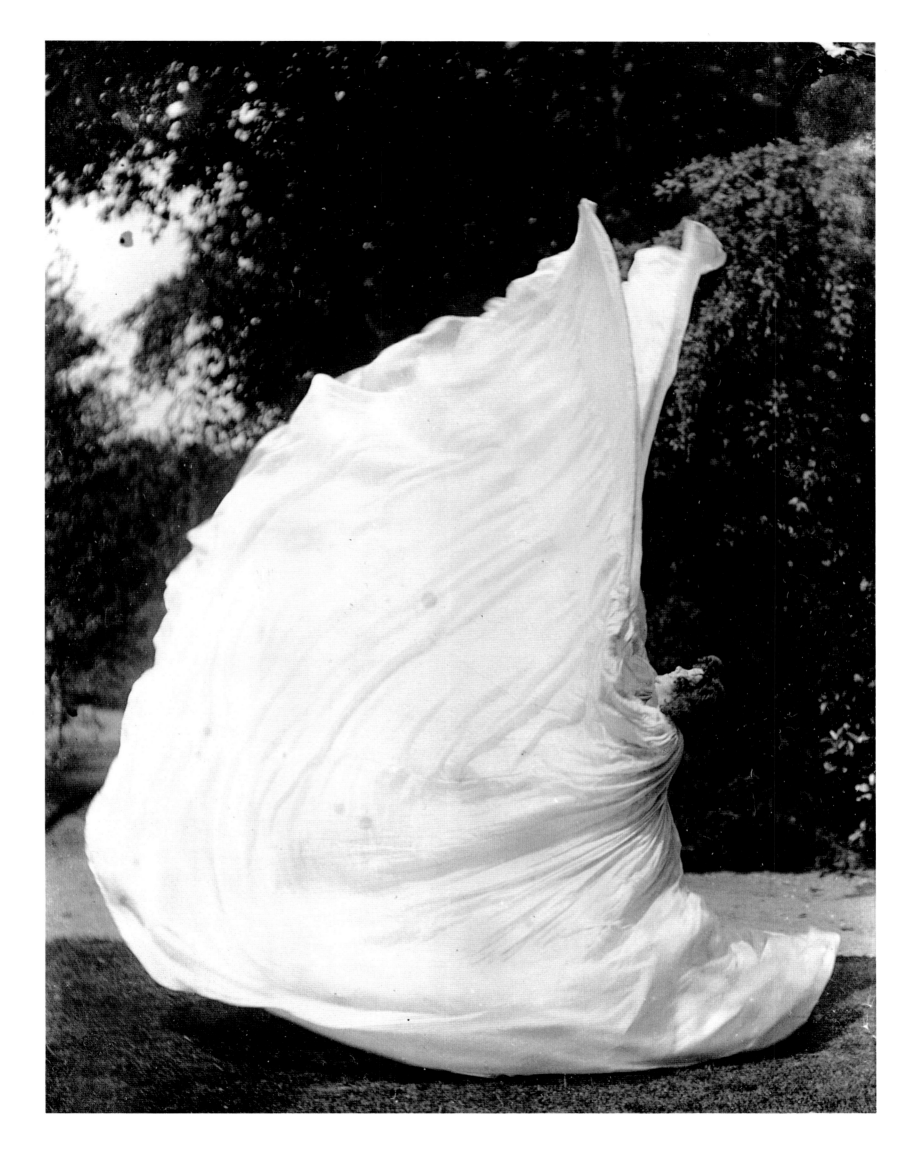

54 Lydia Sokolova as Kikimora in *Contes Russes*, 1916. Anonymous photograph.

55 Photograph by Horst of the costumes designed by Salvador Dali and made by Chanel for Massine's *Bacchanale*, 1939.

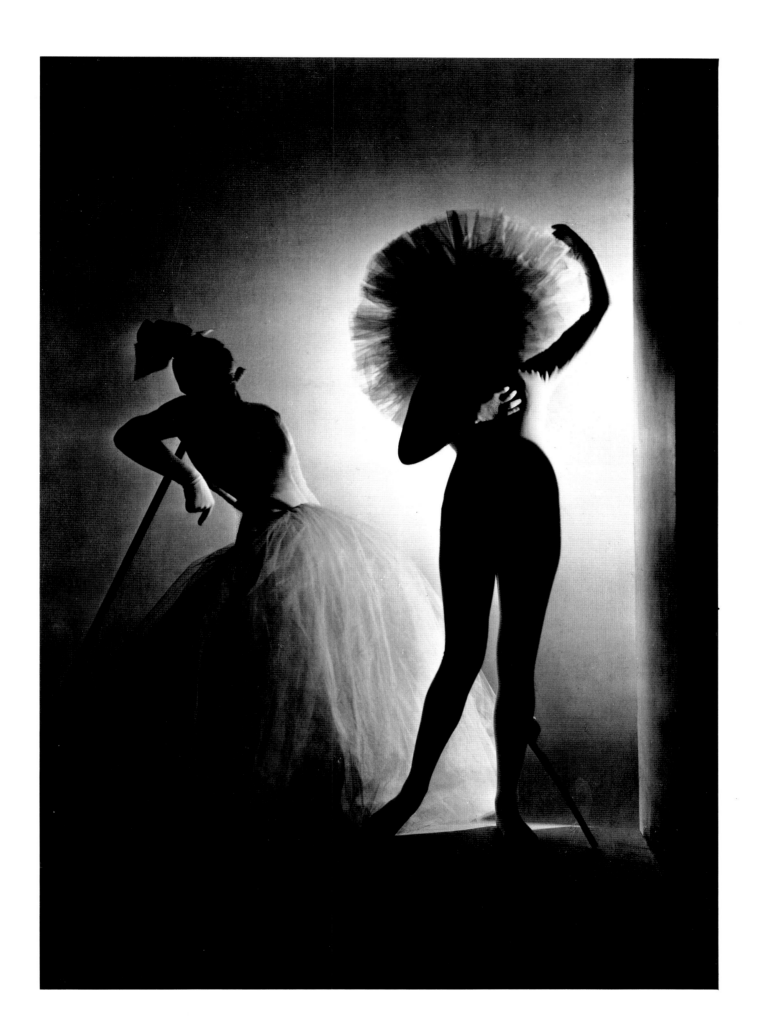

56 Dancing in the garden at Garsington
Manor, *c*.1918. Anonymous photograph.

57 Anna Pavlova dancing for Arnold Genthe,
c.1915. This is possibly the earliest photograph
of the dancer in free movement.

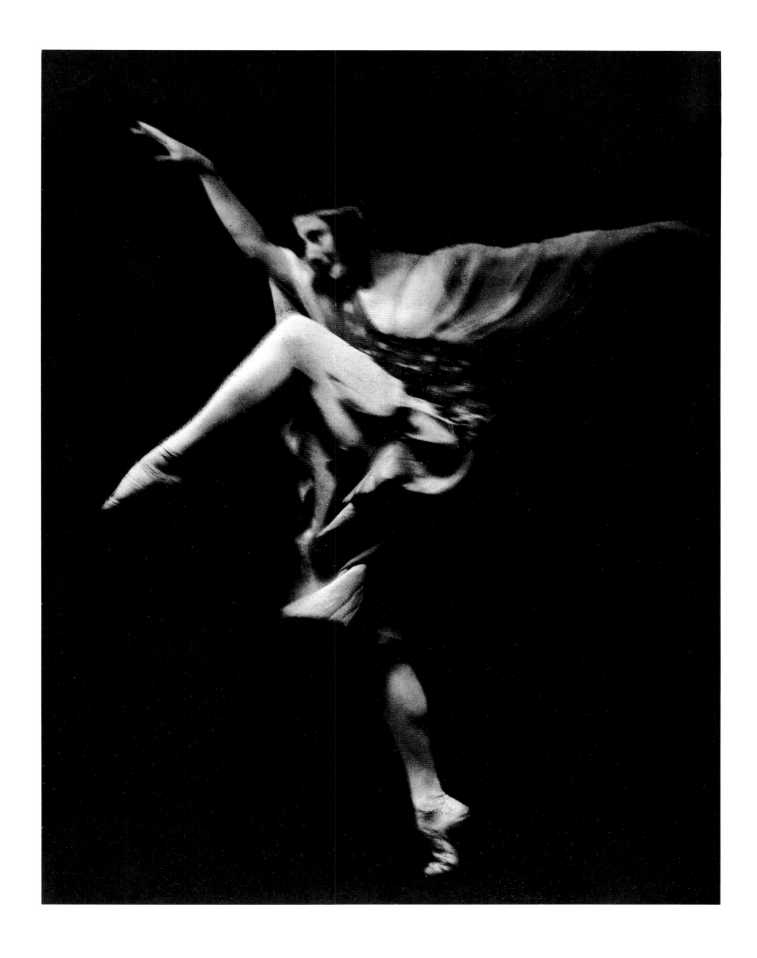

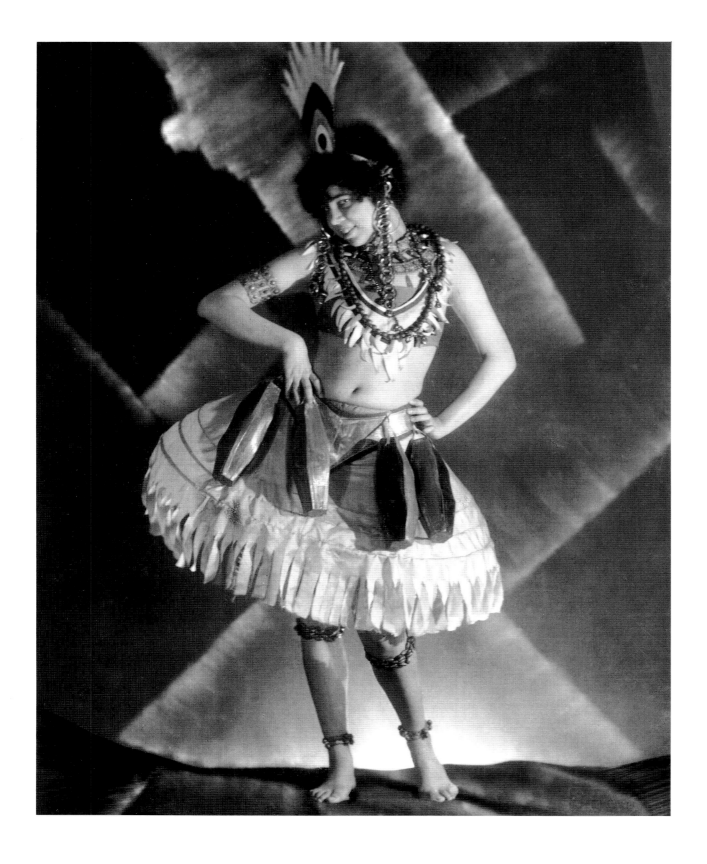

58 Ervína Kupferova in *Firedrum*, *c*.1921,
photographed by František Drtikol. The set
and costumes were by Filippo Marinetti.

59 Grace Jones in body paint and costume
designed by Keith Haring and photographed
by Robert Mapplethorpe, 1984.

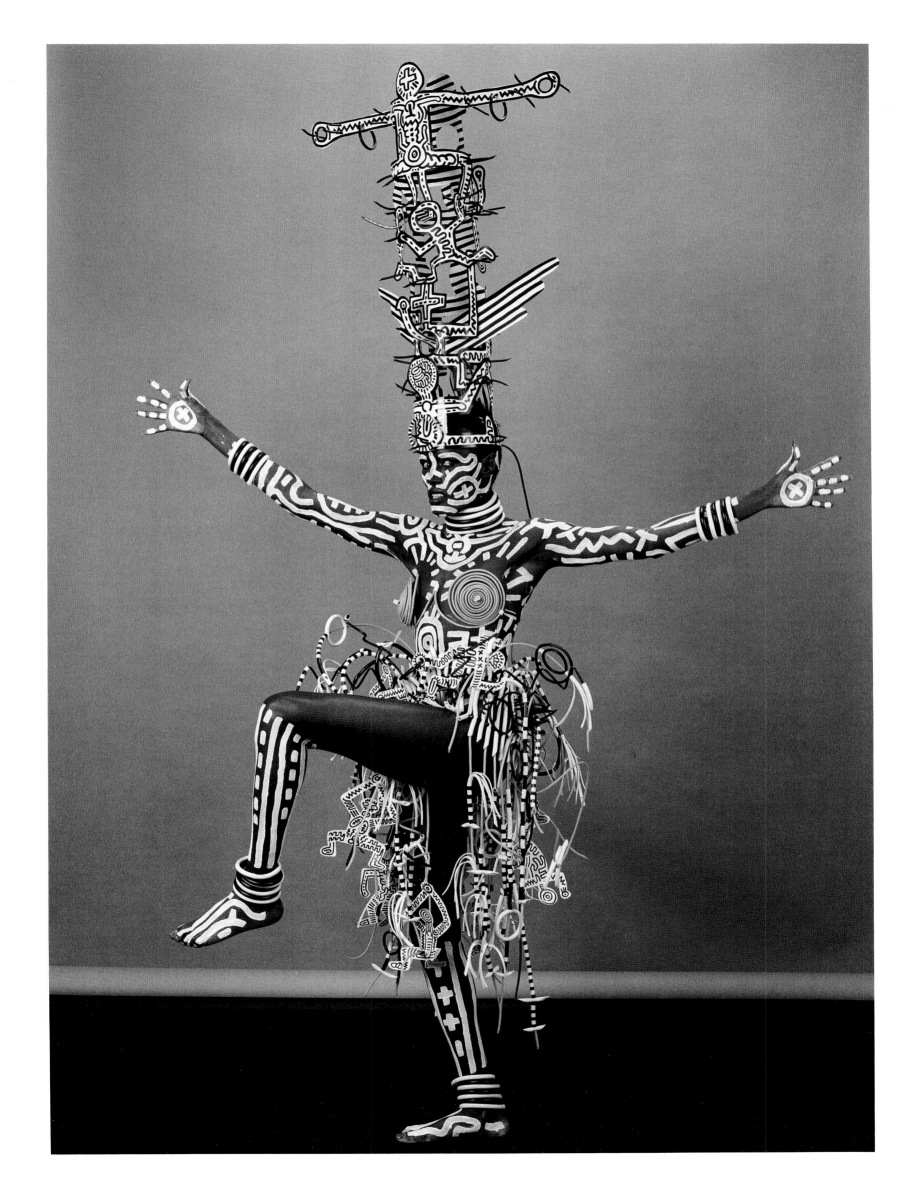

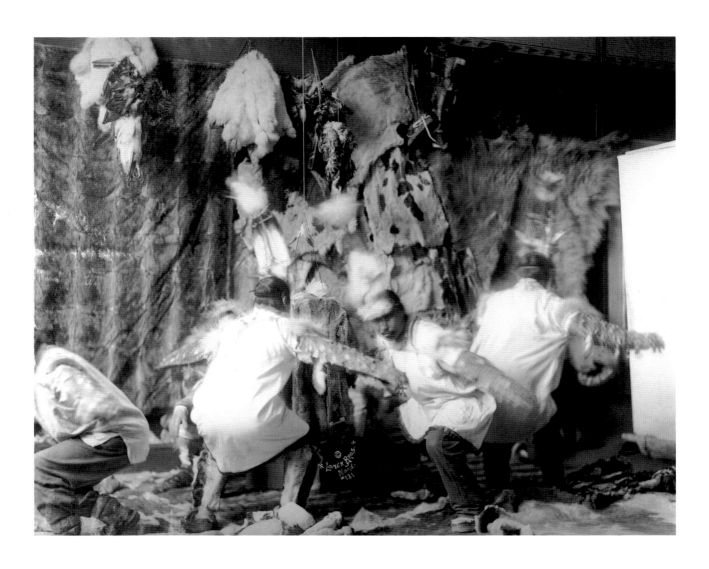

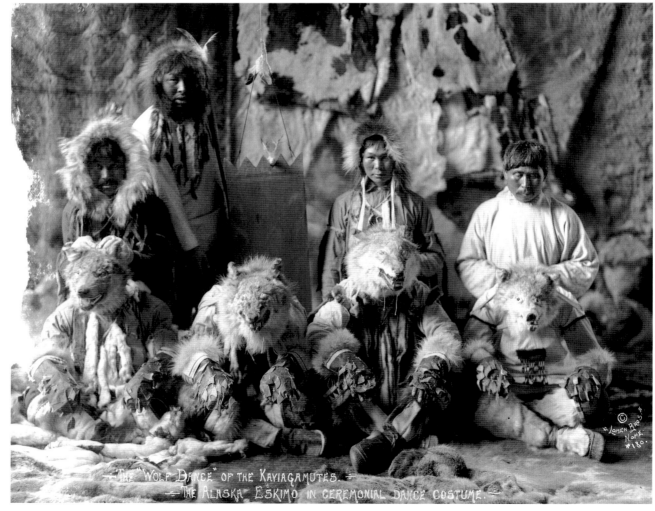

THE "WOLF DANCE" OF THE KAVIAGAMUTES.
THE ALASKA ESKIMO IN CEREMONIAL DANCE COSTUME.

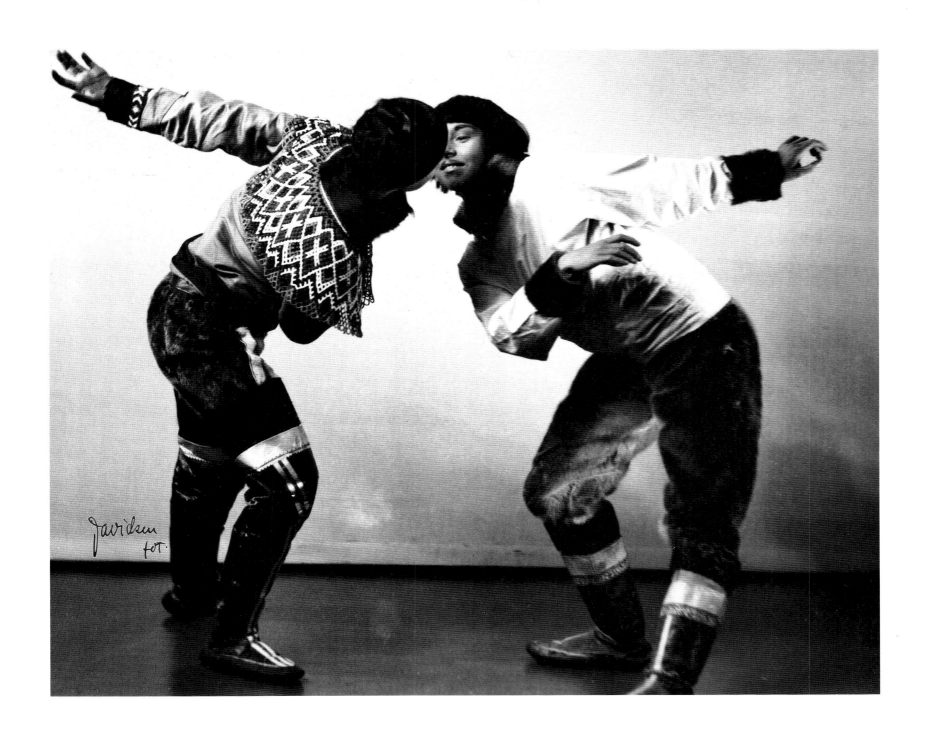

60, 61 The Wolf Dance of the Kaviagamutes:
a ceremonial dance of the Alaskan Eskimoes.
Undated photographs by Lomen Brothers
Studio, Nome, Alaska.

62 The Eskimo Dance of Triumph. Undated
photograph by Davidsen Studio.

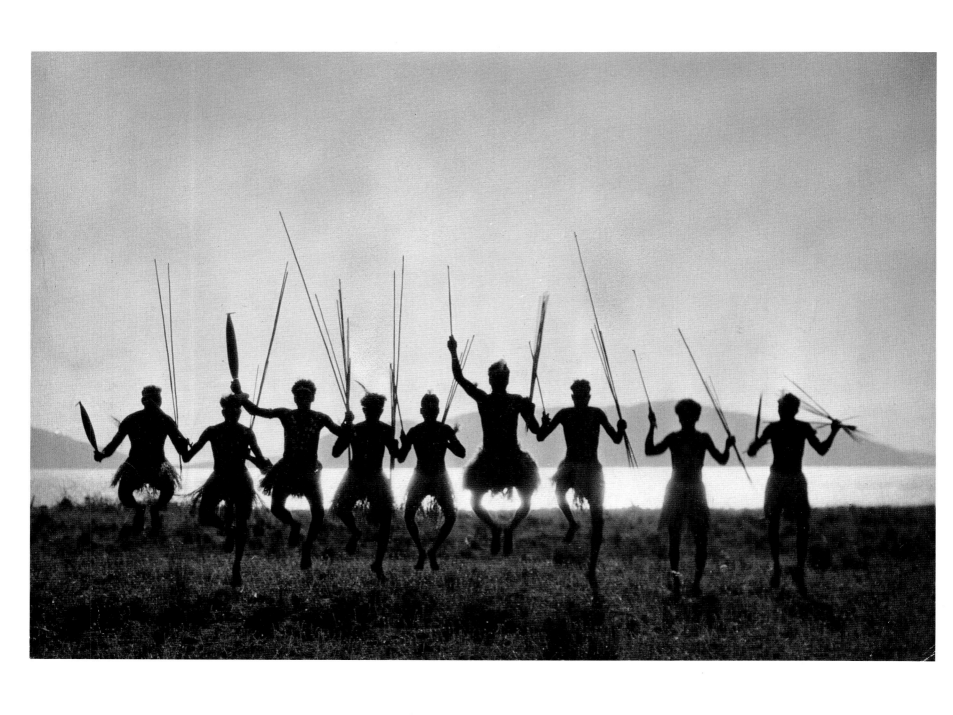

63 The Corrobereo, or Dancing Festival,
Australia, by E.O. Hoppé, 1930.

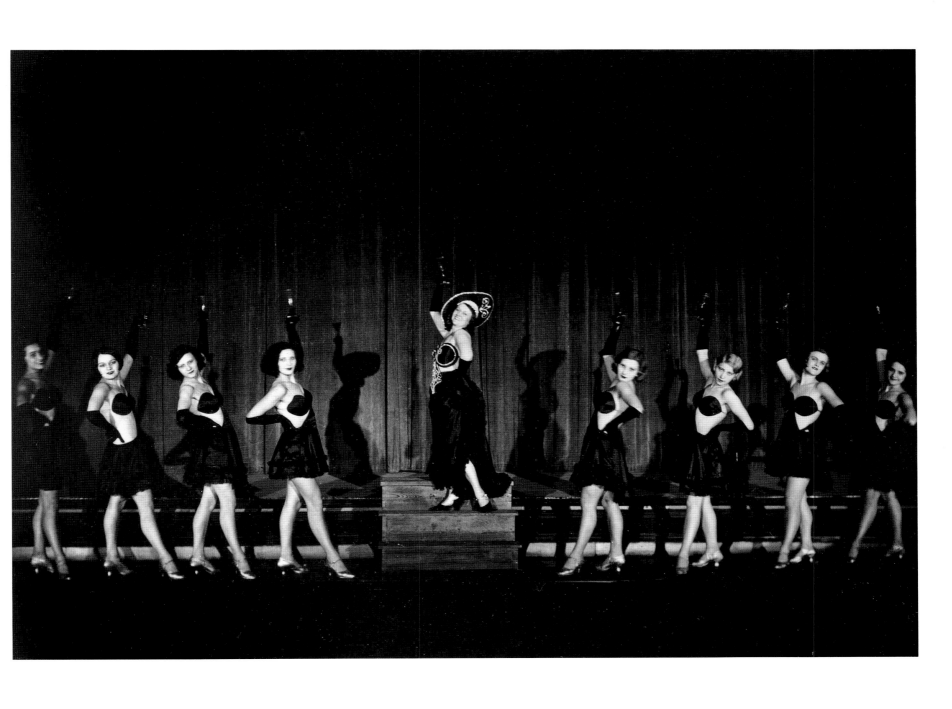

64 **Chorus line, by August Sander,** 1929.

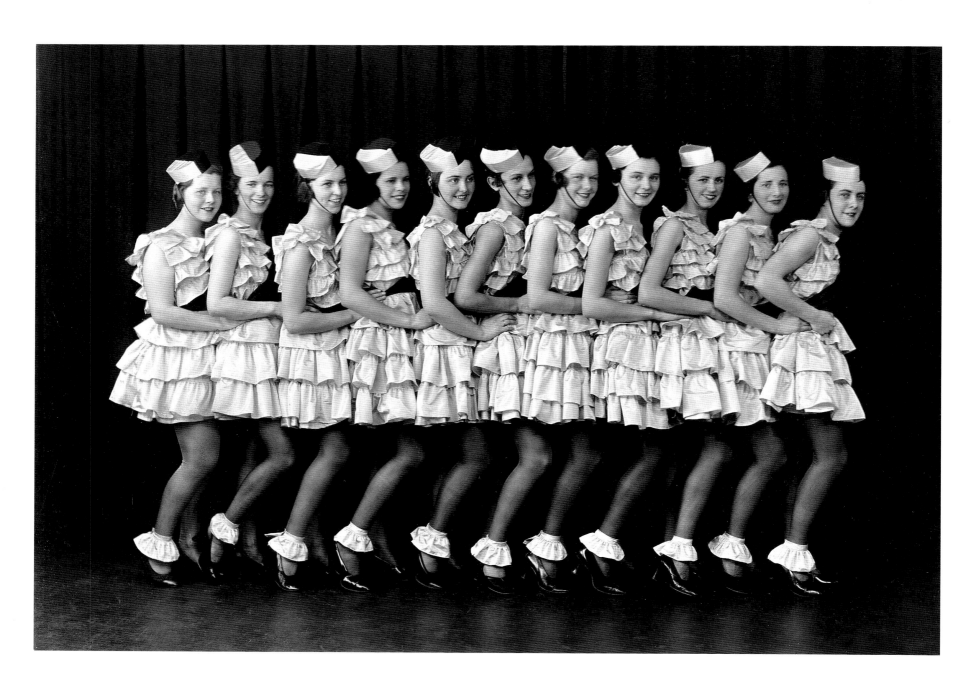

65 'The Red and White Review' at McGill
University, by the studio of William Notman
and Son, Montreal, *c*.1933.

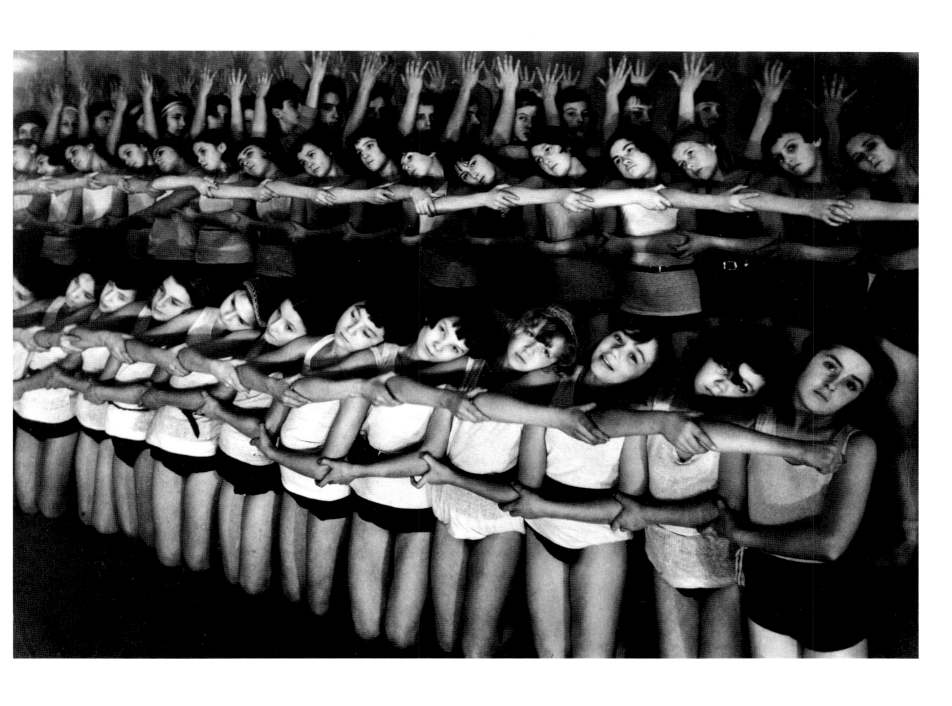

66 Soviet ballet, by Margaret Bourke-White,
1936.

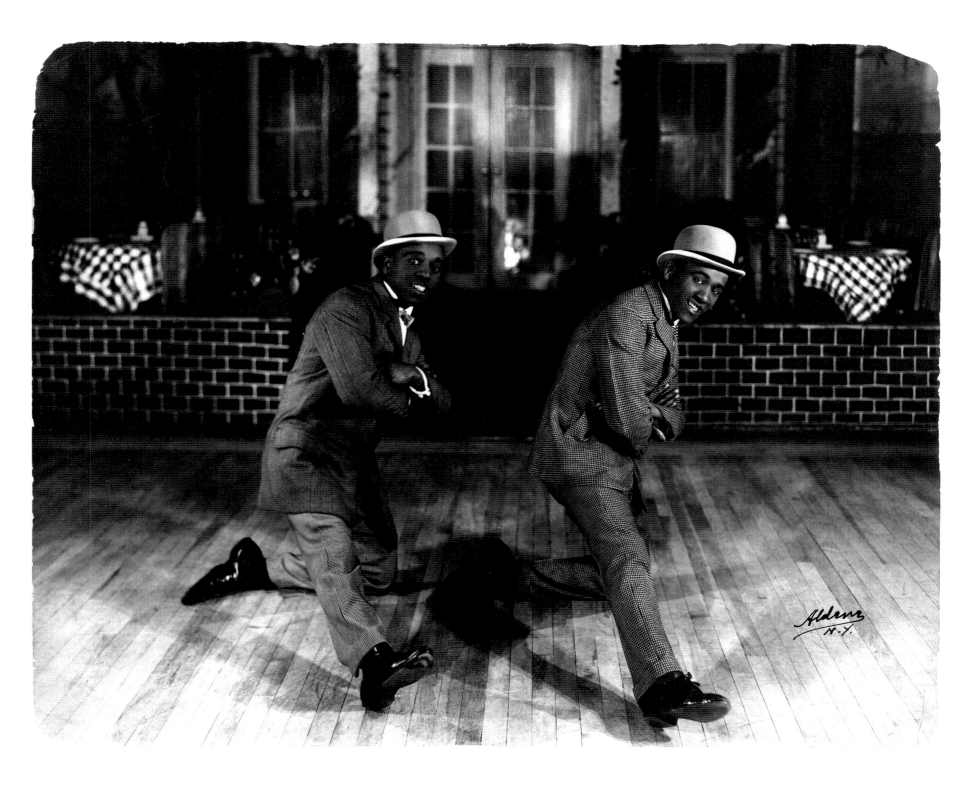

67 **Nightclub act, New York, by Aldene Studio,** *c.*1920.

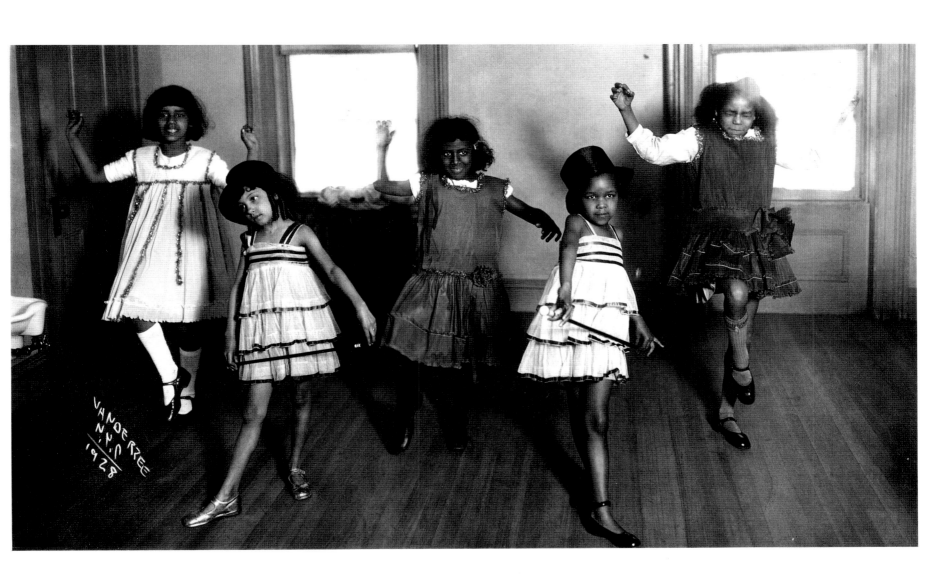

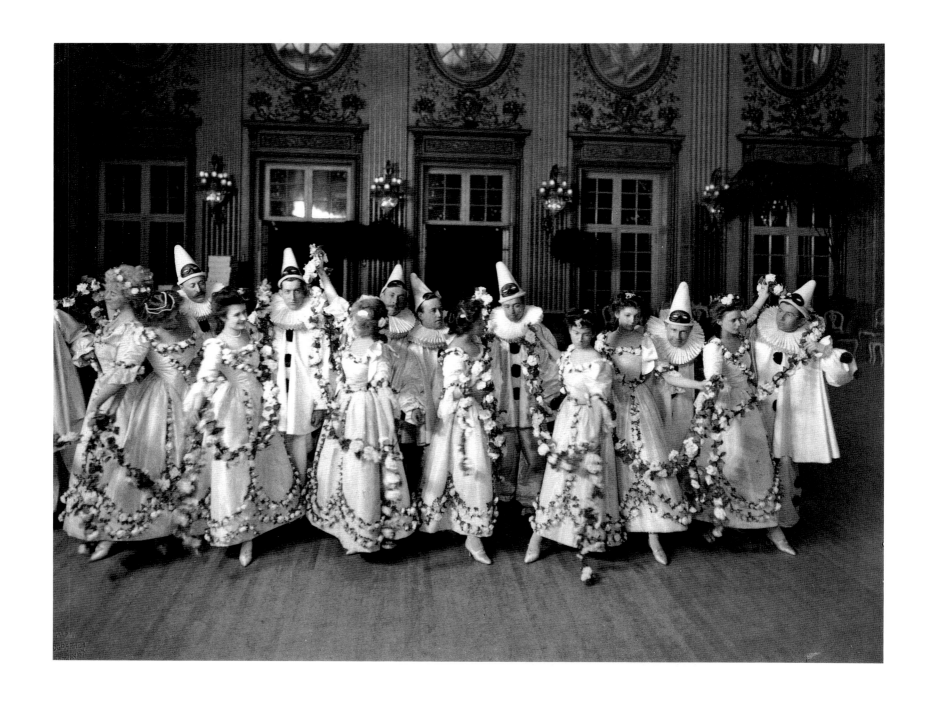

69 'Jarwett Hyde's Quadrille', photographed
at a society ball in New York by Joseph Byron,
c.1915.

70 The Silver Hoop Number at the Roxy
Theater, New York City, 1938, by
Jack A. Partington.

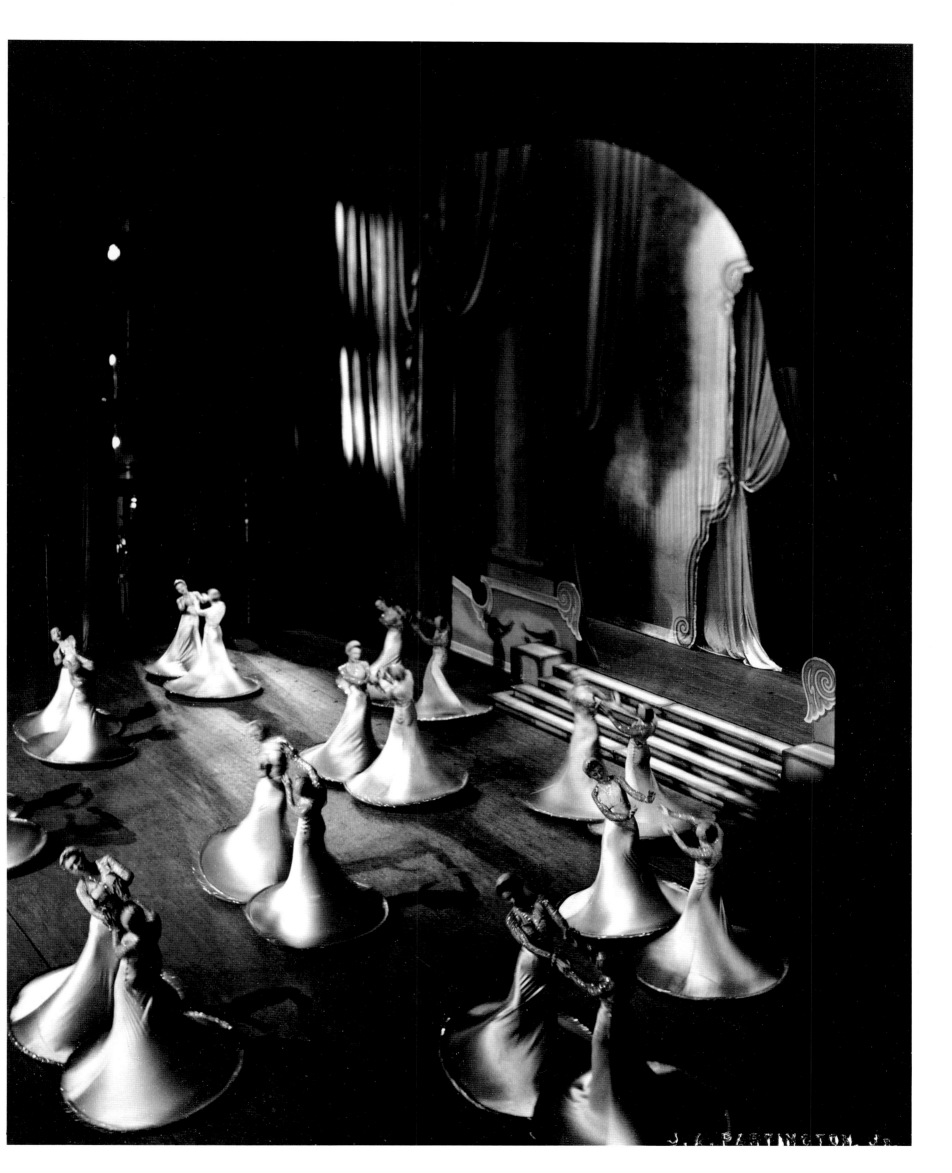

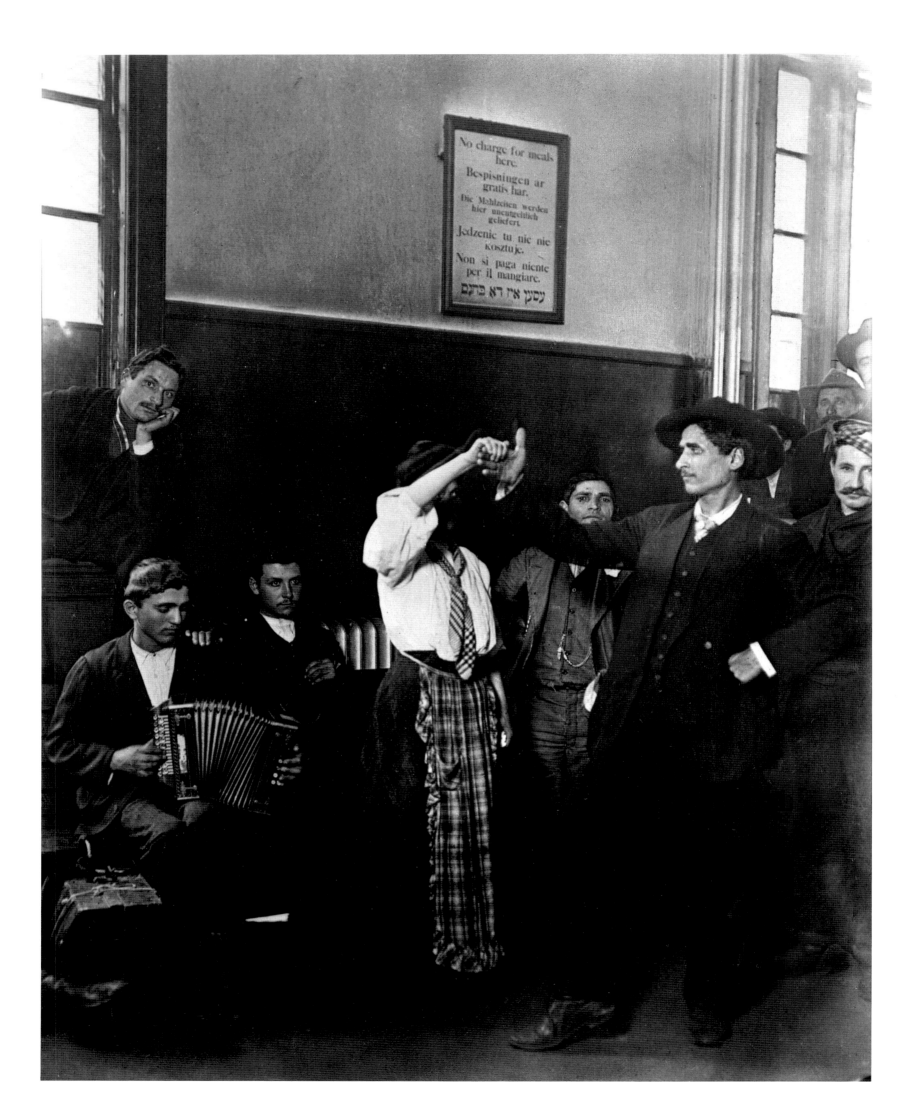

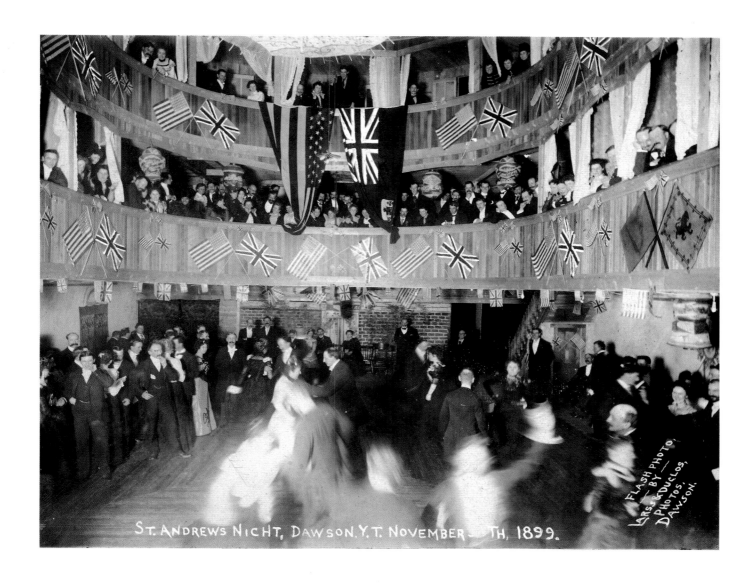

ST. ANDREWS NIGHT, DAWSON. Y.T. NOVEMBER — TH, 1899.

FLASH PHOTO, BY LARSS & DUCLOS, PHOTOS, DAWSON.

71 **Immigrants waiting at Ellis Island, by Lewis W. Hine,** *c.***1905.**

72 **St Andrew's Night at the Palace Grand Theatre, Dawson, Yukon Territories, by Larss and Duclos Studio, 1899.**

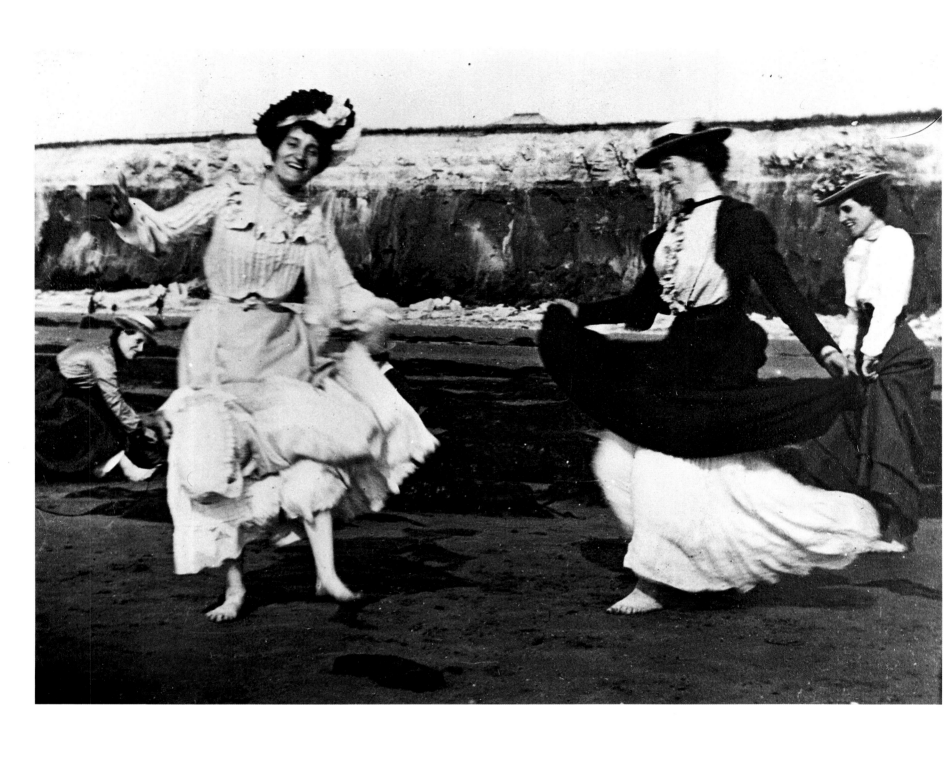

73 Celebration, Southern Ontario, by
William James, *c*.1906

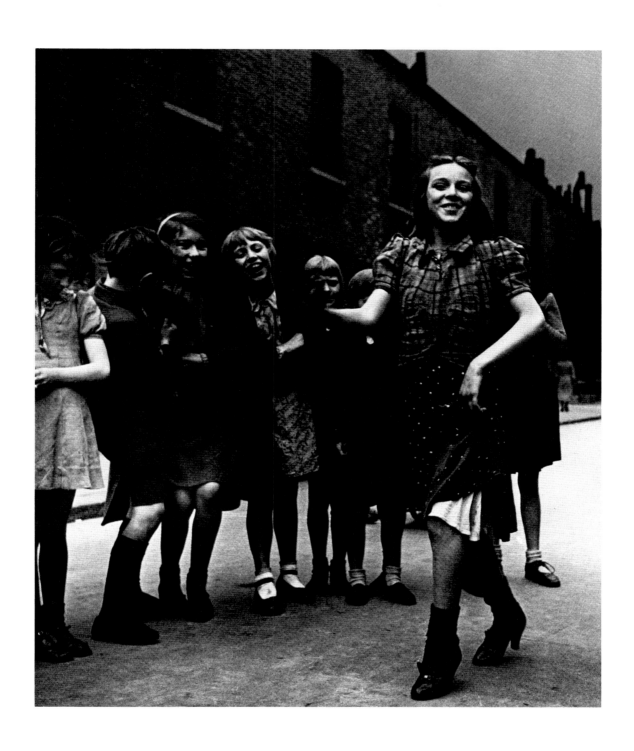

74 **East End girl dancing the Lambeth Walk,**
 photographed by Bill Brandt in the 1930s.

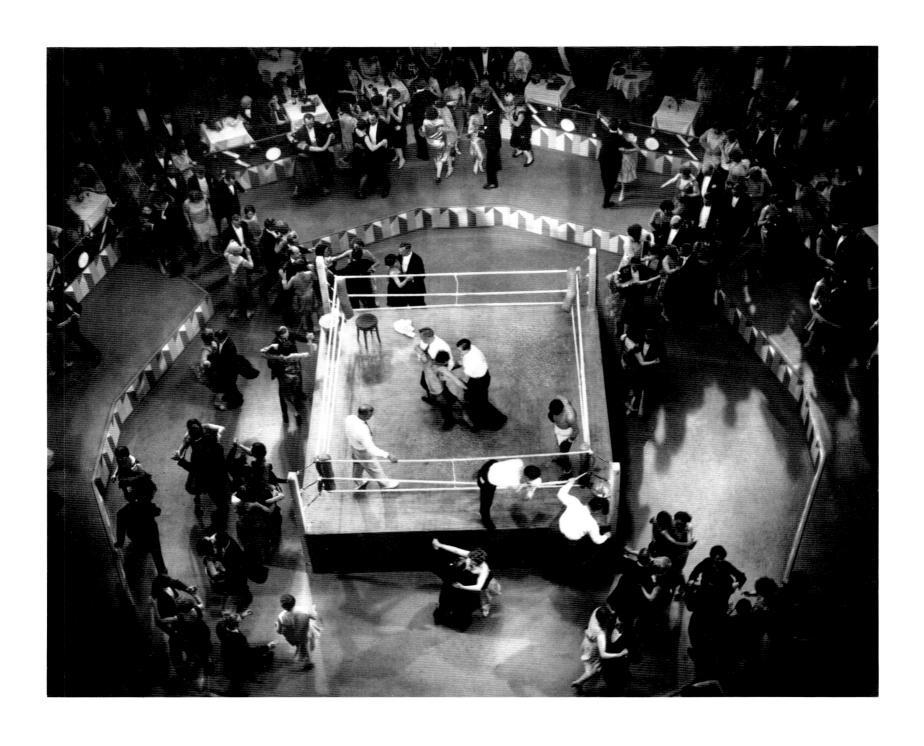

75 Marathon dance, by an anonymous
photographer, *c*.1930.

76 The Moiseyev Folk Dance Ensemble in *Football*, 1955, by Al Taylor.

Overleaf
77 *Man Walking Down the Side of a Building*, an 'equipment dance' by Trisha Brown performed by Joseph Schlichter and photographed by Peter Moore, New York, 1970.

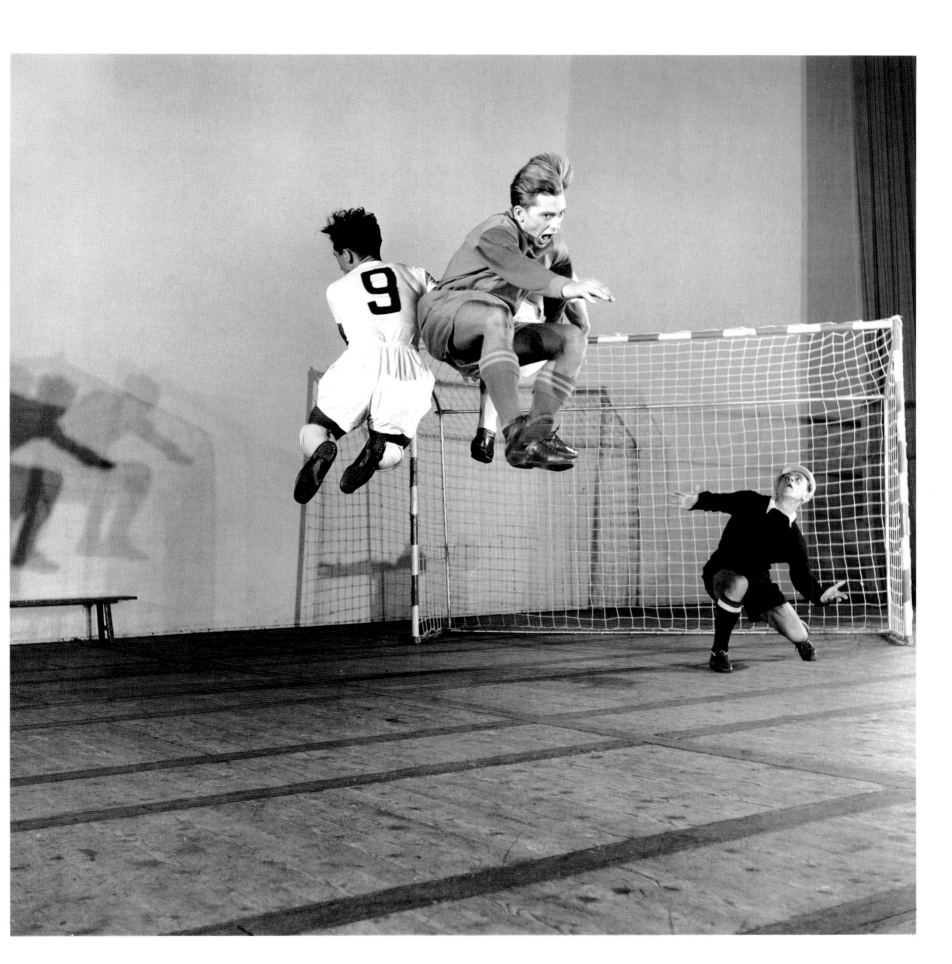

III
Icon and Idol

78 George Balanchine, by George Platt Lynes, *c.*1941.

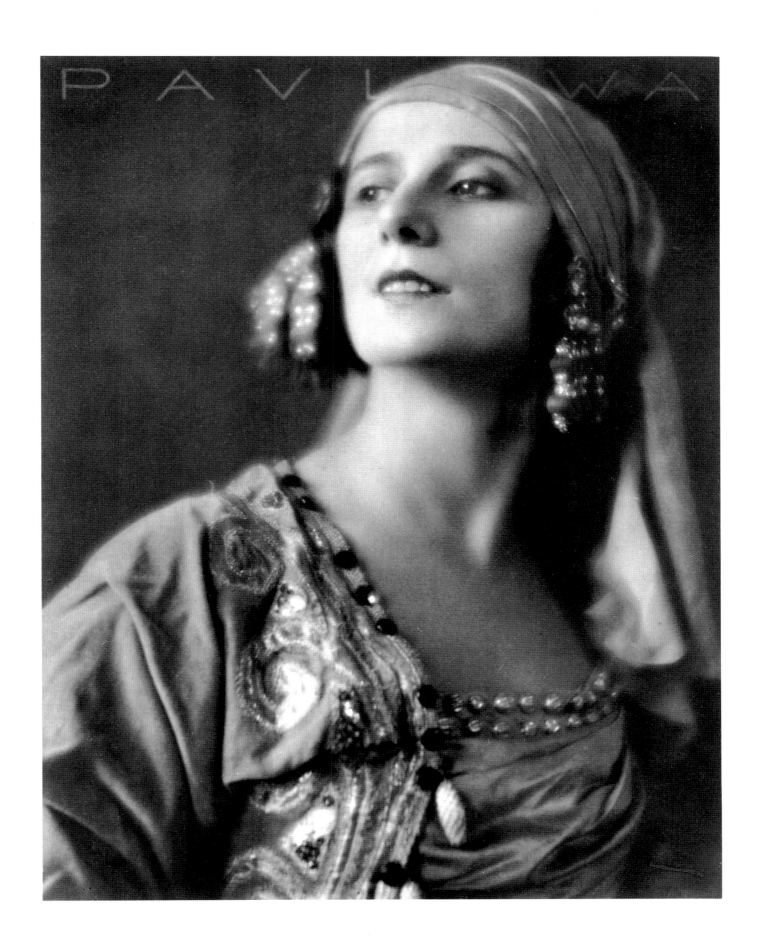

79 Anna Pavlova, by Eugene Hutchinson, 1915.

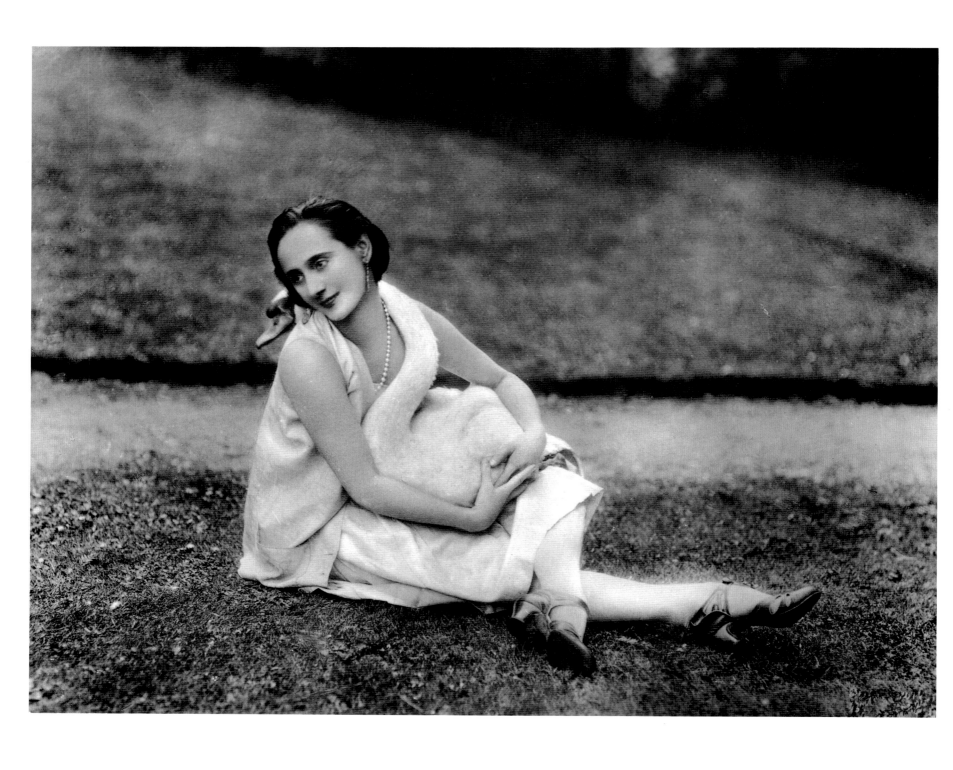

80 Anna Pavlova, by Lafayette Studio, *c*.1920. 81 Agnes de Mille, by Soichi Sunami, *c*.1930.

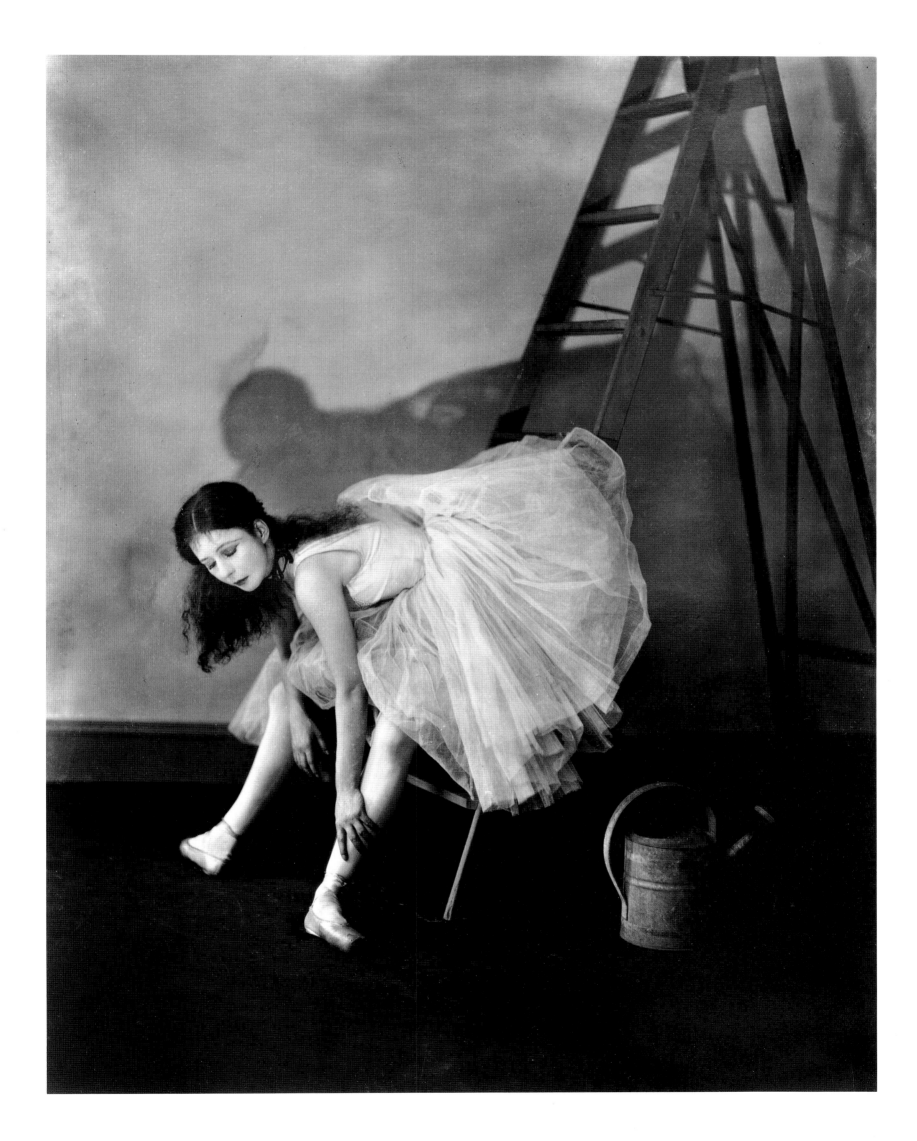

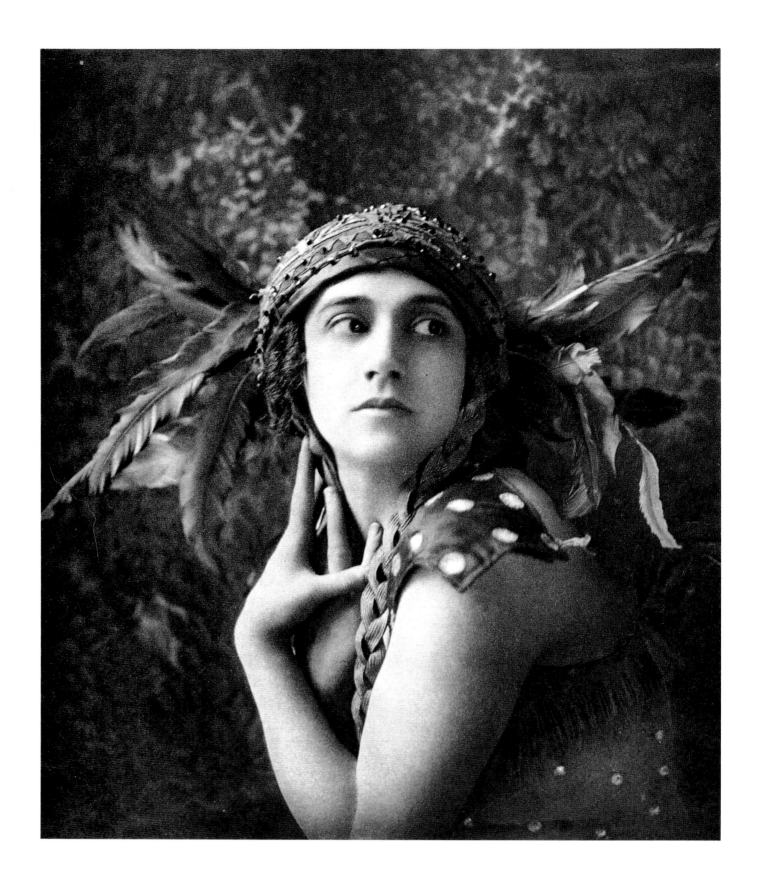

82 Tamara Karsavina as the Firebird, by E. O. Hoppé, 1910. 83 Vaslav Nijinsky in *Jeux*, by Gerschel Studio, 1913.

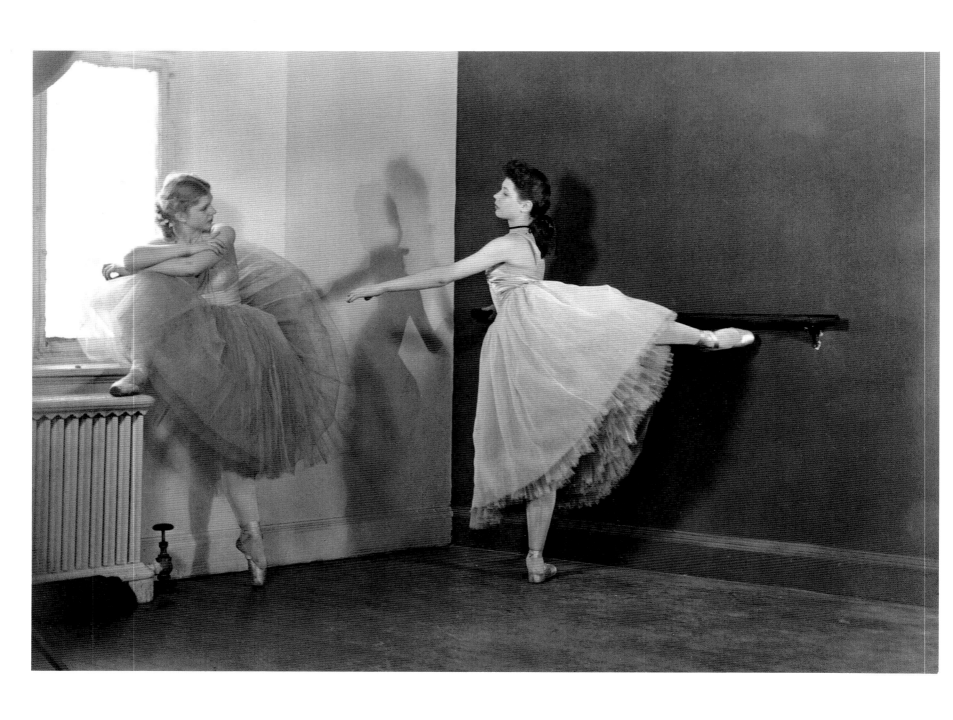

84 Bambi Linn and Diana Adams, by Walter E. Owen, *c*.1943.

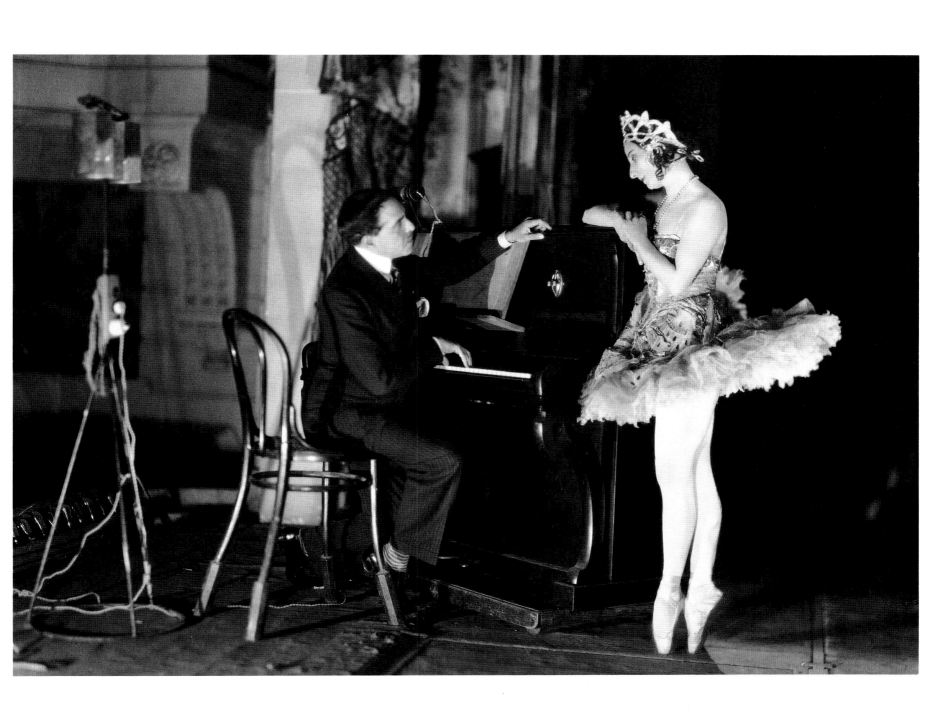

85　Anna Pavlova, by James Abbe, 1927.

86 David Lichine backstage at Covent Garden, by Cecil Beaton, 1936.

87 Irina Baronova backstage at Covent Garden, by Cecil Beaton, 1936.

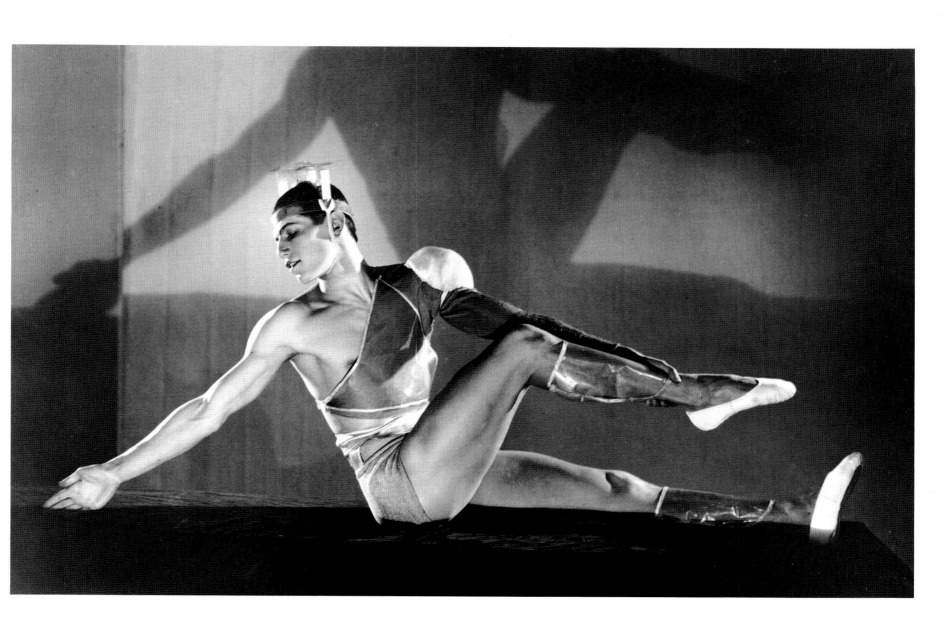

88 **Margot Fonteyn, by E.O. Hoppé,** *c*.1935.

89 **Serge Lifar in** *La Chatte*, **by George Hoyningen-Huene,** 1927.

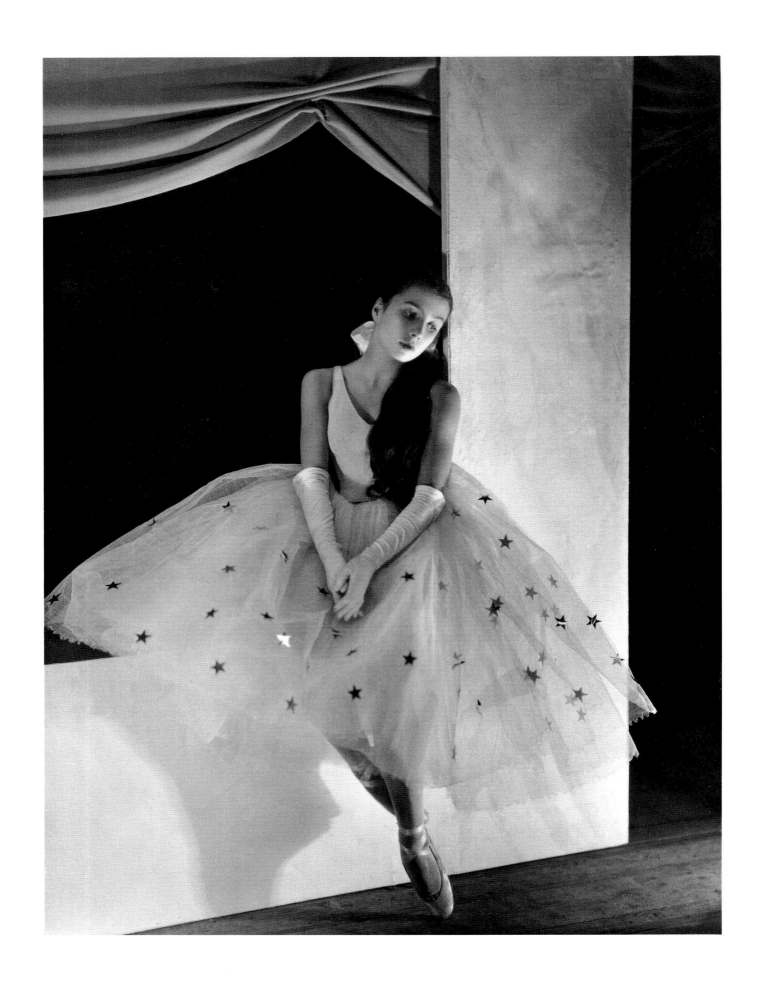

90 Tamara Toumanova in *Cotillon*, by
George Hoyningen-Huene, 1932.

91 Ida Rubinstein, by James Abbe, 1921.

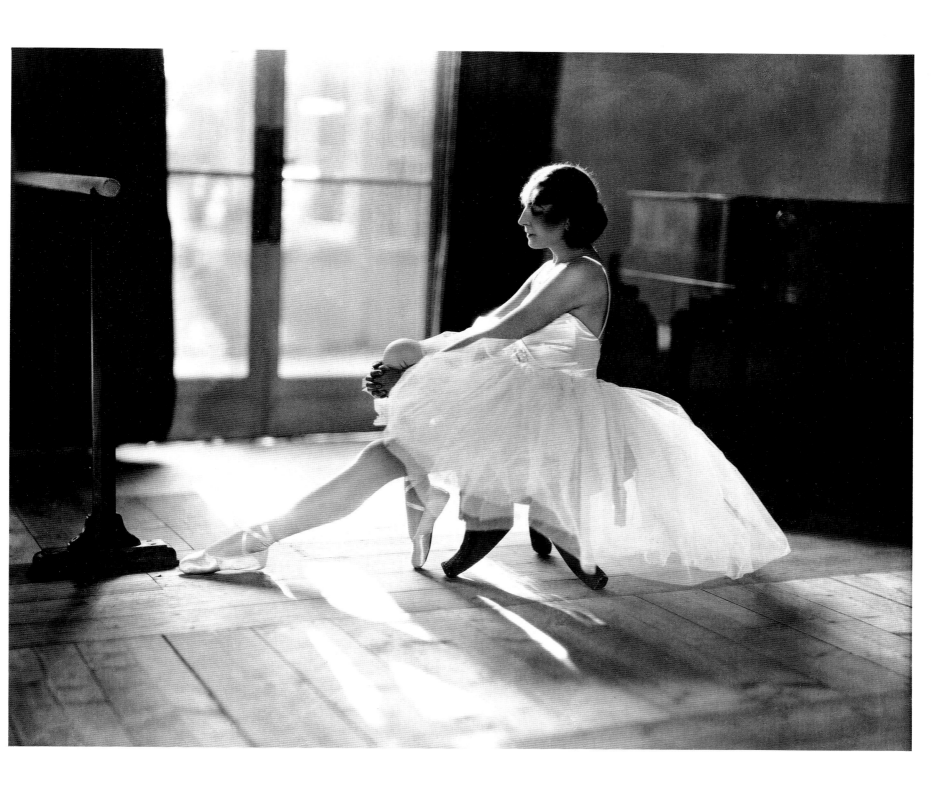

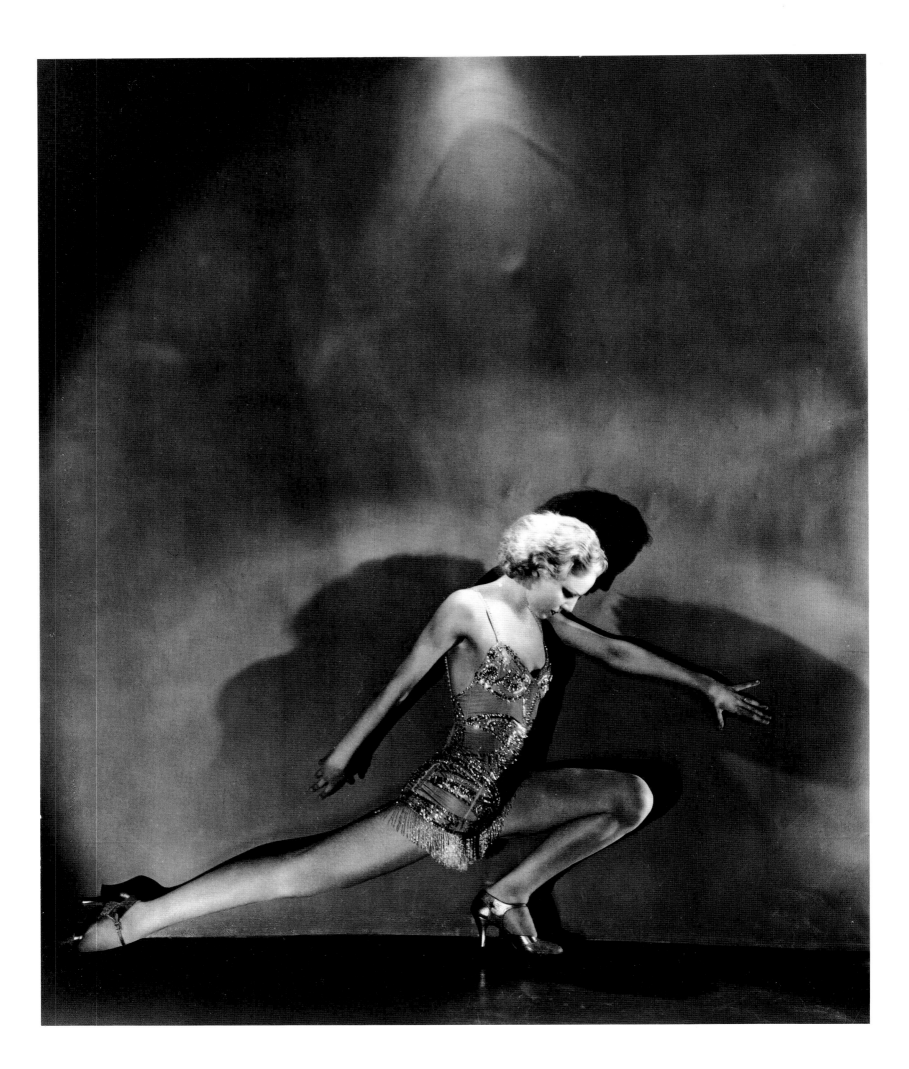

92 Jean Barry, by George Hoyningen-Huene, 1931.

93 Fred and Adele Astaire, by James Abbe, 1921.

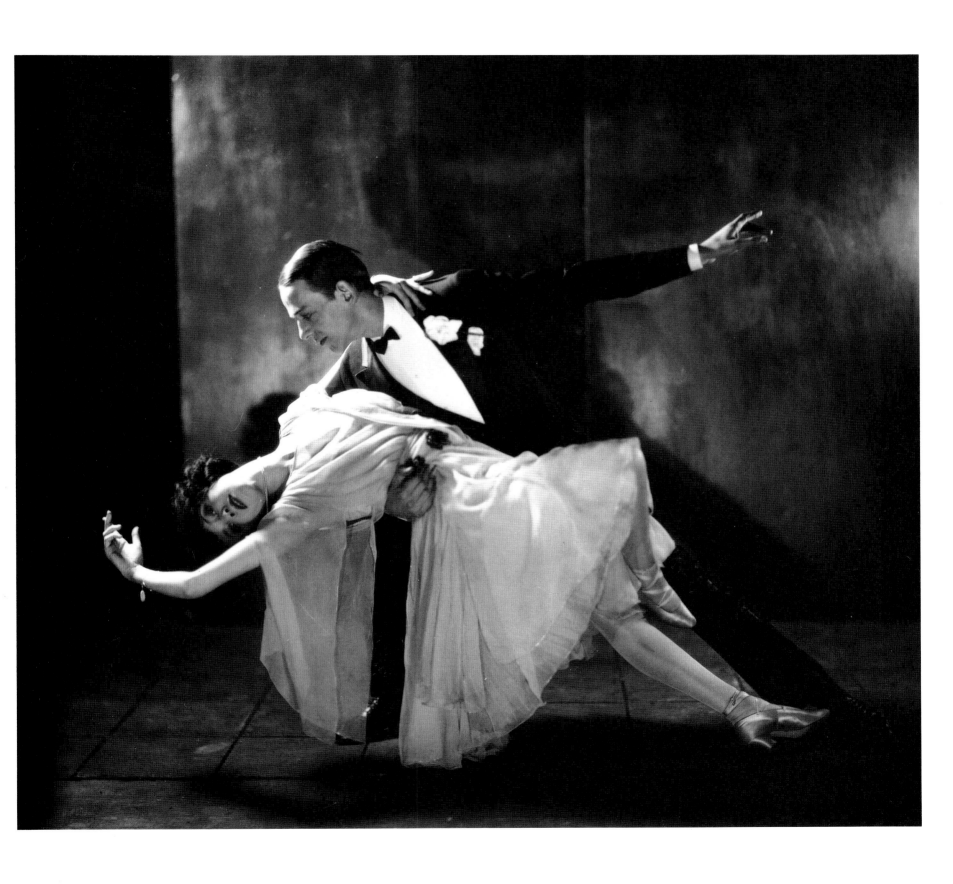

94 At the Folies Bergère, by James Abbe, 1924.

95 The Dolly Sisters, by James Abbe, 1927.

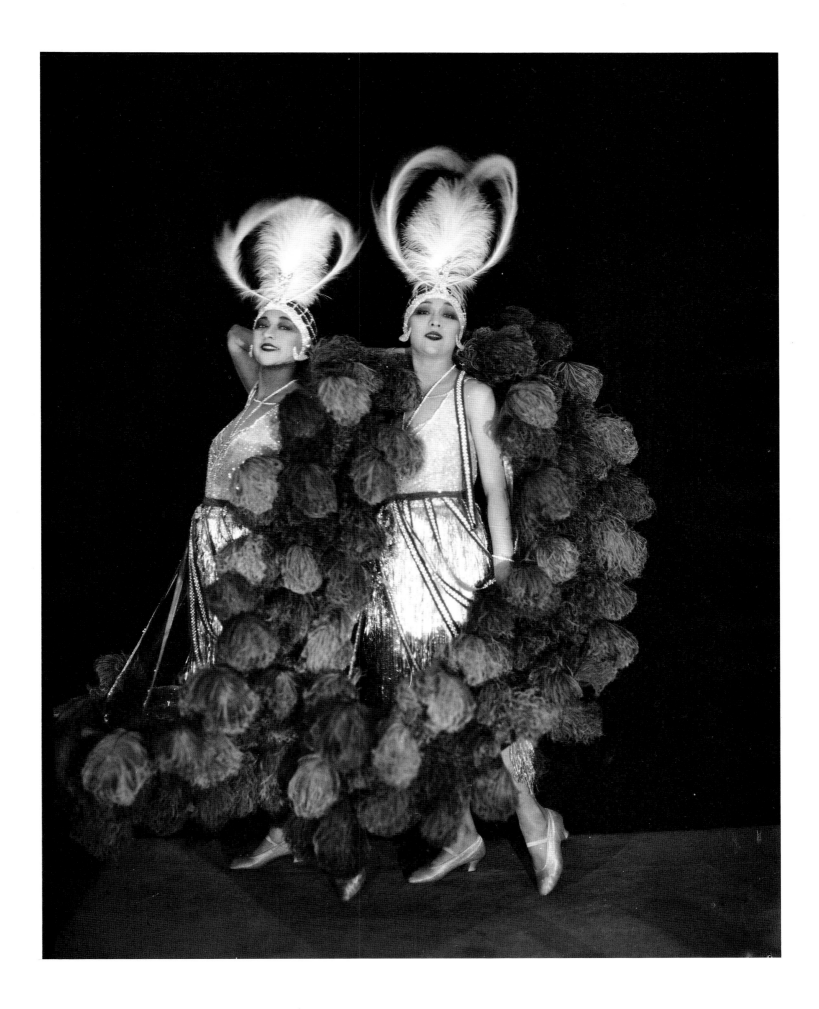

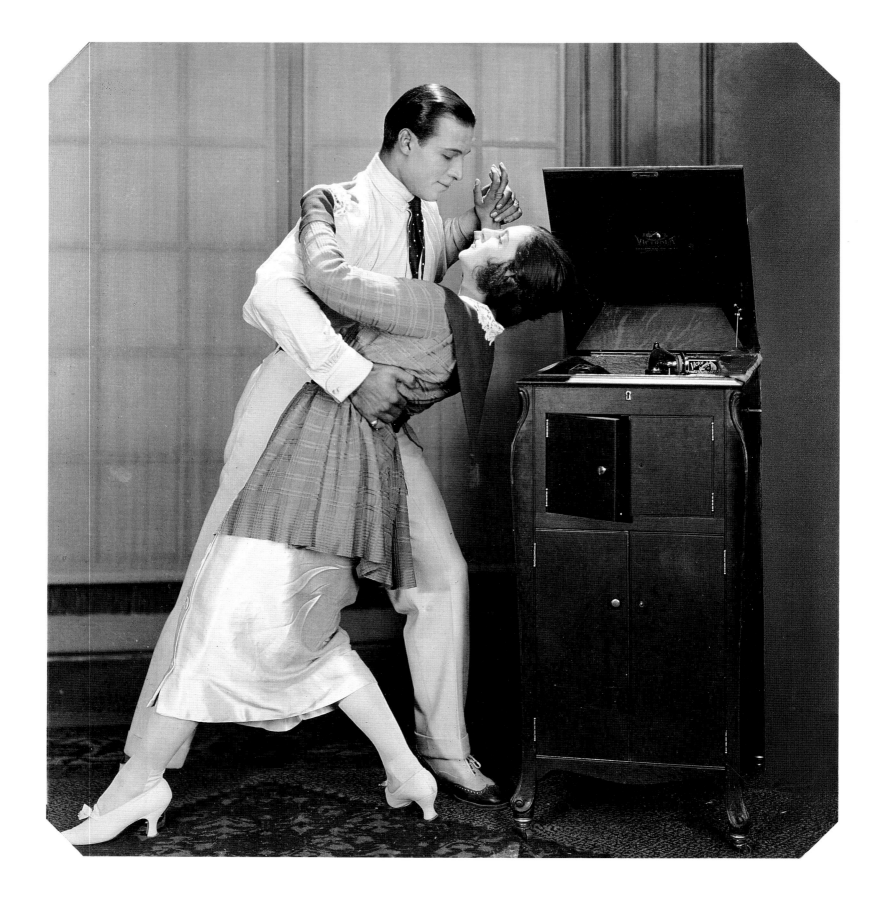

96 Rudolph Valentino and Natasha Rambova,
by an anonymous photographer, *c*.1920.

97 Thomas and Dovanna, New York, by
Robert Mapplethorpe, 1986.

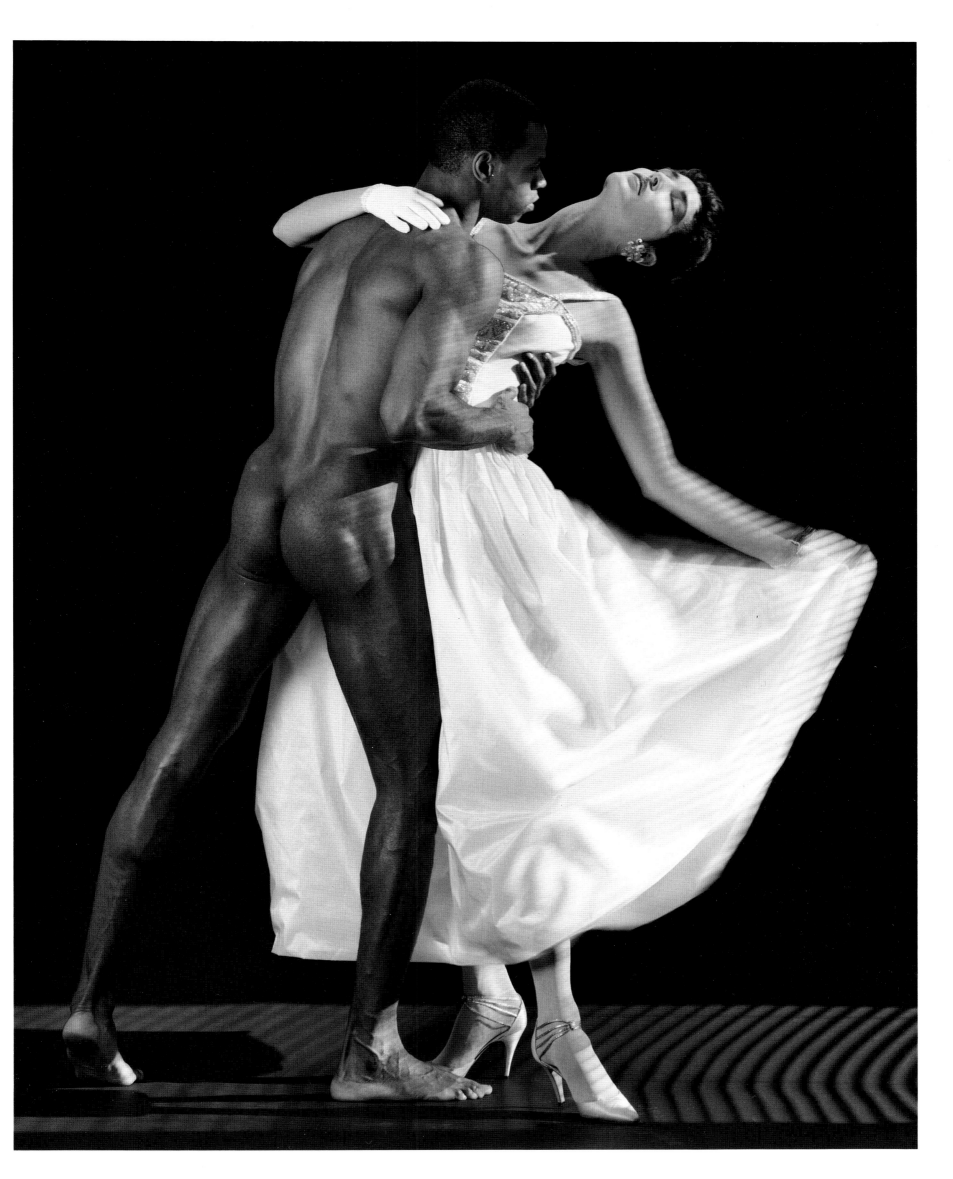

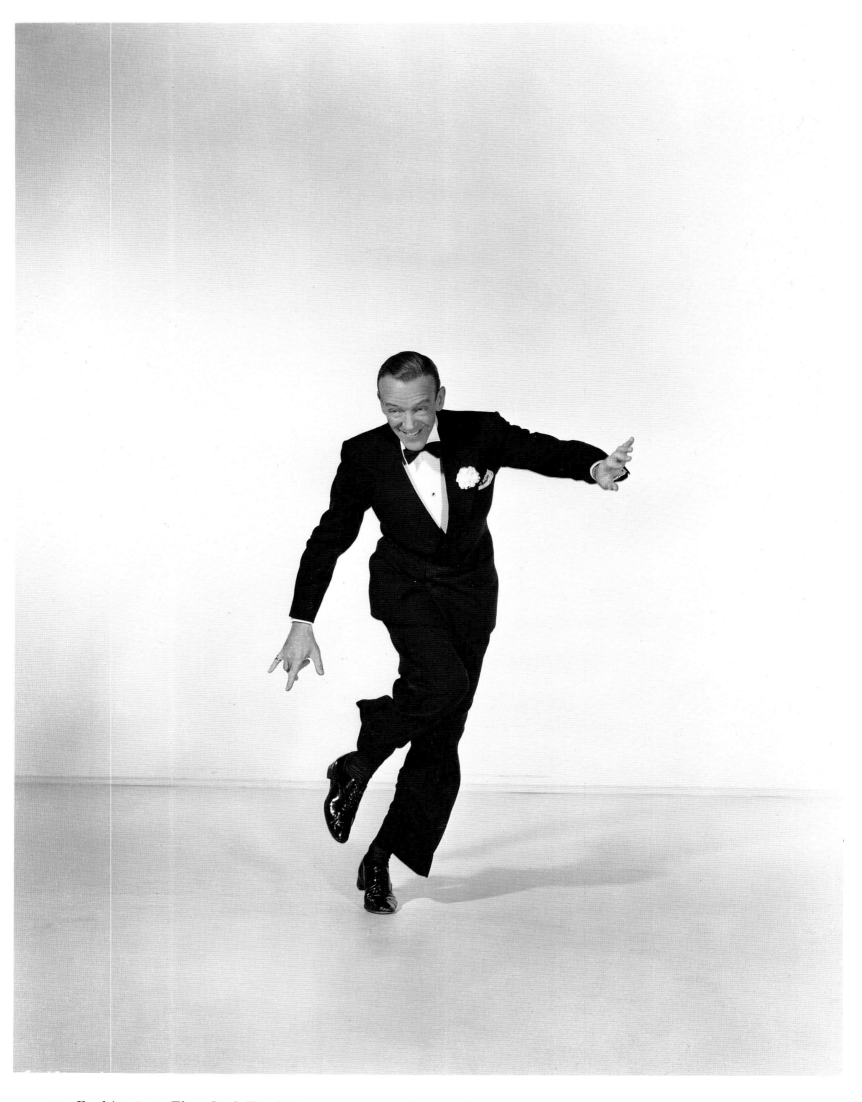

98 **Fred Astaire** in *Three Little Words*, by an anonymous photographer, 1950.

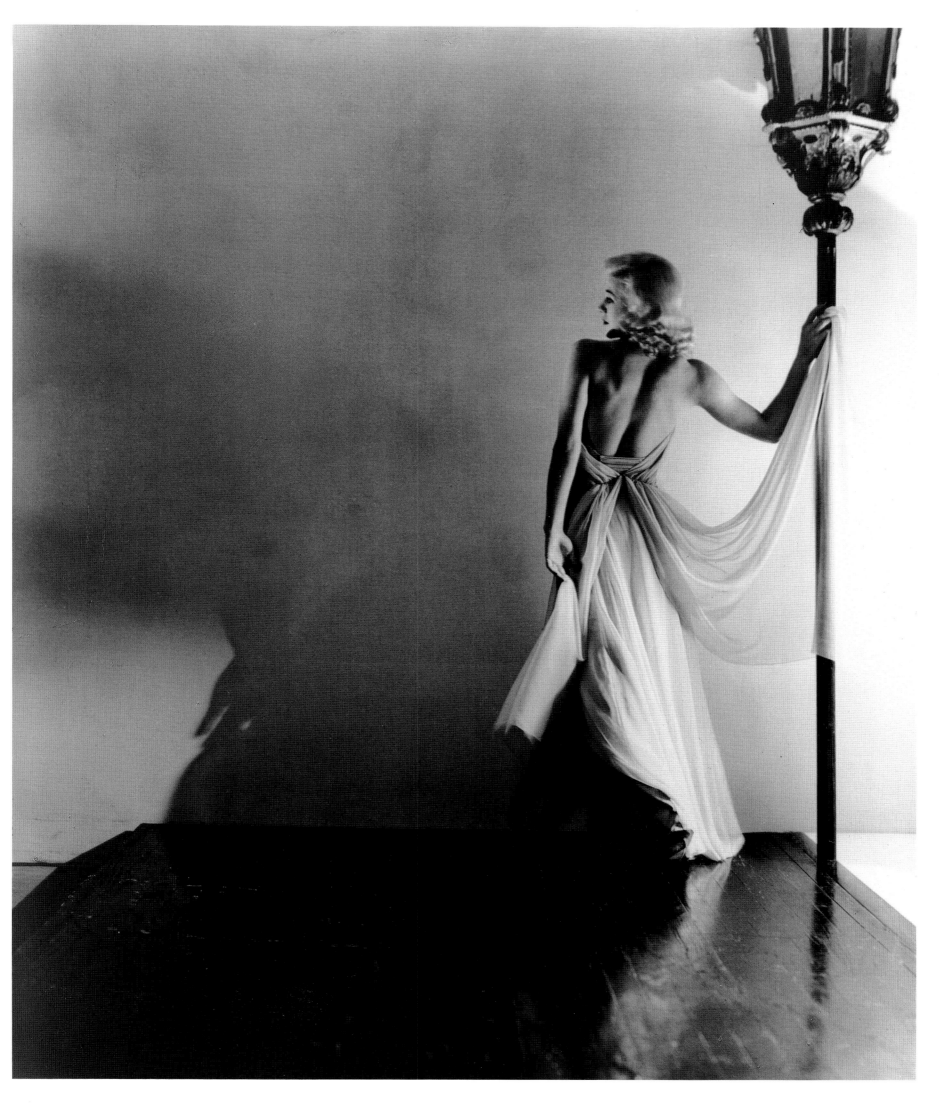

99 Ginger Rogers, by Horst, 1935.

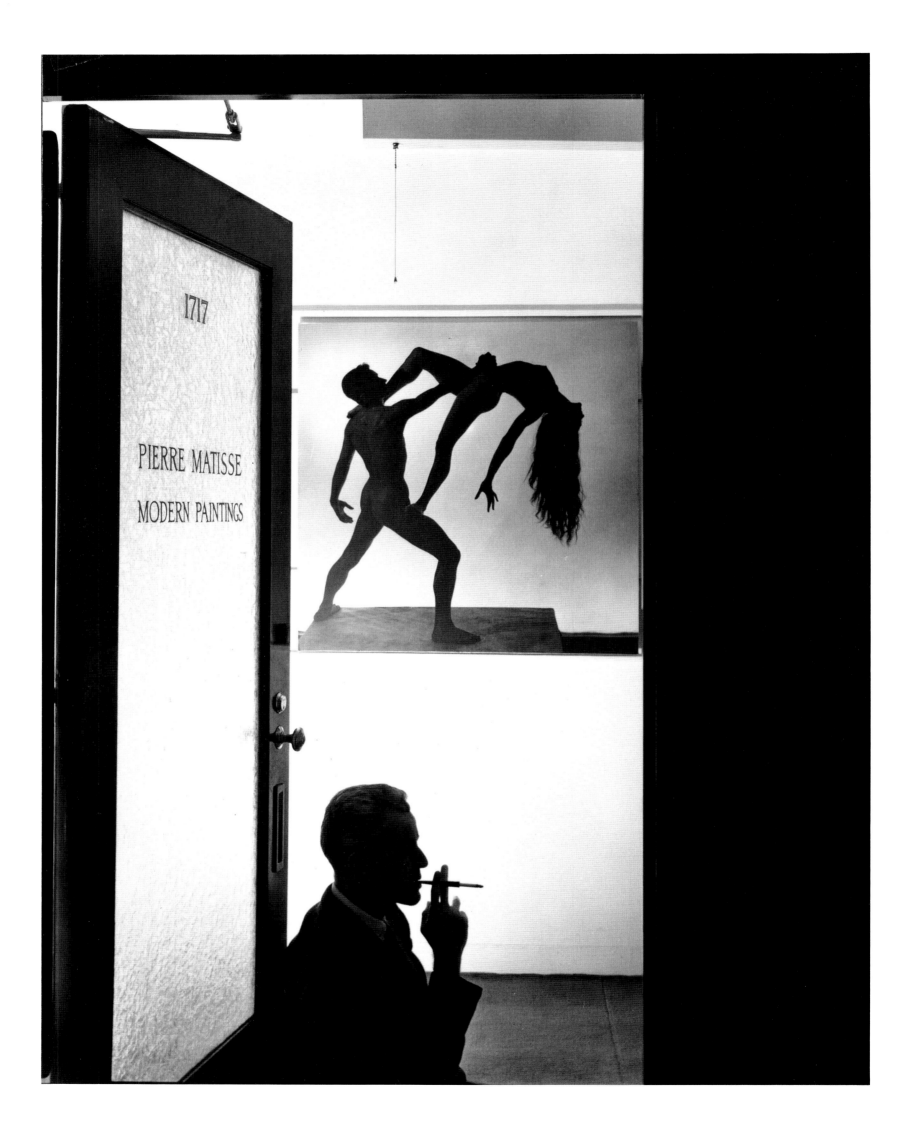

100 A self-portrait by the photographer
George Platt Lynes, with one of his dance
photographs on the far gallery wall. New
York, *c*.1940.

101 Martha Graham, by Arnold Newman, 1961.

102 Tilly Losch, by E.O. Hoppé, *c*.1933.

103 Frederick Ashton, by Arnold Newman, 1978.

104 Natalia Makarova in *Other Dances*, by Max Waldman, 1976.

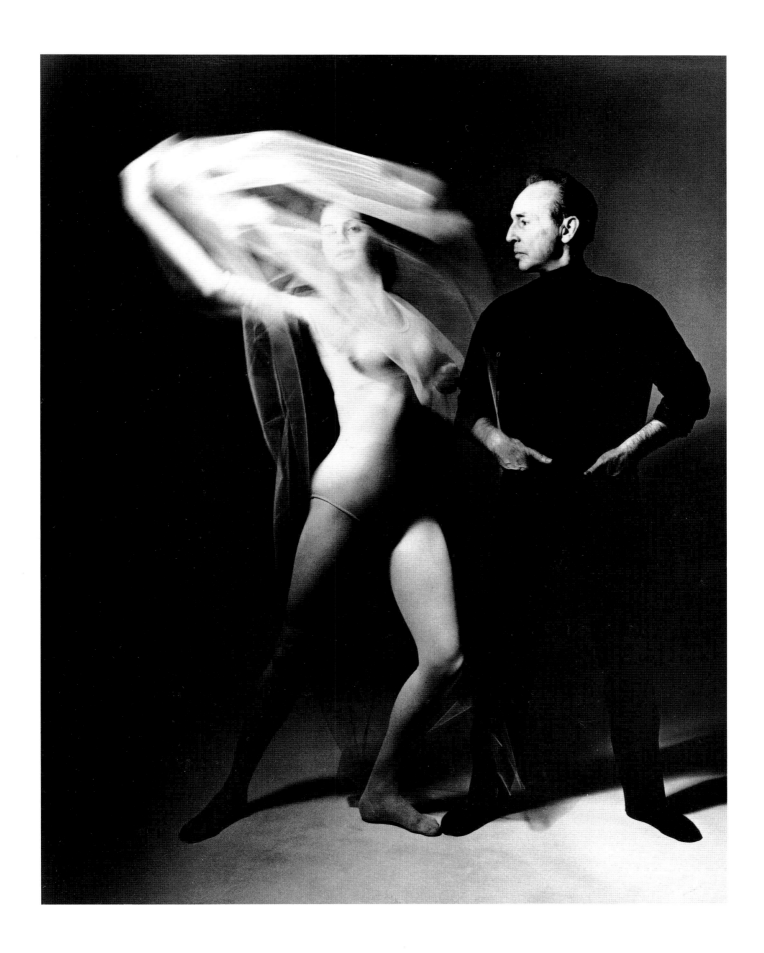

105 **Suzanne Farrell and George Balanchine, by Bert Stern, 1965.**

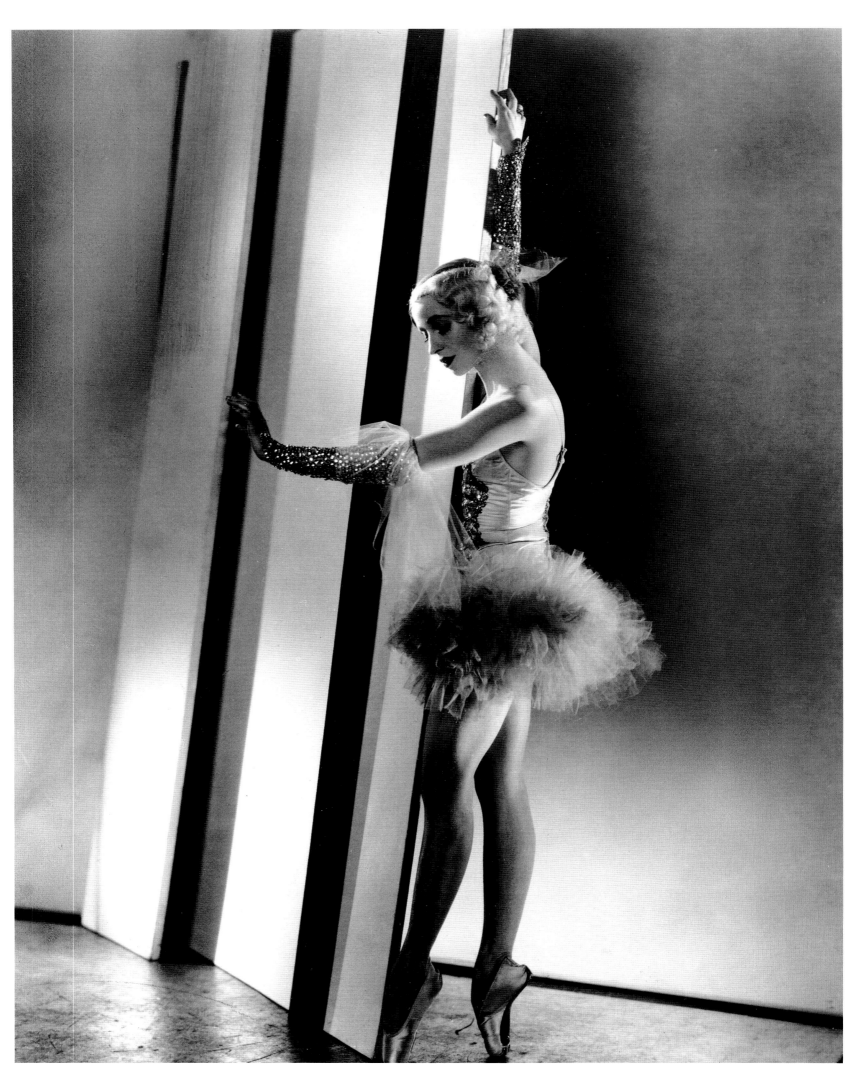

106 Patricia Bowman, by Edward Steichen, 1933.

IV
The Independent Eye

107 *Mid-morning coffee-break, Berlin,*
by Martin Munkacsi, *c.* 1933.

108 Young couple, by Philippe Halsman, *c.* 1950.

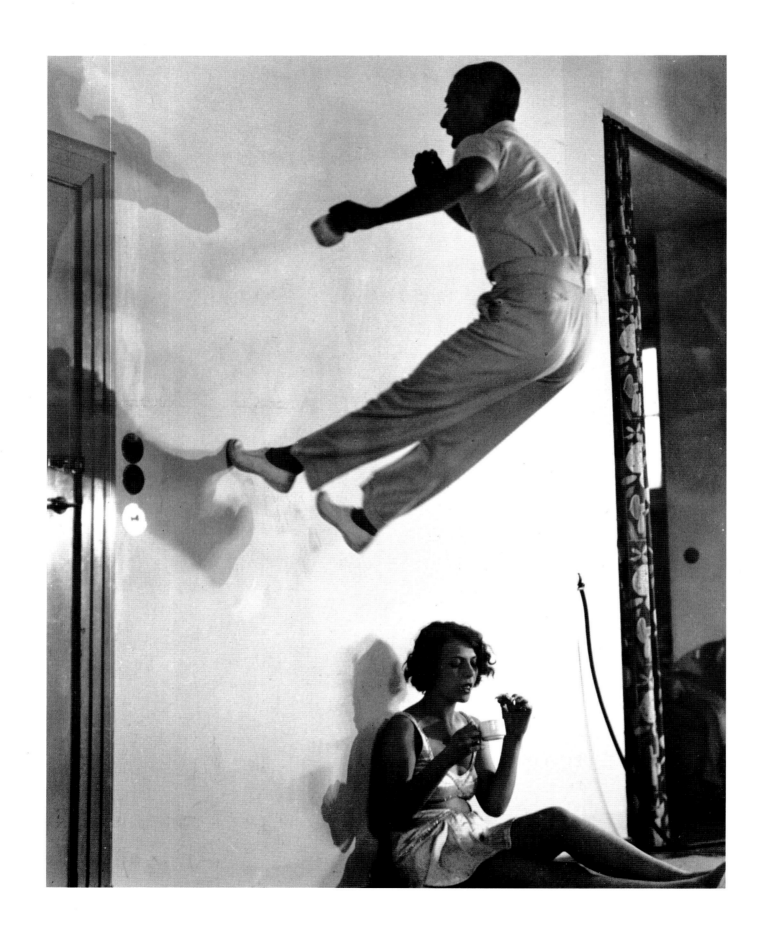

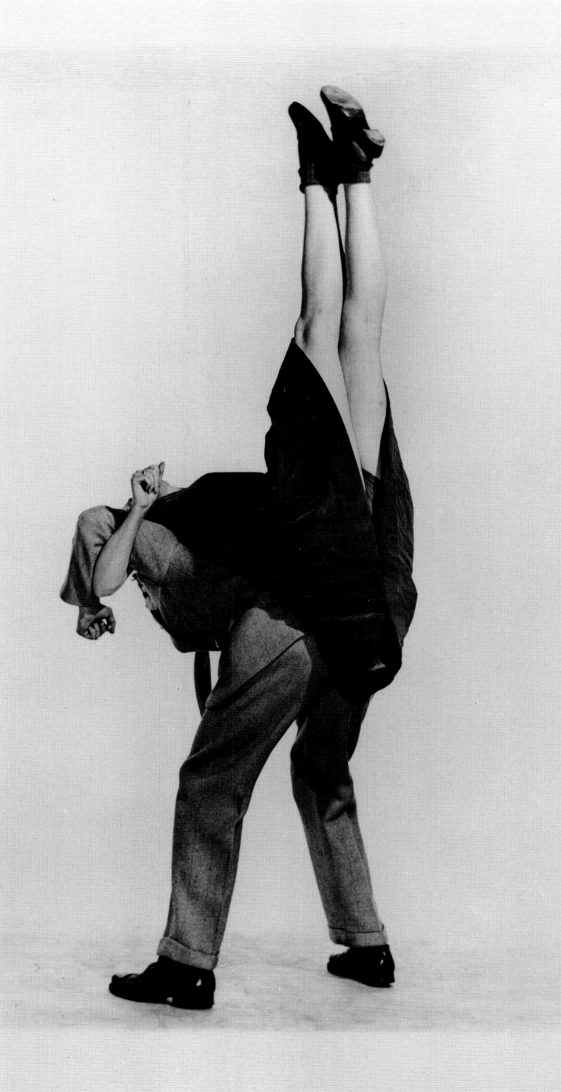

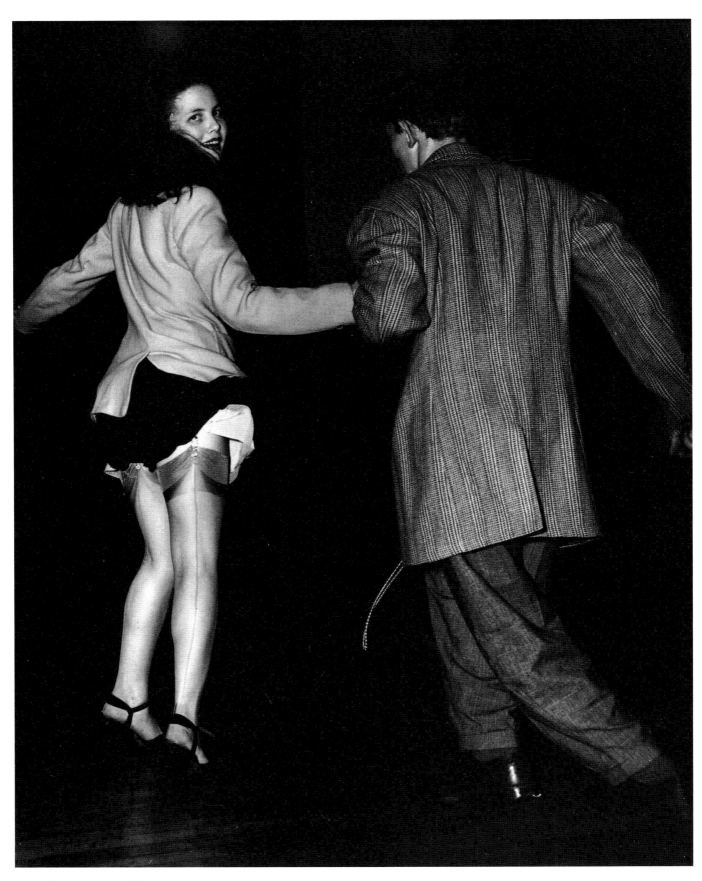

109 Dancers, by Ollie Atkins, 1943.

110 14 July, Rue des Canettes, Paris, by Robert Doisneau, 1955.

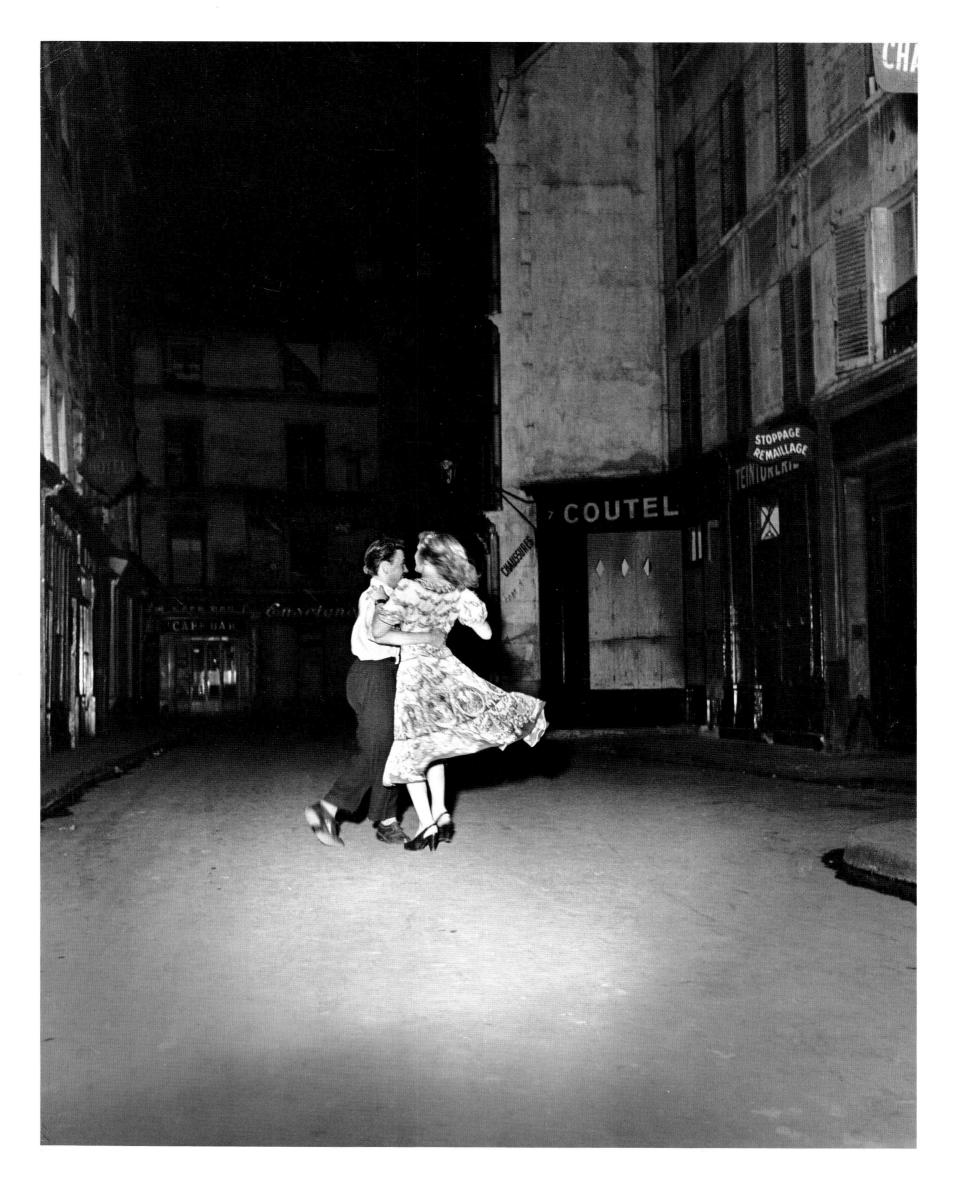

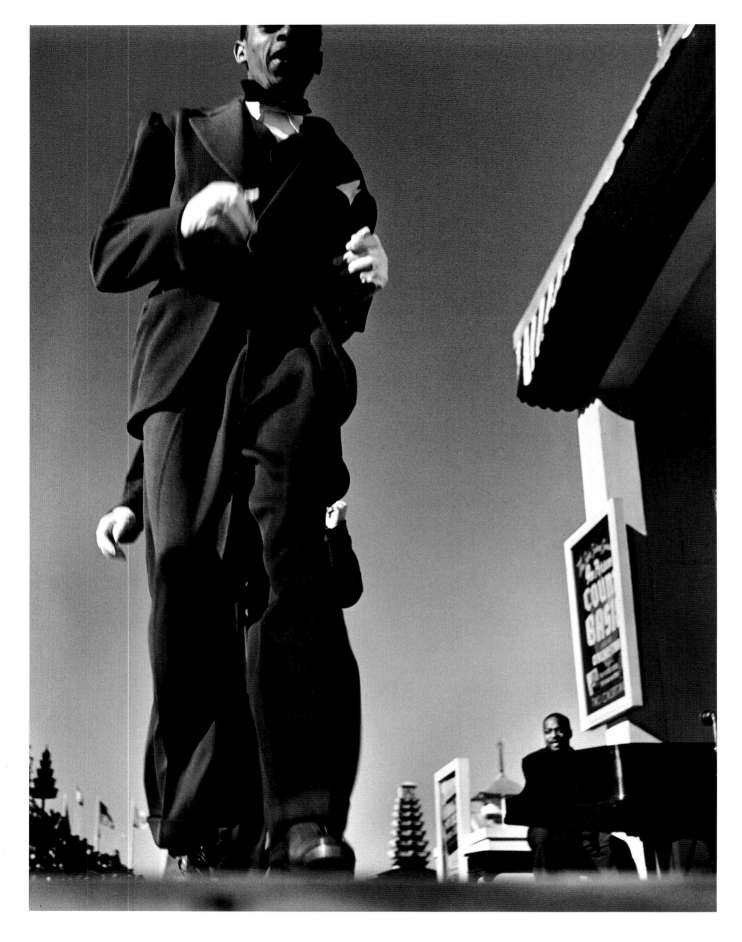

111 The High Hatters with Count Basie, San
Francisco, by John Gutmann, 1939.

112 'Gene Kelly dancing across a London
zebra crossing yesterday', by a *Daily Mirror*
photographer, 1955.

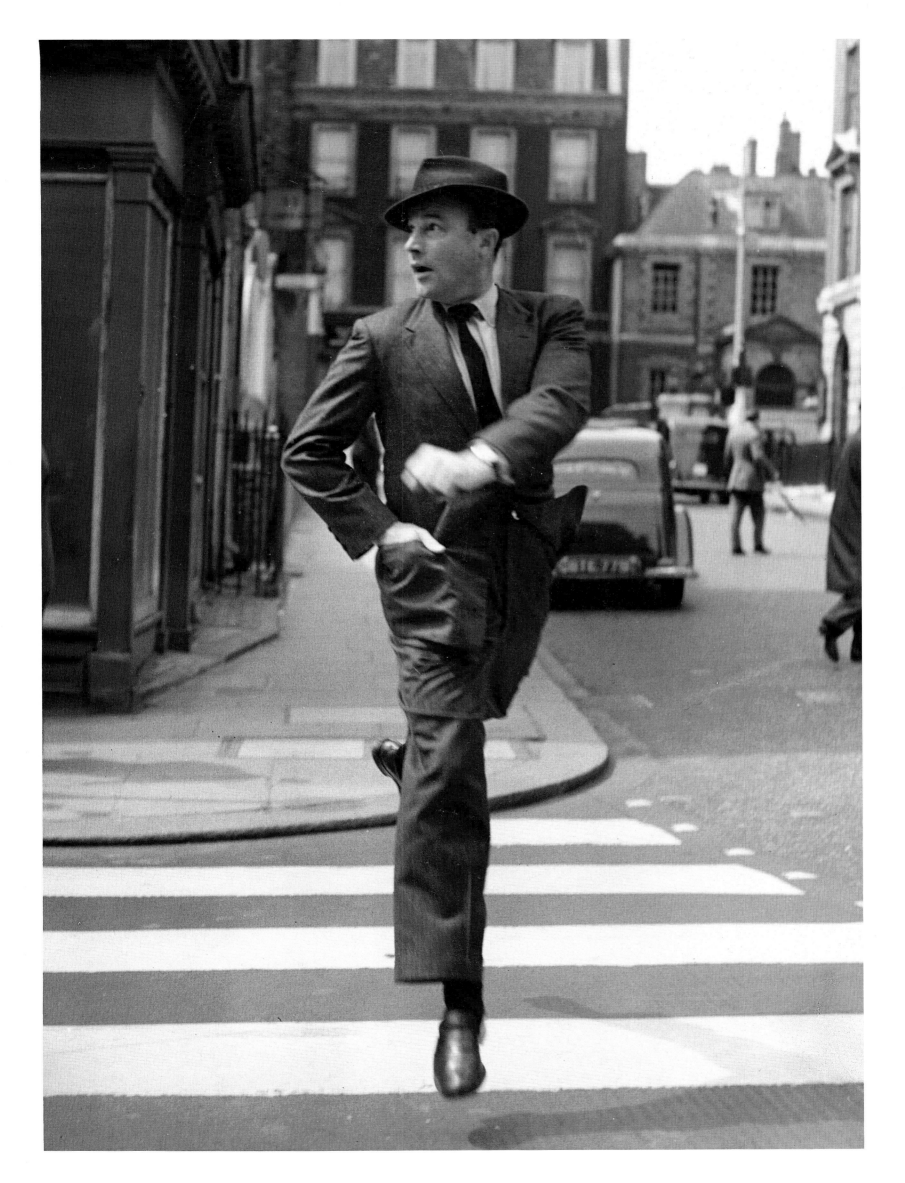

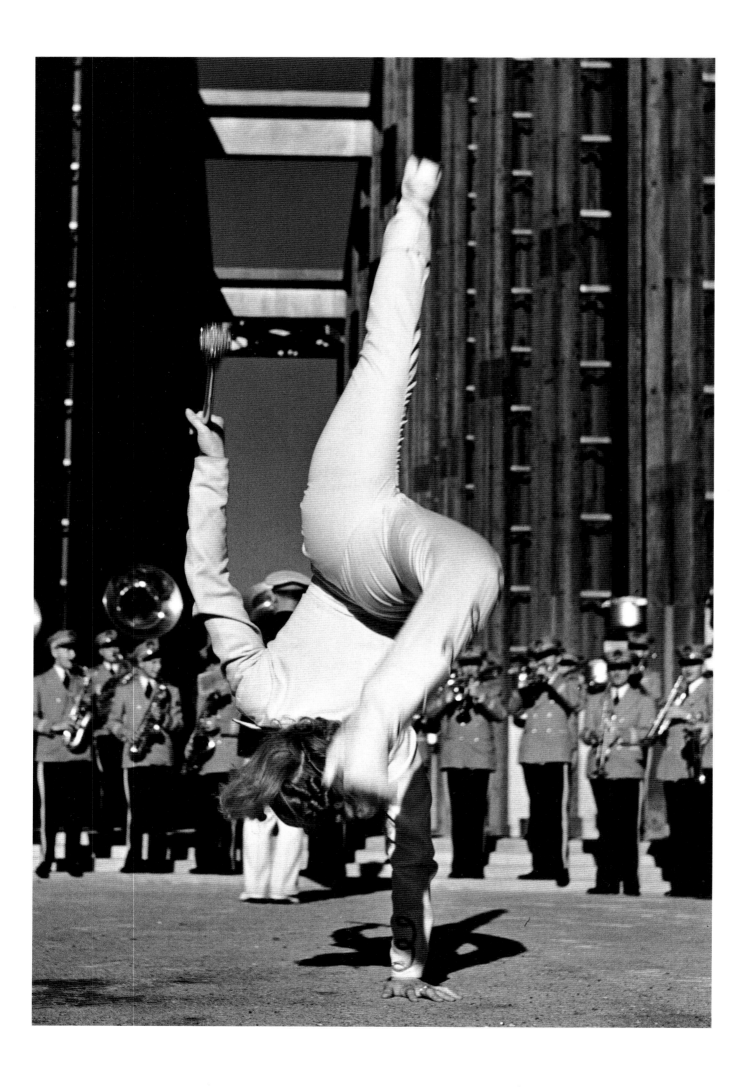

113　Majorette in San Francisco, by John Gutmann, 1939.

114　Savoy Dancers, Harlem, by Aaron Siskind, 1936.

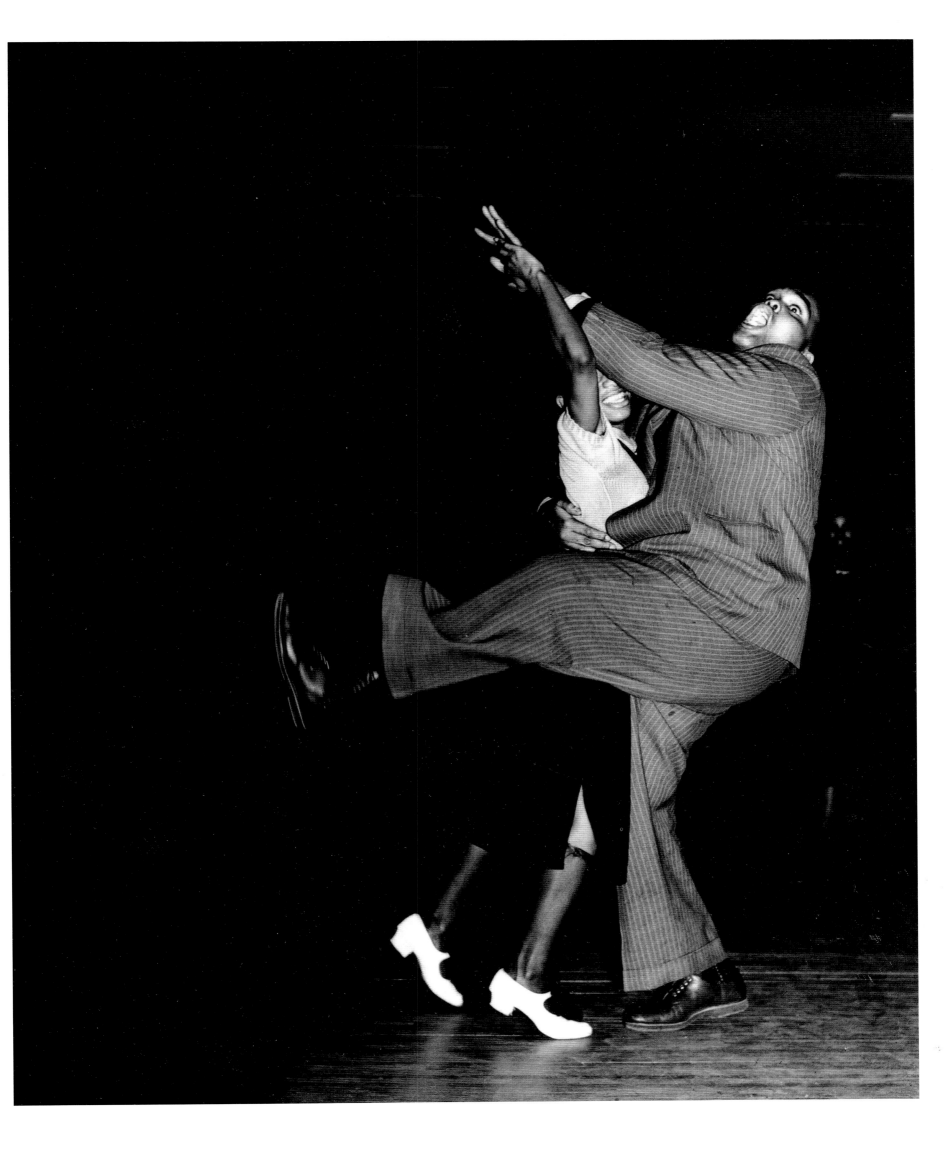

115 Street organ in Amsterdam, by Ilse Bing,
1933.

116 Street dance in Naples, by René Burri.
Undated.

117 Saturday night 'taxi dancers' at Fort
Peck Dam, Montana, by Margaret Bourke-
White, 1936.

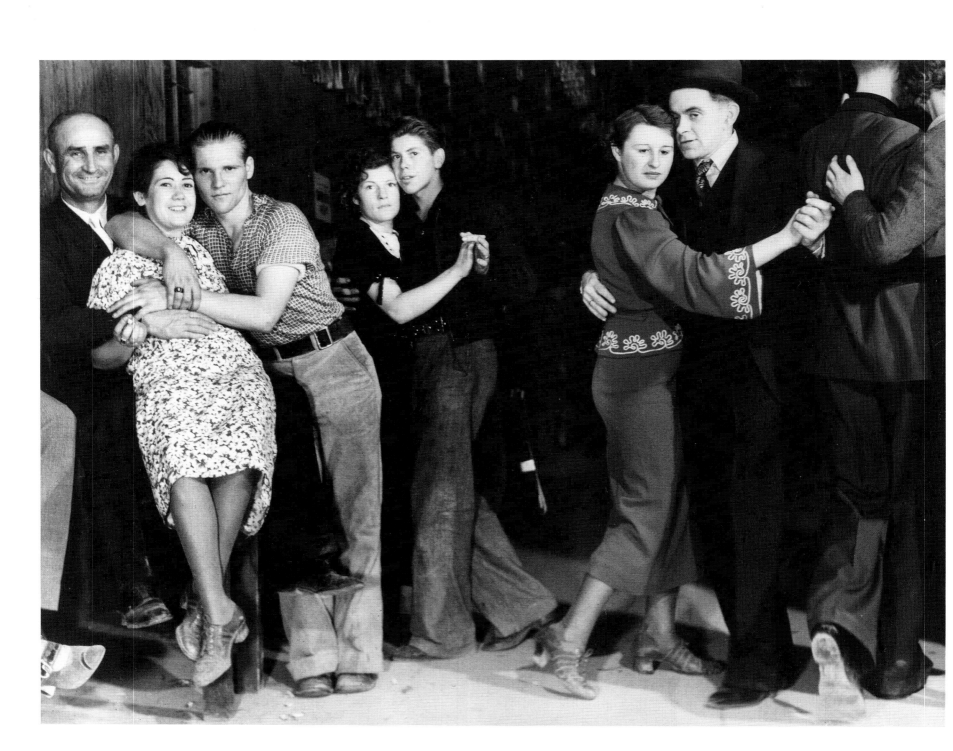

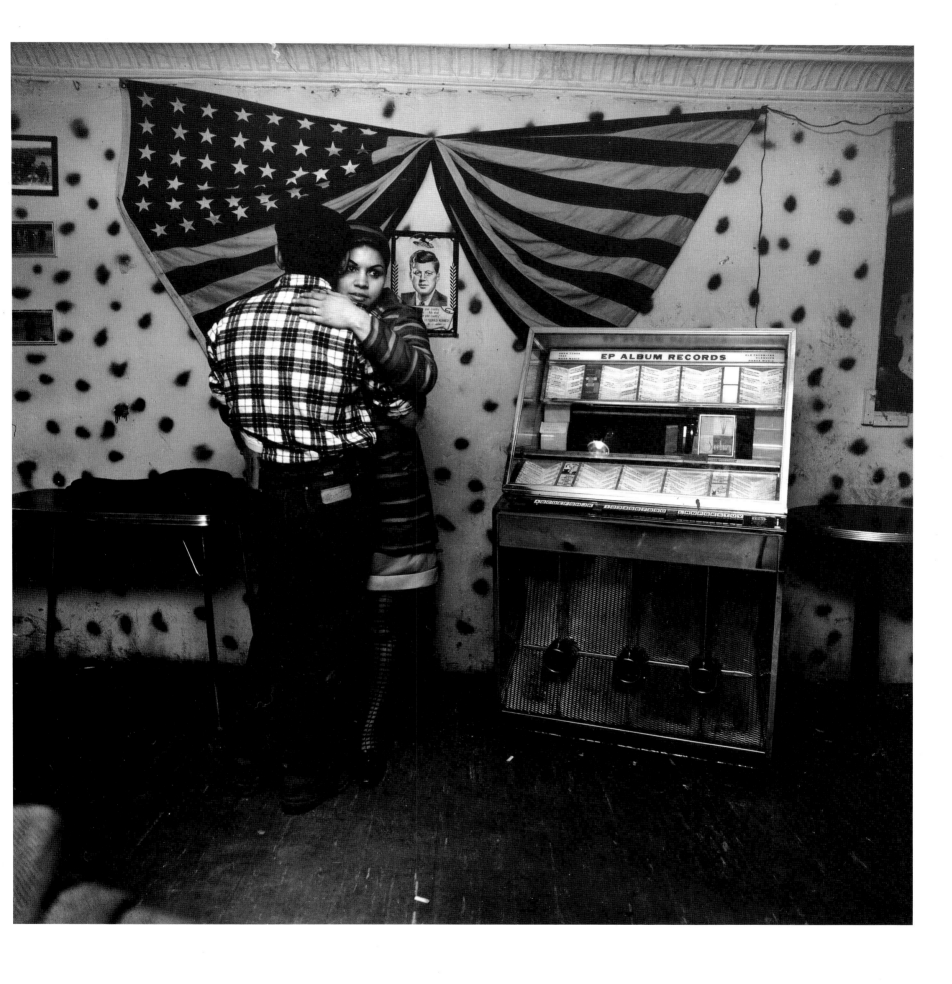

118 From *East 100th Street*, by Bruce Davidson, 1968.

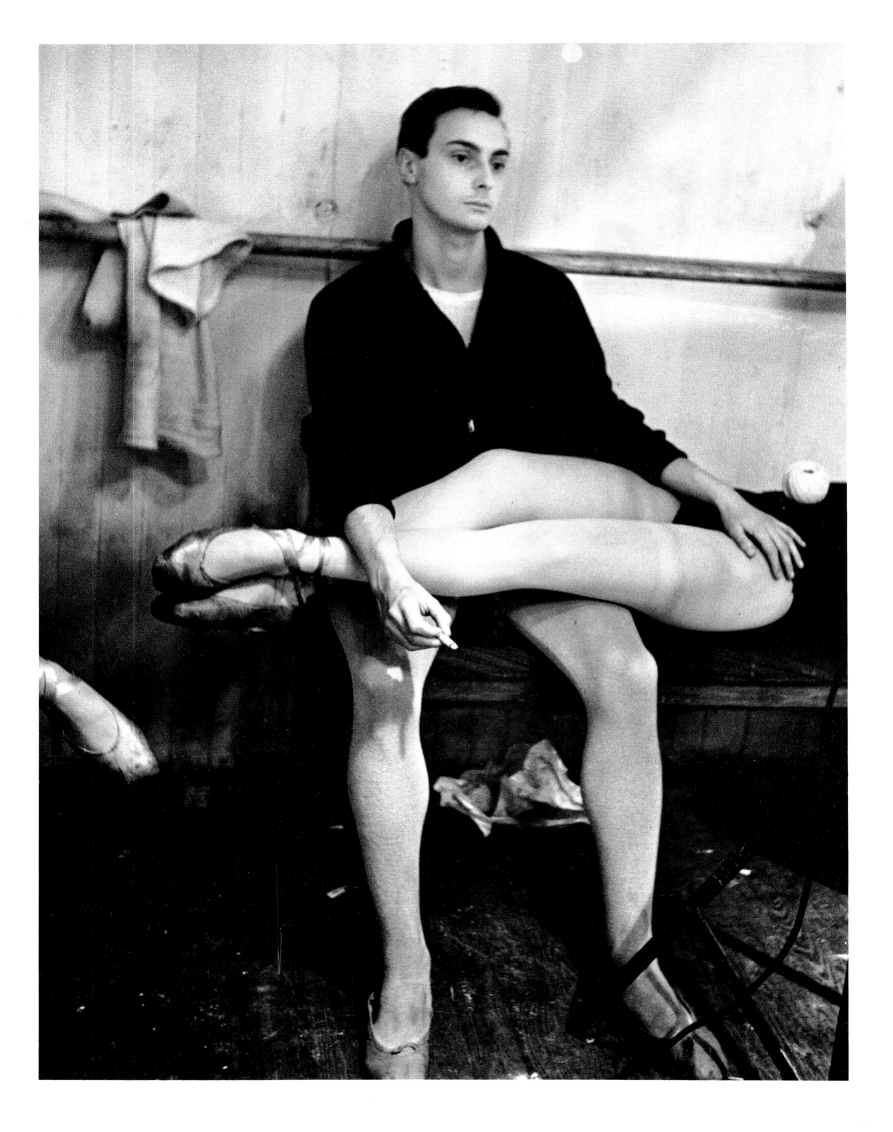

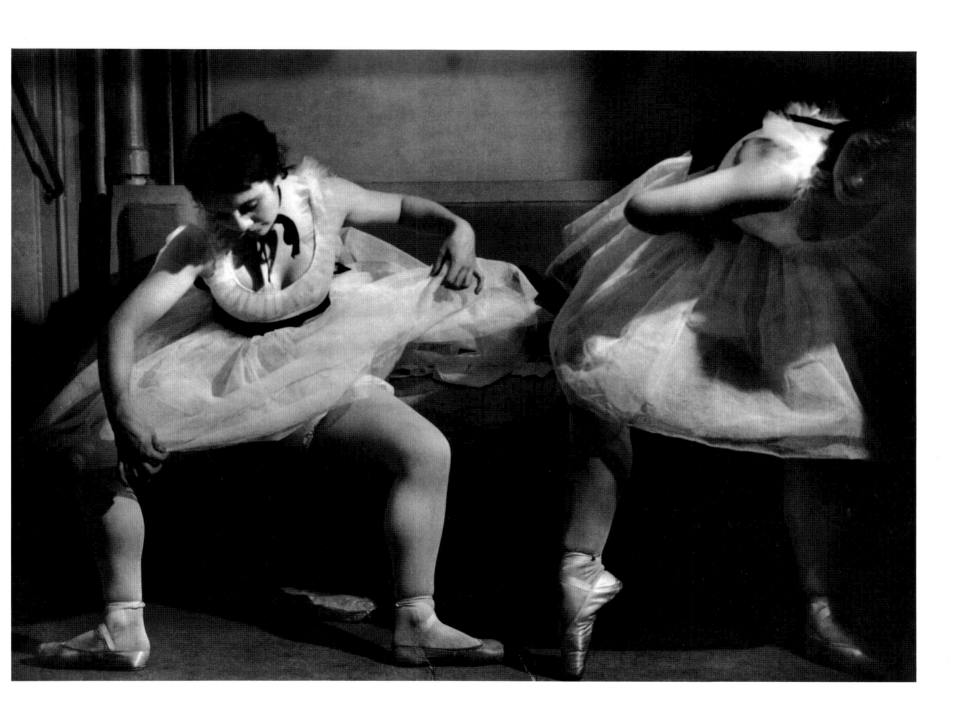

119 Studio de Danse, Paris, by Brassai, 1952.

120 **Ballerinas at the Paris Opéra, by
Brassai,** *c*.1936.

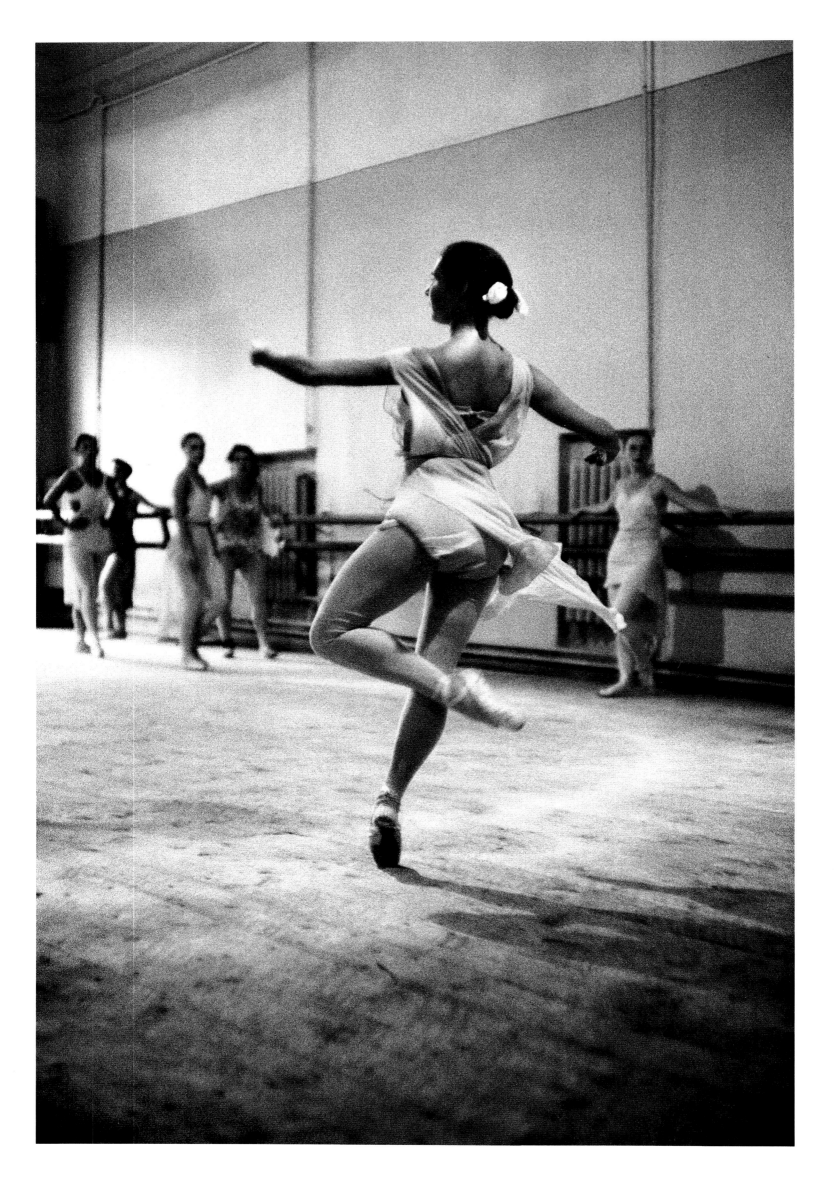

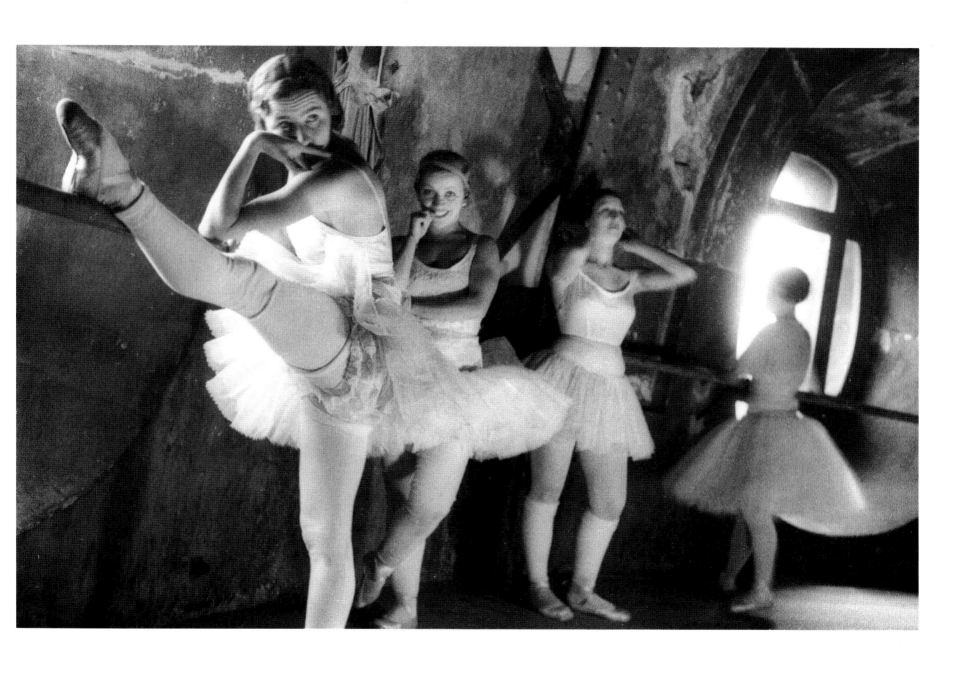

121 The Bolshoi Ballet School, by Dan
Weiner, 1957.

122 Break in practice at the Paris Opéra,
by Lucien Aigner, c.1930.

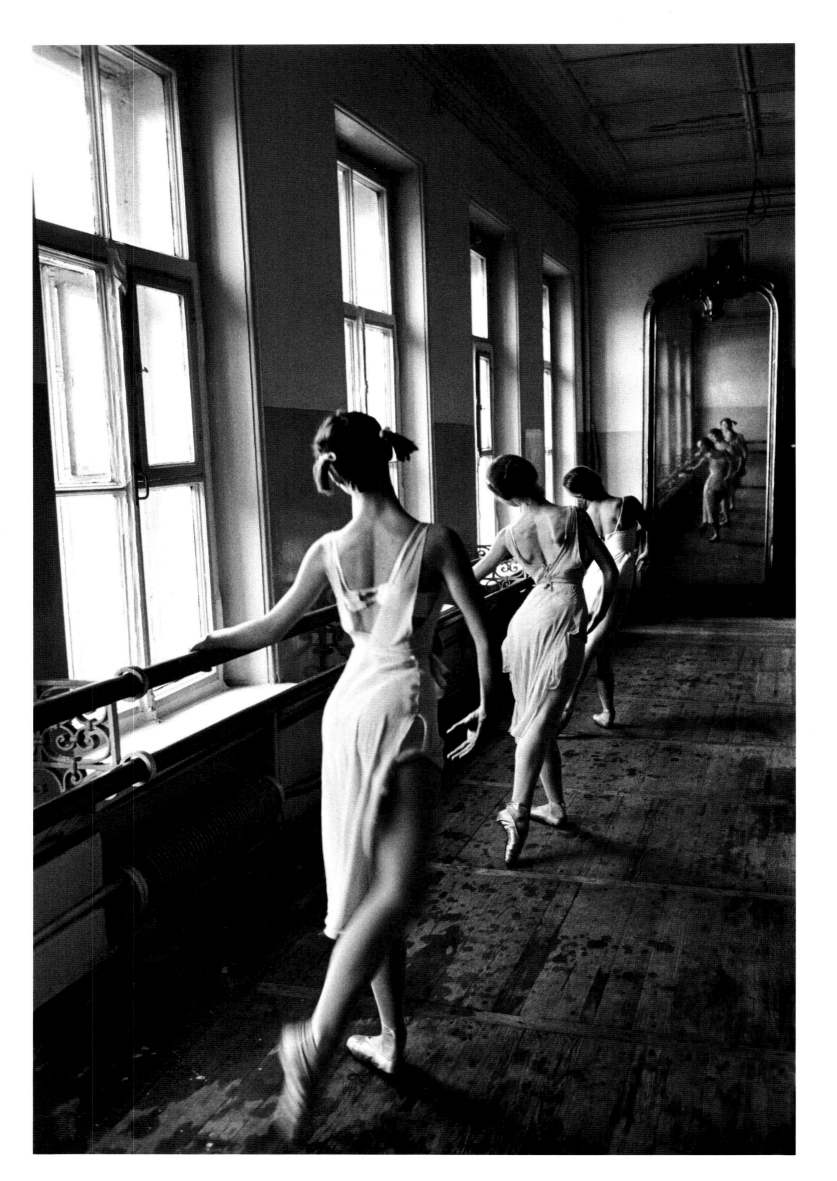

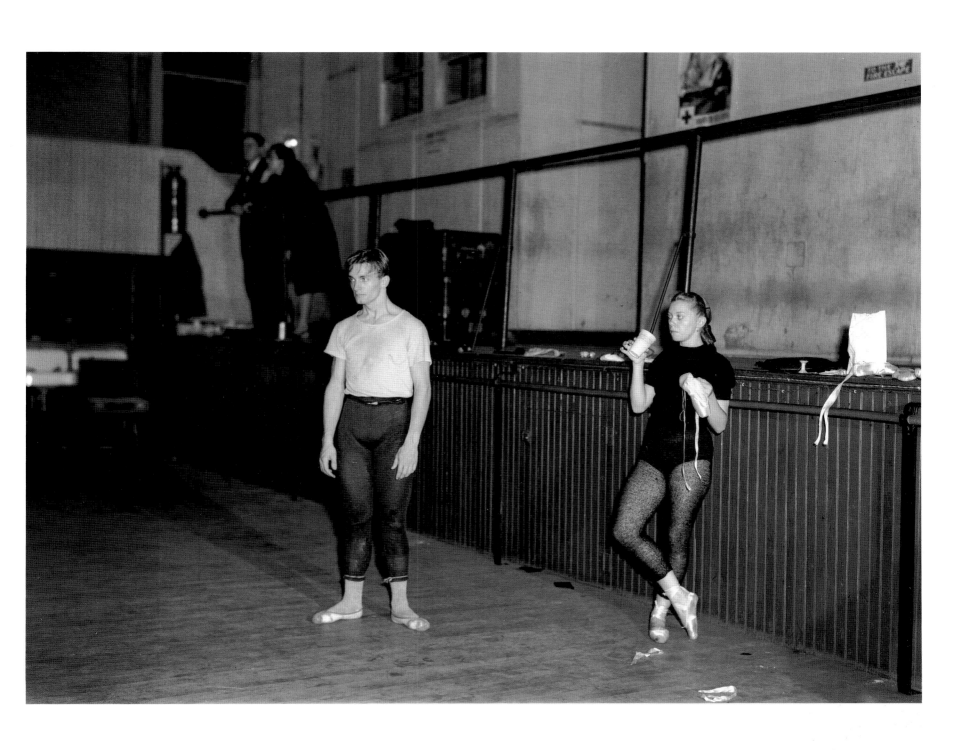

123 The Bolshoi Ballet School, by Cornell Capa, 1958.

124 Ballet Theatre dancers in rehearsal
at the Metropolitan Opera, New York,
by Walker Evans, 1945.

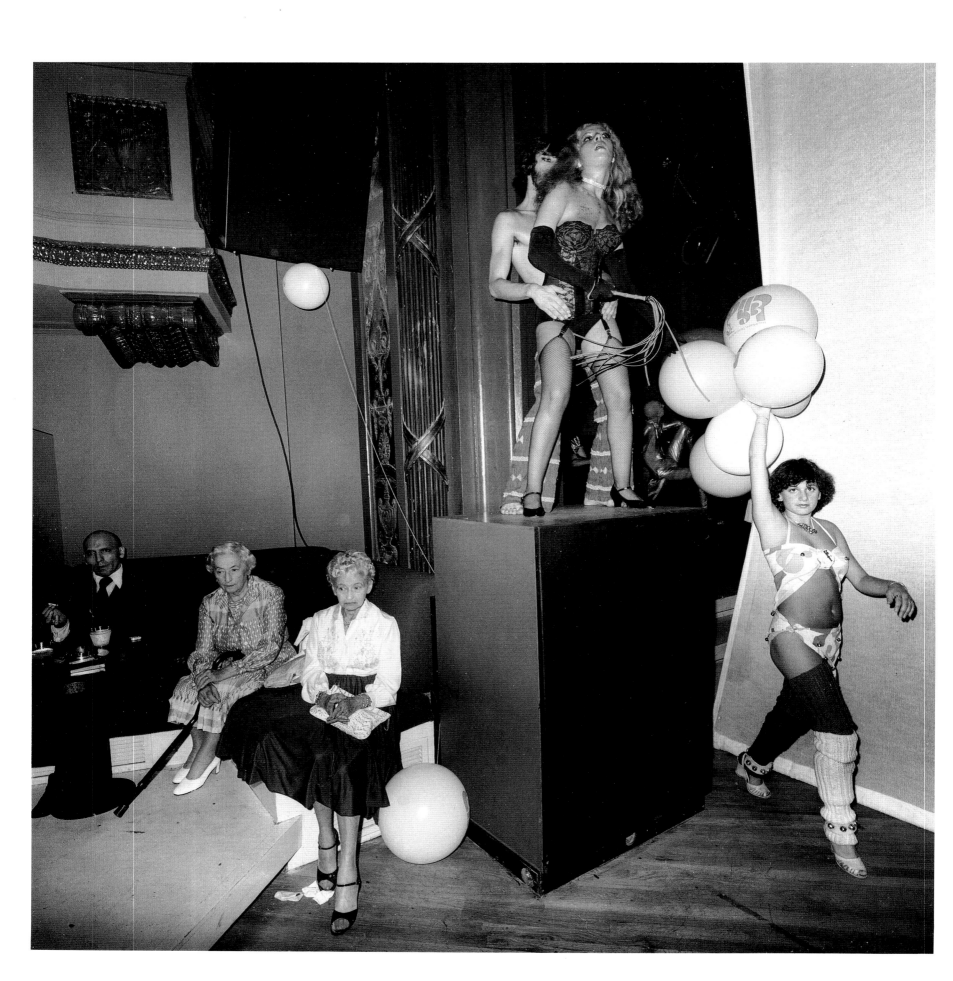

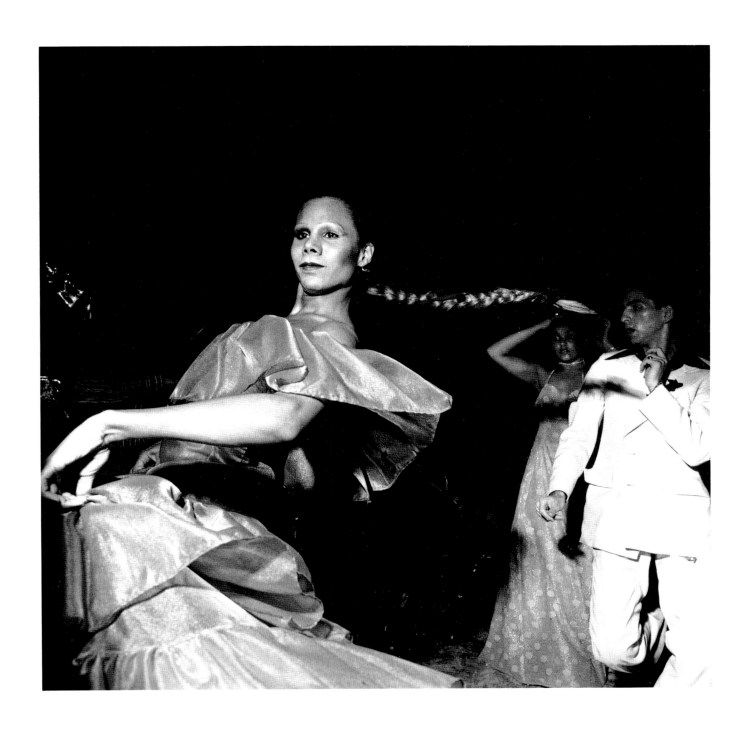

125 At Xenon's, New York, by Toby Old, 1979.

126 Studio 54, New York, by Larry Fink, 1977.

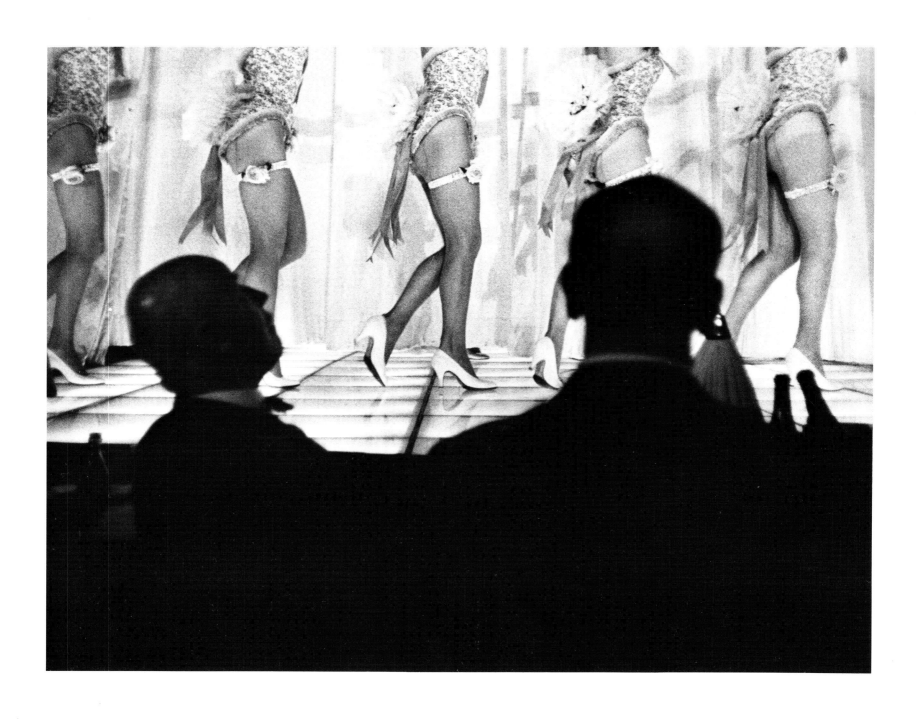

127 *La Nouvelle Eve*, by Jean-Philippe
Charbonnier, 1960.

128 Chouchou during the making of the film
Feu de Baroncelli at Epinay Studios, by
Jacques Henri Lartigue, 1926.

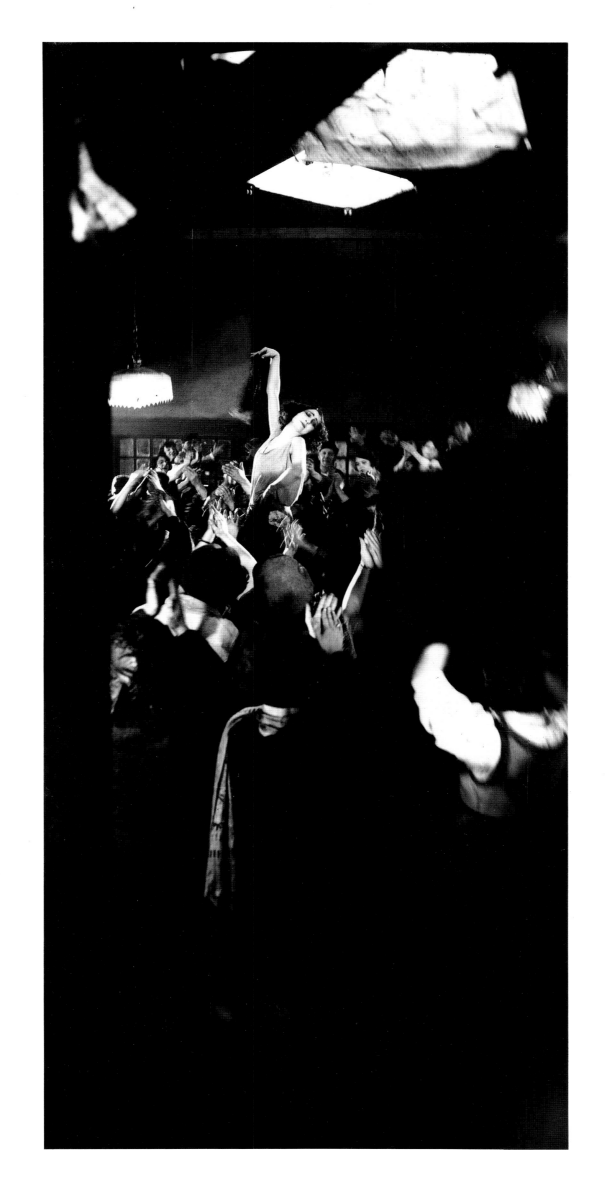

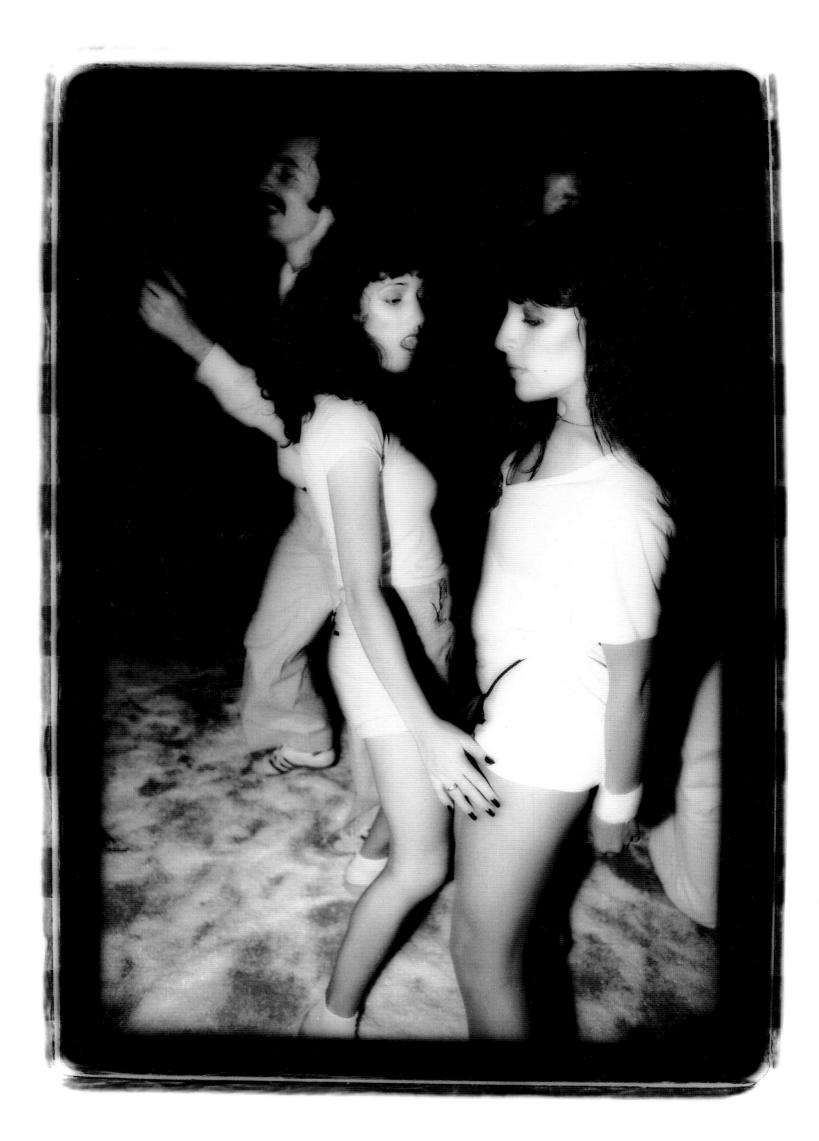

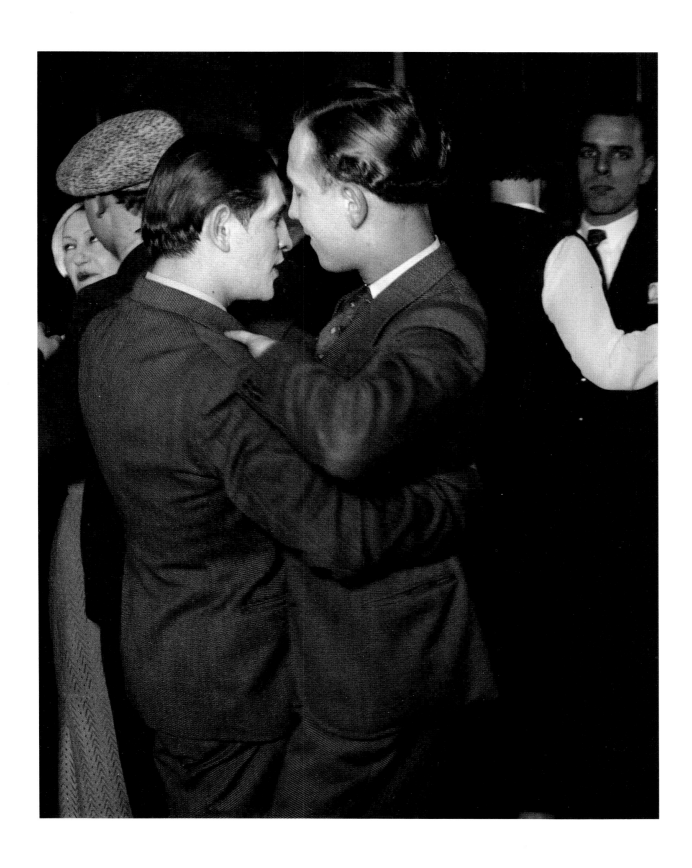

129 **Studio 54, New York,**
by William Coupon, 1978.

130 **Bal de la Montagne Sainte-Geneviève,**
Paris, by Brassai, *c*.1931.

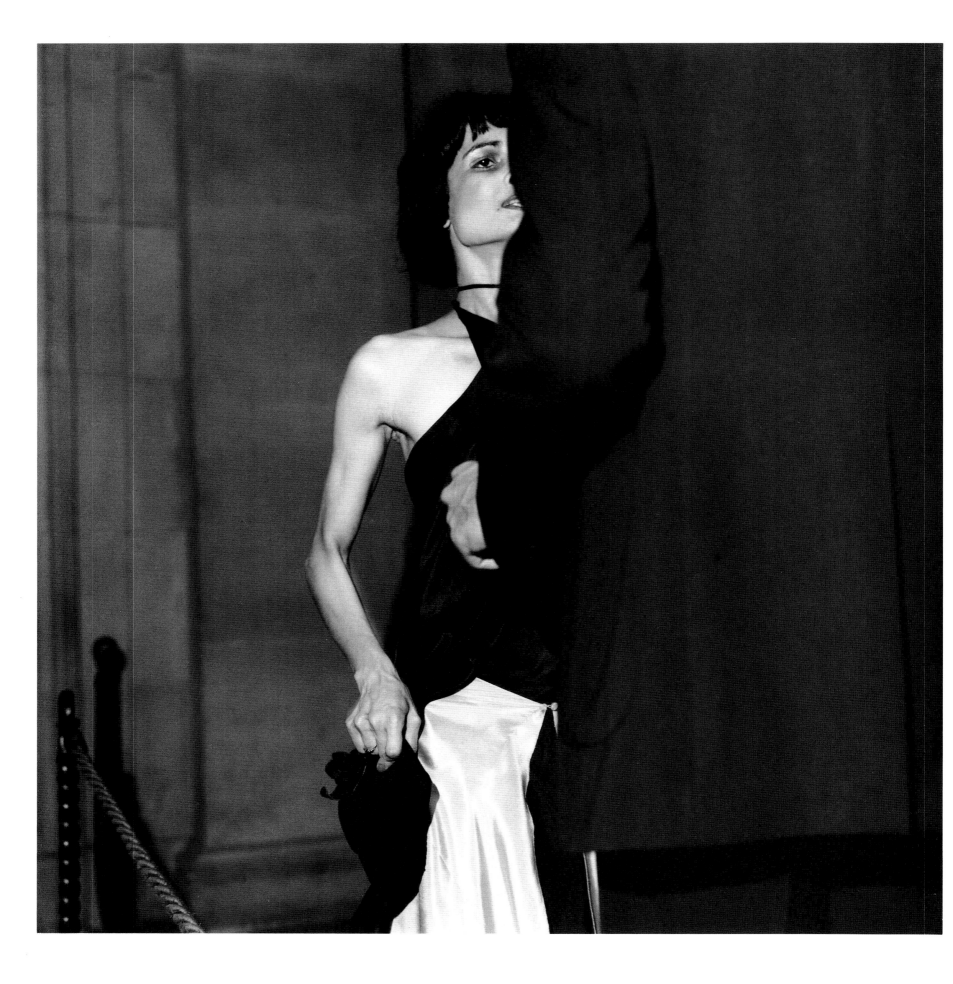

131 *Margarita at the Metropolitan*, by Lynn Davis, 1978.

132 Studio 54, New York, by William Coupon, 1978.

Overleaf
133 De Sade Birthday Party at the 2001
Starship Disco, by Christina Yuin, 1977.

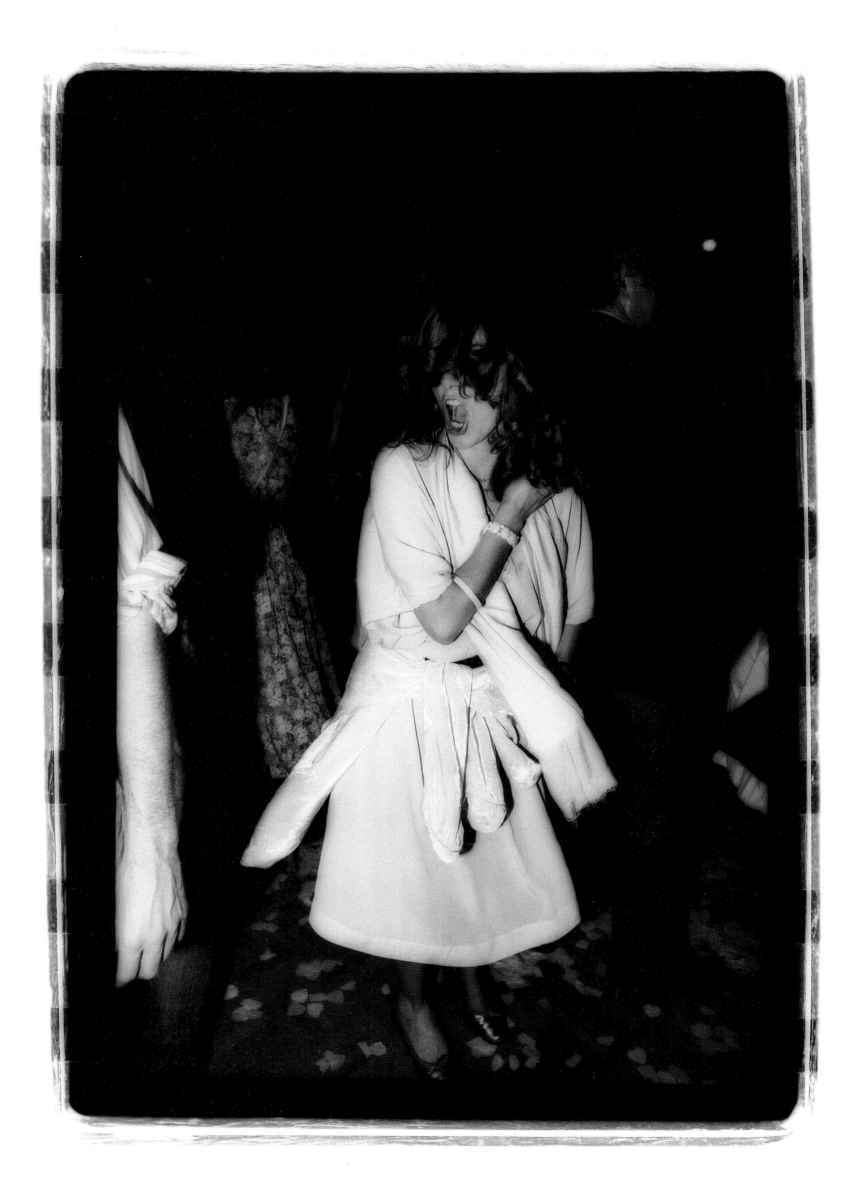

V
Collaborations

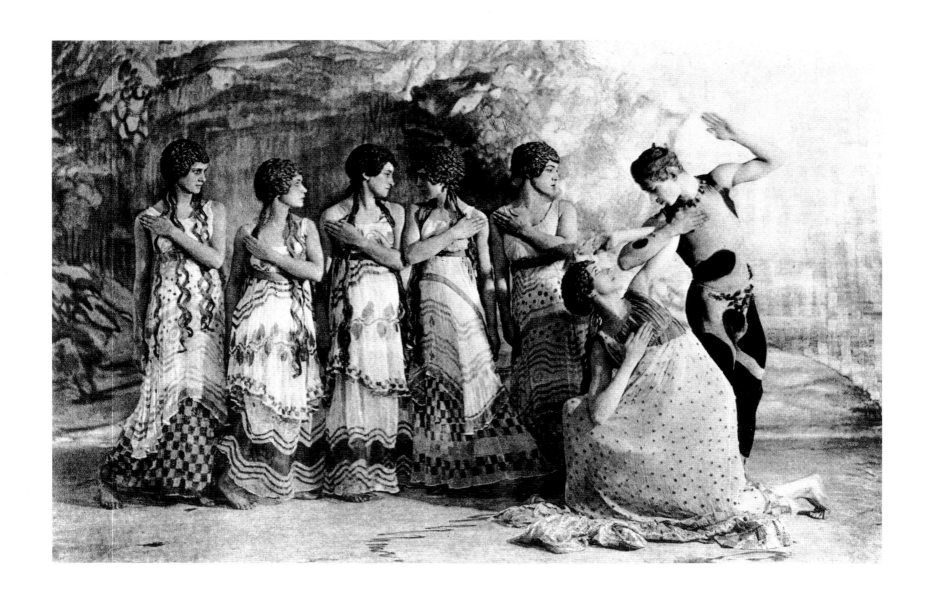

134, 135 Baron Adolf de Meyer photographed
Vaslav Nijinsky in *L'Après-midi d'un faune*
for a portfolio of thirty photographs published
in 1914, from which this selection is taken.

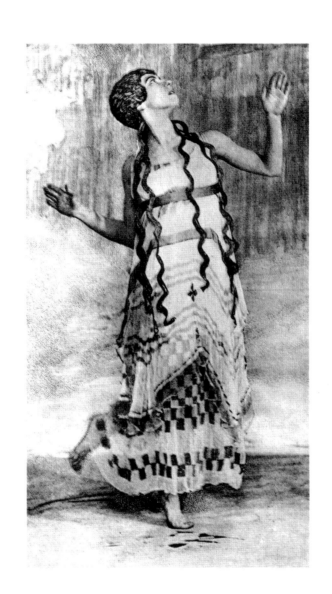

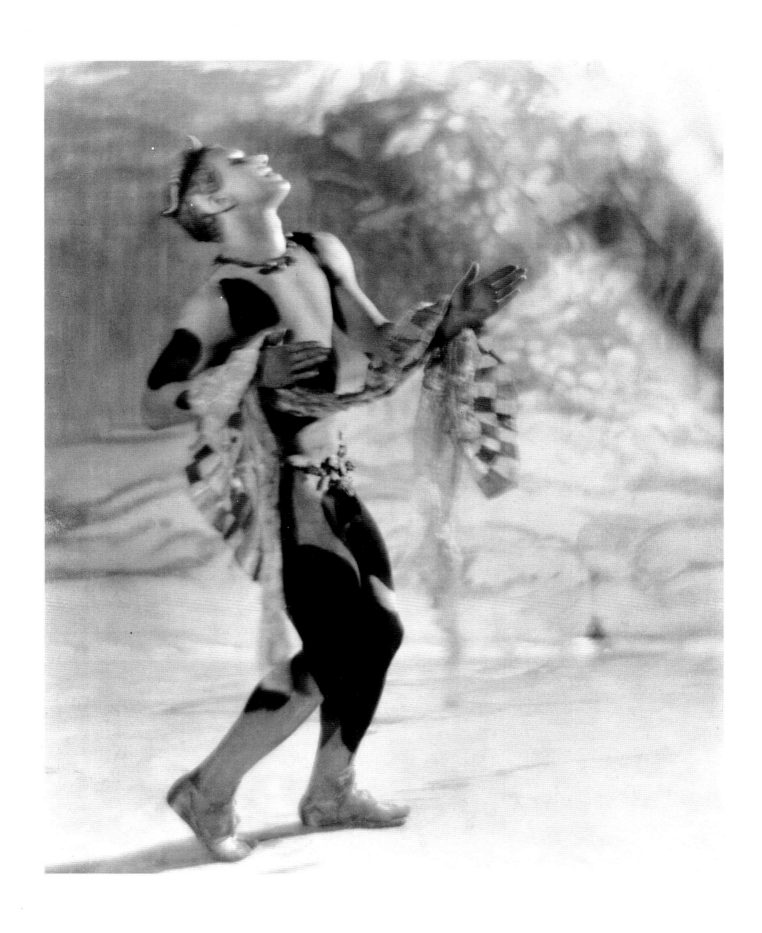

136, 137 Vaslav Nijinsky in *L'Après-midi d'un faune*, by Baron Adolf de Meyer, 1914.

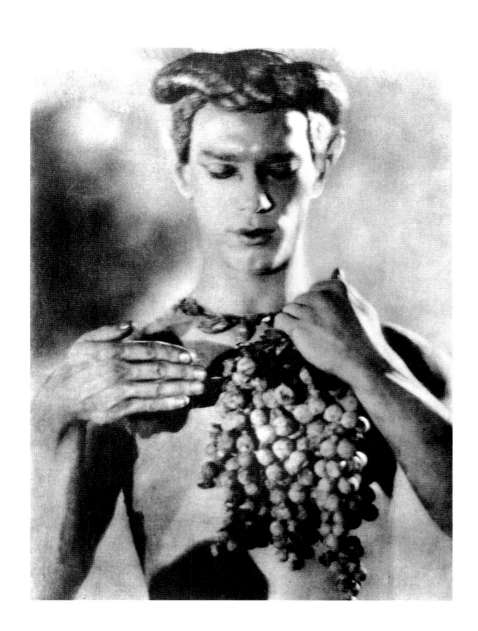

138 Between 1915 and 1918 Arnold Genthe
photographed Isadora Duncan and her pupils,
'the Isadorables', on several occasions during
their tours of the USA. This photograph of
Anna Duncan was titled *Dancing in the
Chequered Shade* by Genthe.

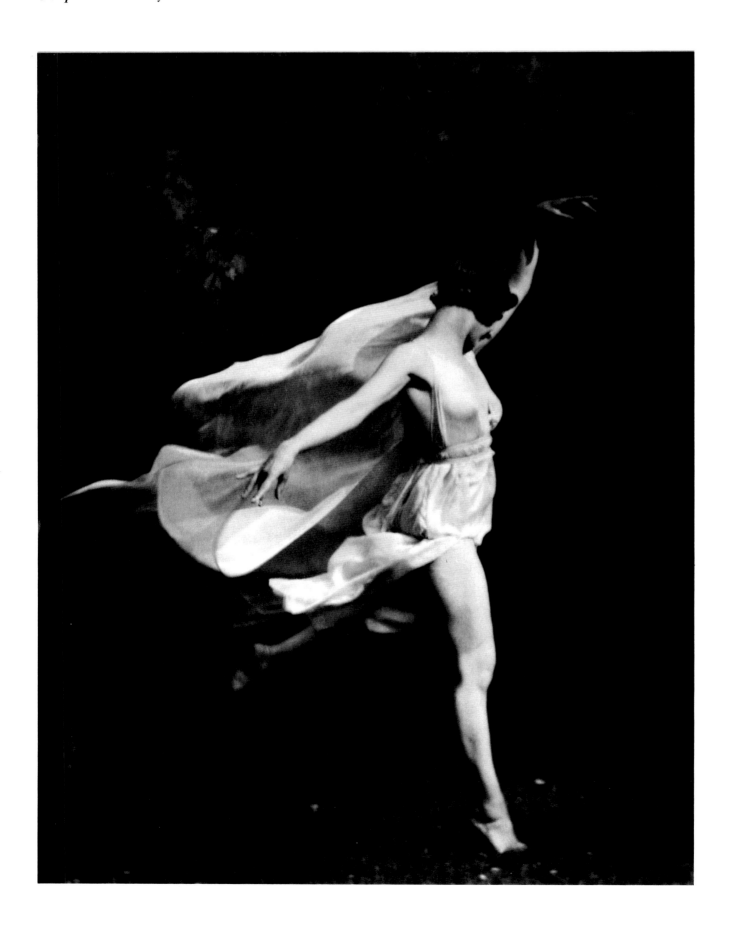

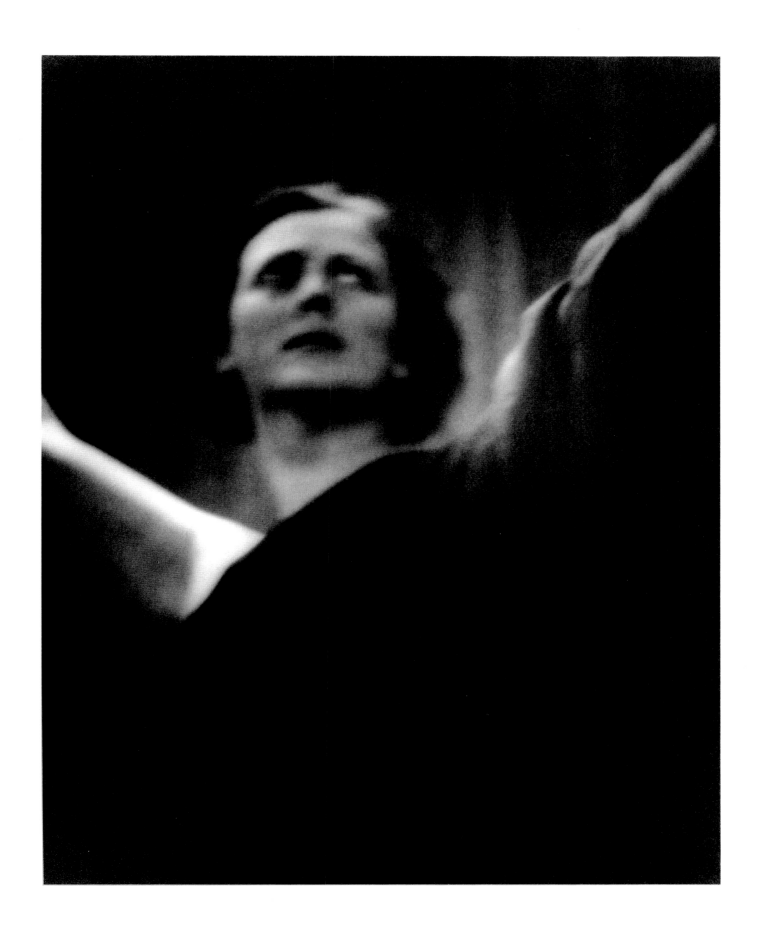

139 Isadora Duncan in *La Marseillaise*, by Arnold Genthe, *c*.1914.

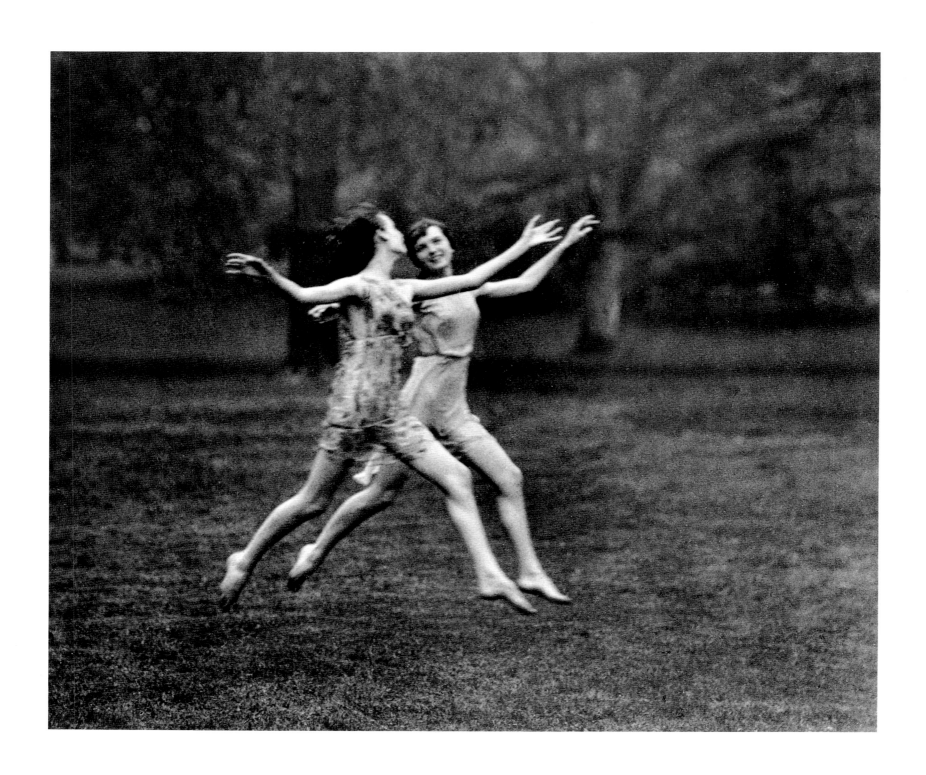

140 Dora and Senta, two 'Isadorables', by Arnold Genthe, *c*.1914.

141 Irma Duncan, by Arnold Genthe, *c*.1915.

142–145 The greatest German pioneer of
modern dance, Mary Wigman, worked with
many photographers, but felt that Charlotte
Rudolph, whom she first met in 1925, most
faithfully captured the spirit of her dancing.
These four photographs show 'Schicksalslied'
from the cycle *Tanzgesange* and are undated.

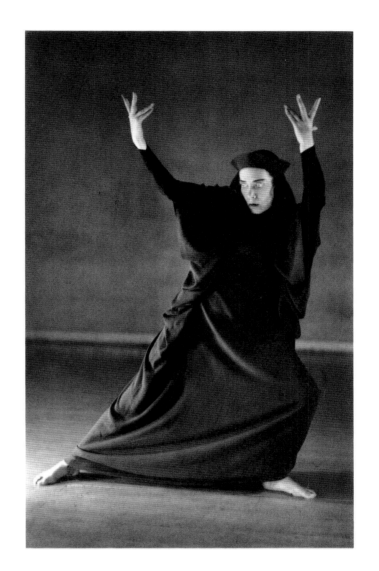

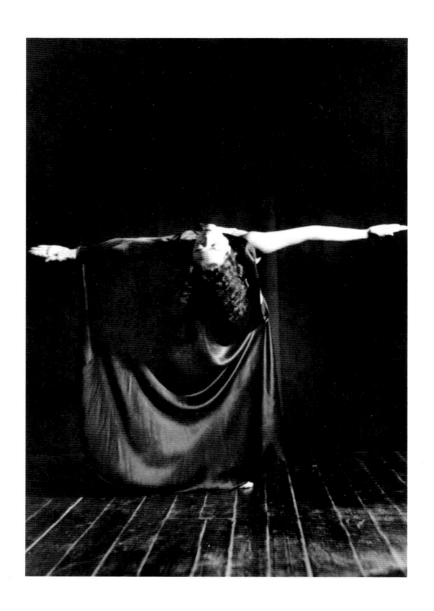

146 Mary Wigman in 'Todesruf' from the
cycle *Opfer*, by Charlotte Rudolph, 1931.

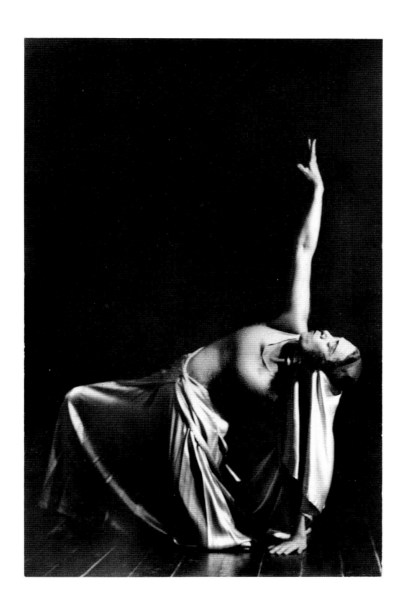

147 Mary Wigman in 'Tanz in den Tod II' from
the cycle *Opfer*, by Charlotte Rudolph, 1931.

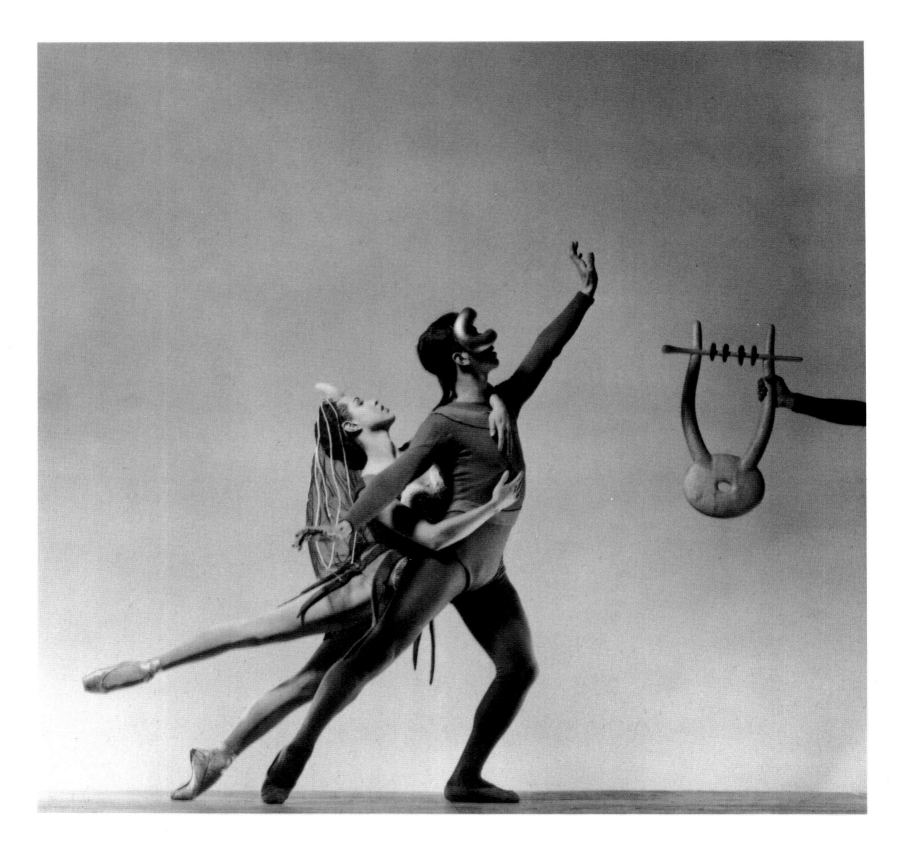

148, 149 George Platt Lynes's photographs of
George Balanchine's *Orpheus* were carefully
supervised by the choreographer. The dancers
are Maria Tallchief, Tanaquil LeClercq,
Nicholas Magallanes and Francisco Moncion.
The production was staged by the Ballet
Society, New York, in 1948.

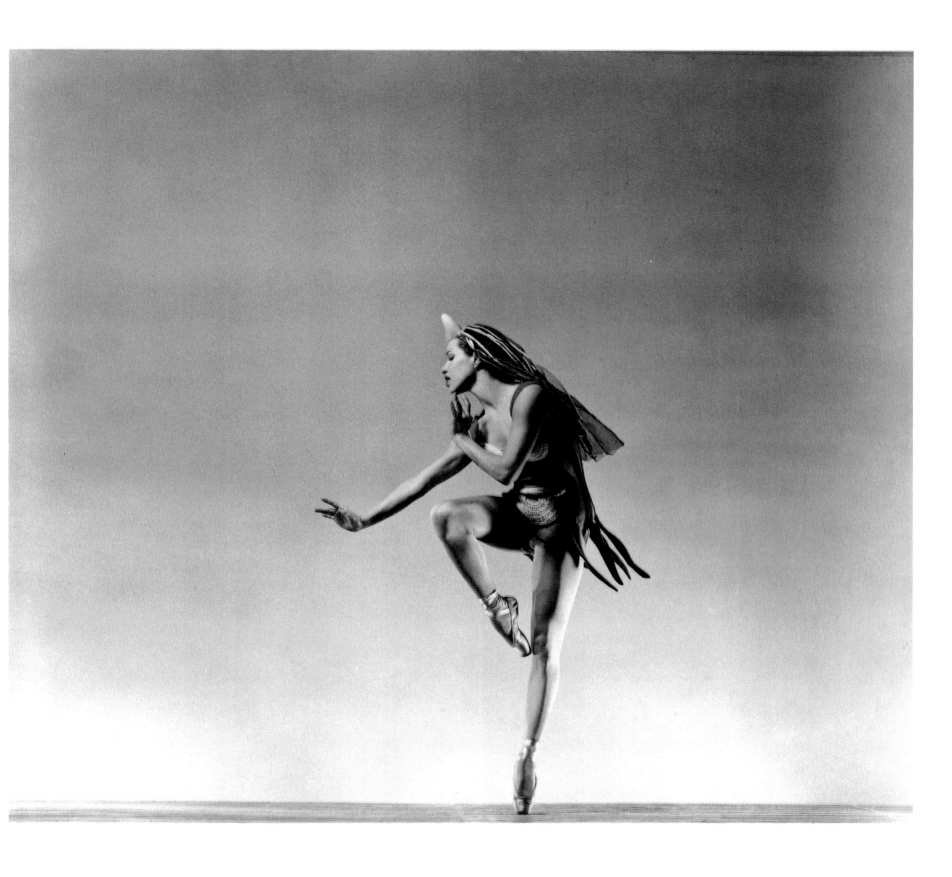

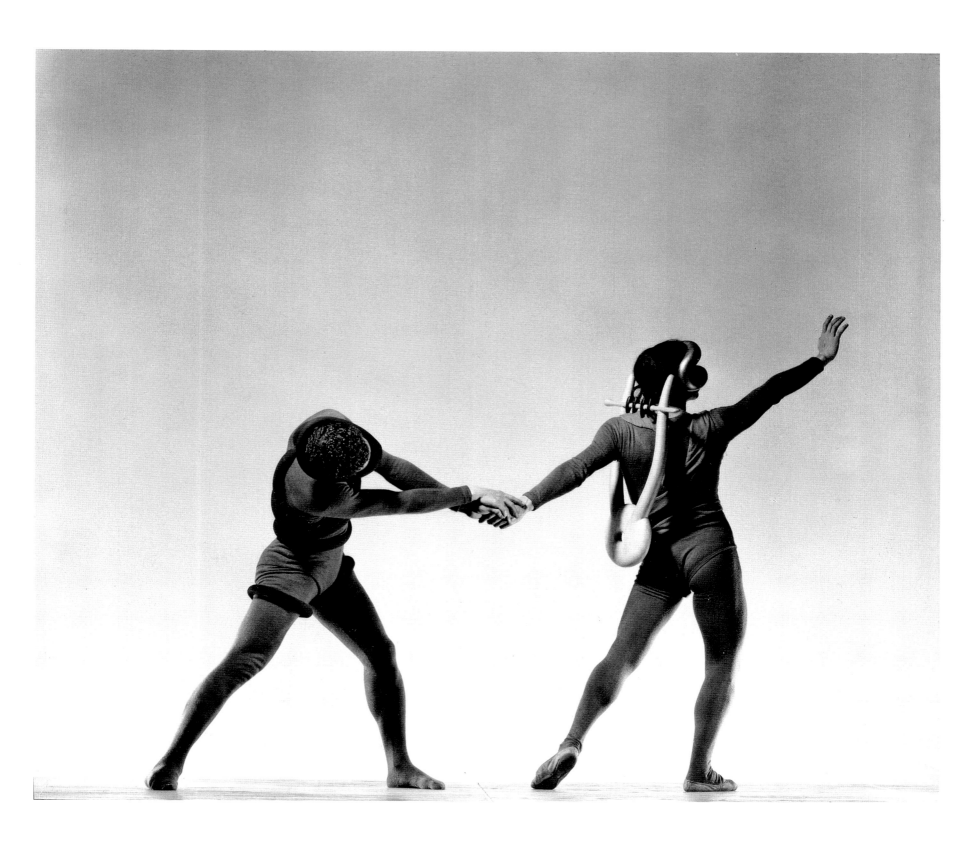

150, 151 Nicholas Magallanes, Francisco
Moncion and Tanaquil LeClercq in *Orpheus*,
by George Platt Lynes, 1948.

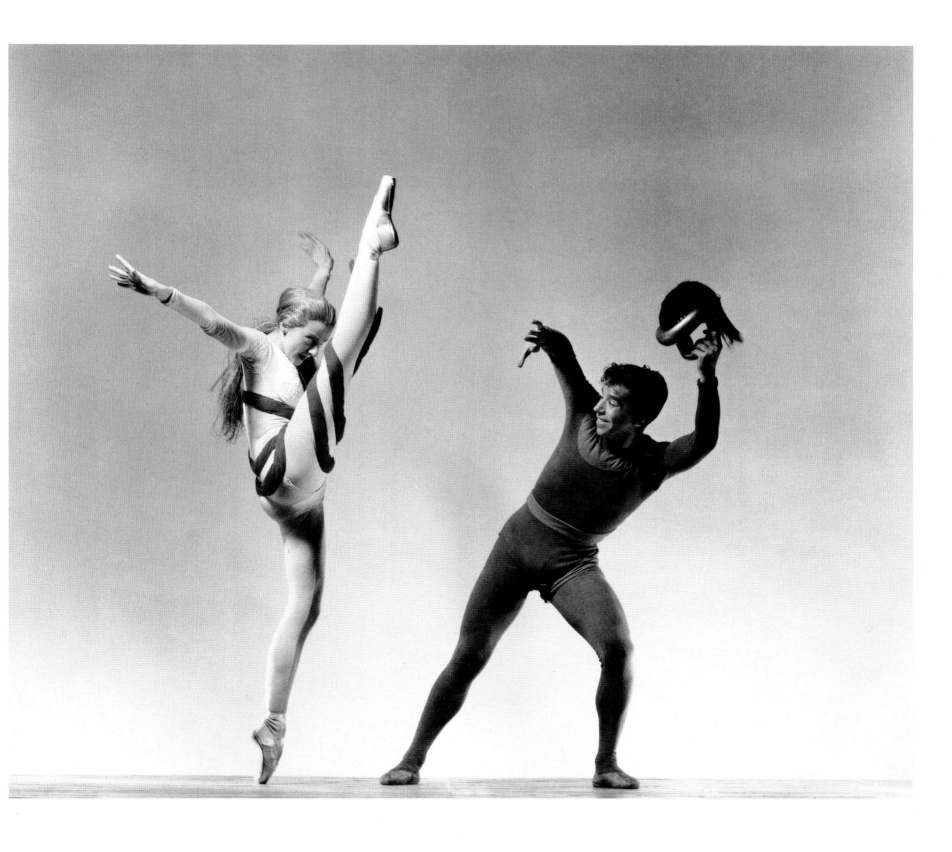

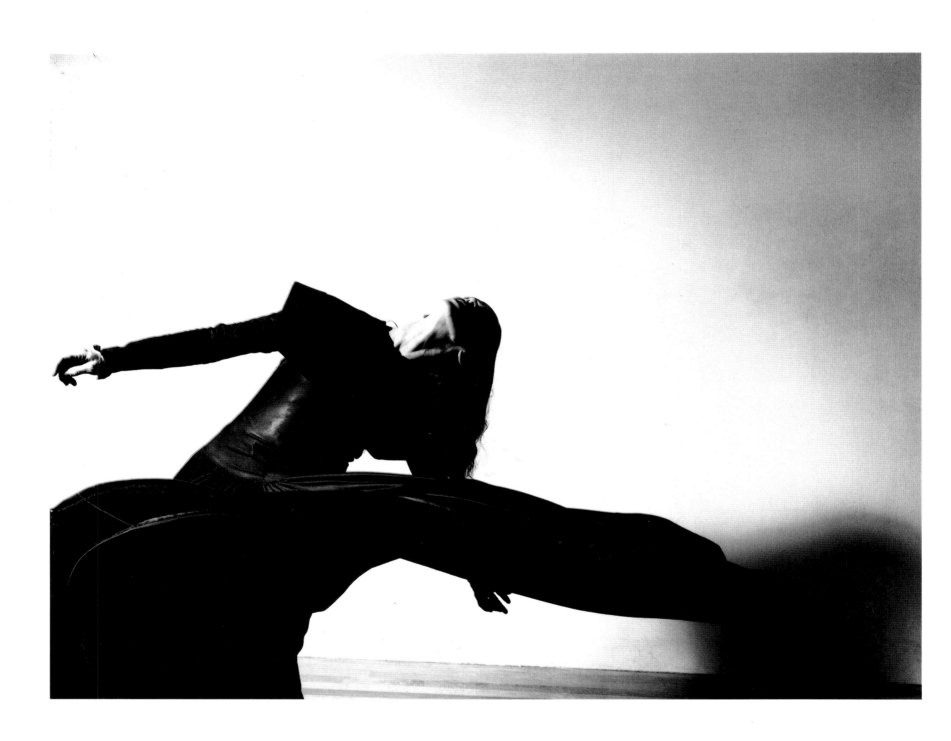

152 Barbara Morgan's photographs of
Martha Graham represent the most celebrated
collaboration between photographer and
dancer in this century, a collaboration that
extended to the creation of the dance *War
Theme*, shown in this photograph, designed
for the camera alone in 1941.

153 **Martha Graham in** *Lamentation*, **by Barbara Morgan,** 1935 (detail).

154 Martha Graham in *Deaths and Entrances*, by Barbara Morgan, 1945.

155 **Martha Graham in** *Letter to the World*, by Barbara Morgan, 1940.

156 In the studio of the contemporary New
York photographer Lois Greenfield, dancers
are not posed but are invited to create a dance
for the camera. This photograph of Daniel
Ezralow was taken in 1982.

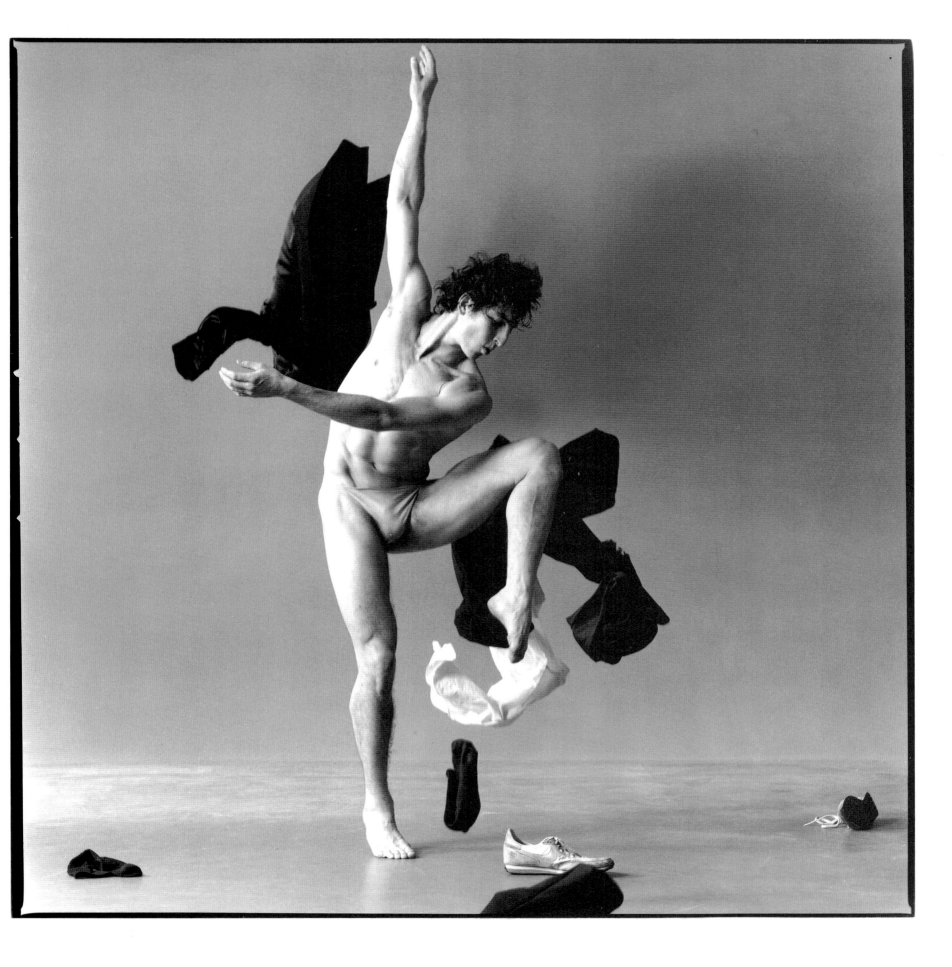

157 Daniel Ezralow, by Lois Greenfield, 1983.

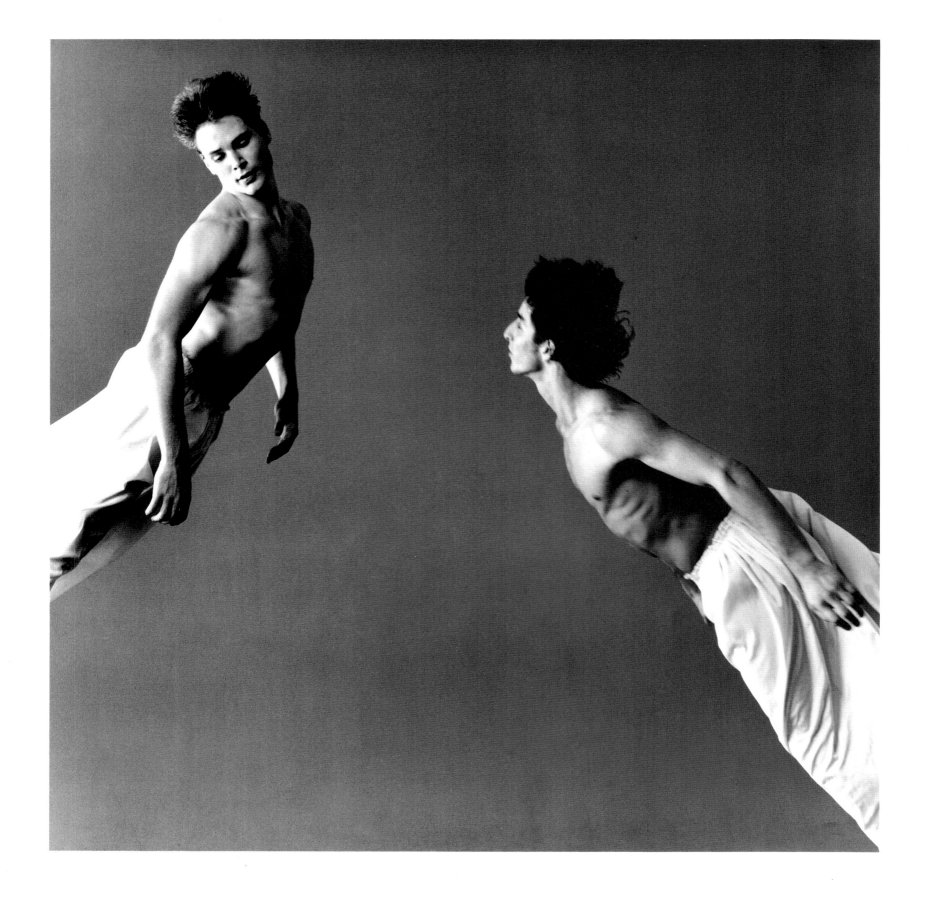

158 David Parsons and Daniel Ezralow, by Lois Greenfield, 1983.

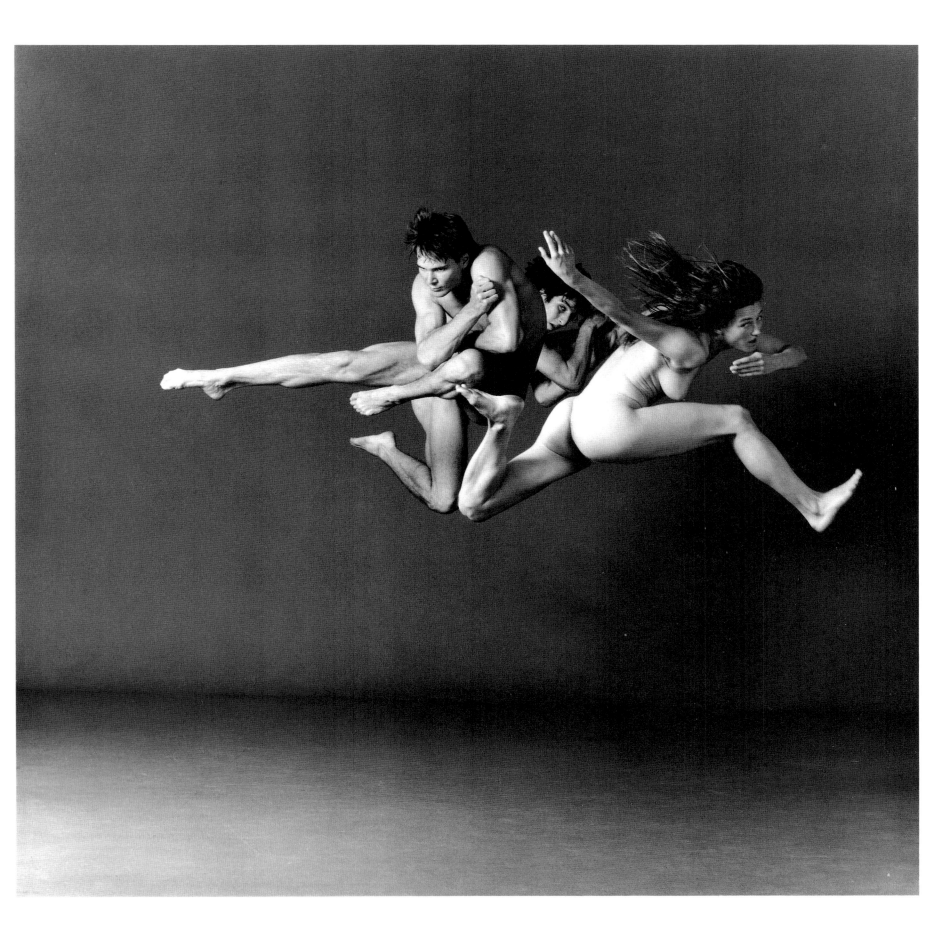

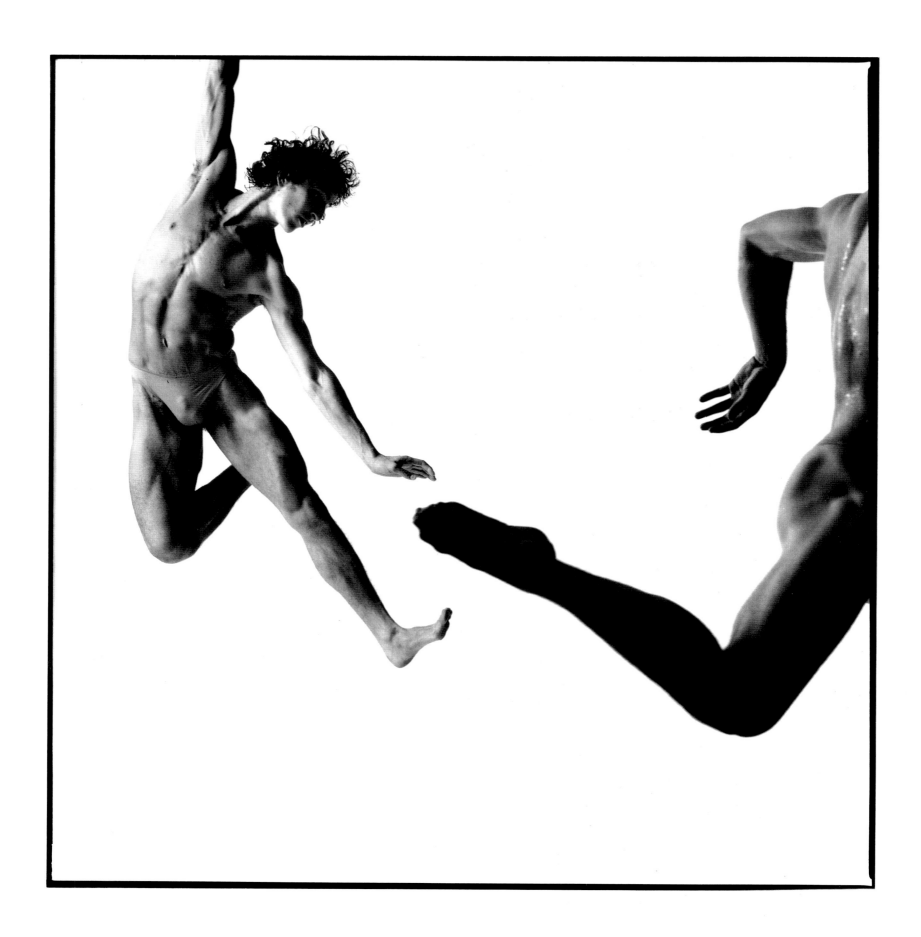

160 Daniel Ezralow and David Parsons, by Lois Greenfield, 1982.

VI
Tour-de-force

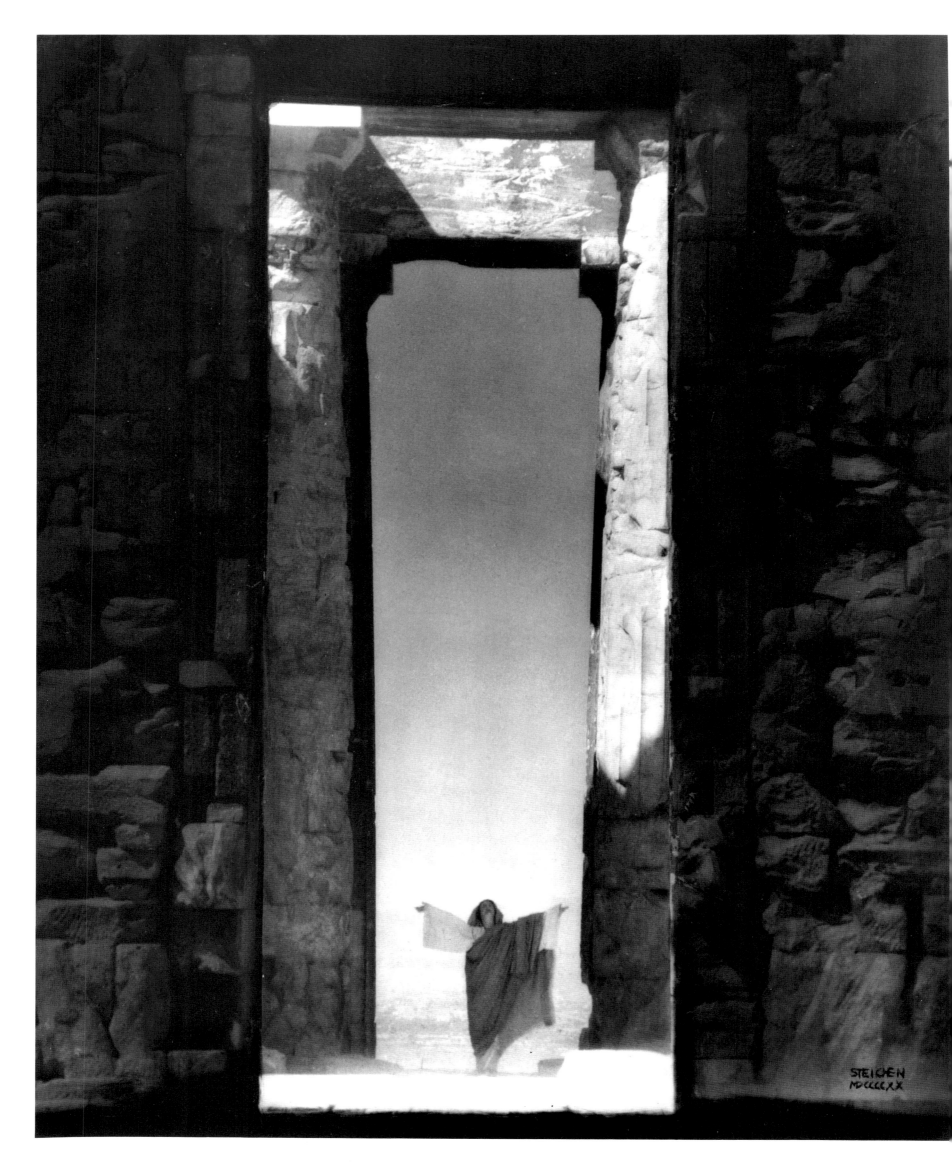

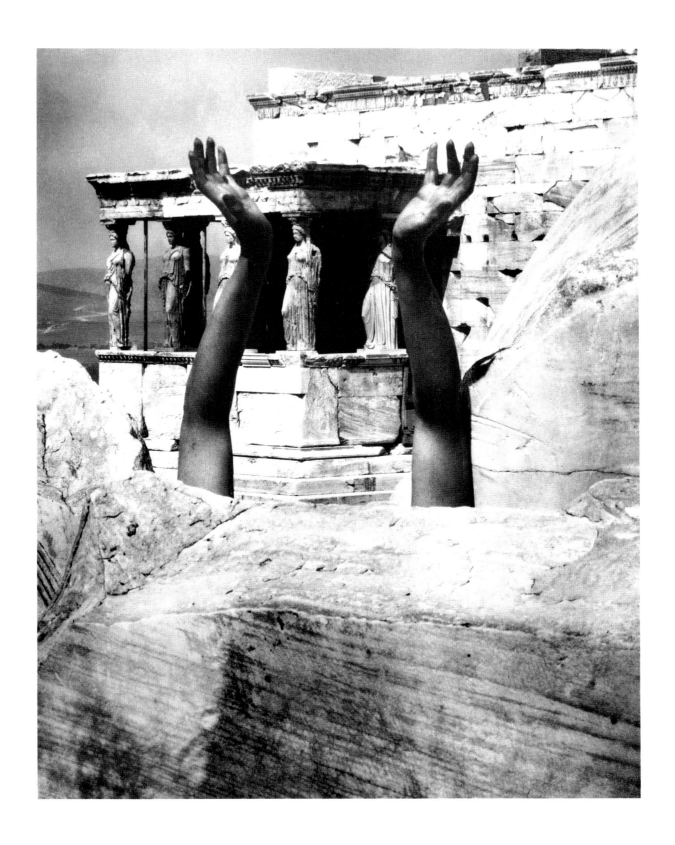

161 Isadora Duncan in the portal
of the Parthenon, by Edward Steichen,
1920.

162 The arms of Maria Theresa against the
background of the Erechtheion, by Edward
Steichen, 1920.

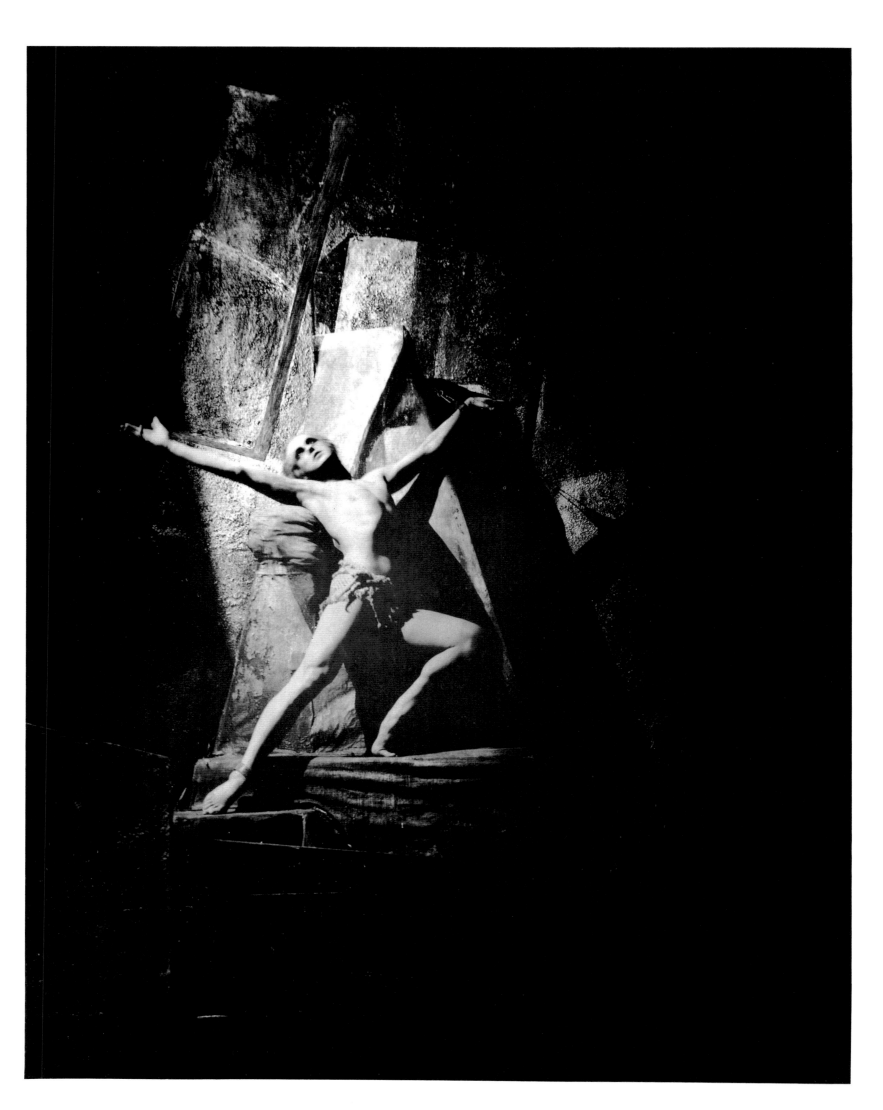

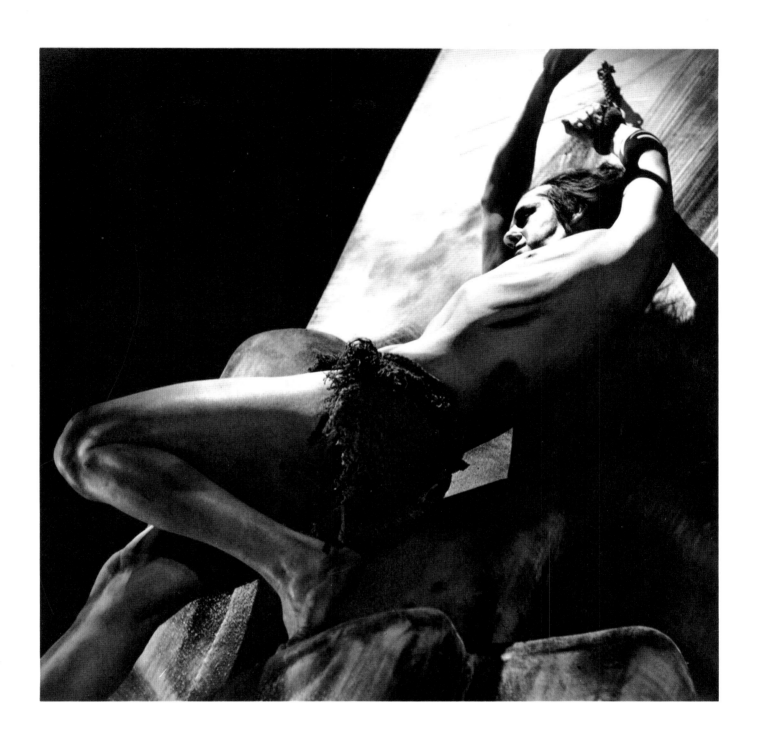

163 Ted Shawn in *Prometheus Bound*, by an
anonymous photographer, 1929.

164 Ted Shawn in *Prometheus Bound*, by
George Hoyningen-Huene, 1942.

165 **Lisa Duncan, by Yvonne Chevalier,** *c.*1930. 166 **Dance study, by Baron Adolf de Meyer,** *c.*1912.

167 Jean Babilée and Leslie Caron in *Le Sphinx*, by an anonymous photographer, 1948.

168 Nicholas Magallanes and Francisco Moncion in *Orpheus*, by George Platt Lynes, 1948.

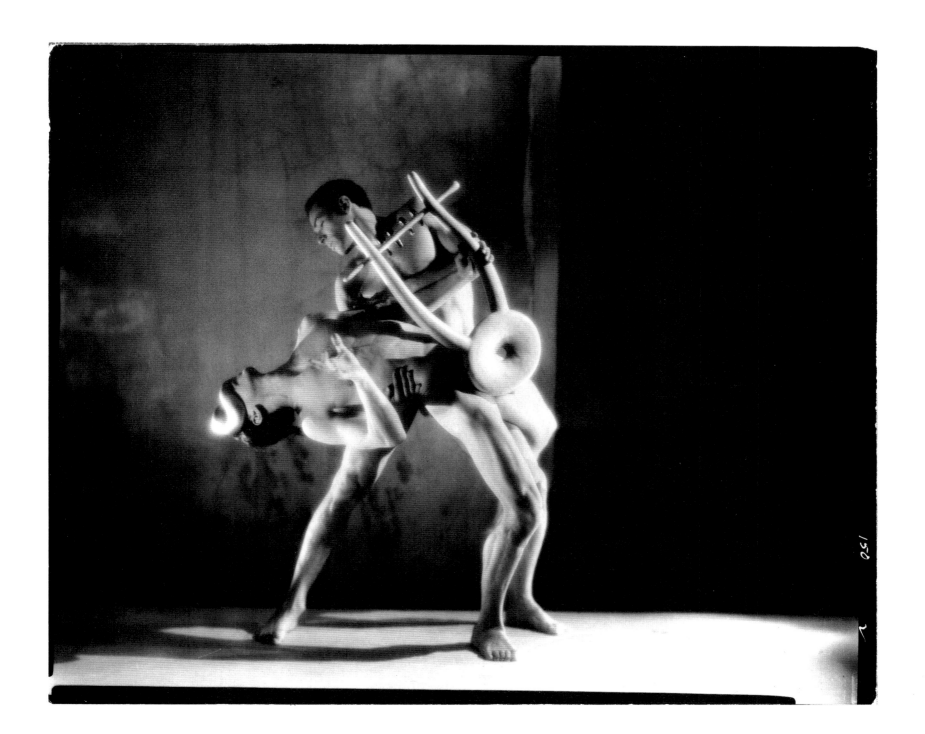

169 **Rudolph Nureyev, by Irving Penn,** 1961.

170 **Jeanne Bresciani, by Lois Greenfield,** 1987.

171 Ruth St Denis at Santa
Monica, California, by an
anonymous photographer,
1915–16.

172 Untitled study, by Jan Unger, *c*.1935.

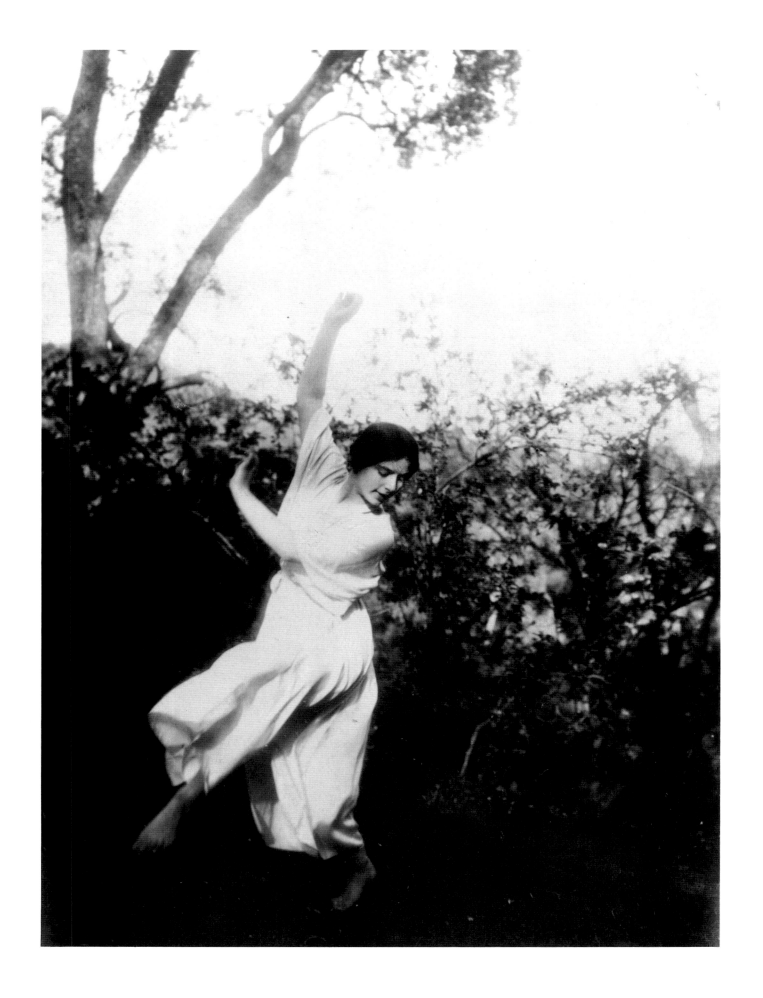

173 Marie Rambert, by an anonymous photographer, *c*.1906.

174 **Michael Maule in the New York City**
Ballet's production of *Lilac Garden*, by
George Platt Lynes, 1951.

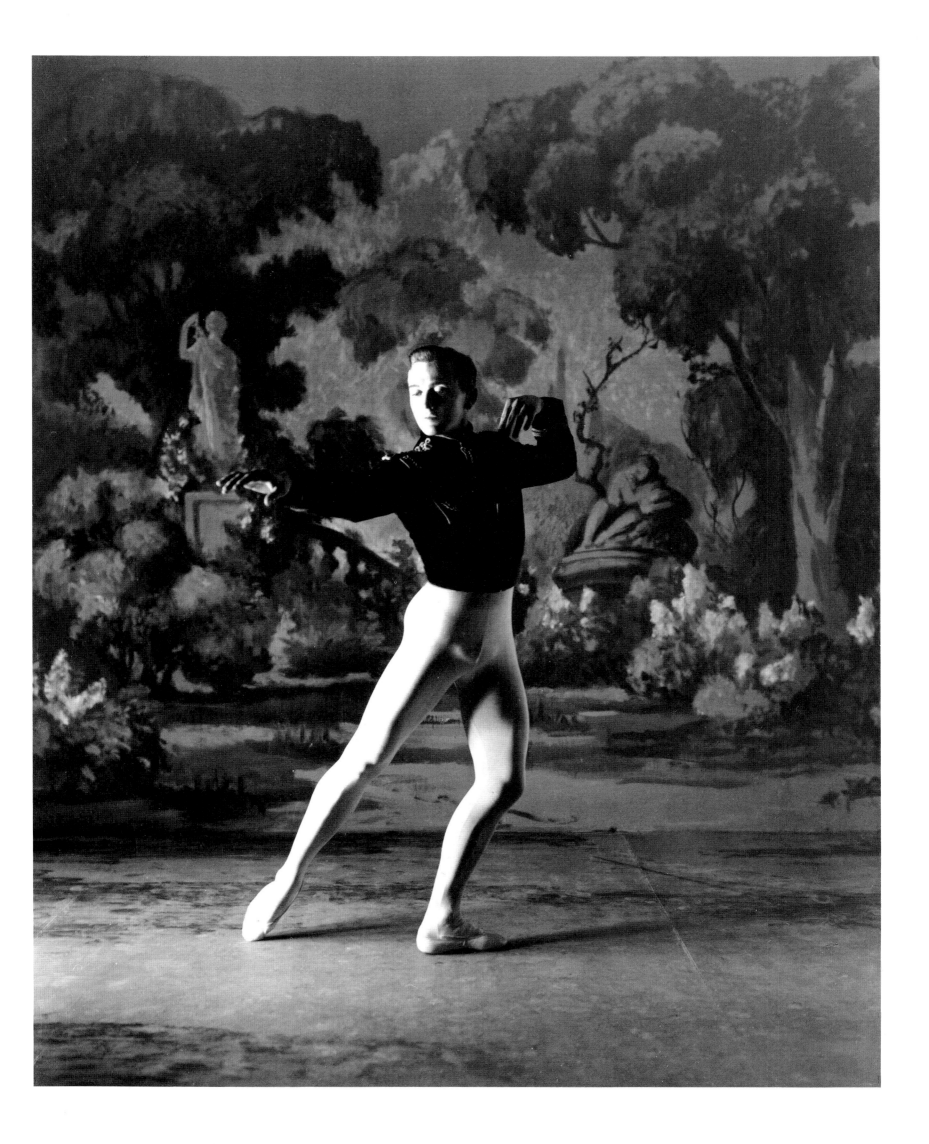

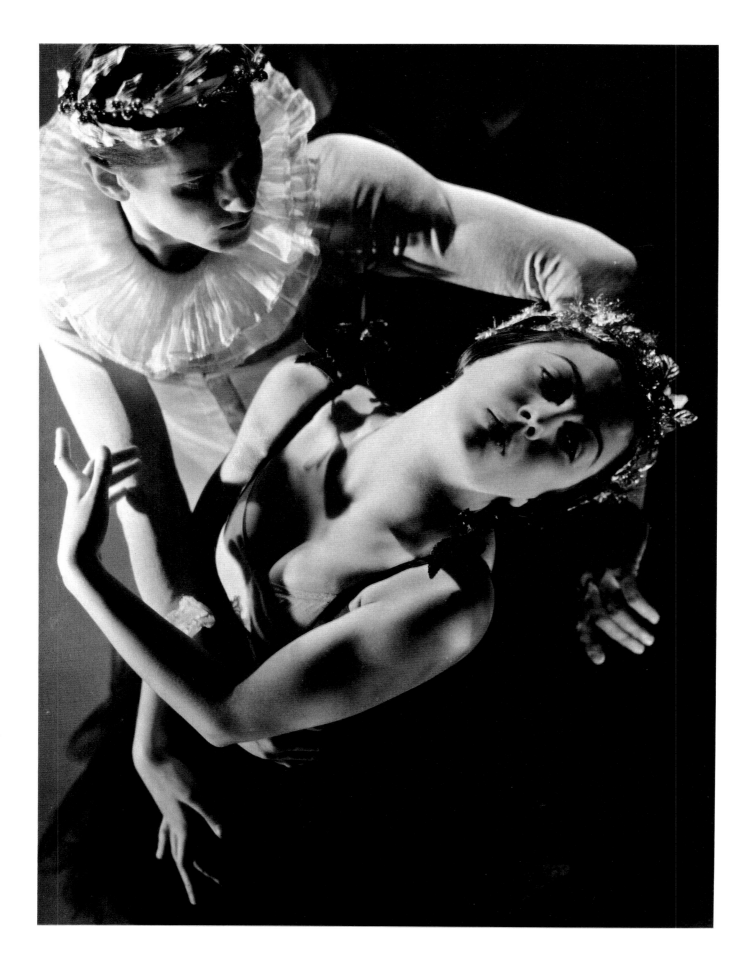

175 Roman Jasinski and Tamara
Toumanova in *Mozartiana*, by
George Hoyningen-Huene, 1933.

176 *Rest at the Ballet School*,
by Pierre Dubreuil, 1895.

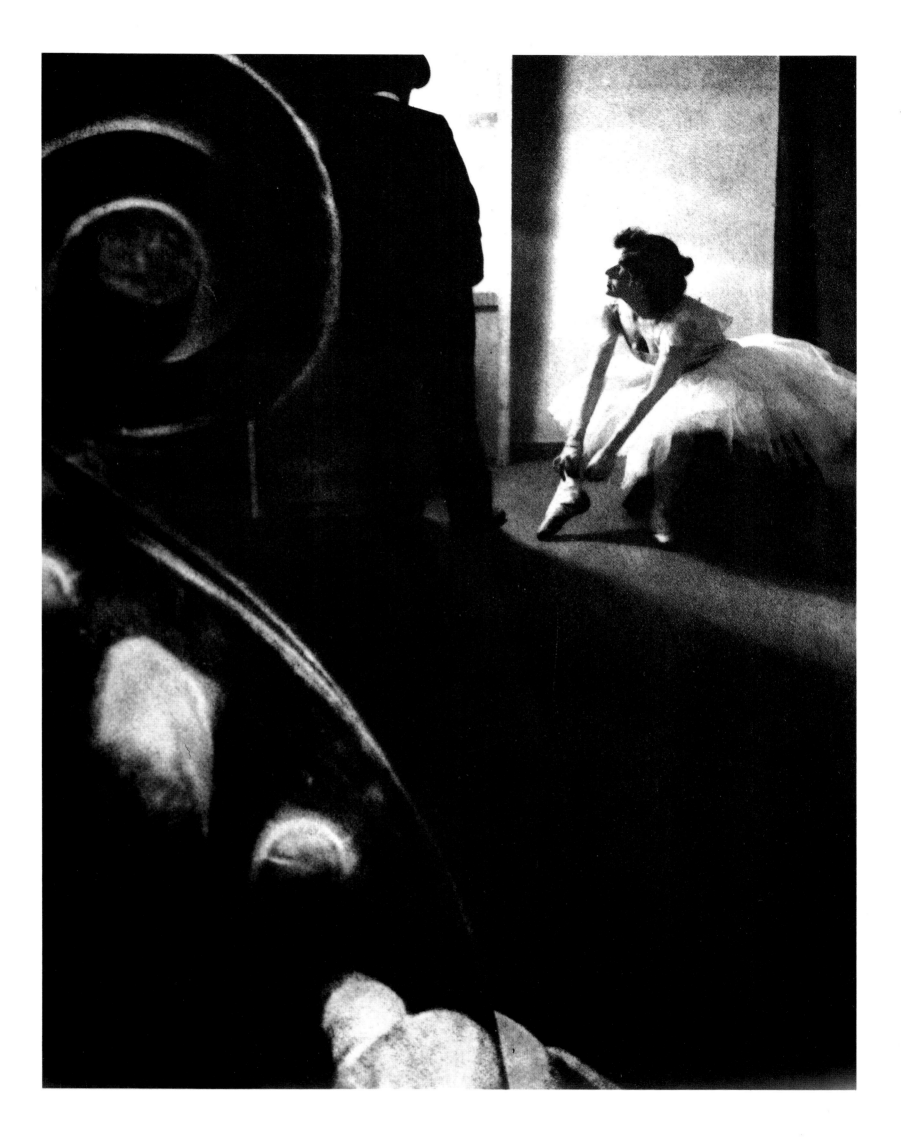

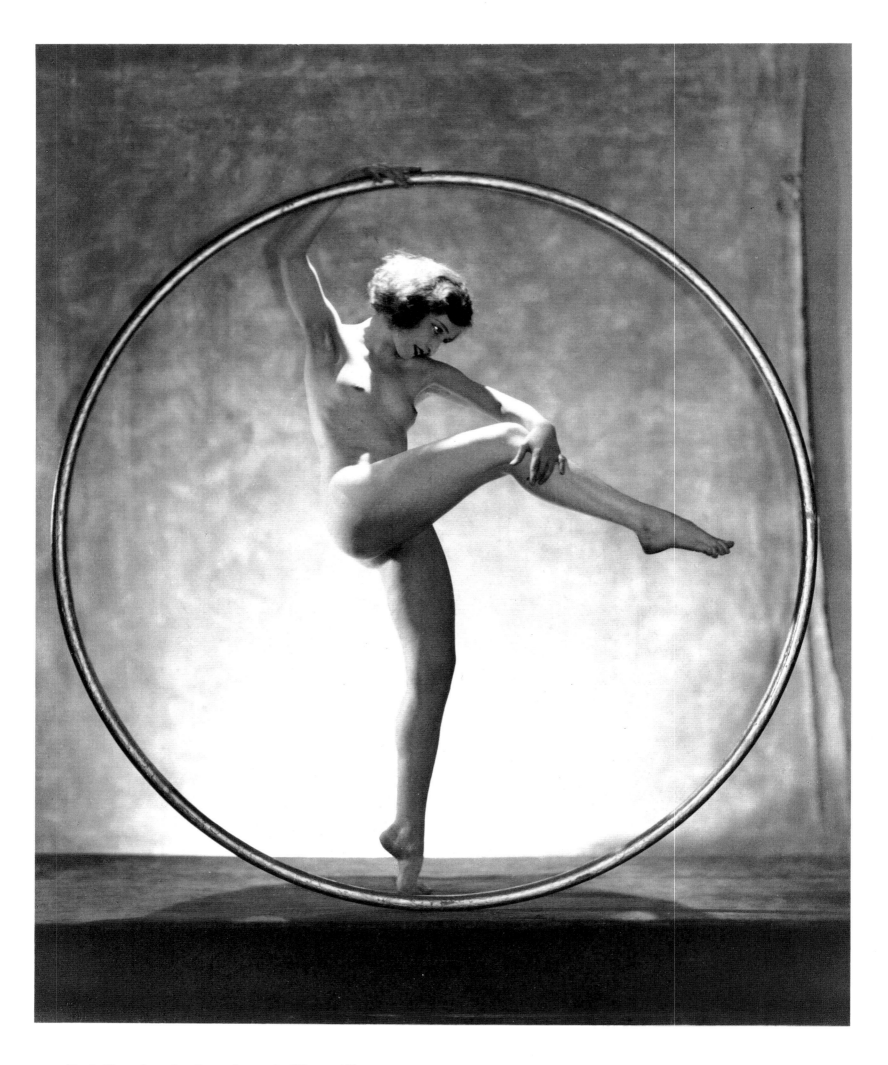

177 Doris Humphrey in a hoop dance, by Wayne Albee, *c*.1924.

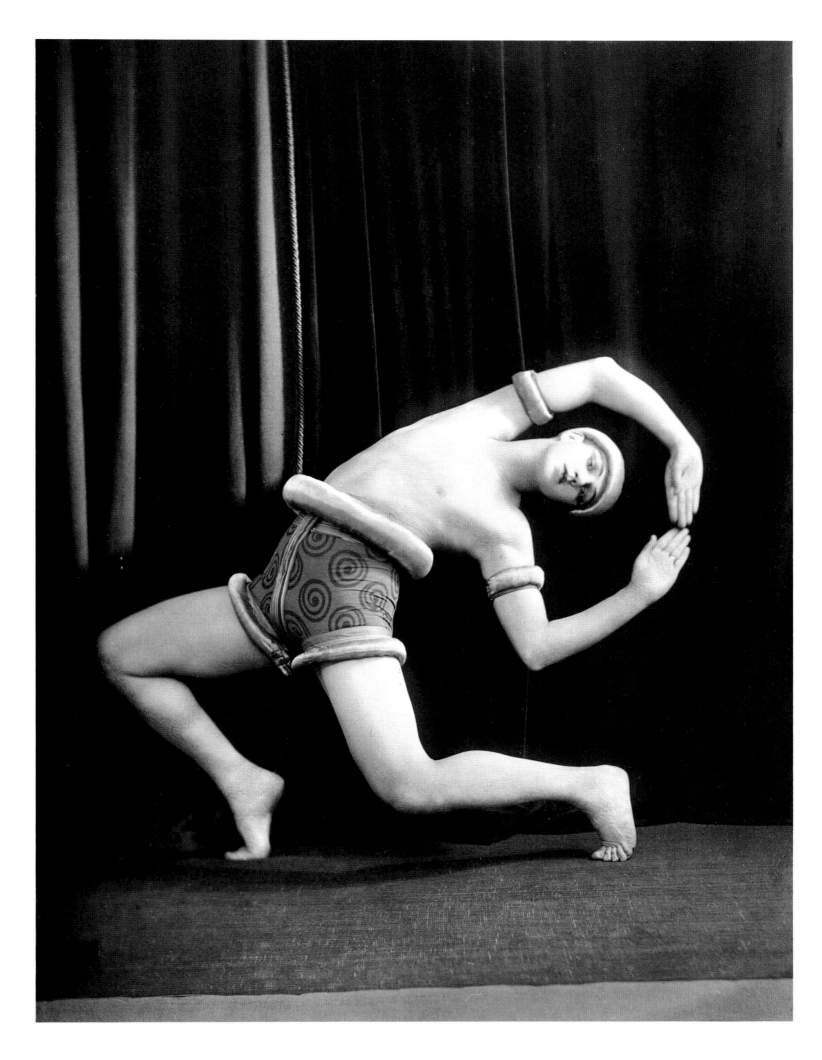

178 **Ted Shawn** in *Gnossiene*, by Witzel Studios, Los Angeles, 1919.

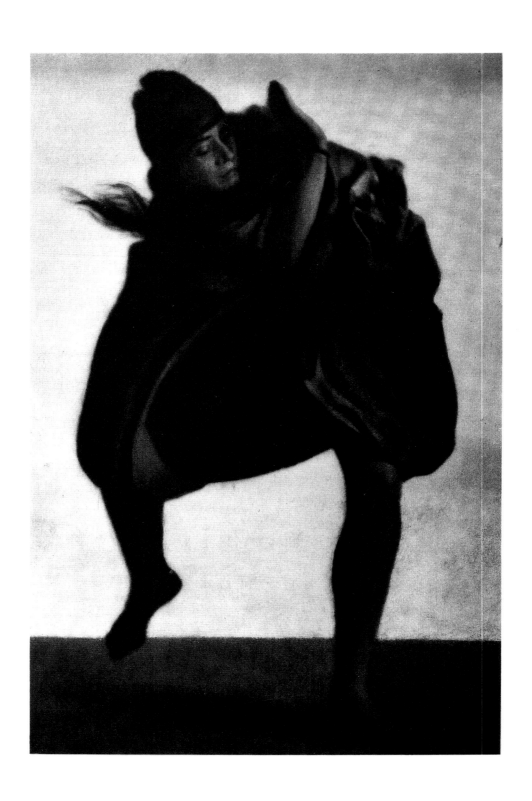

179 Mary Wigman in *Hexentanz I*, by Hugo
Erfurth, Dresden, 1914.

180 **Movement study, by Rudolf Koppitz**, 1926.

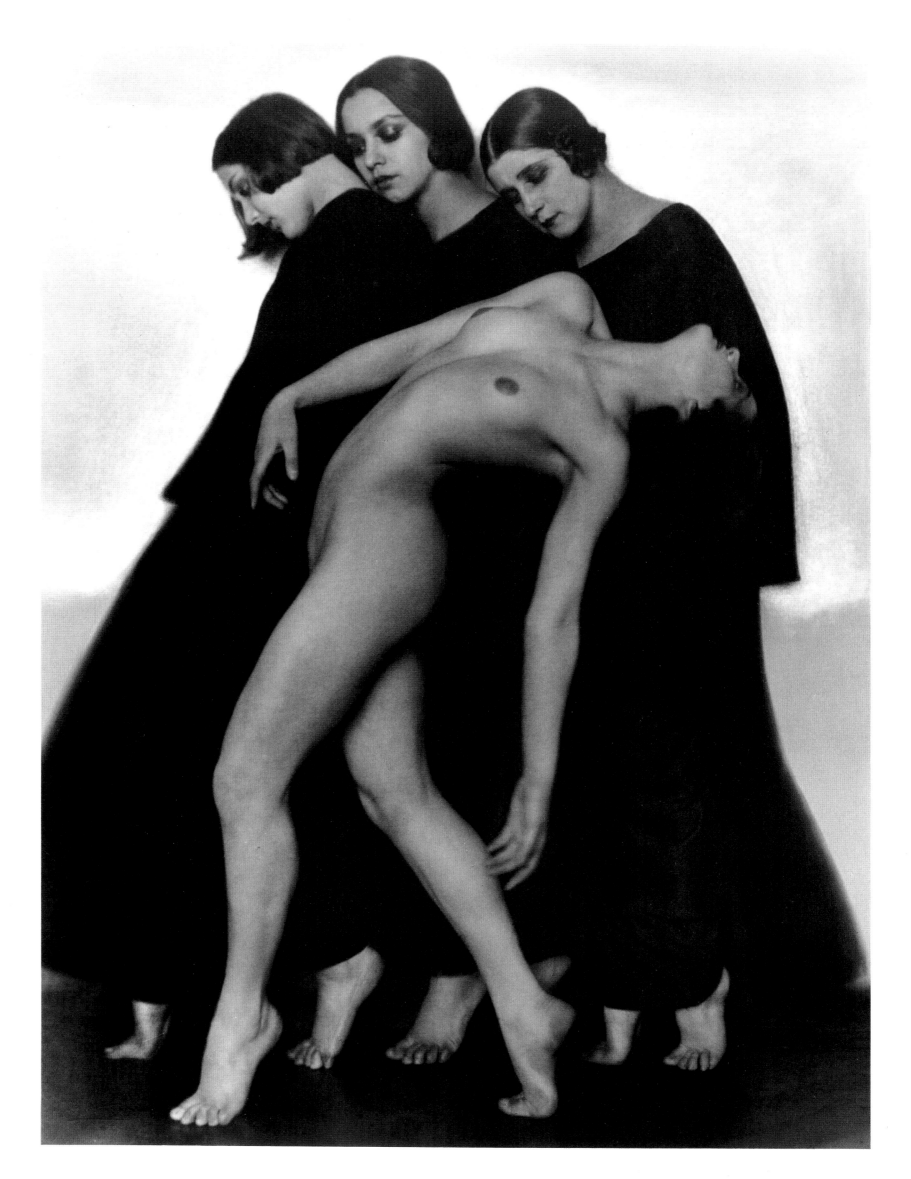

181 Valerie Bettis, by Barbara Morgan. Undated contact print. 182 Gregory Hines, by Robert Mapplethorpe, 1985.

183 **Doris Humphrey in *Grieg Concerto*, by Soichi Sunami, 1929.** 184 **Michio Ito as Pierrot, by Nickolas Muray, 1927.**

185 **Michael Kessler, by Lynn Davis**, 1983.

186 **Merrill Ashley, by Irving Penn,** 1979.

187 Daniel Clark of the Alvin Ailey American
Dance Theater, by Jack Mitchell, 1985.

188 Mikhail Baryshnikov at rehearsal, by
Max Waldman, *c*.1975.

189 Igor Youskevitch in *Le Carnaval*, by Gordon Anthony. Undated.

190 The De Marcos dancers, by Edward Steichen, 1935.

191　Satiric dancer, by André Kertész, 1926.

192 Serge Lifar. Undated anonymous photograph.

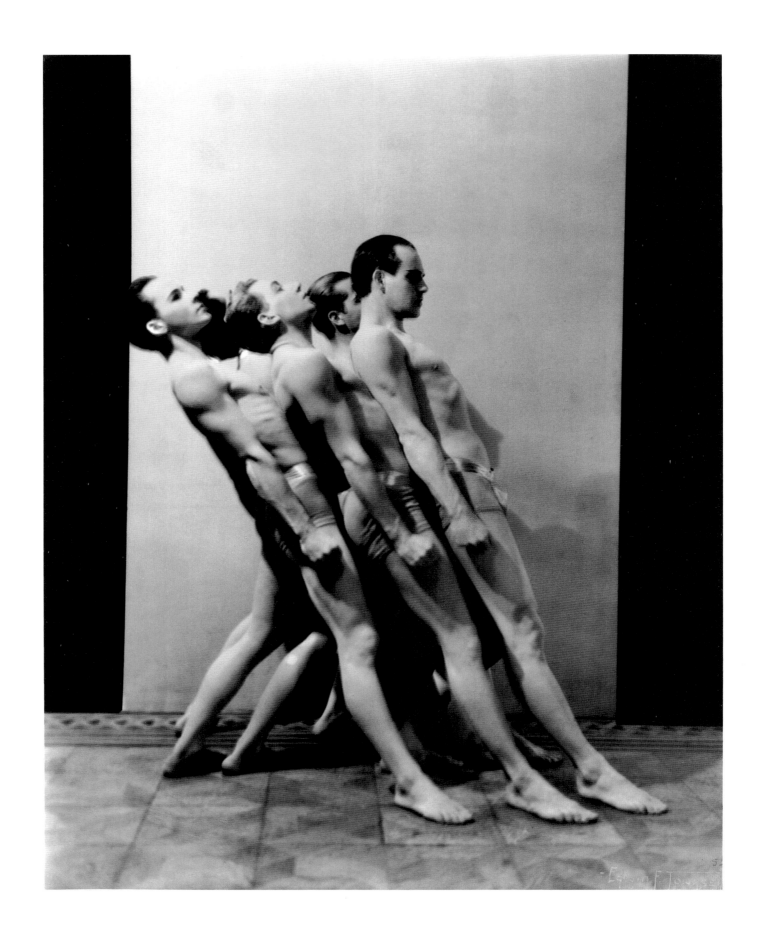

193 Ted Shawn and his male dancers, by Edwin F. Townsend. *c.* 1935.

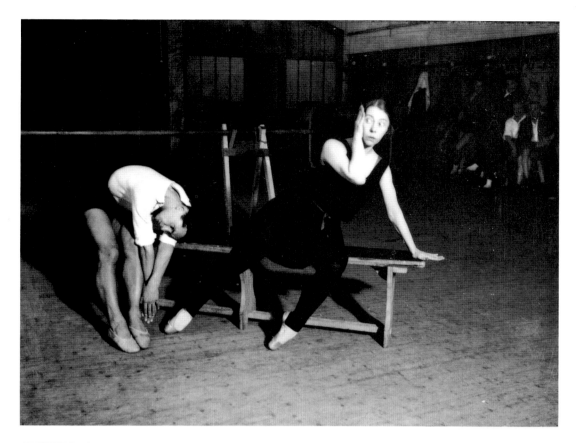

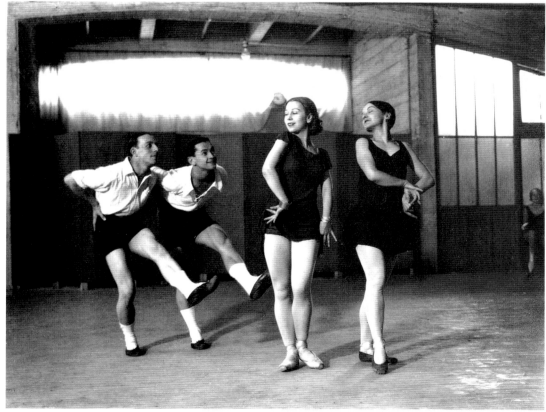

194, 195 Bronislava Nijinska and dancers in Paris, by André Kertész. Undated.

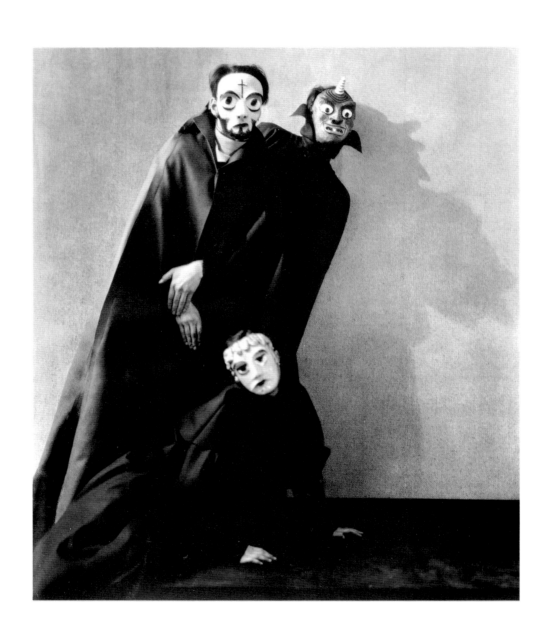

196 **Charles Weidman, José Limón and Sylvia Manning in** *The Happy Hypocrite*, **by Soichi Sunami,** *c*.1930.

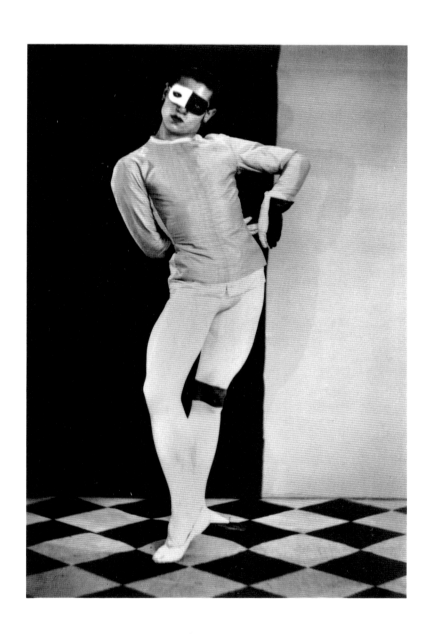

197 Serge Lifar in *Romeo and Juliet*, by Man Ray, 1926.

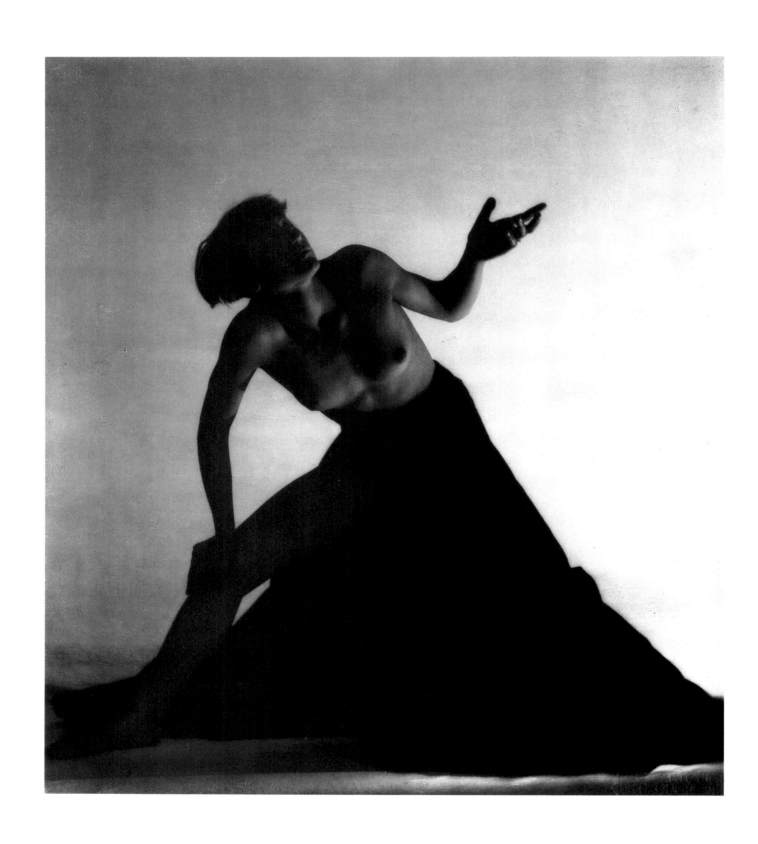

198 *Movement*, by František Drtikol, 1927.

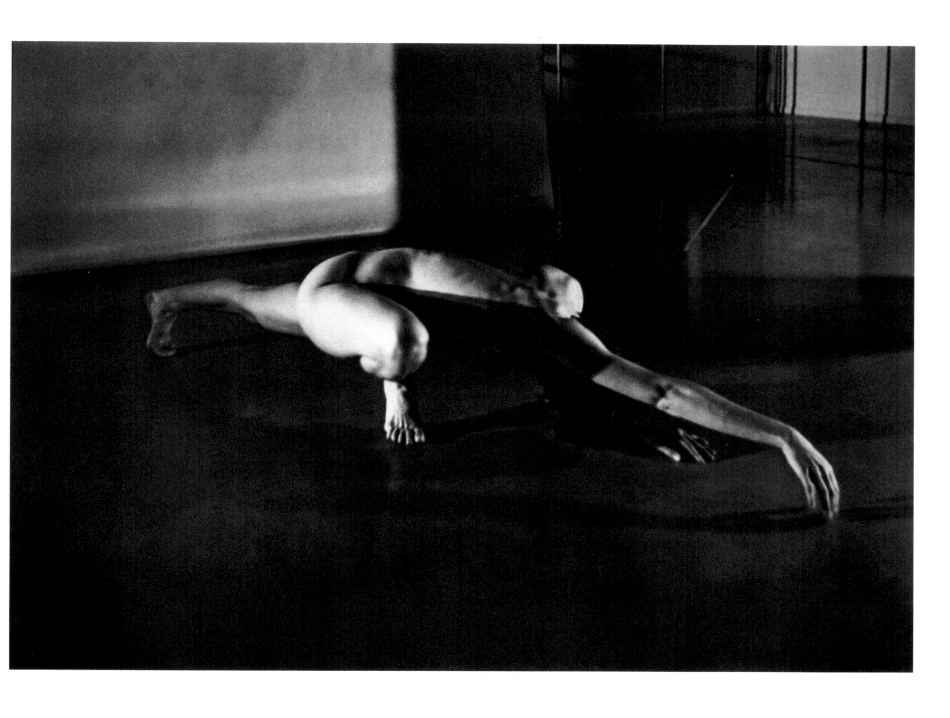

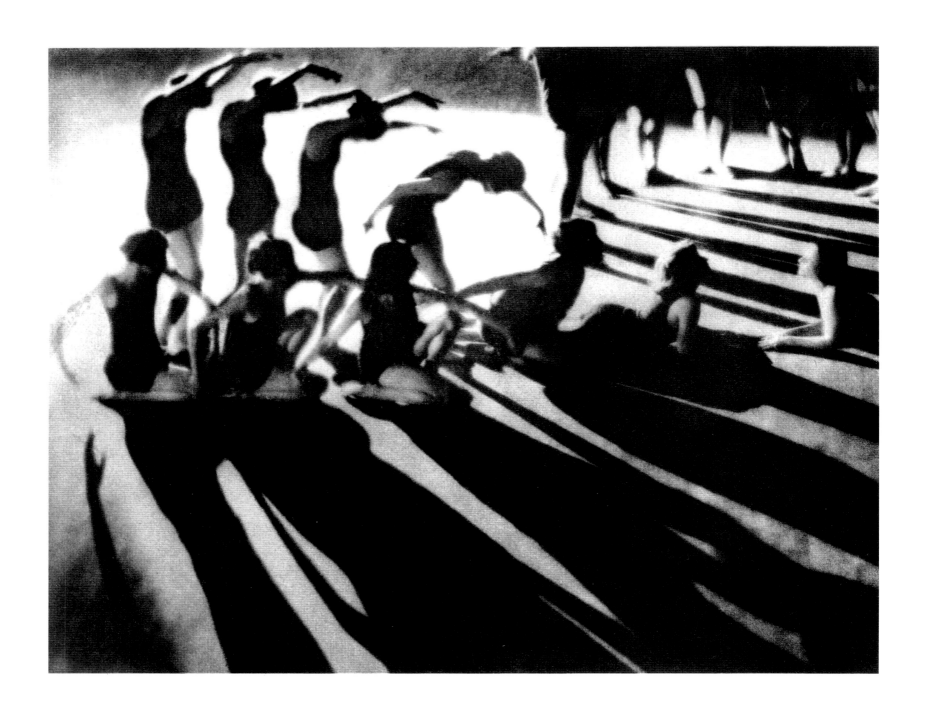

200 The Humphrey-Weidman Dancers,
by an anonymous photographer, *c*.1930.

201 Claire Bauroff, by Lotte Jacobi, *c*.1928.

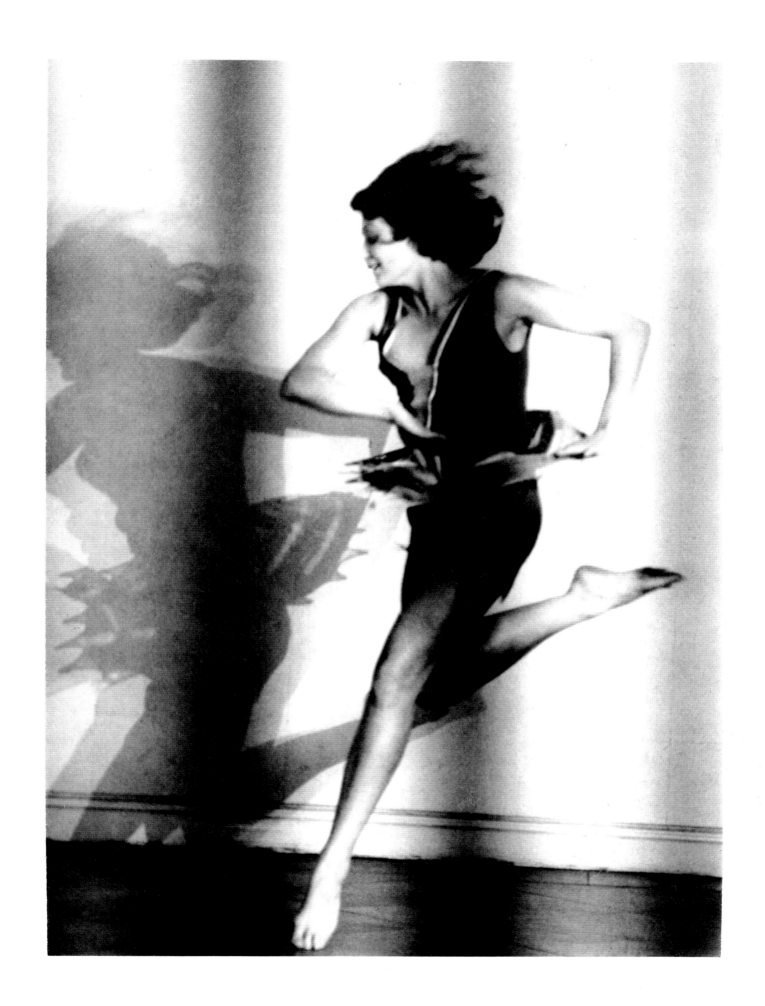

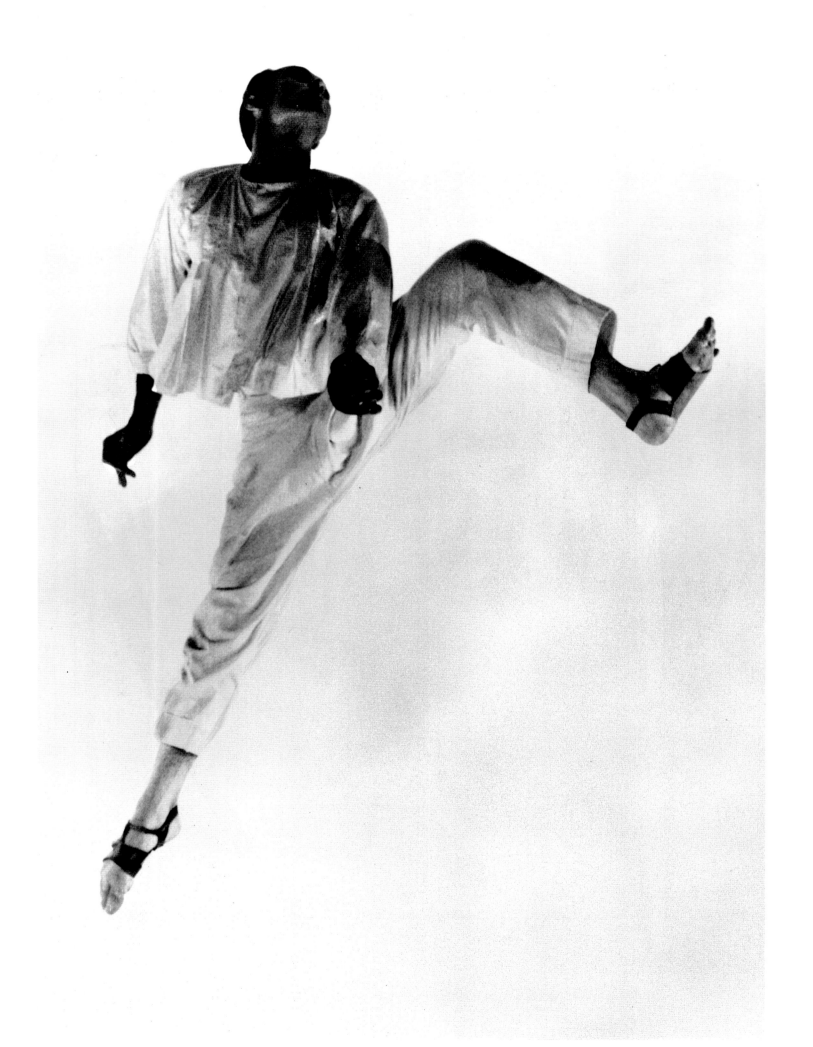

202 José Limón, by Walter Strate. Undated.
203 Harald Kreutzberg, by Soichi Sunami, *c*. 1933.

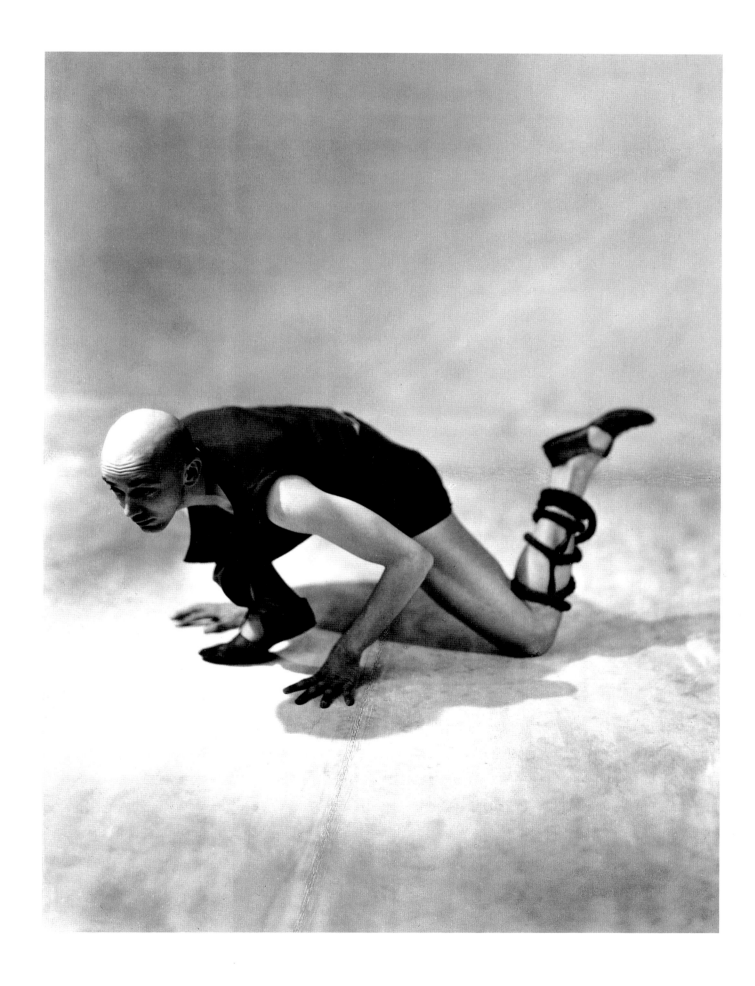

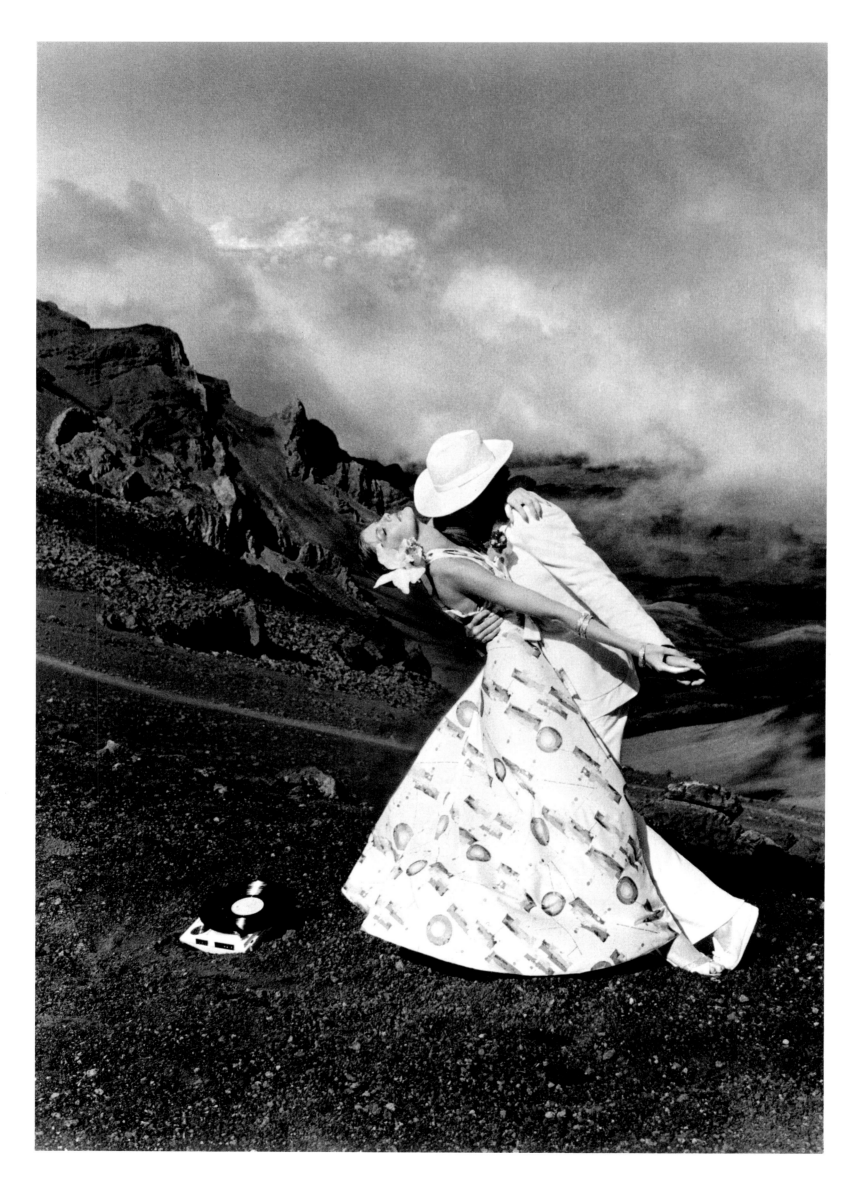

204 **Fashion Study for** *Vogue*, by Helmut Newton, 1974.

205 **Ted Shawn and Martha Graham in** *Malagueña*, by E.O. Hoppé, *c.* 1921.

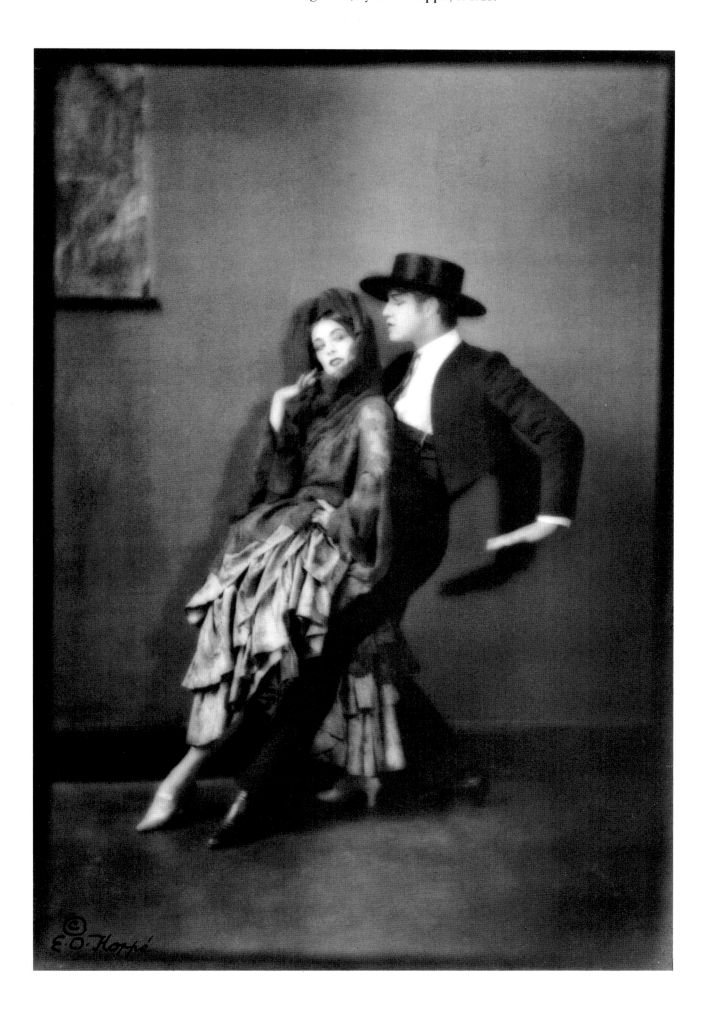

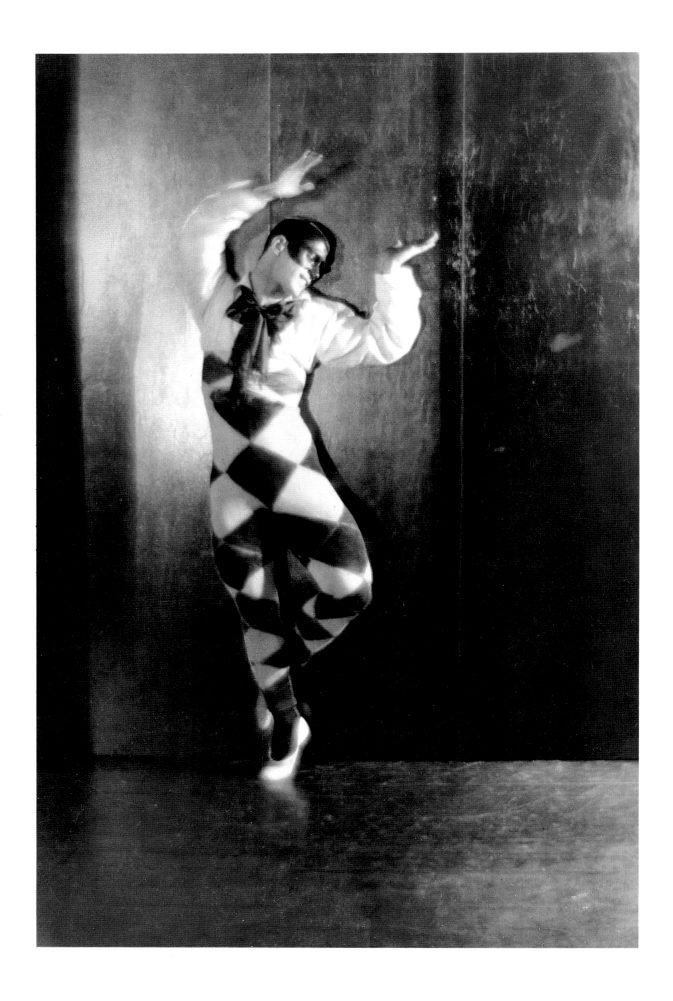

206　Vaslav Nijinsky in *Le Carnaval*, by Baron Adolf de Meyer, 1911.

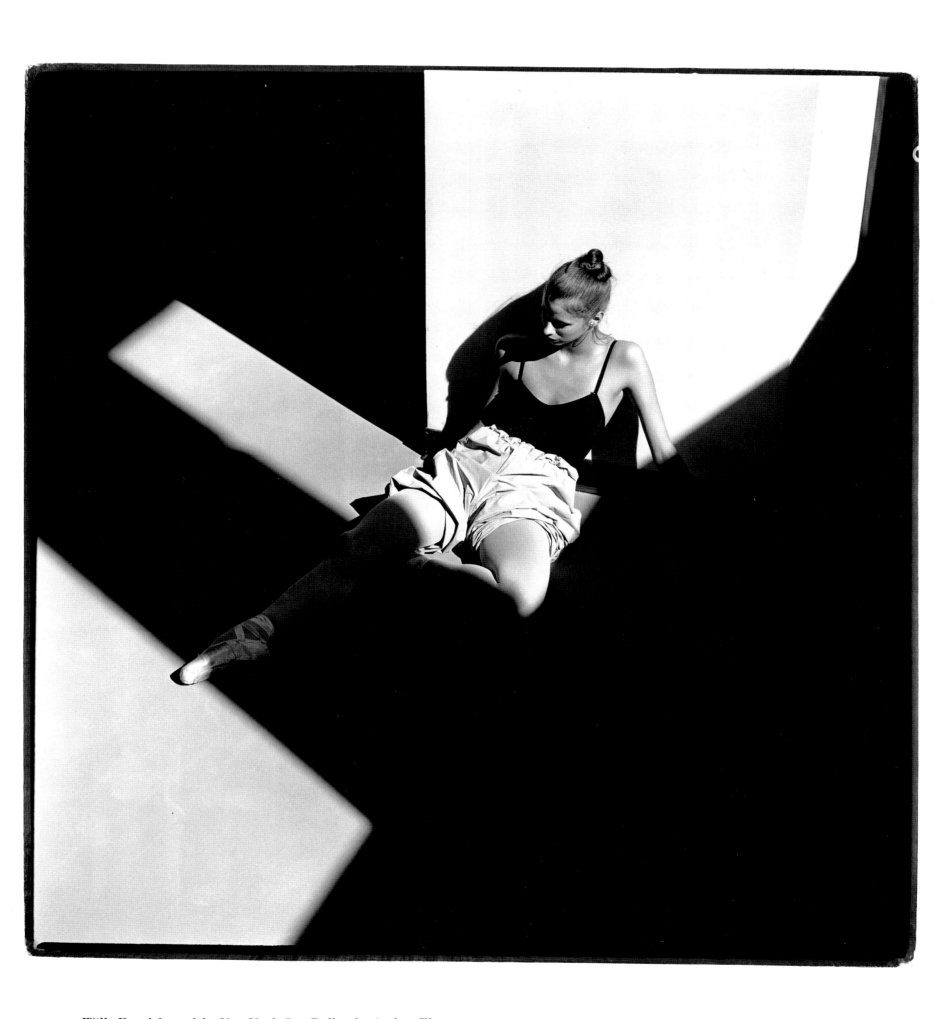

207 **Willy Frankfurt of the New York City Ballet, by Arthur Elgort,** 1976.

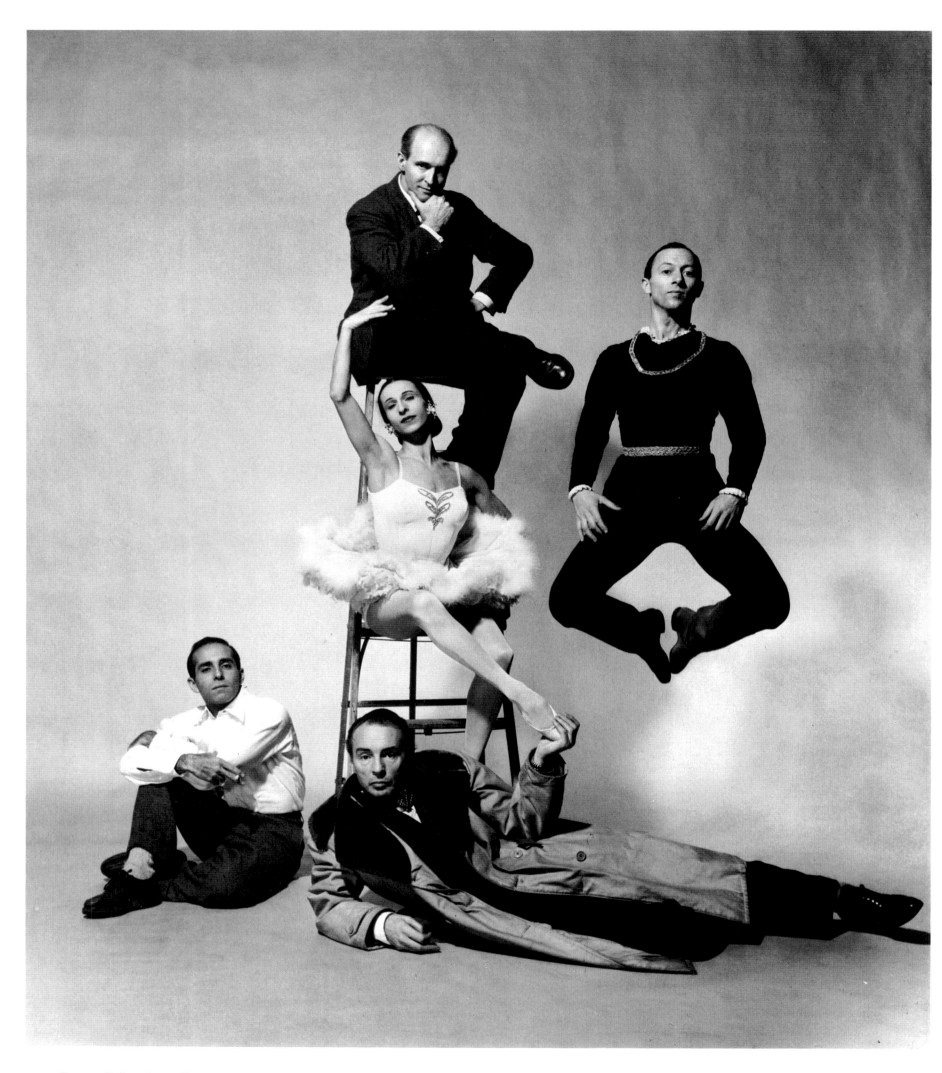

208 George Balanchine, Jerome Robbins, Ruthanna Boris, Antony Tudor and Todd Bolender (clockwise from bottom), by Philippe Halsman, 1951.

Acknowledgments

This book grew out of an exhibition of dance photography which I and my assistant, Ruth Silverman, organized at the International Center of Photography, New York, in 1978. Pressures of finance and time did not allow us to develop our ideas to the extent that we wished. I have now attempted to further that development.

I am grateful for the assistance given to me by numerous people during my work on this book. I owe a special debt of gratitude to Parmenia Migel Ekstrom, who gave me many valuable and pleasurable hours and allowed me access to her personal collection as well as to that of the Stravinsky-Diaghilev Foundation. She was free with her ideas and constructively critical. I also found her own books especially helpful. I am most grateful, in addition, to Genevive Oswald of the Dance Collection of the New York Public Library, for pointing out invaluable material which I would otherwise have overlooked and for her assistance in tracking down certain photographs. Kay Bardsley, of the Isadora Duncan International Institute, is also due special thanks for her advice and encouragement.

I would like to give particular thanks to the following individuals who gave help or advice in tracking down photographs or information: Kathryn Abbe; Jaroslav Anděl; Pierre Apraxine; Susan Arthur; Kay Bardsley; Edward Cavell; Lisa Dirks; Barbara Galasso; Ian Jeffrey; Lee Marks; Howard Read; Ruth Silverman; Stanley Triggs; Robert Tuggle; and Judith Yardley.

In addition, I received assistance and encouragement from the following people, to whom I express my thanks: Caralee Aber; Lucien Aigner; Gordon Anthony; Terry Ariano; Richard Benson; Ilse Bing; Veronique Bouillot; Noya Brandt; Gilberte Brassai; David Buckland; Gail Buckland; Cornell Capa; Cynthia Cathcart; Ron Cayen; Debra Cohen; Faith Coleman; William Coupon; Lydia Cullen; Henri Dauman; Lynn Davis; Jack Deaso; Penelope Dixon; Suzanne Donaldson; Diana Edkins; Arthur Elgort; Ute Eskildsen; Larry Fink; Regina Fiorito; Carole Ford; Marianne Fulton; Alex Giri; Bob Golden; Robert Gordon; Howard Greenberg; Lois Greenfield; Carole Greunke; John Gutmann; Monika Half; Yvonne Halsman; Beatrice Helg; Gail Henry; John Hill; Paul Himmel; Horst P. Horst; Heidi Hummler; Barry Joule; Chris Karitevlis; Paul Kasmin; Leslie Katz; Teresa Kirby; John Kobal; Reiko Kopelson; Max Kozloff; Jean-Claude Lemagny; Harriette and Noel Levine; Valerie Lloyd; Harry Lunn; Pat McCabe; Nesta Macdonald; Dennis McGovern; Robert Mapplethorpe; Michael Maule; David Mellor; Robert and Joyce Menschel; Jack Mitchell; Alison Moore; Barbara Moore; Peter Moore; Barbara Morgan; Douglas Morgan; Lloyd Morgan; Jiri Mucha; Joan Munkacsi; Arnold Newman; Grant Nicolson; Ruth Nivola; the late Jack A. Partington; Elizabeth Partridge; Irving Penn; Pilar Perez; Jane Pritchard; Toby Old; Toby Quitslund; Howard Ricketts; Gary Sampson; Gerd Sander; Alain Sayag; Lee Sievan; Aaron Siskind; Bert Stern; Penelope and Gerald Stiebel; Tina Summerlin; Richard Tardiff; Donna Mussenden Van Der Zee; the late Sam Wagstaff; Sandra Weiner; Mark Wilson; Anna Winand; David Wooters; Christina Yuin; and Count Zichy.

I would like to thank the following institutions for the help that they have given me and for granting permission to reproduce photographs: Ballet Rambert, London; Bibliothèque et Musée de l'Opéra, Paris; Bibliothèque Nationale, Paris; Christie's, South Kensington, London; Christie's East, New York; La Cinemathèque Française, Paris; The Condé Nast Publications Inc., New York; The Dance Collection, The New York Public Library at Lincoln Center; Dimond Library, University of New Hampshire, Durham, New Hampshire; Eakins Press Foundation, New York; Edwin Houk Gallery, Chicago; Estate of Walker Evans, New Haven; Gilman Paper Company Collection, New York; Glenbow Museum Archives, Calgary; Howard Greenberg/Photofind Gallery, New York; International Museum of Photography at George Eastman House, Rochester, New York; Isadora Duncan International Institute (Anita Zahn Collection and Kay Bardsley Collection); The J. Paul Getty Museum, Santa Monica, California; the Estate of André Kertész, New York; Life Magazine Picture Service, New York; Light Gallery, New York; Magnum Photos, New York; The Mansell Collection, London; Metro-Goldwyn-Mayer Studios, Los Angeles; The Metropolitan Museum of Art, New York; The Metropolitan Opera Archives, New York; Musée d'Orsay, Paris; Museum of the City of New York; The Notman Archives, McCord Museum, McGill University, Montreal; The Photographers' Gallery, London; Rapho Agence Photographique, Paris; Robert Miller Gallery, New York; Sander Gallery, New York; Sports Illustrated Magazine, New York; Stephen White Gallery, Beverly Hills, California; Stravinsky-Diaghilev Foundation, New York; City of Toronto Archives; City of Vancouver Archives; Estate of James Van Der Zee, New York; Waldman Archives, Westport, Connecticut; Washburn Gallery, New York.

I owe a very special debt of thanks to the four photographers who took great pains to make superb reproduction prints for the book. The majority of these prints were produced by Sal Lopes; Scott Hyde, Ian Jones and David Spear also contributed.

I am indebted to the following major sources for information relating to the dance and for quotations in the text: Susan Au, *Ballet and Modern Dance*, Thames and Hudson, London and New York, 1987; Kay Bardsley, 'Isadora Duncan's first school: the first generation founders of the tradition', in *Dance Research Annual*, X, 1979; Mary Clarke and David Vaughan (eds.), *The Encyclopedia of Dance and Ballet*, G.P. Putnam's Sons, New York, 1977; Barbara Naomi Cohen-Stratyner, *Biographical Dictionary of Dance*, A Dance Horizons Book, Schirmer Books, New York and London, 1982; Edwin Denby, 'Notes on the accompanying Nijinsky photographs', in *Dance Index*, 1943; *Encyclopedia of Photography*, International Center of Photography, A Pound Press Book, Crown, New York, 1984; *Floods of Light* (exhibition catalogue), ed. Robert Martin, The Photographers' Gallery, London, 1982; Robert Greskovic, 'Caught in Time', in *Ballet News*, October 1979 and January/February 1980; Lincoln Kirstein, *Dance: A Short History of Classical Theatrical Dancing*, G.P. Putnam's Sons, New York, 1935; Lincoln Kirstein, 'Dance and the curse of Isadora', in the *New York Times*, 23 November 1986; Horst Koegler, *The Concise Oxford Dictionary of Ballet* (second ed.), Oxford University Press, London and New York, 1982; John and Roberta Lazzarini, *Pavlova, Repertoire of a Legend*, Schirmer Books, New York, 1980; John Martin, *The Dance : The Story of the Dance Told in Pictures and Text*, Tudor Publishing Company, New York, 1946; Parmenia Migel, *The Ballerinas: from the Court of Louis XIV to Pavlova*, Macmillan, New York, 1972; Parmenia Migel (ed.), *Great Ballet Stars in Historical Photographs*, Dover Publications, New York, 1985; Keith Money, *Anna Pavlova, Her Life and Art*, Knopf, New York, 1982; Bronislava Nijinska, *Early Memoirs* (ed. Irina Nijinska and Jean Rawlinson), Holt, Rinehart and Winston, New York, 1981; F. Reyna, *A Concise History of Ballet*, Thames and Hudson, London, 1964; G.P.L. Wilson, *A Dictionary of Ballet* (third ed.), Theatre Arts Books, New York, 1974.

Notes on the plates

ABBREVIATION: The Dance Collection = Courtesy of the Dance Collection, The New York Public Library at Lincoln Center.

1 Invention

1 Anonymous American daguerreotypist. The unknown dancer is wearing a costume showing Spanish or Neapolitan influence, of the kind inspired by Fanny Elssler, who toured the USA in 1840. This is probably a portrait of a visiting European star, possibly Celeste Keppler. The exposure time could have been as long as sixty seconds, but may have been between fifteen and twenty: many daguerreotypists developed their own methods of accelerating the exposure time. Courtesy International Museum of Photography at George Eastman House, Rochester, New York.

2, 3 Etienne-Jules Marey (French, 1830–1904). These photographs were taken at about the time that Marey was producing the first 'films', which he projected at sixty images per second in a mechanism which stopped the film abruptly at each frame as it moved past a lens. He wrote a number of books between 1863 and 1901, including *Le Mouvement* (1894). Courtesy La Cinémathèque Française, Paris.

4 Eadweard Muybridge (British, 1830–1904). Other dance subjects included by Muybridge in *Animal Locomotion* include a man and a woman waltzing (plate 197) and a woman dancing alone ('nautch', plate 190, and 'fancy', plate 191). Muybridge's achievements were acknowledged by Marey, the Lumière Brothers and Thomas Edison. Courtesy International Museum of Photography at George Eastman House, Rochester, New York.

5 André Adolphe Eugène Disdéri (French, 1819–89). When this picture was taken, Fanny Cerrito, one of the Romantic Ballet's most brilliant stars, was a mother with a one-year-old child, but this did not prevent her continuing her career of dancing and choreography. In *The Ballerinas: from the court of Louis XIV to Pavlova*, Parmenia Migel Ekstrom remarks 'Although Fanny Cerrito did not contribute anything as novel and startling as Taglioni's point dancing or Elssler's exploitation of the Spanish dance, she was nevertheless one of the great ornaments of the Romantic Ballet.' For other pictures by Disdéri, see pages 16 and 19. Courtesy International Museum of Photography at George Eastman House, Rochester, New York.

6 Ira Hill Studio, New York. In all likelihood, the whirling markings and drawn-in leg and foot were added by Pavlova herself. For other pictures of Pavlova, see page 12 and plates 49, 57, 79, 80 and 85. The Ira Hill Studio was a well established enterprise which photographed many celebrated dancers, actors and actresses. Hill later made a composite picture of several photographs of Pavlova as the Dragonfly, showing tiny figures flitting between large drawn flowers (reproduced in *Anna Pavlova, Her Life and Art* by Keith Money). The Dance Collection.

7 Paul Himmel (American, b. 1914). The dancers are Maria Tallchief and André Eglevsky, although the photographer was less concerned with portraiture than with a general statement about the nature of ballet itself. The grain is an intentional effect, and the movement was carefully planned in a exposure of approximately one second per step; the ballerina's movement was counted out by the photographer. Himmel published this and other dance pictures in *Ballet in Action*, G.P. Putnam's Sons, New York, 1952. Courtesy Paul Himmel, New York.

8 Cecil Beaton (British, 1904–80). Beaton photographed many dancers during his long and celebrated career. *Apparitions* was choreographed by Frederick Ashton; for other portraits of Fonteyn, see page 8 and plate 88. Courtesy Sotheby's, London.

9 George Hoyningen-Huene (Russian, naturalized American, 1900–68). Huene, one of the most important fashion photographers of the century, infused his entire *oeuvre* – fashion, portraiture, travel – with the spirit of classical Greece. When this image ('Miss Sonia, evening pyjamas by Vionnet') was reproduced in *Vogue*, the caption marvelled at 'the look of restrained flight', but did not mention that the effect had been contrived by having the model lying on the floor. Huene was well known for his ingeniously simple solutions to complex technical problems. Courtesy *Vogue*. Copyright © 1931 (renewed 1959) by The Condé Nast Publications Inc., New York.

10 Gjon Mili (Albanian, naturalized American, 1904–84). Mili was an engineer and self-taught photographer who was the first to use the strobe as a pictorial strategy (he worked with Harold Edgerton, one of the three inventors of the strobe). In 1939 he began a long association with *Life* magazine. The Lindy Hop was inspired by Charles A. Lindbergh's 1929 flight to France. By the 1940s jazz dancing had become even more exhibitionist and daring. Courtesy *Life* magazine, © Times Inc., New York.

11 Gjon Mili. *A pas de bourrée* is a progression on the points or demi-points by a series of small, even steps with the feet close together, the idea being to project the illusion that the body is flowing across space. Nora Kaye (b. 1920) was the outstanding ballerina of Ballet Theatre's most famous years. Courtesy *Life* Magazine, © Time Inc., New York.

12 Ilse Bing (German, naturalized American, b. 1899). Sougez, a photographer of the period, wrote in *L'Art Vivant* in 1935 that 'without the blurring these photographs would have been trivial reporting. It was a haze by "superimposed instances". . . Mystery, and at the same time, reality, and, above all, something new.' Courtesy Ilse Bing, New York.

13 Alexei Brodovitch (Russian, naturalized American, 1898–1971). Brodovitch, best remembered perhaps as the art director of *Harper's Bazaar*, photographed the Ballets Russes de Monte-Carlo on stage while the company was touring the USA in the 1930s. The resulting book, *Ballet*, published in 1945, is rightly considered a tour-de-force of high-contrast form, dreamlike abstraction and dramatic design. Courtesy Robert and Joyce Menschel, New York.

14, 15 Edgar Degas (French, 1834–1917). For discussion of these photographs, see page 19. Courtesy Bibliothèque National, Paris.

16 Bertram Park (British, 1883–1972). The soft-focus effect was probably achieved in the printing, rather than by use of a special lens. More conventional, sharp-focus pictures by Park of this ballet also exist. Alicia Markova (b. 1910) created many roles in Ashton's early ballets. Courtesy Ballet Rambert, London.

17 Robert Demachy (French, 1859–1936). The gum-bichromate medium is a non-silver printing method in which the photographer prepares and applies the coating for the paper. A great deal of control is allowed during this process and then again while the image is exposed. The painterly effects that could be achieved made the method very popular with the pictorialists (see pages 19–20). Courtesy the Metropolitan Museum of Art, New York. Gift of Alfred Stieglitz, 1933.

18–22 Alphonse Mucha (Czech, 1860–1939). A frequent motif in Mucha's Art Nouveau decorative work was a dreamlike female figure. These studies, almost certainly never intended for display as artworks in their own right, suggest the artist's restless search for ideas. Courtesy Jiri Mucha, Prague.

23 Charlotte Rudolph (German, dates unknown). This is a uniquely photographic event: a camera study which could not be perceived by an audience at an actual performance. The Dance Collection.

24 Martin Frič (Czech, 1902–68). Frič's interest in dance photography developed out of his daughter's work as a dancer. Here he makes use of a prism to create a *corps-de-ballet* from a single dancer. Courtesy Jaroslav Anděl, New York.

25 Baruch Studio, Berlin. Photomontage had first been used as an artistic device by the Berlin Dadaists just after World War I; here it is in a commercial firm just ten years later. Kreutzberg (1902–68) was the leading male exponent of modern dance in Europe. Courtesy *Vanity Fair*. Copyright © 1928 (renewed 1956) by The Condé Nast Publications Inc., New York.

26 Edward Steichen (Luxembourg, naturalized American, 1879–1973). Steichen visited the Parthenon with Isadora and her young followers with the intention of making a film, but she refused to co-operate. Maria Theresa, one of her pupils, was the subject of some of Steichen's most interesting work on this expedition, which, according to recent research by Kay Bardsley, took place in 1920, not 1921, as is usually stated. The Dance Collection.

27 This snapshot is one of several thousand photographs of Shawn and St Denis in the Denishawn Collection at the Dance Collection. As small as Shawn's figure is, it presents a remarkable silhouette; the gesture of nature worship is clear. The Dance Collection.

28 George Fiske (American, 1835–1918). Fiske is poking fun at the revered tradition of American landscape photography: this is a parody of the relationship between man and nature evoked by Shawn in plate 27. Courtesy Stephen White Collection, Beverly Hills.

29, 30 George Platt Lynes (American, 1907–55). Lynes has left one of the century's great legacies of dance photographs, although in his lifetime he was probably better known as a fashion photographer. Courtesy private collection, New York.

31 Imogen Cunningham (American, 1883–1976). Cunningham was one of the foremost pioneers of West Coast Modernism and a founding member of the Group f/64. Her first dance photographs were of Adolph Bolm in 1921. In 1931 she created a series of

Martha Graham pictures, each as inventive as this; one was published by *Vanity Fair* in 1932. Courtesy The Imogen Cunningham Trust, San Francisco.

32 František Drtikol (Czech, 1883–1961). This avant-garde Czech photographer's work was always charged with symbolism and deep emotional undercurrents. He is perhaps best known for his nudes, photographed in combination with geometric decoration. His 'cut-outs' represented 'an inclination away from the materialist way of thinking and complete submersion in my own inner feelings . . . And so I arrived at the idea of replacing a live body, which I could not locate in space in the manner in which I would have liked, with figures which I composed, cut out and painted plastically myself.' Courtesy The J. Paul Getty Museum, Santa Monica.

33, 34 Karl Paspa (Czech, dates unknown). These two letters are from the book *ABECEDA*, 'choreographed compositions by Milca Mayerova; design, typography and montage by Karel Teige; published by J. Otto, Prague 1926'. Courtesy Jaroslav Anděl, New York.

35 Barbara Morgan (American, b. 1900). Morgan solarized the print (i.e. flashed the lights in the darkroom during development) to lend the picture a magical effect in keeping with the intended atmosphere of the dance. Morgan and Graham's collaboration in the 1940s produced some of the most famous images in the history of dance photography (see page 25). Hawkins (b. 1909), who was married to Graham (b. 1894), was a member of Martha Graham's company from 1938 to 1951 and created roles in many of her dances. Courtesy Barbara Morgan, Scarsdale, New York.

36 George Hoyningen-Huene. *Bacchus and Ariadne* was choreographed by Lifar himself; the decor was by de Chirico. Spessivtseva was *étoile* at the Paris Opéra 1924–32, where she created roles in Lifar's *Creatures of Prometheus* in 1930 and *Bacchus and Ariadne* in the following year. Lifar was director and *premier danseur étoile* at the Opéra from 1929 to 1945. Courtesy *Vanity Fair*. Copyright © 1931 (renewed 1959) by The Condé Nast Publications Inc., New York.

37 Jack Mitchell (American, b. 1925). Cunningham's pose was part of a piece that Mitchell was required to photograph with normal frontal lighting that showed details of costume and face. But Mitchell noted that the outline would work better as a silhouette, an idea which was accomplished by unplugging the front strobes. Copyright © Jack Mitchell, New York.

38 Jack Mitchell. In this dance, which Shawn created in 1924, the dancer begins whirling before the curtain rises and continues until after it has come down. The dervish's whirling symbolizes the solar system and represents an effort to attain union with God. The same dance is portrayed in a number of photographs at the Dance Collection by John Lindquist, Ralph Hawkins, Robertson Studio and others; in the studio pictures, the costume is supported by half-a-dozen wires, which were later re-touched out. Mitchell's decision to accept and dramatize the blur was a far more successful strategy. Copyright © Jack Mitchell, New York.

39–41 Jack Mitchell. After photographing so many dances which necessitated reworking an event to suit the medium, Mitchell became intrigued by the idea of creating a work solely for the camera. These pictures were produced over two weeks with the assistance of five students while he was in residence at the Atlantic Center for the Arts in New Smyrna Beach, Florida. Copyright © Jack Mitchell, New York.

42 Anonymous photographer. The cinema as hybrid of animation and still photography : this sequence took two months to produce and required more than 10,000 hand-painted frames. Courtesy MGM Studios, Los Angeles.

43 Bob Golden (American, b. 1939). Golden, an established commercial photographer based in New Jersey, constructed this miniature room in less than an hour for an advertisement. The walls were made askew purposely, to give the setting visual dynamic, and the curtains, which appear to be blowing in the wind are in fact stationary by virtue of spray starch. Courtesy Bob Golden, Hackensack, New Jersey.

44 Irving Penn (American, b. 1917). Although Penn, one of the giants of twentieth-century photography, constructed the 'corner' in which Dolin stands in order to trigger an emotional response in his sitters, it can also be read as a metaphor for the confines of the studio, which earlier photographers had gone to absurd lengths to disguise. Penn accepts it, draws attention to it and transcends it. Dolin (1904–83) was one of the first great British male dancers; he joined the newly formed Ballet Theatre in 1940 and danced with it until 1946. Courtesy Irving Penn. Copyright © The Conde Nast Publications Inc.

45 Count Zichy (British, b. 1908). Count Zichy began making his surreal assemblages while hiding from bombs underground in war-time London. After the war he produced a limited-edition publication of these pictures, which seem like fragments of a dream. Interestingly, he had no knowledge of similar work by surrealist artists. He later worked for the London photographer Baron before pursuing a career in filmmaking. Courtesy Count Zichy, London.

II Record and Document

46 Lou Goodale Bigelow (American, dates unknown). *O-Mika* was a Japanese-inspired dance created by St Denis in the year before she met Shawn; she also designed the costumes. The Dance Collection.

47 Baron Adolf de Meyer (French, 1868–1946). This is an 'Ouled Nail' dance of North Africa, from *Ourieda – A Romance of a Desert Dancing Girl*. During 1912–13 de Meyer also photographed St Denis in a number of other dances, including *Bakanali* and *O-Mika*. The Dance Collection.

48 William Notman and Son. The studio of William Notman and Son was Canada's pre-eminent society photographer, with locations across eastern Canada and in the USA as well. At the time of this photograph, the chief photographer was Charles Notman (1870–1955). Courtesy The Notman Photographic Archives, McCord Museum, McGill University, Montreal.

49 Anonymous photographer. The straightforward nature of the picture – there is no illusory backdrop – suggests that Pavlova may have had it taken for study purposes. Courtesy Parmenia Migel Ekstrom, New York.

50 White Studio, New York. *The Polovtsian Dances*, part of Borodin's opera *Prince Igor*, were performed as a separate ballet by Diaghilev's Ballets Russes. Fokine's vigorous choreography caused a sensation at the first performance in Paris in 1909. Bolm (1884–1951) had a great influence on dance in America; he introduced dance divertissements to the American cinema and created the first film synchronized to orchestral music. White Studio was well known for theatrical and dance subjects. Courtesy Metropolitan Opera Archives, New York.

51 Arthur Kales (American, dates unknown). The dance pictured may be *Invocation to the Thunderbird*. No information is available on the photographer. The Dance Collection.

52, 53 Theodore Rivière (French, 1857–1912).

Loie Fuller had made a success as an actress, singer, dancer and playwright in the USA before arriving in Paris in 1892, where she received popular and critical acclaim for her performances at the Folies-Bergère. Her experiments with lighting, diaphanous draperies and sticks to extend her arms attracted the attention of many artists and photographers. *The Butterfly* was first performed in 1892. Courtesy Gilman Paper Company Collection, New York.

54 Anonymous photographer. The dancer appears to be Lydia Sokolova (1896–1974) the first English ballerina to appear with Diaghilev's company (her real name was Hilda Munnings). The costume is that of Kikimora in Massine's *Contes Russes*, a part which she danced in the first performances of the complete ballet in 1917. However, in Boris Kochno's *Le Ballet* (1954) the picture is captioned 'maquillage de Nijinska'. Courtesy Stravinsky-Diaghilev Foundation, New York.

55 Horst (German, naturalized American, b. 1906). Although these costumes were not actually used in *Bacchanale*, the photograph elucidates Dali's conception of the ballet, a fantasy on the life of Ludwig of Bavaria danced to music by Wagner. Courtesy Horst, New York.

56 Anonymous photographer. This photograph comes from the collection of Dorothy Brett, a friend of many members of the Bloomsbury set, for whom Lady Ottoline Morrell's country house, Garsington Manor near Oxford, was a refuge during and immediately after World War I. The dancers are probably fellow students of Dorothy Brett's from the Slade art school, and it is likely that she was the photographer; however, the pictures are quite similar to some taken at the same period by the Bloomsbury artist Vanessa Bell. Courtesy Gilman Paper Company Collection, New York.

57 Arnold Genthe (German, naturalized American, 1869–1942). Genthe was enormously proud of this picture of Pavlova, which he claimed was the first ever of the dancer in free movement. It certainly fulfils his declared aims in photography. 'I was determined to show people a new kind of photography: there would be no stilted poses; as a matter of fact, no poses at all. I would try to take my sitters unawares.' See also plates 138–141. Courtesy Gilman Paper Company Collection, New York.

58 František Drtikol. A Futurist design by the movement's chief poet and polemicist. Courtesy Jaroslav Anděl, New York.

59 Robert Mapplethorpe (American, b. 1946). Mapplethorpe's elegant, often erotic, photography can be compared in many respects to Lynes's. Haring is the most important artist to have popularized 'graffiti' art, which he began in the New York subway. Courtesy Robert Mapplethorpe, New York.

60, 61 Lomen Brothers Studio, Nome. This studio took numerous photographs of Eskimo dancers, both indoors and out. Courtesy Glenbow Archives, Calgary.

62 'Davidsen'. Nothing is known of the photographer and even the location of the photograph is uncertain. A caption affixed to the original print reads: 'The Eskimo Dance of Triumph . . . Although traditional, the dancers were not always required to follow prescribed steps, but could make up their own in accordance with mood and music.' Courtesy The Mansell Collection, London.

63 Emil Otto Hoppé (German, naturalized British, 1878–1972). Hoppé is best known as a highly accomplished portrait photographer, but he photographed several dance subjects, including a series on Diaghilev's Ballets Russes, produced as a gravure

portfolio. After 1925 he travelled extensively, documenting his journeys; his final years were devoted to photojournalism and abstract nature studies. Courtesy The Mansell Collection, London.

64 August Sander (German, 1876–1964). Sander's most famous project was an in-depth study of the German people, conceived of by himself and called *Man in the Twentieth Century*. Courtesy Sander Gallery, New York. Copyright © August Sander Archive.

65 William Notman and Son. 'The Red and White Review' was an annual review produced by the students of McGill University, Montreal. Courtesy The Notman Photographic Archives, McCord Museum, McGill University, Montreal.

66 Margaret Bourke-White (American, 1904–71). Bourke-White established her reputation as one of America's foremost photo-journalists in the 1930s. Of her several trips to the USSR, Vicki Goldberg has written: 'She brought back from Russia the most extensive photographic account a foreigner has published, and it made her famous.' The photograph shows the 'sitting chain', a popular motif of the Soviet ballet. Courtesy Margaret Bourke-White, *Life* magazine, © 1936 Time Inc.

67 Aldene Studio. Nothing is known of the subject or the photographer. Courtesy Barry Joule Collection, London.

68 James Van Der Zee (American, 1886–1983). Van Der Zee's seventy years as a photographer in Harlem produced an unequalled record of Black American life. He did not restrict himself to the studio, but visited churches, lodges, clubs and the dance rehearsal hall shown here. Courtesy Estate of James Van Der Zee, New York.

69 Joseph Byron (British, naturalized American, 1844–1923). The studio of Joseph Byron and his son Percy (1878–1959) documented turn-of-the-century New York society with unsurpassed thoroughness. Valerie Lloyd notes their extraordinary use of flashlight: '[It] was discreet and masterly . . . There are almost no glaring reflections of the flash itself, and the faces of the famous and the poor alike are never over-exposed or featureless . . . The Byrons do not intrude their presence. Their composition and their attitude was to record, supremely well.' (*Floods of Light*, exhibition catalogue.) Courtesy Robert Mapplethorpe, New York.

70 Jack A. Partington (American, 1914–87). The 'Silver Hoop Number' was choreographed for the 'Roxyettes' by Gae Foster and soon become a favourite of Roxy audiences. The material of the dresses was an icy-blue satin. Partington studied at the Clarence White School and worked as an assistant to Louise Dahl-Wolfe. In 1937 he became official photographer at the Roxy, having approached the management initially with the idea of taking candid performance shots. With a break for army service, he worked there until 1950, taking some 12–15,000 photographs. He was required to photograph every costume and every set and to take publicity pictures. Courtesy Jack A. Partington, New York.

71 Lewis W. Hine (American, 1874–1940). Hine first photographed immigrants at Ellis Island in 1904 and continued for five years using magnesium powder flash as a light-source. He began a new series on Ellis Island in 1926, after achieving considerable fame for his studies of child labour. Courtesy International Museum of Photography at George Eastman House, Rochester, New York.

72 Larss and Duclos Studio, Dawson City, Yukon Territories. The new-found sophistication of the gold-rush Yukon Territories took the form of a dance hall made from the remains of two

old steamboats. Courtesy City of Vancouver Archives.

73 William James (Canadian 1866–1948). James was an extremely active and talented freelance photo-journalist who worked in Toronto. Courtesy City of Toronto Archives.

74 Bill Brandt (British, 1904–83). Brandt's pictures, characteristically printed with high contrast to eliminate middle tones, often tinge present reality with nostalgia. Of this and other pictures, David Mellor has written 'What was being projected was a world where folkish customs and values could regroup and flourish in the face of modernity.' Courtesy Noya Brandt, London.

75 Anonymous photographer. The marathon dance, a feature of the depression era, pitted young couples against each other to see who could last longest. To break the monotony for the spectators, entertainment — in this case, boxing — was offered. Courtesy The Mansell Collection, London.

76 Al Taylor (American, dates unknown). Taylor worked for *Sports Illustrated* magazine in the 1950s. The picture was severely cropped when reproduced. Courtesy *Sports Illustrated*.

77 Peter Moore (American, b. 1932). Brown is an American dancer and choreographer who came to prominence with the Judson Dance Theatre in 1962; since 1970 she has had her own company. Moore has covered the full range of experimental performances since 1962. Among his many subjects have been the happenings of Kaprow and Oldenberg and the dances of Yvonne Rainer and James Waring. Copyright © 1970 Peter Moore, New York.

III Icon and Idol

78 George Platt Lynes. Lynes was the official photographer of the American Ballet, which had emerged from the School of American Ballet founded by Lincoln Kirstein and George Balanchine (1904–83) in 1933. Courtesy International Museum of Photography at George Eastman House, Rochester, New York.

79 Eugene Hutchinson (American, dates unknown). Nothing more is known of this regal portrait or its photographer, except that it was taken in Chicago. Courtesy Gilman Paper Company Collection, New York.

80 Lafayette Studio, London. The picture was taken at Ivy House, Pavlova's London home. She is shown with her pet swan Jack. The swan was, of course, her leitmotif: she first performed her most famous solo, *The Dying Swan*, in 1907. Courtesy Parmenia Migel Ekstrom, New York.

81 Soichi Sunami (Japanese, naturalized American, 1885–1971). Agnes de Mille (b. 1909) is one of the USA's foremost dancers and choreographers, who has often worked in film and TV. She is responsible for the choreography of several Broadway musicals, most famously *Oklahoma!* (1943). Sunami began his career as a retoucher in the Nickolas Muray Studios in New York. After five years as a painter he opened a photographic studio. When Martha Graham came by for some publicity photos in 1926, a five-year collaboration was born, which ended, Sunami believed, because the dancer broke a mirror in his studio and so refused to return. In 1938 Sunami began a thirty-eight-year career as photographer for the Museum of Modern Art, New York. Courtesy the Sunami Family, New York.

82 Emil Otto Hoppé. This image of Diaghilev's most famous female star, Tamara Karsavina (1885–1978), is taken from Hoppé's published portfolio of studies of the Ballets Russes. Karsavina created the role of the Firebird in 1910. Courtesy Parmenia Migel Ekstrom, New York.

83 Gerschel Studio, Paris. *Jeux*, choreographed by Nijinsky to music by Debussy and first performed in 1913, was the first ballet on a contemporary subject in Diaghilev's repertory. Bakst's rather fanciful designs for the tennis costumes were fiercely criticized for inaccuracy when the ballet was performed in London. The Dance Collection.

84 Walter E. Owen (American, 1896–1963). Bambi Linn (b. 1926) created the parts of Aggie in *Oklahoma!* and Louise in *Carousel* (1945); Diana Adams (b. 1926), who has created roles in ballets by Robbins and Balanchine, made her debut in *Oklahoma!* Owen's work on the dance was published in *Ballerinas of the New York City Ballet* (Dance Mart Publications, New York, 1953). The Dance Collection.

85 James Abbe (American, 1883–1973). Pavlova was a great admirer of Abbe, whose work included fashion and photojournalism as well as portraiture and the dance. Courtesy Washburn Gallery, New York; copyright © Kathryn Abbe, New York.

86 Cecil Beaton. David Lichine (1910–72) was a Russian dancer and choreographer who danced with Ida Rubinstein's company and with Pavlova before becoming a soloist with the Ballets Russes de Monte Carlo in 1932. Courtesy Sotheby's, London.

87 Cecil Beaton. Irina Baronova (b. 1919) was given her first roles by Balanchine in 1932 as the youngest of the three 'baby ballerinas' of the Ballets Russes de Monte Carlo (the others were Toumanova and Riabouchinska). She danced in films and musical comedies as well as in ballet and retired in 1946. Courtesy Sotheby's, London.

88 E.O. Hoppé. Dame Margot Fonteyn (b. 1919) made her debut with the Vic-Wells Ballet in 1934 and rapidly became established as one of the century's greatest ballerinas. Courtesy The Mansell Collection, London.

89 George Hoyningen-Huene. Lifar danced with Spessivtseva in this ballet created for her by Balanchine in 1927. The ballet's elaborate Constructivist decor was by Naum Gabo and Antoine Pevsner. Courtesy *Vogue*. Copyright © 1927 (renewed 1955) by The Condé Nast Publications Inc., New York.

90 George Hoyningen-Huene. Balanchine engaged Tamara Toumanova (b. 1919) for the Ballets Russes de Monte Carlo in 1932, where she created roles in three of his ballets. *Cotillon*, danced to music by Chabrier, is a bitter-sweet ballet set in a ballroom. Courtesy *Vanity Fair*. Copyright © 1932 (renewed 1960) by The Condé Nast Publications Inc., New York.

91 James Abbe. The Russian dancer Ida Rubinstein (1885–1960) was a member of the Diaghilev ballet 1909–11, when her exceptional beauty created a sensation in Fokine's *Cléopâtre* in Paris in 1909. She went on to create a rival company to Diaghilev's, and commissioned many new ballets. Courtesy Washburn Gallery, New York; copyright © Kathryn Abbe, New York.

92 George Hoyningen-Huene. Jean Barry was an American cabaret dancer who performed in Paris in 1931, when Huene took a series of pictures for *Vanity Fair* and *Vogue*. Courtesy *Vanity Fair*. Copyright © 1931 (renewed 1959) by The Condé Nast Publications Inc., New York.

93 James Abbe. The Astaires were launched as a vaudeville act as children by their parents in 1906. After extensive touring in the USA, they made their way into musicals and revues in New York and London. Adele retired in 1932 when she married. Courtesy Washburn Gallery, New York; copyright © Kathryn Abbe, New York.

94 James Abbe. The Dolly Sisters, Yansci and

Roszika, were a Hungarian tandem dance team, trained in ballet and ballroom dancing. They performed in New York vaudeville, London music halls and Parisian cabarets. Courtesy Washburn Gallery, New York; copyright © Kathryn Abbe, New York.

95 James Abbe. Despite the photograph's suggestion that the dancers have been caught unawares by the photographer backstage, the girls project an air of coy titillation that was very much part of their performance. Courtesy Washburn Gallery, New York; copyright © Kathryn Abbe, New York.

96 Anonymous photographer. The photograph was probably taken for one of the many newspaper and magazine articles illustrating social dances of the day. Courtesy The Kobal Collection, London.

97 Robert Mapplethorpe. Mapplethorpe brings new meaning to the concept of black-and-white photography, playing with our notions of the body, costume, race and sexuality. Courtesy Robert Mapplethorpe, New York.

98 Anonymous photographer. Astaire (b. 1899) embodies tap dancing at its zenith, yet his mastery was just one part of a repertory that included ballet, ballroom dancing and acrobatics. Courtesy The Kobal Collection, London.

99 Horst. Ginger Rogers (b. 1911) began her career with a vaudeville act, went on to Broadway and eventually Hollywood, where she began her famous partnership with Astaire in *Flying Down to Rio* (1933). Courtesy Horst.

100 George Platt Lynes. This self-portrait is a characteristically complex piece of iconography. The photographer's elegant pose suggests a carefully calculated view of ballet, symbolized by the open door. Courtesy Robert Miller Gallery, New York.

101 Arnold Newman (American, b. 1918). Newman is renowned for his portraiture, in which setting and composition reflect and comment upon the sitter. His finest portraits were published in *One Mind's Eye* (1974) and *Artists: Portraits from Four Decades* (1980). Copyright © Arnold Newman, New York.

102 Emil Otto Hoppé. Tilly Losch (1904–75), the Austrian dancer and actress, worked with Balanchine, Kreutzberg and Astaire in the course of an illustrious career. In the caption on the back of this print, she is described as 'the famous hand dancer' and the photographer has lit the hands to communicate their expressivity. Courtesy The Mansell Collection, London.

103 Arnold Newman. Newman took several photographs of the famous British choreographer for an exhibition of specially commissioned photographs at the National Portrait Gallery, London, which was eventually published as a book, *The Great British*. This study was not included in the book and is hereby published for the first time. Copyright © Arnold Newman, New York.

104 Max Waldman (American, 1919–81). *Other Dances* was choreographed in 1976 by Jerome Robbins for Natalia Makarova (b. 1940) and Mikhail Baryshnikov. It is a plotless piece, danced to mazurkas and a waltz. Waldman was a much respected dance photographer who invested his work with a tragic element that often depersonalizes the subjects. *Waldman on Dance*, with an introduction by Clive Barnes, was published by William Morrow and Co., New York, 1977. Copyright © Waldman Archives, Westport, Connecticut.

105 Bert Stern (American, b. 1929). Suzanne Farrell (b. 1945) became a soloist at the New York City Ballet in 1965. During her years with the company she became the ballerina most closely associated with Balanchine's work. Bert Stern is a well-known com-

mercial photographer. Courtesy *Vogue*. Copyright © 1965 by The Condé Nast Publications Inc., New York.

106 Edward Steichen (American, 1879–1973). Patricia Bowman (b. 1908) danced as prima ballerina at New York's Roxy Theater 1937–9 and joined Ballet Theatre in 1940. For several years she had an active career in radio and television. The picture is a fine example of the pioneering modernist spirit Steichen brought to photography, with crisp tones and strong diagonals. Courtesy *Vanity Fair*. Copyright © 1933 (renewed 1961) by the Condé Nast Publications Inc., New York.

IV The Independent Eye

107 Martin Munkacsi (Hungarian, naturalized American, 1896–1963). Before Munkacsi emigrated to America, where he became an outstanding fashion photographer, he worked as a photojournalist in Germany. He had a particular talent for capturing spontaneous movement, as in this shot of the dancers' coffee-break. Courtesy Joan Munkacsi, New York.

108 Philippe Halsman (Latvian, naturalized American, 1906–79). Humour is the hallmark of Halsman's work, as his celebrated spontaneous portraits of celebrities demonstrate. In the course of a career which produced 101 covers for *Life* magazine he photographed numerous dance subjects. Courtesy Yvonne Halsman, New York.

109 Ollie Atkins (American, 1917–77). Atkins had a long career on the staff of newspapers and magazines in Birmingham, Alabama, Fairfax, Virginia and Washington, DC. This is a notably brilliant use of flash. Courtesy Barry Joule, London.

110 Robert Doisneau (French, b. 1912). 'A pool of placid, romantic, protecting light' is how David Mellor describes Doisneau's use of flash in this photograph. 'The marvels of daily life are exciting', Doisneau has written; 'no movie director can arrange the unexpected that you find in the street.' Courtesy Agence Rapho, Paris.

111 John Gutmann (German, naturalized American, b. 1905). Gutmann has left a superb document of San Francisco street life from the 1930s onwards. His approach was informed by a mature vision developed in his native Germany. Courtesy John Gutmann, San Francisco.

112 Anonymous photographer. Courtesy The Kobal Collection, London.

113 John Gutmann. Courtesy John Gutmann, San Francisco.

114 Aaron Siskind (American, b. 1903). Siskind is best known today for his formal and aesthetic concerns, but in the late 1930s he was occupied by documentary interests, most notably his compilation *The Harlem Document*. Courtesy Light Gallery, New York.

115 Ilse Bing. Newly invented tiny cameras in the 1930s allowed photographers freedom for the first time to take such pictures without startling their subjects. Courtesy Ilse Bing, New York.

116 René Burri (Swiss, b. 1933). Burri is a well-known photojournalist. Courtesy Magnum Photos, New York.

117 Margaret Bourke-White. In 1936 Bourke-White was sent to Montana by the newly formed *Life* magazine to document the construction of Fort Peck Dam. One of her pictures from the series made the cover of the magazine. Courtesy Margaret Bourke-White, *Life* magazine, © 1936 Time Inc.

118 Bruce Davidson (American, b. 1933). Throughout his long career as a documentary photographer, Davidson has pursued stories of his own con-

ception as well as accepting assignments from *Life*, *Esquire*, *Vogue* and other magazines. His two-year project on New York's Spanish Harlem was published in 1970. A sense of uncertain cultural identity and shifting allegiances characterizes the work. Courtesy Magnum Photos, New York.

119, 120 Brassai (Gyula Halasz; Romanian, naturalized French, 1899–1984). Brassai's studies of dancers recall Degas, but unlike many who imitated only the surface of the paintings, Brassai demonstrates a kinship with their spirit. As Henry Miller wrote, 'Brassai possesses a rare gift which most artists despise: *a normal vision*. He needs neither to deform or distort, nor to lie or to preach.' Copyright © Gilberte Brassai 1987, Paris.

121 Dan Weiner (American, 1919–59). Weiner was a well-known photojournalist. He photographed the Bolshoi Ballet School as part of an extensive assignment for *Fortune* magazine. Courtesy Sandra Weiner, New York.

122 Lucien Aigner (Hungarian, naturalized American, b. 1901). Aigner was an innovative photojournalist active in Paris before the war. His framing, as demonstrated here, was always unusual. Here he has found his way to an attic of the Paris Opéra, where the *élèves* (far down the hierarchy of dancers) pose shyly for his camera. Copyright © Lucien Aigner, Great Barrington, Massachusetts.

123 Cornell Capa (Hungarian, naturalized American, b. 1914). Capa went to the USSR on assignment for six weeks in 1958 where (by his own admission) he took the finest photographs of his career. *Harper's Bazaar* published a six-page feature on the Bolshoi Ballet School on his return: the story centred on the continuation of the Bolshoi's traditions. Courtesy Cornell Capa, New York.

124 Walker Evans (American, 1903–75). Evans enjoyed a long friendship with both Balanchine and Kirstein and in 1945, the year in which he became sole staff photographer at *Fortune* magazine, he took a remarkable series of backstage rehearsal pictures of Ballet Theatre. Courtesy Estate of Walker Evans.

125 Toby Old (American, b. 1945). Old covered the nightclub scene in New York from 1975 to 1981. Courtesy Toby Old, New York.

126 Larry Fink (American, b. 1941). Fink's work is well known for its trenchant social observations; underlying the apparent chaos of a typical Fink image is a complex pictorial order. Courtesy Light Gallery, New York.

127 Jean-Philippe Charbonnier (French, b. 1921). Charbonnier is a well-known documentary Parisian photographer. Courtesy Agence Photographique TOP, Paris.

128 Jacques Henri Lartigue (French, 1894–1986). Lartigue is renowned for his photographic record of the Belle Epoque, accomplished while he was still a child. Later he made a series of photographs of films in progress by Abel Gance, Claude Renoir, François Truffaut and others. Copyright © Association des Amis de J.H. Lartigue, Paris.

129 William Coupon (American, b. 1952). Brassai was on Coupon's mind when he visited Studio 54 in Manhattan, but he was struck by the blatant exhibitionism of the dancers, in contrast to the Parisians, who seemed to cherish their privacy. These were the first photographs Coupon had ever taken. He has since gone on to become a well-known portraitist. Courtesy William Coupon, New York.

130 Brassai. The Bal de la Montagne Sainte-Geneviève was a Parisian dance hall. 'When the music wasn't playing', wrote Brassai, 'the place was like an ordinary popular dance hall . . . But when the band

launched into a java, a waltz, however, the ambiguity knocked one over. On the floors were only couples of men or couples of women . . . never a woman and a man . . . though women had always been allowed to dance together, men doing so was one of the forbidden pleasures.' Copyright© 1987 Gilberte Brassai, Paris.

131 Lynn Davis (American, b. 1944). Although Davis is best known for her remarkable nudes and singular studio portraits, the precision of her approach is also apparent in her candid work. Courtesy Lynn Davis, New York.

132 William Coupon. Courtesy William Coupon, New York.

133 Christina Yuin (American, born in Taiwan, 1950). Yuin used infra-red film for a series of photographs of New York nightlife in order not to startle the subjects. The grain was not intended and was, as she puts it, 'a bonus'. Courtesy Christina Yuin, New York.

V Collaborations

134–137 Baron Adolf de Meyer. As Lincoln Kirstein writes in *Nijinksy Dancing* (Thames and Hudson, London, 1975), 'There are no films of Nijinksy's performances, as there are of Pavlova's. But de Meyer's images communicate more of his essential authority than the wavering and fragmentary clips of the ballerina . . .' Courtesy Washburn Gallery, New York.

138–141 Arnold Genthe. In his introduction to the photographer's *The Book of the Dance*, Shaemus O'Sheel wrote 'The common pictorial error of arrested motion – motion cut into bits, petrified, mocked and denied – that you will not find here; but motion as it flows and is, as it creates, and is created.' Courtesy Anita Zahn Collection in the Isadora Duncan International Institute, New York (plates 138, 140, 141), and the Kay Bardsley Collection in the Isadora Duncan International Institute, New York (plate 139).

142–147 Charlotte Rudolph. When Wigman met Rudolph in 1925 the dancer's vision and style were mature. Hedwig Muller writes: 'Charlotte Rudolph's photographs were faithful . . . it is not, however, sure that their value is other than strictly documentary. Nevertheless they do powerfully echo the cultural and historical resonance of Expressionist dance.' The Dance Collection.

148–151 George Platt Lynes. Lynes did not agree that the depiction of movement was necessarily the first aim of dance photography: 'I am inclined to think that these attitudes (i.e. bodies in the air) are less suggestive of the dance as a whole than sedentary or relaxed poses.' See also plate 168. The Dance Collection.

152–155 Barbara Morgan. The photographer has written: 'My pictures are designed to arrest time and to capture the dance at its visual peak. Using still pictures, it is impossible to convey the emotion of thematic motion in literal sequence. The dance photograph must therefore select the most pregnant moments, and for emphasis make photographic use of lighting, scale and perspective. Yet it must not exaggerate or betray the spirit of the dance in the interests of sensational photography.' Courtesy Barbara Morgan, Scarsdale, New York. Copyright© 1972, 1979 Barbara Morgan.

156–60 Lois Greenfield (American, b. 1949). David Parsons began his career with Alvin Ailey and later became a leading dancer with the Paul Taylor Company. He has also choreographed numerous works and is currently forming his own company.

Daniel Ezralow has danced for Pilobolus, MOMIX and the Paul Taylor Company; he is currently with ISO, his newly formed company. With Greenfield, Ezralow and Parsons work towards, in her words, 'an imaginary dance that cannot be seen on stage. They are uniquely photographic events.' Courtesy Lois Greenfield, New York.

VI Tour-de-force

161, 162 Edward Steichen. According to Steichen, 'that visit to the Parthenon was the only time Isadora posed for photographs there. She always said she was so completely overwhelmed by what she felt there that she could not pose.' (Edward Steichen, *A Life in Photography*, Doubleday, New York, 1963). Courtesy the Kay Bardsley Collection in the Isadora Duncan International Institute, New York.

163, 164 Anonymous photographer; George Hoyningen-Huene. A number of photographers depicted Shawn in this piece betwen 1929 and 1942. Their approaches are fascinatingly varied. The Dance Collection.

165 Yvonne Chevalier (French, 1899–1982). Courtesy Bibliothèque Nationale, Paris.

166 Baron Adolf de Meyer. This bizarre study of an unidentified dancer was made in the same year as the photographer's work on *L'Après-midi d'un faune*. Courtesy The Metropolitan Museum of Art, The Alfred Stieglitz Collection, 1949.

167 Anonymous photographer. *Le Sphinx* (its full title was *La Rencontre, ou Edipe et le Sphinx*) was first performed by the Ballets des Champs-Elysées in 1948. The choreography was by Lichine and the decor was by Bérard. The ballet set the encounter between Oedipus and the Sphinx in a circus, allowing Babilée (b. 1923) to demonstrate his dazzlingly athletic technique. Leslie Caron (b. 1931) is a French-American dancer and actress, best remembered perhaps for her role in Gene Kelly's film *An American in Paris* (1951). Courtesy Stravinsky-Diaghilev Foundation. New York.

168 George Platt Lynes. The photographer restaged *Orpheus* in a private version for himself in which the roles were all danced by nude men. His treatment is softly romantic, in contrast to the earlier series (plates 148–151). Much of Lynes's private work had a strong homoerotic content which prevented it being exhibited in his lifetime. The Dance Collection.

169 Irving Penn. This remarkable and unorthodox study, which strikes a curious balance between still-life and dance photography, was made by Penn for *Vogue* in Paris shortly after Nureyev had defected to the west. Courtesy Irving Penn, New York. Copyright © 1964 (renewed 1974) by The Condé Nast Publications Inc.

170 Lois Greenfield. Bresciani is a young dancer best known for her revivals of works by Isadora Duncan. Courtesy the Kay Bardsley Collection in the Isadora Duncan International Institute, New York.

171 Anonymous photographer. St Denis was frequently photographed out-of-doors, but few of the results can be compared with the superb timing of this image. The Dance Collection.

172 Jan Unger (Czech, dates unknown). Nothing is known of the dancer or the occasion, but the image of a dancer in flight in the open is a favourite theme of Central European photography of the period. Courtesy Jaroslav Anděl, New York.

173 Anonymous photographer. This snapshot was taken shortly after Marie Rambert (1888–1982) had arrived in Paris from Warsaw. Courtesy Ballet Rambert, London.

174 George Platt Lynes. *Lilac Garden* (originally known as *Jardin aux Lilas*) is one of the best known ballets by Antony Tudor (see plate 208). Danced to music by Chausson and first performed in 1936, it is an intimate psychological drama of thwarted love. Maule (b. 1926) is a South-African-born dancer who pursued his career in America. After a debut on Broadway, he joined Ballet Theatre in 1947 and moved to the New York City Ballet in 1950. He has worked closely with Jerome Robbins, Alicia Alonso and many other choreographers. Courtesy Michael Maule. New York.

175 George Hoyningen-Huene. *Mozartiana* is a plotless ballet choreographed by Balanchine to music by Tchaikovsky; the decor was by Bérard. The ballet was first performed at the Théâtre des Champs Elysées in 1933. Jasinski (b. 1912), a Polish-American dancer, danced with the Ballets Russes de Monte Carlo 1933–50. Courtesy Harvard Theatre Museum.

176 Pierre Dubreuil (Belgian, 1872–?1944). This photograph was reproduced in *Vogue* in 1937, when the magazine commented: 'Although it looks exceedingly modern, partly because of the compositional device of the cello in the foreground and the ballet girl in the background, it was photographed long before the moderns were influenced by close-ups in Russian movies.' Courtesy The Condé Nast Publications Inc.

177 Wayne Albee (American, dates unknown). Humphrey (1895–1958) was one of the most important dancers to emerge from Denishawn. The performing group which she formed with Charles Weidman in 1928 championed modern dance as an independent art. No information is available on the photographer. The Dance Collection.

178 Witzel Studios, Los Angeles. Shawn's dance was subtitled 'the dance of a Cretan priest'. The Dance Collection.

179 Hugo Erfurth (German, 1874–1948). This magnificent study was taken at the time of Wigman's Munich debut. Erfurth was perhaps Europe's foremost portrait photographer of the early twentieth century. His work is an odd combination of modernist sympathies and a pictorialist manner. Courtesy Wilhelm Helg, Geneva.

180 Rudolf Koppitz (Austrian, 1884–1936). The background of this sombre study has been extensively worked by hand in this bromoil print, and one of the feet was drawn in by the photographer's wife. Koppitz was a respected Viennese photographer and teacher. Courtesy Collection of Penelope and Gerald Stiebel, New York.

181 Barbara Morgan. A previously unpublished photograph. Valerie Bettis (b. 1920) is an American dancer and choreographer who formed her own group in 1944. She has worked extensively for television. Courtesy Barbara Morgan, Scarsdale, New York.

182 Robert Mapplethorpe. Hines began his career as a tap dancer in tandem with his brother Maurice. He gave up dancing for a short period of song-writing and performing as a rock musician, but reappeared in 1978. Courtesy Robert Mapplethorpe, New York.

183 Soichi Sunami. This characteristically abstract treatment of Humphrey by Sunami was taken shortly after the dancer had founded her own company. Courtesy the Sunami family, New York.

184 Nickolas Muray (Hungarian, naturalized American, 1892–1965). Ito (1892?–1961) was a Japanese dancer who studied with Dalcroze 1912–14. Until World War II most of his career was spent in the USA; his poetic style was deeply influenced by Noh theatre and by his collaborations with W.B. Yeats and Ezra Pound. Muray is best known for his celebrity

portraits, but he made several dance studies of Graham, de Mille and St Denis among others. His work appeared regularly in *Vogue*, *Vanity Fair* and *Dance Magazine*. Courtesy International Museum of Photography at George Eastman House, Rochester, New York.

185 Lynn Davis. Michael Kessler is an American choreographer and dancer. Davis asks her subjects – who are not necessarily professional dancers – to collaborate with her in the studio. They are never posed according to preconceived notions, but move freely as Davis studies them. In this instance, Kessler's legs suddenly appeared to her 'as the legs of a doe'. Courtesy Lynn Davis, New York.

186 Irvin Penn. Merrill Ashley (b. 1950) joined the New York City Ballet in 1967 and became the company's principal dancer in 1977. She has created roles in ballets by Robbins and Balanchine. Penn's confinement of the dancer in the tight frame recalls the constructed corner of his Dolin study (plate 44). Courtesy *Vogue*. Copyright © Irving Penn 1986.

187 Jack Mitchell. Clark is shown in his costume for Louis Johnson's ballet *Lament*. As originally choreographed, this jump occurred behind two foreground dancers, but Mitchell found it so strong that he requested this version of Clark alone and encouraged him to jump higher and further open the split. Copyright © Jack Mitchell, New York.

188 Max Waldman. This photograph was taken shortly after Baryshnikov (b. 1948) had defected to the west in 1974. The high grain is characteristic of Waldman's work (see also plate 104). Copyright © Waldman Archives, Westport, Connecticut.

189 Gordon Anthony (British, b. 1902). Youskevitch (b. 1912) began his career as an athlete in Yugoslavia. He began to study dance in 1932 and from 1938 to 1943 was a soloist with the Ballets Russes de Monte Carlo, where he created roles in several Massine ballets; he was for long Alicia Alonso's regular partner. *Le Carnaval*, one of Fokine's finest ballets, was originally danced by Nijinksy (see plate 206). Anthony, one of Britain's best-known dance photographers, is the brother of the choreographer and dancer Ninette de Valois. Courtesy Robert and Joyce Menschel, New York.

190 Edward Steichen. A superbly timed image of the famous dancers Tony and Renée De Marcos, who were billed as 'America's No. 1 Ballroom Dance Team'; Harold Edgerton also took a series of photographs of them using shutter speeds of one-hundred-thousandth of a second. Courtesy *Vanity Fair*. Copyright © 1935 (renewed 1963) by The Condé Nast Publications Inc., New York.

191 André Kertész (Hungarian, naturalized American, b. 1894). Kertész arrived in Paris in 1925, and worked there for ten years as a photojournalist for such magazines as *Vu*, *UHU* and the London *Sunday Times*. This is one of his most celebrated images. Kertész has remarked that he said to the dancer, called Magda, '"do something with the spirit of the studio corner" and she started to move on the sofa. I took two

photographs. No need to shoot 100 rolls like people do today.' (*Kertész on Kertész*, ed. Anne H. Hoy, Abbeville Press, New York, 1986.)

192 Anonymous photographer. The Dance Collection.

193 Edwin F. Townsend (American, dates unknown). After Denishawn came to an end in 1932, Shawn established an All-Male Dancers Group in the following year, with which he made frequent tours of the USA. His choreography stressed workaday movements and warlike drills. The Dance Collection.

194, 195 André Kertész. These pictures are among several by Kertész taken of Nijinska rehearsing *Petrushka*, in which she had created a role in the original 1911 production. Courtesy Parmenia Migel Ekstrom, New York.

196 Soichi Sunami. Charles Weidman choreographed several witty, satirical dances for the Humphrey-Weidman company. *The Happy Hypocrite* retold Max Beerbohm's tale of Lord George Hell, whose dissolute life is reformed when he puts on the mask of a saint. Limón was one of Humphrey and Weidman's most important pupils (see plate 202). Courtesy the Sunami family, New York.

197 Man Ray (American, 1890–1976). This version of *Romeo and Juliet* was that choreographed by Nijinska and Balanchine for the Ballets Russes de Diaghilev in 1926; it was danced to music by Constant Lambert. Courtesy Parmenia Migel Ekstrom, New York.

198 František Drtikol. Drtikol had no interest in mirroring the physical world. Fascination with the oriental and the occult led him to a deeply personal photographic investigation that was heavily influenced by *Jugendstil* and Symbolism. He regarded shadow as not a secondary consideration but a material object as important as the subject itself. Courtesy Robert Miller Gallery, New York.

199 David Buckland (British, b. 1949). Siobhan Davies (b. 1950) is a dancer, choreographer and teacher who has worked with the London Contemporary Dance Theatre since it was founded in 1967. She formed her own group of dancers in 1981. Buckland is a well-known photographer of the British dance scene who has designed costumes and sets for Ballet Rambert and other companies. Courtesy David Buckland, London.

200 Anonymous photographer. The Dance Collection.

201 Lotte Jacobi (German, naturalized American, b. 1896). Jacobi was the fourth generation of her family to earn her living as a photographer. She moved to Berlin in 1928 where she photographed many of the leading dance personalities of her day, including Wigman, Kreutzberg, Trudi Schoop (see page 29) and Rolf Arco. This study of Bauroff, whom she particularly admired, is perhaps her finest photograph. Courtesy the Lotte Jacobi Negative Archive, Dimond Library, University of New Hampshire, Durham.

202 Walter Strate (American, dates unknown). José Limón (1908–72) began his career with the

Humphrey-Weidman company, for whom he both danced and choreographed. In 1947 he founded the José Limón American Dance Company, with Doris Humphrey as artistic co-director. The Dance Collection.

203 Soichi Sunami. For Kreutzberg, see plate 25. Sunami seldom used props which might distract from the focus on the dancer; his main concern was to forge a striking image of the dancer alone. Courtesy the Sunami family, New York.

204 Helmut Newton (German, naturalized Australian, b. 1920). Newton is well-known for his unorthodox approach to his fashion assignments. A dance pose allows him to show off the dress to maximum advantage; the gramophone makes the pose credible. Courtesy *Vogue*. Copyright © 1974 by The Condé Nast Publications Inc., New York.

205 Emil Otto Hoppé. Martha Graham began studying at Denishawn in 1916 and was a member of the Denishawn Dancers until 1923. Hoppé produced two versions of this picture: the soft, pictorial one shown here and a hard, crisp version. Courtesy The Mansell Collection, London.

206 Baron Adolf de Meyer. *Le Carnaval* was a pantomime ballet in one act by Fokine, first performed in 1910 in St Petersburg. Decor and costumes were by Bakst. 'The spectator is transported far from the realm of adamantine fact, and in a region of pure sentiment sees materialized the whole idea of carnival' wrote a contemporary (quoted in *The Russian Ballet* by A. E. Johnson, Houghton Mifflin Co., New York, 1913). The Dance Collection.

207 Arthur Elgort (American, b. 1940). Elgort is a noted fashion photographer who appreciates dance training in his models; when he sees a spontaneous movement and wishes it repeated for the camera, a dance-trained model is more easily able to oblige. They are also freer with their bodies. This photograph resulted from a session spent with Nina Federova, Heather Watts and Willy (Wilhelmina) Frankfurt at the School of American Ballet. When Frankfurt sat down for a rest, Elgort asked her to maintain her unposed position while he mounted a ladder to take the photograph. The light falling on her toe was apparently fortuitous, but it is crucial to the composition. Courtesy Arthur Elgort, New York.

208 Philippe Halsman. This photograph was shot for a *Life* magazine story called 'Tops in the Dance'. Balanchine is joined by two other great choreographers, British-born Antony Tudor (1908–87) and American Jerome Robbins (b. 1918). Ruthanna Boris (b. 1918) and Todd Bolender (b. 1914) were both stars of the New York City Ballet. Bolender appears to be still, but he was in fact in mid-leap; Balanchine's hand on Boris's foot not only suggests the choreographer's control over the dancer but may also be a reminder of the days when dancers needed props to hold their poses for long periods in the studio. The entire picture is a playful dig at dance photography as well as masterly portraiture. Courtesy Yvonne Halsman, New York. Copyright © Philippe Halsman.

Index

240